Introduction to the Environmental Humanities

In an era of climate change, deforestation, melting ice caps, poisoned environments, and species loss, many people are turning to the power of the arts and humanities for sustainable solutions to global ecological problems. *Introduction to the Environmental Humanities* offers a practical and accessible guide to this dynamic and interdisciplinary field.

This book provides an overview of the Environmental Humanities' evolution from the activist movements of the early and mid-twentieth century to more recent debates over climate change, sustainability, energy policy, and habitat degradation in the Anthropocene era. The text introduces readers to seminal writings, artworks, campaigns, and movements while demystifying important terms such as the Anthropocene, environmental justice, nature, ecosystem, ecology, posthuman, and non-human. Emerging theoretical areas such as critical animal and plant studies, gender and queer studies, Indigenous studies, and energy studies are also presented. Organized by discipline, the book explores the role that the arts and humanities play in the future of the planet.

Including case studies, discussion questions, annotated bibliographies, and links to online resources, this book offers a comprehensive and engaging overview of the Environmental Humanities for introductory readers. For more advanced readers, it serves as a foundation for future study, projects, or professional development.

J. Andrew Hubbell is Associate Professor of English at Susquehanna University, USA, and Adjunct Researcher at the University of Western Australia. His interests include nineteenth-century British literature, literary theory, climate narratives, empirical humanities, and new social movements. He is the author of *Byron's Nature: A Romantic Vision of Cultural Ecology* and *The Story of Transition in Western Australia: How Local Communities are Pioneering Sustainable Society*.

John C. Ryan is Adjunct Associate Professor at Southern Cross University, Australia, and Adjunct Senior Research Fellow at the Nulungu Institute, Notre Dame University, Australia. His interests include contemporary poetry, Indigenous Australian and Southeast Asian literature, ecomedia studies, and critical plant studies. He is the author of *Plants in Contemporary Poetry: Ecocriticism and the Botanical Imagination* (Routledge 2018) and co-editor of *Australian Wetland Cultures: Swamps and the Environmental Crisis*.

"J. Andrew Hubbell and John C. Ryan's *Introduction to the Environmental Humanities* is the best introduction to the fundamentals of the Environmental Humanities as a trans-disciplinary field. The book offers unchallenging explanations of the field's key concepts and theories, as well as compelling stories of humans, nonhumans, and environments to induce ecological awareness in the field's storied expanses."

– Serpil Oppermann, Professor of Environmental Humanities, Cappadocia University

Introduction to the Environmental Humanities

J. Andrew Hubbell and John C. Ryan

Routledge
Taylor & Francis Group

LONDON AND NEW YORK

First published 2022
by Routledge
2 Park Square, Milton Park, Abingdon, Oxon OX14 4RN

and by Routledge
605 Third Avenue, New York, NY 10158

Routledge is an imprint of the Taylor & Francis Group, an informa business

British Library Cataloguing-in-Publication Data
A catalogue record for this book is available from the British Library

Library of Congress Cataloging-in-Publication Data
Names: Hubbell, J. Andrew. author. | Ryan, John (John Charles) (Poet) author.
Title: Introduction to the environmental humanities / J. Andrew Hubbell and John
C. Ryan.
Description: Abingdon, Oxon ; New York, NY : Routledge, 2022. | Includes
bibliographical references and index.
Identifiers: LCCN 2021010136 (print) | LCCN 2021010137 (ebook)
Subjects: LCSH: Sustainability. | Energy policy. | Human ecology and the
humanities. | Environmental justice. | Climatic changes.
Classification: LCC HC79.E5 H794 2022 (print) | LCC HC79.E5 (ebook) | DDC
304.2--dc23
LC record available at https://lccn.loc.gov/2021010136
LC ebook record available at https://lccn.loc.gov/2021010137

ISBN: 978-0-815-39192-0 (hbk)
ISBN: 978-0-815-39193-7 (pbk)
ISBN: 978-1-351-20035-6 (ebk)

DOI: 10.4324/9781351200356

Typeset in Goudy
by SPi Technologies India Pvt Ltd (Straive)

Contents

Figures

Preface

Introduction to the Environmental Humanities

The Environmental Humanities is a relatively new, yet rapidly changing field of scholarship that integrates the perspectives of diverse disciplines—from anthropology, sociology, and geography to earth sciences to art, communications, ethnic and indigenous studies, history, literature, philosophy, religion, and theater. *Introduction to the Environmental Humanities* offers a practical, grounded, and accessible guide to the field designed for first- or second-year undergraduate students, but also useful to graduate researchers, environmental scholars, and general readers. The primary themes include climate change, sustainability, biodiversity, species loss, energy policy, the Anthropocene, environmental activism and justice, indigenous studies, and inter- and transdisciplinarity, as well as the role played by the arts and humanities in the future of the planet.

This book traces the evolution of the Environmental Humanities since the dramatic and global environmentalist turn in the post-WWII period, which took place in both academic and social settings. This historical context shaped the specific disciplinary debates out of which current practices in the Environmental Humanities emerged. Our purpose in organizing our *Introduction* around these disciplines is to ground beginning students and scholars in the history of the movement, enabling them to enter the latest multi-, inter-, and transdisciplinary research with an understanding of why they matter.

Environmental Humanities is both a product of and an agent in the radical reorganization of knowledge. In another context, we would strenuously defend this reorganization as necessary if we are to reorient human civilization away from its existential brink, a crisis caused in no small part by the knowledge-power divisions fomented since the Enlightenment. Yet students and teachers in academia are still enmeshed in this old knowledge order, with its disciplines, departments, silos, and specializations. An introductory Environmental Humanities course is likely to gather students who identify themselves by major and organize their thought by discipline. Its teachers are likely to be specialists housed in specific humanities departments. By organizing our *Introduction to the Environmental Humanities* around current disciplines, we appeal to where students and teachers are now. Historicizing the field will enable students to understand why our intertwined Anthropocene crises have required environmental humanists to develop inter-, multi-, and transdisciplinary approaches.

By acknowledging the field's disciplinary divisions and providing the means to integrate them, we also hope to enable as many opportunities to adopt this *Introduction* as possible. With a first chapter that surveys the Environmental Humanities as a whole, followed by two chapters that build essential knowledge in the science of climate change and the Anthropocene, then ten chapters detailing key disciplinary orientations, and a final chapter that opens out into the fractalization of study areas, *Introduction to the Environmental Humanities* can be

a main textbook for an introductory course. Its relatively short chapters can also be used to create part-term modules on the Environmental Humanities or supplement advanced courses within a wide range of disciplines and programs, from business and the social sciences to English, art history, and international studies.

Introduction to the Environmental Humanities assumes no prior knowledge of the key terms, concepts, theorists, and debates within the field. While recognizing the importance of the Environmental Humanities in US-Canadian, European, and Australia-New Zealand contexts, this *Introduction* provides numerous examples from African, Asian, South American, and Antarctican environments and cultures to achieve international reach and relevance. By means of this global emphasis, the text introduces readers to seminal writings, artworks, events, movements, ideas, legislation, and organizations to provide global literacy on environmental problems, actions, and solutions.

Each chapter starts with a real-world case study that provokes the questions and methods of environmental humanists. Subsequent sections contextualize the emergence of the field, offer instruction on how to practice it, and conclude with discussions of where the field is going now. Case Study, Reflection, and Waypoint boxes offer definitions, examples, current events, real-world debates and meditation on complex problems. At the end of each chapter, we offer exercises and projects that require students to use the skills and knowledge introduced by that chapter. An annotated bibliography and weblinks section in each chapter provide resources for further reading, completion of projects, and foundational knowledge in the field. While aimed at undergraduate readers, the extensive resources, global perspective, and discussion of emergent study areas will also be of interest to graduate researchers, established scholars, and the general public.

J. Andrew Hubbell,
Susquehanna University (USA) and
University of Western Australia (AU)

John Charles Ryan,
Southern Cross University (AU) and
the Nulungu Institute, Notre Dame University (AU)

Acknowledgements

The authors extend their sincere thanks to Rosie Anderson, Rebecca Brennan, and the Routledge team for supporting this project.

John C. Ryan acknowledges the School of Arts and Social Sciences at Southern Cross University, Australia, and the Nulungu Research Institute at the University of Notre Dame, Australia, for their encouragement. He dedicates this book to colleague and mentor Dr Rod Giblett, pioneer of the Environmental Humanities in Australia and founder of the field of critical wetland studies.

J. Andrew Hubbell wants to express deep gratitude to his mother for her lifelong support of his scholarship; his father who enjoyed hearing early drafts of chapters but did not live to see this book completed; and his mates everywhere who make life joyful. He thanks Dr Rod Giblett for his warm and supportive friendship. He dedicates this book to Melissa Frame, his wife, whose love, compassion, zest for our life together, enthusiasm for this project, and forbearance has shown him what beauty humans are capable of.

1 Introduction to the Environmental Humanities

History and theory

Chapter objectives

- To become familiar with the core aims of the Environmental Humanities (EH) and key terminologies used in the field
- To understand the historical roots of the Environmental Humanities in a number of disciplinary areas including art, history, and literature
- To appreciate the potential contributions of the field to practices and theories of sustainability in an age of environmental crisis

Book overview

Introduction to the Environmental Humanities consists of fourteen chapters structured around key debates in the emerging field of the Environmental Humanities (abbreviated as "EH" throughout this book). This introductory chapter will demonstrate how EH integrates dialogues between the humanities, arts, social sciences, and sciences. By crossing disciplines, EH fosters a variety of new approaches to thinking about the relationship between nature and culture as well as the urgencies of the ecological problems that face the planet (DeLoughrey et al. 2015, 9). Moreover, the current momentum of the field reflects its origins in the environmental movement in the 1960s and 1970s.

As an academic area, EH has emerged from environmental inquiry in particular disciplines. In this chapter, we will characterize EH as discipline-crossing. But we hope not to lose sight of the individual disciplines upon which the field is built. These include geography (Chapter 5), history (6), philosophy (7), religious studies (8), art (9), literature (10), theater (11), film (12), and media studies and journalism (13). Our position, as authors, is that a good understanding of disciplines is a cornerstone to appreciating environmental interdisciplinarity and its raucous relatives (see Waypoint 1.1). Your trans-, inter-, and multidisciplinarity will be more productive with a solid grounding in the core disciplines. Considerations of space limited our focus to disciplines that we consider integral to EH, but we hope that, after reading this, you'll be inspired to challenge us—what do you think we should have included?

Each chapter features real-world "Case Studies" that conclude with questions to stimulate your participation in the Environmental Humanities. We also include shorter "Reflections" that center on ethical questions that EH reveals. "Waypoints" summarize key background information. We use *waypoint* in its geographical sense as "an intermediate point along a route." EH is much like a trek through the mountains that are depicted in artist Wang Jian's painting in Figure 1.3. We're pleased that you've decided to join us! Tie your bootlaces and

DOI: 10.4324/9781351200356-1

let's get going! We'll start with the story of the auroch for what it shows about the necessity of interdisciplinary thinking for understanding complex social-environmental problems in the modern world.

Resurrecting the auroch

In 1627, the last lonely auroch died in the forests of Poland, extinguished by the now-familiar combination of overhunting, loss of habitat, and competition from domesticated species. Once common throughout Europe, Asia, and North Africa, they are now the extinct ancestors of domestic cattle. Genetically, however, they still live on. At every fast-food establishment across the globe, every hamburger contains a gamey hint of auroch. The ancient animal survives also in its flattering scientific name, *Bos taurus primigenius*, for "the original genius cow." And also in prehistoric art. Their hulking forms feature in the French cave paintings of Lascaux and Chauvet created over 17,000 years ago (Rokosz 1995, 6) (see Figure 1.1).

Surprisingly, the auroch story doesn't end with extinction. In the 1930s, the German zoo directors Lutz and Heinz Heck (who were affiliated with the Nazi party) made the first attempt to resuscitate the species through a process called *back-breeding* or, literally, breeding in reverse (Tanasescu 2017). After twelve years of toil, the brothers produced a breed known as Heck cattle, which didn't resemble aurochs much at all. Since then, efforts to revive the auroch have helped give birth to the science of *resurrection biology* or *species revivalism*. In 2015, for instance, a team led by biologist Stephen Park sequenced the first auroch genome, or complete set of genes, from a fossil specimen. Heck, is this a foretaste of a new episode of *Jurassic Park*, *Frankenstein*, or the *MaddAdam* trilogy?

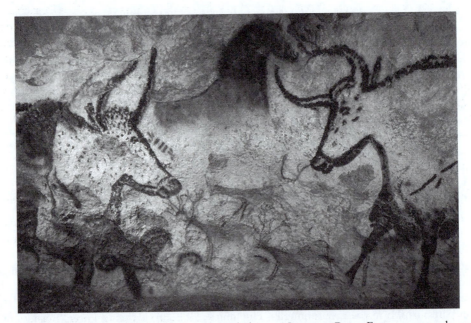

Figure 1.1 This painting of aurochs, horses, and deer at Lascaux Cave, France was made over 17,000 years ago.

Image credit: Wikimedia Commons.

Case Study 1.1 De-extinction

De-extinction is the use of cutting-edge genetic technologies to recover species that no longer exist. Those against it argue that funding should be used to conserve endangered species. Those in favor stress that humankind has a duty to reverse extinctions and restore the natural balance. Some proponents of de-extinction, moreover, support the value of *rewilding* the land with animals and plants from the past (Rewilding Europe n.d.). How do you feel about the issue? Consider the consequences for existing ecologies. Would other actions, perhaps those suggested by E. O. Wilson in his book *Half-Earth* (2016), be less risky?

What on earth are the Environmental Humanities?

Environmental historian Sverker Sörlin poses the question that most people ask when a literary, art, religion, history, or philosophy scholar starts analyzing topics like the auroch, traditionally considered to "belong" to the sciences: "what do the humanities have to do with the environment?" (2012, 788). A fair question. So, try this thought experiment: imagine you are a member of a committee tasked with investigating the benefits and risks of resurrecting *B.t. primigenius*. In order to take different interdisciplinary perspectives into account, your committee would need to include biologists, conservationists, economists, geneticists, geographers, and historians. Natural scientists would need to partner with philosophers. Anthropologists would need to collaborate with media experts to survey public opinion on the issue. Sociologists would work on identifying the possible social and cultural implications of reintroduction. Filmmakers would join forces with computer programmers to design virtual reality simulations of aurochs roaming the land once more. In other words, the auroch debate is fundamentally *interdisciplinary*. It demands that people from a range of disciplines listen to one another, participate in a lively dialogue, and contribute ideas to the decision-making process.

Waypoint 1.1 Crossing the divides between disciplines (CMIT)

EH practitioners often describe their work as *crossdisciplinary*, *multidisciplinary*, *interdisciplinary*, and/or *transdisciplinary*. Although these tongue-twisting terms tend to be used interchangeably, there are important differences between them. To begin with, keep in mind that the building blocks of these concepts are the *disciplines*—biology, history, philosophy, and so on—with their specialized forms of knowledge and well-defined methods. You can use the acronym **CMIT** to recall these four forms of working between and across disciplines.

Disciplines

- *Crossdisciplinary* means viewing a discipline from the perspective of another discipline (so, for instance, understanding biology through history, and vice versa).
- *Multidisciplinary* entails various disciplines working together toward a common goal.
- *Interdisciplinary* involves a blending of knowledge from numerous disciplines within the scope of a single project.
- *Transdisciplinary* goes one step further by melding perspectives to the extent that individual disciplinary stances seem to all but vanish.

Extinction, species resurrection, biodiversity, rewilding, urban-wildland interfaces, land development, and resource use are a few of the extremely complex issues that our civilization must understand and solve in order to sustain the health and wellbeing of current and future generations. Until recently those issues would be studied in different disciplines and the knowledge would stay isolated. But you can see how that approach can lead to catastrophic mishandling of even a relatively simple problem like whether to resurrect the auroch. The truth is we can't afford to look at problems in narrow ways anymore—we know too well that our existence is beset by all the unintended consequences of narrow-minded problem-solving.

A more coherent approach to problem-solving in the twenty-first century requires the disciplines to communicate with each other: to teach each other what they know and learn to see from other disciplinary perspectives. It may even require combining disciplines into a more holistic method of knowledge. EH aspires to that more holistic combination of disciplines. That gives us more complete, practical knowledge to address the complex social-environmental problems we face today.

The return of the auroch from the dead is but one example of the diversity of contemporary issues examined in the relatively new field of the Environmental Humanities. The field resists a view of the world that divides nature from humankind, weaving social, cultural, and ecological concerns together into a tapestry. The Environmental Humanities is the broad catch-all field (capitalized in this book) including environmental art, history, and other specialized fields. We hope *Introduction to the Environmental Humanities* will persuade you that *now* is an exciting time to be studying EH and the humanities in general.

To say the least, the complexities of environmental problems across the globe have become herculean. Genetic engineering, global warming, melting icecaps, rising seas, disappearing islands, climate refugeeism, plastic waste, water and air pollution, unsustainable logging, rainforest destruction, and biodiversity loss are some of the myriad issues that bombard us daily in the news and elsewhere. As Chapter 3 will explore in detail, scientists have even gone so far as to argue that human meddling with the biosphere since the beginning of the Industrial Revolution in the late eighteenth century has resulted in a new geological epoch, the Anthropocene, replacing the Holocene that began about 12,000 years ago (Zalasiewicz 2017).

Let's take a deep breath and look at a few statistics that point to the dire shape of the environment globally. Since 1970, humankind (not-so kindly) has wiped out 60% of mammals, fish, and reptiles (Carrington 2018). In 2018 alone, three bird species became extinct. These are the beautifully named cryptic treehunter (*Cichlocolaptes mazarbarnetti*) of Brazil, Alagoas foliage-gleaner (*Philydor novaesi*), also of Brazil, and po'o-uli (*Melamprosops phaeosoma*) of Hawai'i. Known as the world's rarest marine mammal, the vaquita is a type of porpoise with less than thirty individuals remaining in the wild (Figure 1.2). What's more, the endangered red wolf of the south-eastern United States could disappear by 2025.

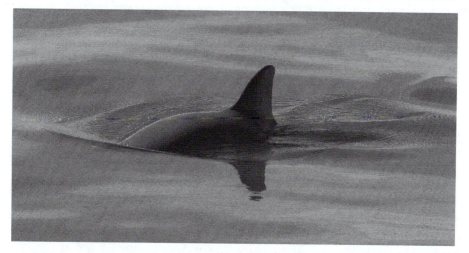

Figure 1.2 The vaquita (*Phocoena sinus*) is a critically endangered porpoise of the northern areas of the Gulf of California.

Image credit: Paula Olson, NOAA (Wikimedia Commons).

Sadly, the list grows and grows while statistics conceal the real consequences (material, emotional, spiritual, family-related) of species loss for people, communities, and nature. Each extinction is less life, diminishing the vibrant energy in our shared home. At the same time, the Earth is suffering from a serious fever. Each year is warmer than the previous while climate patterns have become ever more erratic and, in fact, pattern*less*, that is, lacking any rhyme or reason. According to the National Oceanic and Atmospheric Association (NOAA), the planet's surface temperature in 2018 was the fourth hottest since 1880 when official record-keeping began (NASA 2019). By all accounts, the warming trend is set to continue.

These statistics come from scientific disciplines such as biology, chemistry, and geology. So, what can the humanities tell us about the natural world? How on Earth can humanistic inquiry, with its traditional preoccupation with the human condition, save the vaquita and turn the tide of global ecological degradation? These are the kinds of questions explored in this book. In the Environmental Humanities, we are not just interested in possible solutions to some of the most urgent challenges of the twenty-first century. We also want to broaden the kinds of questions we *can* ask about the world and our place within it. Engaging our environmental condition is not simply about solving problems; it is about thinking differently so we can inhabit this planet differently.

Put simply, EH opens our eyes, minds, and hearts to the interconnections between all life in a radically changing world. Historian David Nye and his colleagues write that "scholars working in the Environmental Humanities are posing fundamentally different questions, questions of value and meaning informed by nuanced historical understanding of the cultures that frame environmental problems" (Nye et al. 2013, 28). They further comment that "major environmental problems result from human behaviors, as individuals and societies seek their version of a good life" (33). In contrast to the field of environmental studies, focusing on science and social science, the Environmental Humanities studies the natural world, environmental problems, and what "a good life" means for all living beings through the approaches of the arts and humanities.

In particular, EH highlights human behaviors, cultural values, historical patterns, social contexts, public attitudes, political ideas, religious beliefs, spiritual dimensions, moral concerns, and emotional registers (Nye et al. 2013, 4; Sörlin 2012, 788). As such, EH offers a deeper understanding of the human role in the global transformation that we hear about

almost nonstop on the Internet, social media, and television. The discipline-crossing emphasis of the field enables us to appreciate the intricate relationships between people, places, animals, plants, mushrooms, water, soil, land, and air (Tsing 2015). This appreciation oftentimes takes shape through the stories (or narratives) people and communities tell about the environment as well as the stories that the environment tells about itself in its own words (Griffiths 2007).

Waypoint 1.2 Defining the Environmental Humanities

Scholars of EH have outlined numerous characteristics of the field. Here are three for you to think about:

- *Discipline-crossing*: brings together expertise from a variety of perspectives (as in CMIT, which we discussed previously in this chapter)
- *Boundary-defying*: moves across national, cultural, and historical barriers
- *Policy-focused*: engages public policy and informs political decision-making (Nye et al. 2013, 8)

Before we delve further into the Environmental Humanities, it is essential to consider some of the lingo used in the field. So far in this chapter, we have seen that EH is not an academic discipline. It is a field of study that attempts to integrate different disciplines sharing a focus on the natural world and environmental issues. Nonetheless, *environment* is a thorny term chockful of contradictions. Just where is *the environment* located? Outside your house? Across the street? In your grandmother's kitchen? In a national park or other reserve? Anywhere one can encounter waterfalls, windstorms, and wild animals? Does experiencing the environment require jetting off to a faraway place, such as Antarctica, relatively free of human interference?

Reflection 1.1 An environmental issue

Select an environmental issue frequently reported in the media. How might a discipline-crossing, boundary-defying, and policy-focused strategy lead to solutions to the issue? If this question is stumping you, concentrate on one or two rather than all three at once. These characteristics will become clearer as we progress through the book.

For decades, scholars have struggled with *environment* and its elusive relatives like *nature*. Summarized in Waypoint 1.3, these terms refer to real phenomena (plants, animals, water, soil) but also to ideas, concepts, and principles. Criticisms of terms such as *environment* call attention to the role language plays in furthering the separation between nature (environment) and culture (humankind). Some EH writers have even resorted to creating their own words (known as neologisms) to describe the inseparability of non-humans/nature and humans/culture. Prominent feminist philosopher Donna Haraway (2003), for example, speaks of *naturecultures* whereas philosopher of science Bruno Latour refers to *nature-cultures* (Latour 1993, 7).

Waypoint 1.3 EH terminology

- *Ecology*: an area of biology exploring the relationships between organisms and their natural environments; the term comes from the Greek word *oikos* for "household"
- *Ecosystem*: a particular community of organic and inorganic elements interacting in a relatively stable manner over time (Tansley, 1935)
- *Environment*: the physical surroundings of an organism as well as a concept that links the local and regional to the planetary (Warde, Robin, and Sörlin 2018, 11-17)
- *Landscape*: a natural environment that humans have transformed, resulting in scenic views. Remember: "Landscape is a way of seeing the world" (Cosgrove 1998, 13)
- *More-than-human*: a world that is more than the home of human beings; an ethical concept that is prominent in animal studies and environmental law (Robin 2018, 7)
- *Nature*: a philosophical principle referring broadly to elements of the natural environment (plants, animals, water), often contrasted to culture (Soper 1995)
- *Natural World*: the natural environment as a whole, including organisms and their surroundings, often contrasted to human civilization (Thomas 1983)
- *Non-human*: an entity (organism or machine) that possesses some human qualities, such as the ability to communicate and respond to stimuli (Morton 2017)
- *Other-than-human*: subjects of study, especially in the discipline of anthropology, with will and determination but who are not human; common in studies of animism (Harvey 2013)

Reflection 1.2 Pinning down the language of EH

The nine terms listed in Waypoint 1.3 are not mutually exclusive but overlap to a great extent. For instance, *nature* and *the natural world* are often used interchangeably by EH scholars to refer to the global natural environment as a whole. Try applying the different terms to what you encounter in the world: a field, birds, the sky, your dorm room, a body of water. Does the right *word* help you understand your *world* better?

Historical roots of the Environmental Humanities

To tell the story of EH's origin, it might be useful to imagine that the prehistoric artists who painted the aurochs at Lascaux Cave in France were among the earliest practitioners of the Environmental Humanities (Figure 1.1). Presumably for them, nature and culture were not separate categories but, instead, were intertwined and informed each other continuously. The roots of EH, indeed, stretch deeply into the past and can be traced back to the pre-modern cultures of the West and the East (Estes 2017). The tradition of Chinese landscape painting, or *shan shui*, translated as "mountains and water," is an evocative example of the Environmental Humanities from an historical perspective. The seventeenth-century artist Wang Jian, for instance, depicted an awe-inspiring mountain scene in which huts blend harmoniously with the trees, rocks, and other features of the rugged landscape. The artwork represents the integration, or synthesis, of nature and culture that is at the heart of EH (Figure 1.3).

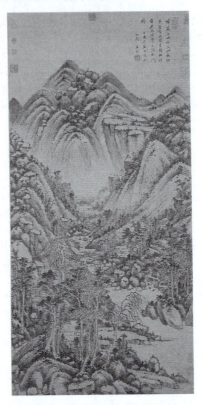

Figure 1.3 Wang Jian's ink illustration "Landscape in the Style of Huang Gongwang" (1657) is an early example of formative work in the Asian Environmental Humanities.

Image credit: Public Domain (https://www.metmuseum.org/art/collection/search/36100).

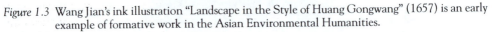

The history of the Environmental Humanities in the West (that is, in Western countries such as the United States, England, and Australia) often takes the form of a return to older ways of knowing nature that were displaced by Western science. As Bruno Latour (2004) argues, starting in the seventeenth century, Western science separated humans from nature, turning nature into a definable, controllable object of scientific knowledge. The starting premise of EH is that this separation is wrong, and so we can identify a set of influential texts, images, and moments that question this separation as part of the EH lineage.

Chief among them is writer-naturalist Henry David Thoreau's *Walden*, published originally in 1854, seven years before the beginning of the American Civil War. In the second chapter of *Walden*, "Where I Lived, and What I Lived For," Thoreau famously explained that "I went to the woods because I wished to live deliberately, to front only the essential facts of life, and see if I could not learn what it had to teach" (1910, 118). Although critical of American society (and sometimes just plain grumpy), Thoreau understood the natural world in hopeful terms as a living source of wisdom for people and culture. Ten years after the appearance of *Walden*, diplomat-turned-environmentalist George Perkins Marsh published *Man and Nature* (1864), a pioneering call for conservation and sustainability.

Moved by the writing of Thoreau and Marsh, forester Aldo Leopold proposed the idea of a "land ethic" in his classic study, *A Sand County Almanac* (1949). Leopold urged policy-makers to consider the natural world as a subject with rights and one to be treated ethically. Leopold's text was followed over two decades later by marine biologist Rachel Carson's *Silent Spring* (1962), a compelling warning about the dangers of pesticide use. From the mid-nineteenth

Figure 1.4 "The Blue Marble" (1972), Apollo 17, Color Photograph.
Image credit: Public Domain (Wikimedia Commons).

to the mid-twentieth centuries, these writings and a multitude of others helped to inspire the environmental movement of the 1960s and 1970s. During this time, environmental specializations within the disciplines of history, philosophy, and politics began to appear in university departments (Robin 2018, 4). In 1970, the first Earth Day celebrations took place across the United States while, in 1972, the crew of Apollo 17 snapped the iconic photograph, *The Blue Marble*, revealing the fragility and beauty of our planet (Nardo 2014) (Figure 1.4).

Reflection 1.3 The Blue Marble

In 1968, astronaut William Anders snapped the first photograph of the planet, *Earthrise*, during the Apollo 8 mission. These two images rank among the most influential in history. Research the effects of *Earthrise* and *The Blue Marble* on people around the globe. How do you feel when you look at images, such as these, of our watery planet seen from space?

The history of the Environmental Humanities parallels this emergence of the worldwide environmental movement, especially during the last fifty years. Its two emphases, one political-activist and the other scholarly-academic, often cross-fertilize each other, as evident, for example, in the Rio de Janeiro Earth Summit, also known as the Rio Conference, held by the United Nations in 1992. The summit aimed to balance environmental protection and economic development through the signing of a number of initiatives by participating nations (Van Dyke 2008, 74). It was partly inspired by and helped integrate decades of scholarship on Indigenous culture, humanistic revaluations of nature, and religious and artistic understandings of the environment. As reflected in the example of the Rio Conference, those working within the broad umbrella of EH have inspired public environmental consciousness and contributed

to changes at the global political level. While the sciences may be unmatched in describing environmental change and crisis, the humanities enable us to think more critically about the moral, ethical, social, and cultural dimensions of environmental change and crisis. They enable us to respond to ecological degradation and the dangers of human development and progress in ways that complicate, complement, and extend scientific inquiry. We will look at the ecological effects of human progress in Chapters 2 and 3 of this book.

As EH slowly emerged, it responded to the way the humanities disciplines have traditionally overlooked environmental dimensions through a strong focus on human experience (or what EH writers call *human pre-eminence*). Literary critics, for example, have traditionally viewed the environment as the static setting for staging human dramas. Since the 1990s, however, the emphasis has steadily begun to shift. An article in the *New York Times* from 1995 declared "the greening of the humanities." The phrase highlights a trend toward greater environmental consciousness in the teaching and study of the arts, humanities, and social sciences (Parini 1995). Feminist theorist Gayatri Chakravorty Spivak (2003), likewise, predicted a humanities "to come" that would be more environmentally attuned and less fixated on human ideals (6). Many EH scholars, therefore, define their purpose as *dehumanizing the humanities* by returning emphasis to the natural world and human–environment relations. This is what is meant by "decentering the human" (a phrase used frequently in the Environmental Humanities).

Case Study 1.2 The 10,000 year clock

Under construction inside a mountain in western Texas, the Clock of the Long Now is a monumental clock engineered to keep time for the next ten millennia. Once finished, it will be about 200 feet (61 meters) tall and will require a day's walk to reach. With more than 3.5 million possible musical combinations, the clock will produce a different chime each day for 10,000 years. Sunlight will warm up a sealed air chamber resulting in a pressure gradient that will drive a piston and supply power (Möllers 2014). For a technical account of the clock, see Hillis et al. (2011).

Designed by inventor Danny Hillis and author-activist Stewart Brand, the mammoth contraption reflects design principles of longevity, maintainability, transparency, evolvability, and scalability (The Long Now Foundation 2002, 2). The philosophy behind the project is that short-term thinking has got us into a global mess. The colossal clock is meant to remind us of the far-reaching consequences of our decisions. To echo virologist Jonas Salk's question, "Are we being good ancestors?" (Kelly n.d.).

After viewing the website, jot down your impressions of the Clock of the Long Now (http://longnow.org/clock). How might this unusual monument buried in a Texas mountain promote ideas of global environmental conservation?

A humanities to come? EH arrives

Since Spivak spoke over fifteen years ago of a "humanities to come," the Environmental Humanities has arrived with verve. Reflecting its historical roots, EH is a dynamic discipline-crossing field that combines academic scholarship with environmental activism. This doesn't mean that you will have to chain yourself to a bulldozer in an old-growth forest threatened by logging (though we won't stop you). Nor will you need to board a ship bound for Antarctica to protest commercial whaling. But it does mean that, at some point in your exploration of the field, you will most likely find yourself speaking on behalf of the natural

world and engaging with communities of all kinds, including humans *and* more-than-humans. (See Waypoint 1.3 in this chapter for more about the differences between those tricky terms.)

Reflection 1.4 Environmental activism

The Dakota Access Pipeline protests of 2016–17 were initiated by LaDonna Brave Bull Allard in opposition to the construction of an oil pipeline near the Standing Rock Indian Reservation in North Dakota. Chapter 4 will present a case study of this protest, one of the most significant in American history. Many people are uncomfortable with activism: it is disruptive and may often seem angry and anarchic.

What are your general impressions of environmental activism? How do you define activism? Do you consider yourself an activist? If so, what kinds of activism do you take part in? Check out this website for assumption-busting ideas: https://ideas.ted.com/tag/activism/.

The last twenty-five years in particular have seen an upsurge of activity in the Environmental Humanities worldwide. Undergraduate and graduate programs have been created at universities in North America, Europe, Asia, Africa, Australia, and elsewhere. Collaborative research centers dedicated to the field have begun to appear. For example, based in Munich, Germany, the Rachel Carson Center for Environment and Society, named after the author of *Silent Spring*, is "an international, interdisciplinary center for research and education in the environmental humanities and social sciences" (RCC n.d.). What's more, located in Sweden but reaching across the globe, the Seed Box is an EH research hub focused on creating "an interface between academia and other parts of society" (The Seed Box n.d.). Scholarly journals, such as *Environmental Humanities*, *Green Humanities*, *Resilience*, and *Landscapes*, publish the latest research in the field.

In Australia, the field is known as the *Ecological Humanities* and is distinctive for its attention to Aboriginal Australian cultures. In 2004, anthropologist Deborah Bird Rose and historian Libby Robin published one of the earliest articles to define the field as it relates to Australia (Rose and Robin 2004). Taking their lead, we want to emphasize that EH-related teaching, research, and activism are not restricted to Western nations, but embrace cultural, geographical, and biological diversities. In order to showcase that diversity, we now turn to three case studies from South America (the rights of nature), Southeast Asia (sustainable cities), and the Antarctic (ecotourism). The proof of global momentum in the Environmental Humanities is in this kind of dynamic, cross-fertilizing critical inquiry.

Case Study 1.3 Ecuador and the rights of nature

In 2008, the South American country of Ecuador became the first nation in history to recognize officially the rights of nature in its constitution. Prior to this, the idea of nature having rights existed on the radical fringes of politics where it was not taken seriously. The Ecuadorian politician and activist Alberto Acosta played an important part this landmark event. In a number of papers published on the website of the Constitutional Assembly, he used Aldo Leopold's idea of the "land ethic" to make a case for the fundamental rights of nature (Tanasescu 2013).

The Constitution lists four articles, numbered 71 to 74, under the heading, "The Rights of Nature." The first article states that "Nature, or Pacha Mama, where life is reproduced and occurs, has the right to integral respect for its existence and for the maintenance and regeneration of its life cycles, structure, functions and evolutionary processes" (Republic of Ecuador, 2008, Title II, Chapter 7). Referencing *Pacha Mama*, the Andean fertility goddess, article 71 acknowledges the importance of Indigenous people. Article 72 goes on to state that nature has a "right to be restored." Article 73 places limits on the extinction of species and the destruction of ecosystems. Read the Constitution to find out what Article 74 says.

Do you think that nature has rights? What sorts of issues might come up if your country were to formally recognize nature's rights within its constitution?

Case Study 1.4 The Garden City of Singapore

Singapore is a city-state about half the size of London. Known as the Garden City and spread out over 64 islands, it has become one of the greenest cities in the world, despite being almost 100% urbanized. Environmentally friendly design has been compulsory since 2008. Vegetation lost to development is replaced by greenery in high-rise gardens. The tallest public housing complex in the world, the Pinnacle@Duxton, contains seven buildings linked by garden walkways (Figure 1.5). Cheong Koon Hean, the first woman in charge of the nation's urban development agency, has been a major force behind this vision of Singapore as sustainable (Kolczak 2017).

Singapore's futuristic Gardens by the Bay opened in 2012. Critics have described the massive project as a "sci-fi super-garden" (Lim 2014, 443). The nature park consists of three waterfront gardens, including the Cloud Forest with its enormous 115-foot (35-meter) waterfall. The biggest of the three, Bay South Garden, features Flower Dome, the largest greenhouse in the world, and Supertree Grove with its solar-powered tree statues up to 16 stories high (Figure 1.6). The project aims to minimize environmental impacts through a number of strategies, such as the circulation of rainwater to cool the structure.

What are your first impressions of Gardens by the Bay? How might this "sci-fi super-garden" promote environmental awareness in Southeast Asia and elsewhere? Does Singapore represent a new harmony between humans and nature, or just another technofantasy?

If you really want to dive into this question, look here: http://factsanddetails.com/southeast-asia/Singapore/sub5_7a/entry-3795.html.

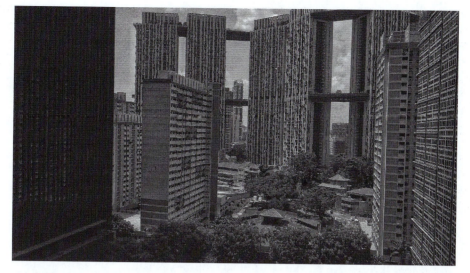

Figure 1.5 The Tanjong Pagar Housing Estate in Singapore is shown with the Pinnacle@Duxton in the background.

Image credit: Bob T. (Wikimedia Commons, 2019).

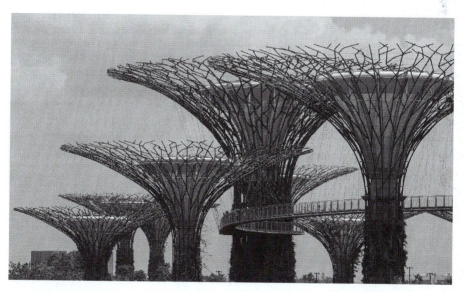

Figure 1.6 The Supertree Grove in The Gardens by the Bay is located in Singapore, an increasingly green Southeast Asian nation.

Image credit: CEphoto, Uwe Aranas (Wikimedia Commons 2015).

Case Study 1.5 Ecotourism in the Antarctic

Ecotourism is a form of alternative tourism that is more sensitive to the social, cultural, and ecological features of a destination. Keen for adventure, ecotourists travel to places to learn more about the ecosystems there. They often participate in low-impact

activities such as trekking, cycling, swimming, and birdwatching. What's more, eco-tourists sometimes volunteer on conservation projects while staying in a country or region. A premier destination for a segment of ecotourists is the southernmost conti-nent on the planet, Antarctica. This largest area of wilderness left in the world lacks permanent human settlement and is covered by an ice sheet 1.3 miles (2.1 kilometers) thick on average.

Over 50,000 people head to Antarctica each year during the summer season from October to February. The continent is managed by the Antarctic Treaty System of 1959, which sets out guidelines for conservation and research. Typical ecotourism activities are wildlife viewing and photography, soaking in hot springs, and gazing at the frigid landscape from the comfort of an icebreaker (Fennell 2003, 181–183). Antarctic ecotourism, nonetheless, is not always free of ecological impacts. For exam-ple, a musician on an ecotour once scared off a waddle of penguins with his first Antarctic flute performance (Fennell 2003, 183). In addition, there is the question of waste and sewage generated by 50,000 people using carbon-intensive transportation, and the disturbance of landscapes and animal ecologies unused to human intruders.

Should ecotourism in Antarctica be allowed? Or should the last wilderness on Earth be left alone?

Chapter summary

This chapter has introduced the core aims and key terminologies of the Environmental Humanities. We traced the historical roots of EH to a number of disciplinary areas, including art, history, and literature, and showed how the history of EH parallels the development of the worldwide environmental movement during the last fifty years. We described the way EH has responded to the various environmental concerns that humanities disciplines have overlooked because of their traditional focus on the human. The upsurge of worldwide EH activity in the last twenty-five years reflects an increasing awareness among scholars of the importance of balancing scientific and technological solutions to environmental problems with the approaches of the humanities, art, and social sciences. We concluded with three case studies that demonstrate the importance of humanities perspectives on ecological problems.

Exercises

1. Select a current environmental issue that is affecting your town, city, or region. Describe the effects of this issue at three scales: local, national, and global. Write a brief summary.
2. The Environmental Humanities focuses on stories of people and place. Find a story from your local newspaper about your town, city, or region. The story could be of the past, present, or future. Examine the human (cultural) and more-than-human (natural) ele-ments of the story. Evaluate the story's balance of nature and culture—is nature just a setting or a dynamic agent of change? What are the implications for how your newspaper represents human–nature relationships?
3. The Environmental Humanities makes the bold suggestion that the environment is able to tell its own stories. Return to the story you selected for Exercise 2. Consider what the story would be like if told from the perspective of the environment. The story could be told by an animal, plant, rock, river, ocean, or the planet as a whole.

4. The idea of community is central to the Environmental Humanities. Yet, we have shown in Chapter 1 that humans are not the only members of communities. Think of a community you are currently part of. It could be a school, work, civic, or sporting community. Describe the human, non-human, and more-than-human participants.

5. The crossing of disciplines is essential to EH. Get in touch with a friend, colleague, or family member from a different discipline to your own. Perhaps your sister-in-law is a computer scientist and you are an artist. Perhaps your mother is an architect and you are a social worker. Talk with her for 15 minutes about her discipline and what that discipline presumes about the environment. Compare her discipline's presumptions about the environment to your own. How might the two disciplines be combined? What would the advantages and disadvantages be of that synthesis?

Annotated bibliography

Abram, David. 1997. *The Spell of the Sensuous: Perception and Language in a More-than-Human World.* New York: Vintage. This classic work in an area of philosophy known as *phenomenology* suggests that written language is an instrument that divides human beings from the natural environment. Abram explores the sensuous relationship between Indigenous people and the natural world. He contrasts this experience to the separation from the environment central to cultures with written languages.

Adamson, Joni, and Michael Davis, eds. 2017. *Humanities for the Environment: Integrating Knowledge, Forging New Constellations of Practice.* New York: Routledge. This volume begins with a consideration of the Anthropocene and includes contributions on a range of geographies, ecosystems, climates, and social contexts. The book includes sixteen chapters divided into three sections: "Integrating Knowledge, Extending the Conversation;" "Backbone;" and "Country," all of which touch on prevailing themes in the field.

Cronon, William, ed. 1996. *Uncommon Ground: Rethinking the Human Place in Nature.* New York: W.W. Norton. In this landmark study, historians, critics, and scientists call into question the idea of wilderness that has been pivotal to the American conservation movement. The contributors argue that wilderness as not a solution to the global ecological predicament. Rather than focusing on wilderness preservation exclusively, environmentalists should help people acquire the skills needed to live sustainably on the planet.

DeLoughrey, Elizabeth, Jill Didur, and Anthony Carrigan, eds. 2015. *Global Ecologies and the Environmental Humanities: Postcolonial Approaches.* New York: Routledge. This edited collection focuses on the relationship between the history of globalization and imperialism on environmental issues and their representation. The chapters by noteworthy scholars in EH discuss climate change, militarism, deforestation, petrocapitalism, and the commodification of nature through a postcolonial lens.

Emmett, Robert, and David Nye. 2017. *The Environmental Humanities: A Critical Introduction.* Cambridge, MA: MIT Press. Drawing from current research, concepts, examples, and case studies, this book is a genealogy of the Environmental Humanities in European, Australian, and American contexts. The text includes ideas of postcolonialism, animal studies, queer ecology, and new materialism.

Heise, Ursula, Jon Christensen, and Michelle Niemann, eds. 2017. *The Routledge Companion to the Environmental Humanities.* New York: Routledge. With 45 contributions from leading Environmental Humanities scholars today, this edited collection examines the complex transnational and interdisciplinary scope of EH scholarship. Sections address the Anthropocene, posthumanism, multispecies theory, environmental justice, environmental history, environmental arts (including media and technology), and future directions for the field.

Kornfeldt, Torill. 2018. *The Re-Origin of the Species: A Second Chance for Extinct Animals.* Melbourne: Scribe Publications. This is a timely study of the genetic science known as *resurrection biology.* Written by a science journalist, the book examines the benefits and risks of bringing extinct species back to life.

Merchant, Carolyn. 1980. *The Death of Nature: Women, Ecology, and the Scientific Revolution*. San Francisco: Harper & Row. Written from an ecofeminist perspective, this seminal study highlights the role of gender in the history of science. Merchant argues that the Scientific Revolution put in place a mechanistic view of the world that now underlies the interlinked exploitation of nature and women.

Oppermann, Serpil, and Serenella Iovino, eds. 2016. *Environmental Humanities: Voices from the Anthropocene*. Lanham, MD: Lexington Books. Featuring notable scholars in the Environmental Humanities, this edited volume addresses themes of environmental history, transdisciplinarity, ecofeminism, ecocriticism, environmental justice, environmental ethnography, and so forth.

Weblinks

Environmental Humanities. This leading journal in the field features open-access articles free to download. www.environmentalhumanities.org

Intervention: An EHL Podcast. These twelve podcasts were produced by the KTH Environmental Humanities Laboratory at the Royal Institute of Technology (KTH) in Stockholm, Sweden. www.kth.se/en/abe/inst/philhist/historia/ehl/ehl-intervention-pod

Penn Program in the Environmental Humanities, Penn Sustainability. This is one of the leading EH programs in the United States. www.sustainability.upenn.edu/partners/penn-program-environmental-humanities

The Aurochs: Europe's Defining Animal. Rewilding Europe. This online resource provides more about the auroch debate discussed earlier in this chapter. https://rewildingeurope.com/rewilding-in-action/wildlife-comeback/tauros/

The Environmental Humanities, High Meadows Environmental Institute. This institute features guest lectures by leading figures in the field. environment.princeton.edu/research/environmental-humanities/

Welikia Project. Welcome to New York City, 1609, Beyond Mannahatta. The Welikia Project is a cutting-edge example of using digital technologies in the Environmental Humanities. www.welikia.org/explore/mannahatta-map

What Is the Environmental Humanities? University of California at Los Angeles, Environmental Humanities Program. This website provides a useful introduction to the field. environmental.humanities.ucla.edu/?page_id=52

References

Carrington, Damian. 2018. "Humanity Has Wiped Out 60% of Animal Populations Since 1970, Report Finds." *The Guardian* October 29.

Carson, Rachel. 1962. *Silent Spring*. Boston: Houghton Mifflin.

Cosgrove, Denis. 1998. *Social Formation and Symbolic Landscape*. Madison: University of Wisconsin Press.

Estes, Heide. 2017. *Anglo-Saxon Literary Landscapes: Ecotheory and the Environmental Imagination*. Amsterdam: Amsterdam University Press.

Fennell, David. 2003. *Ecotourism: An Introduction*. 2nd ed. London: Routledge.

Griffiths, Tom. 2007. "The Humanities and an Environmentally Sustainable Australia." *Australian Humanities Review* 43. http://australianhumanitiesreview.org/2007/03/01/the-humanities-and-an-environmentally-sustainable-australia/.

Haraway, Donna. 2003. *The Companion Species Manifesto: Dogs, People, and Significant Otherness*. Vol. 1. Chicago: Prickly Paradigm Press.

Harvey, Graham, ed. 2013. *The Handbook of Contemporary Animism*. London: Routledge.

Hillis, Danny, Rob Seaman, Steve Allen, and Jon Giorgini. 2011. "Time in the 10,000-Year Clock." *arXiv.org* December 13.

Kelly, Kevin. n.d. *"The 10,000 Year Clock."* Accessed March 3, 2019. http://longnow.org/clock/.

Kolczak, Amy. 2017. "This City Aims To Be the World's Greenest: As Singapore Expands, A Novel Approach Preserves Green Space." *National Geographic* February 28. https://www.nationalgeographic.com/environment/urban-expeditions/green-buildings/green-urban-landscape-cities-Singapore/.

Latour, Bruno. 1993. *We Have Never Been Modern*. Translated by Catherine Porter. Cambridge: Harvard University Press.

Leopold, Aldo. 1949. *A Sand County Almanac: And Sketches Here and There*. Oxford: Oxford University Press.

Lim, Eng-Beng. 2014. "Future Island." *Third Text* 28 (4–5): 443–453. doi: 10.1080/09528822.2014.929879.

Marsh, George Perkins. 1864. *Man and Nature; Or, Physical Geography As Modified by Human Action*. New York: Charles Scribner.

Möllers, Nina. 2014. "*Clock of the Long Now*." Accessed March 3, 2019. http://www.environmentand-society.org/exhibitions/anthropocene/clock-long-now.

Morton, Tim. 2017. *Humankind: Solidarity with Non-Human People*. New York: Verso Books.

Nardo, Don. 2014. *The Blue Marble: How a Photograph Revealed Earth's Fragile Beauty*. North Mankato: Compass Point Books.

NASA. 2019. "2018 Fourth Warmest Year in Continued Warming Trend, According to NASA, NOAA." Accessed March 1, 2019. https://climate.nasa.gov/news/2841/2018-fourth-warmest-year-in-continued-warming-trend-according-to-nasa-noaa/.

Nye, David, Linda Rugg, James Flemming, and Robert Emmett. 2013. *The Emergence of the Environmental Humanities*. Stockholm: Mistra.

Parini, Jay. 1995. "The Greening of the Humanities." *New York Times* October 29. https://www.nytimes.com/1995/10/29/magazine/the-greening-of-the-humanities.html.

Rachel Carson Center for Environment and Society (RCC). n.d. "*About the Rachel Carson Center for Environment and Society*." Accessed March 4, 2019. https://www.carsoncenter.uni-muenchen.de/about_rcc/index.html.

Republic of Ecuador. 2008. "*Constitution of the Republic of Ecuador*." Accessed March 4, 2019. http://pdba.georgetown.edu/Constitutions/Ecuador/english08.html.

Rewilding Europe. n.d. "*Making Europe a Wilder Place*." Accessed March 4, 2019. https://rewilding-europe.com/.

Robin, Libby. 2018. "Environmental Humanities and Climate Change: Understanding Humans Geologically and Other Life Forms Ethically." *WIREs Climate Change* 9 (1): 1–18. doi: 10.1002/wcc.499.

Rokosz, Mieczysław. 1995. "History of the Aurochs (*Bos taurus primigenius*) in Poland." *Animal Genetic Resources Information* 16: 5–12. doi: 10.1017/S1014233900004582.

Rose, Deborah Bird, and Libby Robin. 2004. "The Ecological Humanities in Action: An Invitation." *Australian Humanities Review* 31–32. http://australianhumanitiesreview.org/2004/04/01/the-ecological-humanities-in-action-an-invitation/.

Soper, Kate. 1995. *What is Nature? Culture, Politics, and the Non-Human*. New York: John Wiley & Sons.

Sörlin, Sverker. 2012. "Environmental Humanities: Why Should Biologists Interested in the Environment Take the Humanities Seriously?" *BioScience* 62 (9): 788–789.

Spivak, Gayatri Chakravorty. 2003. *Death of a Discipline*. New York: Columbia University Press.

Tanasescu, Mihnea. 2013. "The Rights of Nature in Ecuador: The Making of an Idea." *International Journal of Environmental Studies* 70 (6): 846–861. doi: 10.1080/00207233.2013.845715.

Tanasescu, Mihnea. 2017. "The Quest To Revive Extinct Aurochs To Restore Ancient Lands." *The Conversation* October 6. https://theconversation.com/the-quest-to-revive-extinct-aurochs-to-restore-ancient-lands-84649.

Tansley, Arthur. 1935. "The Use and Abuse of Vegetational Concepts and Terms." *Ecology* 16 (3): 284–307.

The Long Now Foundation. 2002. *The Clock of The Long Now: Mechanical Drawings and Assemblies*. San Francisco: The Long Now Foundation.

The Seed Box. n.d. "*About Us*." Accessed March 4, 2019. https://theseedbox.se/about-us/our-mission/.

Thomas, Keith. 1983. *Man and the Natural World: Changing Attitudes in England 1500–1800*. London: Penguin Books.

Thoreau, Henry David. 1910. *Walden*. New York: Thomas Y. Crowell. Original edition, 1854.

Tsing, Anna Lowenhaupt. 2015. *The Mushroom at the End of the World: On the Possibility of Life in Capitalist Ruins*. Princeton: Princeton University Press.

Van Dyke, Fred. 2008. *Conservation Biology: Foundations, Concepts, Applications*. 2nd ed. Berlin: Springer Science and Business Media.

Warde, Paul, Libby Robin, and Sverker Sörlin. 2018. *The Environment: A History of the Idea*. Baltimore: Johns Hopkins University Press.

Wilson, E. O. 2016. *Half-Earth: Our Planet's Fight For Life*. New York: Liveright.

Zalasiewicz, Jan. 2017. "The Extraordinary Strata of the Anthropocene." In *Environmental Humanities: Voices from the Anthropocene*, edited by Serpil Oppermann and Serenella Iovino, 115–131. London: Rowman & Littlefield.

2 Climate change

The great disrupter

Chapter objectives

- To summarize the science of climate change and define important concepts
- To distinguish the key reasons we debate climate change
- To identify the important contributions that the Environmental Humanities makes to understanding and addressing climate change
- To provide case studies, data, projects, additional resources, and inspiring stories that empower you to address climate change

More than an inconvenient truth

Climate scientists record and measure changes to the physical operation of the Earth's systems. Based on sixty years of accumulated evidence, the top association of climate scientists, the Intergovernmental Panel on Climate Change (IPCC), declared that:

> human influence on the climate system is clear, and recent anthropogenic emissions of green-house gases are the highest in history. Recent climate changes have had widespread impacts on human and natural systems. Warming of the climate system is unequivocal, and since the 1950s, many of the observed changes are unprecedented over decades to millennia. The atmosphere and ocean have warmed, the amounts of snow and ice have diminished, and sea level has risen.
>
> IPCC (2014, 2)

Complex in its details, but simple in its conclusions, the scientists are telling us that humans have altered the climate system in fundamental, long-lasting ways, with consequences we can deduce but cannot know definitively—until they break upon us.

And yet, many people continue to debate this issue, believing that it is controversial or too complicated to understand. Almost all of the uncertainty can be traced to disinformation campaigns by industry groups dedicated to distorting the science and manipulating people's fears and prejudices. For example, the Nongovernmental International Panel on Climate Change (NIPCC), an organization of climate deniers funded by fossil fuel companies, claims that:

DOI: 10.4324/9781351200356-2

the IPCC has exaggerated the amount of warming they predict to occur in response to future increases in atmospheric CO_2. Any warming that may occur is likely to be modest and cause no net harm to the global environment or to human well-being.

Idso et al. (2013, 3)

Is climate change the greatest crisis humanity has ever faced or an exaggeration that is unlikely to cause much harm? Who or what is responsible? What, if anything, can we, should we, do about it?

According to recent data from the Yale Program on Climate Change Communication, almost 60% of Americans are "alarmed" or "concerned" about climate change; only 10% deny its existence (Yale 2020). Yet the perception in most English-speaking countries is that climate change is a debatable issue that you "believe" in or not—why?

Climatologist Mike Hulme argues that we disagree about climate change because climate is both a physical phenomenon and a set of cultural ideas (Hulme 2009, xxv–xxvii). Our discussions about the physical phenomenon are filtered through our ideas about what climate means for us—is it a threat, a challenge, a blessing, the determining force of our national character? To make sense of the complications, it is important to understand climate as a physical phenomenon and as an idea that has evolved through history in different cultures. This is where the Environmental Humanities plays a vital role: our specific disciplines are built to understand why an idea is meaningful to a particular culture at a particular time.

How do you feel about climate change? Is it something you fear, brave, enjoy, or ignore? Do you feel it is largely out of your control, or that everyone should do their little bit? Are you confident that someone will invent a technology to solve the problem and that governments will protect us? Feel sad that we've destroyed nature, or angry about the careless arrogance of our species? Underneath your answer is a belief about how humans relate to the natural world.

Case Study 2.1 Greta Thunberg

Greta Thunberg, a young Swedish woman born in 2003, began boycotting school in 2018 to protest Swedish inaction on climate change. At first, she was unable to convince any of her friends to join her, so she protested alone. But by March 2019, she had inspired 1.4 million students around the world to join her, the largest EU school strike in history. Since then, she has spoken before the British Parliament, been featured on the cover of *Time* magazine, and been nominated for a Nobel Peace Prize.

Thunberg's activism started small. She made her own commitment to cut carbon and then persuaded her family, friends, and teachers to make commitments. What is your circle of influence? How could you leverage your personal example to persuade your family, friends, and teachers? Could this be effective?

Here's what we think: we're scared! (Andrew had nightmares while researching this chapter.) For us, a changing climate represents a threat to the things we enjoy, the places and creatures we love, and a reminder that our privilege, freedom, and luxury are made possible by massive carbon emissions—our own and the economic systems on which we depend. And we can't escape what those systems do in our name! We also know that we won't pay too much of a price for our high carbon lifestyles—but we know a lot of people who will: our students; our children, nieces, and nephews; friends and acquaintances on islands, in coastal regions,

and the southern hemisphere, particularly those who are poor and Indigenous. We feel guilty, responsible, grief-stricken, angry, frustrated. Our idea of climate change has caused us to change our lifestyles, change our research interests and the direction of our careers, make difficult moral choices between what we want and what we must limit ourselves to. It is also a driver behind writing this book. What might your idea of climate change make you do?

Case Study 2.2 Youth Climate Activism and Intergenerational Justice

Future Coalition, US Youth Climate Strike, Sunrise Movement, Our Climate Voices, Climate Reality, and Extinction Rebellion, Greenpeace, Sierra Club, 350.org, and Friends of the Earth all have powerful youth coalitions (search their names online). In 2015, one group, Our Children's Trust, sued the US government, claiming "that, through the government's affirmative actions that cause climate change, it has violated the youngest generation's constitutional rights to life, liberty, and property, as well as failed to protect essential public trust resources" (www.ourchildrenstrust.org/juliana-v-us). The lead plaintiff, Kelsey Juliana, a twenty-three-year-old college student in 2019, thinks climate change is an issue of intergenerational justice. Although current and previous generations caused climate change, only children and future generations will experience the harmful effects of their actions. That injustice means the younger generation can claim damages against adults living today, particularly those in business and government who are knowingly directly responsible for blocking climate change mitigation. See #Iamjuliana.

Do you think climate change is an issue of intergenerational justice? Or is dealing with the previous generation's mistakes just something every generation must face? What should older people do now? What should young people do?

In this chapter, we are going to ask you to reflect on what you think and feel about climate change. Both are important, not only because the topic is something all people should know about, but also because the science indicates that you will be directly, massively affected. Climate change is "the great disrupter," altering our expectations for what the future holds. Those who learn about climate change can make good choices now to prepare for an uncertain future. Knowledge is power.

Let's start with the physical phenomenon. Then we can compare the way environmental humanists look at the issue. Finally, we can examine a few of the specific issues that EH addresses, how it addresses them, and why EH's contributions are important.

Waypoint 2.1 Climate fatigue and other terms

Tired of hearing about this crap? Tuning out to what seems hopeless? Well, you can diagnose your condition: "climate fatigue." It's the state of having heard this story too many times, combined with the justifiable fear that you can't do much about it and the unjustified hope that maybe it won't be so bad.

That latter delusion is fed by "organized climate skepticism," a cabal of corporations, media, and conservative interest groups like the Heartland Institute who fund sympathetic journalists and scientists. While 98% of scientists agree that human-made or

anthropogenic climate change is indisputable, a few rogue scientists have been able to cast doubt, using the same strategy that the tobacco industry used do deny that smoking caused cancer; back then, a few of them also worked for the tobacco industry (Oreskes and Conway 2010). Their outsized, moneyed influence has reduced public acceptance of climate science in the US, Australia, and Europe and has helped delay mitigation efforts for the last twenty years.

Their skepticism also fed "climate denialism," an emotional state similar to the denialism that mourners and trauma victims experience as one of the stages of grief (Norgaard 2011). Many people are simply unable to accept the fact that people are destroying the living system of the planet by the combined effects of satisfying their everyday desires. Usually this is related to deeply held beliefs in conservativism, market fundamentalism, or certain Christian doctrine (Dunlap and McCright 2011).

What is climate change?

According to the US National Oceanic and Atmospheric Administration (NOAA), "Climate is determined by the long-term pattern of temperature and precipitation averages and extremes at a location" (NOAA n.d., 1). The World Meteorological Organization (WMO) requires thirty years of such data before determining what is "normal" during a particular time of year for a certain location. By averaging the data from all locations, you can calculate the Earth's climate. As climatologist Mike Hulme (2009) comments, "climate cannot be experienced directly through our senses. Unlike the wind which we feel on our face or a raindrop that wets our hair, climate is a constructed idea that takes these sensory encounters and builds them into something more abstract" (9).

Waypoint 2.2 Climate is not weather

Many people confuse climate with weather. In winter, you've probably heard people say that global warming can't be real if it's cold. That's just what James Inhofe, then Chair of the US Senate Committee on Environment and Public Works, claimed on February 26, 2015. He said that: "global warming is the greatest hoax ever perpetrated on the American people," and, for evidence, lobbed a snowball at the Senate President. Granted, snowballs are rare in Washington, DC's February climate, but not impossible. And that's exactly the difference between weather—what's possible for temperature and precipitation at a given location—and climate—what's likely. With climate change, extreme weather is more likely, meaning we should get used to senators lobbing snowballs at each other in February.

Mr. Inhofe's Snowball was a funny prank on the Senate floor, but the joke is ultimately on him because it shows how little he understood the environment that he oversees. As Hulme (2009) quips, "climate is what you expect, weather is what you get" (9). Mr. Inhofe did not expect a snowball in late February in DC, but that is what he got. His error was mistaking daily weather variation for long-term climate patterns. One snowstorm is a weather event; thirty years of aggregated weather events is climate.

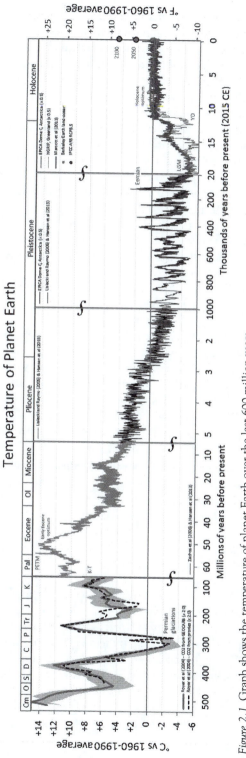

Figure 2.1 Graph shows the temperature of planet Earth over the last 600 million years.

Image credit: Glen Fergus (Wikimedia Commons).

Detecting real changes in climate behind the noise of weather variation requires data collection over many decades. But when climate changes, "the assumption that current and future climate conditions will resemble the recent past is no longer valid" (Jay et al. 2018, 36). What we thought was "normal" is history. Computer modeling suggests that the "new normal" is instability. "Climate chaos" or "climate weirding" is a more accurate term for what is ahead, not simply "climate change."

Why does this matter? Because human society evolved during the Holocene, an 11,700-year period of Earth's history that introduced an unusually stable, warm climate (relative to the previous epoch—see Figure 2.1 and Chapter 3). That stable, warm temperature allowed bands of human hunter-gatherers to create agricultural civilization. For more than 10,000 years, we have built our civilizations on the assumption that "current and future climate conditions will resemble the recent past." If civilization is uniquely adapted to the Holocene's environmental conditions, then changing those conditions will mean that civilization will have to change too. As Naomi Klein (2015) puts it, climate change changes everything.

So, what is causing global climate change? Changes in atmospheric chemistry. The increase of gases like carbon dioxide, methane, and nitrous oxide traps more solar radiation within Earth's atmosphere, heating it up like a greenhouse; thus, we call these gases "greenhouse gases" or GHG. Scientists hypothesized this "greenhouse effect" in the early nineteenth century and confirmed it with global data gathering since the mid-twentieth century.

The atmospheric quantities of these gases fluctuate naturally, being absorbed by "sinks" like soil, plants, and oceans, or expelled by sources like volcanoes and forest fires. All living organisms also affect atmospheric GHG quantities, including early humans who managed forests and grasslands with fire, releasing carbon. The advent of settled agriculture 10,000 years ago increased human GHG impacts, but "sinks" were able to absorb what humans produced, maintaining our unprecedented climate stability. What really threw the system out of its Holocene inertia was fossil-fueled industrialism, which began about 250 years ago—note the accelerating rise in global temperatures since 1850 in Figure 2.2. Since World War II, the scale of human operations and population has produced far more GHG than the "sinks"

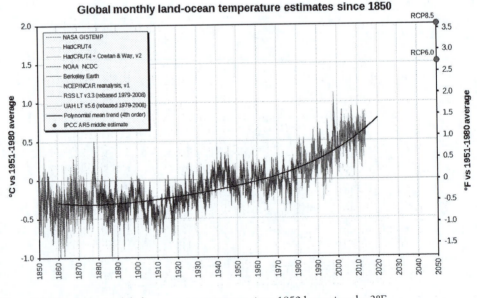

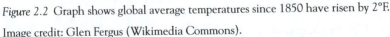

Figure 2.2 Graph shows global average temperatures since 1850 have risen by 2°F.

Image credit: Glen Fergus (Wikimedia Commons).

can absorb. Human-created GHG has now changed the geochemical composition of Earth's systems, causing a rise in global temperature averages.

That's called "anthropogenic" (*anthro-*, human + *genesis*, creation) climate change to distinguish from natural climate change. The climate is always changing, but now anthropogenic GHG and other factors are driving the change up to 100 times faster than nature. Natural systems, including animals, are not able to adapt as fast as the change. Think of driving a car at 10 kilometers per hour—it's easy to "adapt" to roadway conditions. Now accelerate 100 times faster to 1,000 kmh. If you've been driving at 10 kmh for 2 million to 2.4 billion years (like mammals and plants), the sudden acceleration to 1,000 kmh will blow your mind.

So, if we've altered the geochemistry of the planet, where are the predicted catastrophes? Well, if you're a polar bear or coral reef, you've been feeling it for decades; wealthy people in the richest, most industrialized countries, however, are sheltered from the changes. Earth is a complex, self-organizing, adaptive system; like a massive aircraft carrier, there's a long time-lag between the command to change course and when you see the course changing. In scientific terms, spaceship Earth has "multiple driving forces, strong feedback loops, long time-lags, and abrupt change behavior" (Steffen 2011, 21). The system is sensitive to variation in atmospheric chemical cycles, but also highly resilient because other forces, like ocean currents, ice, forests, water vapor, reinforce set patterns. Anthropogenic GHGs will build up slowly in the atmosphere because sinks remove some of it, but eventually they push the system across a tipping point. No one notices any change until BOOM! a quarter of Antarctic ice falls into the ocean, Greenland's ice sheet melts, and the Amazon rainforest dries out and catches fire. Once set in a new direction, inertia makes it very hard to reverse course. If we stopped producing carbon tomorrow, Earth systems would continue to be shaped by anthropogenic climate change for the next 1,000 years. According to leading climate models, which have proved accurate so far, the world is just experiencing the first tickling of change, predominantly in places few humans go: the poles, coral reefs, deserts, oceans, islands.

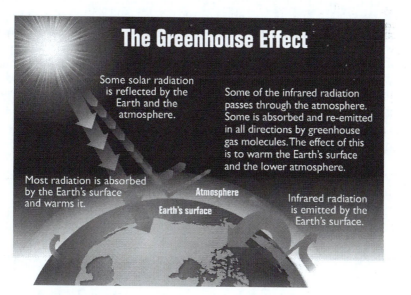

Figure 2.3 "The Greenhouse Effect."

Image credit: US EPA (Wikimedia Commons).

It's a lot like the Covid-19 pandemic: if you're not in a place where the virus impacts are visible every day, it is easy to imagine that it's not a problem. Distance equals invisibility and that has allowed a lot of people to imagine that it's not as bad as scientists say.

As renowned climate scientist Will Steffen writes:

> The core science of climate change—the reality of the greenhouse effect, the observed warming of the Earth's surface over the past century, and the dominant role of human emissions of greenhouse gases in driving the observed changes—is beyond doubt in the credible climate science community.
>
> Steffen (2011, 26)

Harvard Professor of Science and Technology, Sheila Jasanoff, explains "that [the] consensus, moreover, is supported by one of the most inclusive and transparent exercises in international scientific consensus building the world has yet seen, through the successive assessment reports of the Intergovernmental Panel on Climate Change (IPCC)" (Jasanoff 2011, 130). The handful of scientists who quarrel with "the consensus position [including scientists who authored the Not-IPCC report], have well-documented ties to corporate interests that should have deprived them of all credibility" (Jasanoff 2011, 130).

Waypoint 2.3 The IPCC

The Intergovernmental Panel on Climate Change (IPCC) is the world's premiere scientific authority on climate change. Thousands of scientists from around the world volunteer their time to provide a comprehensive summary of what is known about the drivers of climate change, its impacts and future risks, and how adaptation and mitigation can reduce those risks.

The IPCC was created in 1988 by the World Meteorological Organization (WMO) and the United Nations Environment Programme (UNEP). It serves the 197 member states who have ratified the United Nations Framework Convention on Climate Change (UNFCCC) since its inception in 1992. The UNFCCC binds member states to work toward an international treaty on climate change, negotiated during the annual "Conference of Parties" (COP) and guided by the IPCC's reports. However, the treaties fall far short of the reduction required to avoid catastrophic climate change. Furthermore, some member states have either formally withdrawn from treaties or refused to ratify them. This begs the question: can the international treaty process convince states to give up their addiction to fossil-fueled power for the greater good? What other global solutions to the global problem exist?

But don't take our word for it: research the issue for yourself. Look at the IPCC and NIPCC websites and read "Organized Climate Change Denial," by Riley E. Dunlap and Aaron M. McCright (2011). Consider Hulme's (2009) discussion of consensus-building and transparency in the IPCC process (87-105) and compare that to the NIPCC statement of their process. Look at Naomi Oreskes and Erik Conway's *Merchants of Doubt* (2010) listed in the annotated reading list at the end of this chapter. Or watch the 2014 film of the same name.

Reflection 2.1 How much does carbon neutrality really cost?

There is a general assumption, promoted by fossil-fuel interest groups, that it will be too expensive to transition from carbon-based energy. But the IPCC's recent 1.5 Special Report shows that the global cost of energy transition would be around US$2.4 trillion annually spread over twenty years. That sounds like a lot, but it is only 2.5% of global GDP! In contrast, the US spent 3.5% of its GDP on defense in 2018, according to the World Bank, while the UK spent 1.9%. Note that many individuals donate a minimum of 10% of their annual income to their religious institution or philanthropy. It starts to look like an issue of priorities, particularly when you learn that much of the money would just be redirected away from fossil-fuel subsidies.

But, you say, don't military spending and fossil-fuel subsidies create jobs? Sure, but not as many as spending on climate change mitigation and resilience-building, particularly when the costs of *not* mitigating or building resilience are factored in. The most exciting finding in the IPCC 1.5 Special Report is that when investments to reduce climate change are coordinated with investments to reduce global poverty, synergies multiply their effectiveness. Check out their graphic on www.ipcc.ch/sr15/chapter/spm/ Section D; Figure SPM.4.

Most observers agree with Steffen (2011), who points out that "as CO_2 is a well-mixed gas globally, only an international solution, involving at least the most important emitters in a coordinated way, will begin to address the nature of the challenge" (27). An international treaty would neutralize the "incentive for every player to seek to impose the burdens of mitigation on others, while seeking to take as free a ride as possible on their efforts" (Dryzek et al. 2011, 12). However, because the modern nation-state is designed to compete for its short-term, narrow self-interests, it is extremely difficult to get agreement on things that are of universal benefit for the long term.

Getting international agreement is also complicated by the history of GHG emissions. Up through 1980, the developed countries of the West and Global North emitted the vast amount of GHG as they burned fossil fuels to develop their economies. Those in the West and Global North still have the largest per capita carbon footprint (COTAP n.d.). For example, the average US citizen emits seventeen to twenty tons of CO_2 per year while the average Chinese emits six tons; two tons per citizen is what the world can sustain.

Developing nations accuse the developed nations of having hogged the world's "carbon budget" (the estimated amount of CO_2 that Earth systems can absorb before crossing a tipping point) to build their economies. Even more unfair, while "the rich countries of the North do most of the emitting…the poor counties of the South do most of the dying" (Patz et al., cited in Jamieson 2011, 45). In other words, the poor countries that did not contribute to climate change will be hit hardest.

Pretend you had an older brother who used the entire family budget to fund his college education; now, not only do you not get a college education, you also live an immiserated life and die young. You might be angry at your brother and demand that he help you out. Developing nations likewise want the developed nations to help, cutting their own emissions first and funding the renewable transition in developing countries. On the other hand, the

Per capita CO₂ emissions in 2016 vs 1990

Per capita emissions of carbon dioxide (CO₂) in the year 2016 versus 1990 emissions. Countries which lie above the grey line had higher per capita emissions in 2016 than in 1990; countries below the line had lower per capita emissions in 2016.

Figure 2.4 Graph shows the per capita CO_2 emissions in 2016 versus 1990.

Image credit: Our World In Data (Wikimedia Commons).

developed nations point out that they didn't know that they were destabilizing the planet by burning fossil fuels, leaving developing nations without the same options; they claim it is unfair to hold them accountable for unintended consequences (Dryzek et al. 2011). Your older brother didn't know he was taking all the available money for his college education, leaving you none. He's also sorry that you have no food or clean water and will die in coastal flooding—bad luck for you, but how can he be blamed?

Of course, while these nations bicker about fairness, most are burning through fossil fuels like there is no tomorrow—2018 was a record year for US emissions and global emissions are up 60% since the 1990s. Those emissions can be tracked to wealthy elites in all countries—wealth and carbon emissions are directly correlated. As one study argued, "global carbon emissions can be reduced 50% by 2030 [enough to meet the IPCC's 1.5 C mandate], simply by reducing the emissions of the richest one-sixth of the people in the world" (Chakravarty, cited in Jamieson 2011, 45). Currently there is no method of getting the richest, most powerful 1.2 billion people to cut their consumption of fossil fuels, the source of their wealth and power, and the source of climate change. Clear scientific evidence of looming disaster has not persuaded them. Calls on their good will have had almost no effect. The availability of cost-effective alternative energy solutions and market-based options like a carbon tax have been roundly rejected. The only thing that has reduced emissions on pace with IPCC recommendations has been the economic collapse brought on by a global pandemic.

Reflection 2.2 Your carbon emissions

How much carbon do you emit? Use the calculator www.carbonfootprint.com/calculator1.html and then compare your emissions to the per capital global averages. How difficult would it be to reduce your fossil fuel use by 50%? What would you do? Would it be enough? Look at the COTAP website under Weblinks for some ideas, but also consider the issue of having children discussed here: www.sciencemag.org/news/2017/07/best-way-reduce-your-carbon-footprint-one-government-isn-t-telling-you-about. Now consider how you could get the richest one-sixth of the world's people to follow you. Where would you start and with whom?

The Environmental Humanities difference

Environmental problems are usually framed as something for scientists to understand and technologists, politicians, and economists to solve (Hulme 2009, xxvii). But, while climate change may be "the archetypal environmental problem" (Dryzek et al. 2011, 15), everyone needs to engage in problem-solving. This is because responding to climate change requires changing our basic ideas about how we should live.

This is where the Environmental Humanities becomes essential to achieve real change. Scientific and technocratic methods define the problem of climate change as purely a matter of atmospheric chemical imbalance: putting too much GHG into the atmosphere. If we were to solve climate change based on a purely data-driven science, we might have to adopt methods of population control like forced sterilization and euthanasia: reducing GHG emissions by eliminating GHG emitters. So, to achieve ethical, just solutions to climate change, we need more than "mere technical knowledge and traditional forms of governance" (Hulme 2009, 334). A more holistic and empathetic understanding of climate change's diverse contexts and causes can also help ordinary people become agents of change.

Case Study 2.3 Community-scale change and the Transition Initiative

While climate change is a global threat, carbon emissions are produced by local communities, and it is at the community level that individual action can have measurable impact. Rob Hopkins developed the Transition Initiative to mobilize the "collective genius" of local communities to strategize their transition from fossil fuel systems. Not only does this reduce a community's carbon footprint, but it also re-empowers the local community to command its own food, housing, transport, and economic systems, reversing the disempowering effects of globalization, itself a major driver of climate change. A "transitioning" community can inspire other communities, multiplying the effects on a much larger scale.

Transition and other forms of "replacement politics" (as opposed to traditional "resistance politics") blaze the trail to a zero-carbon future that its members create themselves. Why wait for the slow, corrupt process of international climate negotiations or

the uncertain, disorganized choices of individual consumers when you can get together with your neighbors to create a better future for yourselves?

What do you think? Research Transition Initiatives and look for other examples of community organizing in your area. The Stockholm Resilience Centre and the Post-Carbon Institute have collated a substantial amount of information on re-empowering local communities to address climate change. See the Weblinks section at the end of this chapter.

For example, carbon dioxide may be a "a well-mixed gas globally," but how and why it is emitted varies according to a local culture's traditions and capacities for using fossil fuels to achieve "the Good Life." Indeed, it depends on the definition of "The Good Life." The Western, Educated, Industrialized, Rich Democracies' (WEIRD) definition of "the Good Life" just so happens to immiserate billions of other people, cause mass species extinction, and destabilize the climate on which we all depend. This is a cultural problem, not a scientific one.

If we are going to address the cultural causes of carbon emissions, we have to ask fundamental questions about the WEIRD definition of "the Good Life" and insist that our transition to a post-carbon civilization be more just, happier, and authentically free. For example, we need to figure out how to extend the authentic benefits of modern life—health care, reduced mortality, opportunity, and quality of life—to all cultures. And we need to hand our descendants a better, healthier, saner world than what we have now. At its most radical, EH gives us new ways to imagine being human in pursuit of "a Good Life" that is symbiotic, not parasitic.

Climate science tells us that we have to make fundamental changes to the way we power our lives, a life-transforming change. Environmental humanists want to leverage this necessary change to achieve the promises of human freedom, equality, and justice that evolution has afforded us.

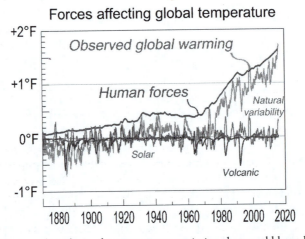

Figure 2.5 The dark center line shows the temperature variation that would have happened if natural forces alone had been in play; the top line shows the effect of human forces alone on climate; the light gray shows actual global temperature averages affected by both human and natural forces combined.

Image credit: R. Craig (Wikimedia Commons).

Environmental Humanities action

In addition to asking these ethical questions, there are two specific things environmental humanists are doing right now. The first is reframing climate change as an idea that motivates change; the second is learning how to do scholarly activism. EH skills and knowledge are immediately applicable to addressing real-world problems like climate change. Unlike many subjects in school (and the traditional way of teaching humanities subjects), you don't have to spend years learning abstract knowledge before you can use it. You can use it now and make a difference.

Waypoint 2.4 Sacrifice zones—"we" are not all in this together

Originally used to identify degraded environments where nuclear testing was carried out, the term "sacrifice zone" has since been applied to places that industrial society writes off as collateral damage in the name of progress. Sacrifice zones are almost always in places where poor and minority populations live.

Almost every town has a "wrong side of the tracks" that correlates with systemic poverty and racism, but in some places like Newark, New Jersey, and Lake Charles, Louisiana, entire communities are written off. Even larger regions, like the coal fields of Appalachia (US) and Upper Hunter Valley (AU), the tar sands of Alberta (CA) or the oil fields of the Niger Delta (NG), have been sacrificed to cheap energy.

Now climate change has created a new list of "climate sacrifice zones" in coastal regions and islands. Wealthy areas like Miami can afford to build infrastructure, but poorer areas like Bangladesh, many parts of Indonesia, all populated atolls in the Pacific, and most Inuit reservations will likely be sacrificed to rising seas. With 2°C warming, these areas will be uninhabitable and may even disappear under the sea. Residents will join the anticipated 140 million climate refugees looking for new homes. Just as sacrifice zones demonstrated the environmental injustice at the heart of industrial culture, climate sacrifice zones demonstrate the injustice of climate change.

Reframing climate change as an idea gets us out of the trap of thinking of it as a problem to be solved by experts—a trap that has condemned us to over thirty years of inaction. It means digging into what people imagine when they think "climate change." As novelist Amitav Ghosh (2016) observes, "The climate crisis is also a crisis of culture, and thus of the imagination" (9).

What Ghosh means is that climate change cuts right to the heart of how we imagine ourselves: that we are the most important species, entitled to do what we want when we want. As history is usually told, humans are the hero species who "had thrown off the shackles of their environment" by virtue of god-like intelligence (Ghosh 2016, 119). This story idolizes human progress as ever-increasing freedom and prosperity. But what kind of freedom and at what cost? And for whom?

In truth, the shackles of the environment were never thrown off; the environment has always been the enabling condition for human agency. Ten thousand years ago, the Holocene's stable climate replaced the Pleistocene's fluctuating climate, enabling hunter-gatherers to free themselves from the necessity of searching for food, water, clothing, and shelter every day for the first time in humanity's 300,000-year history. The Holocene's climate was the condition for settled agriculture, establishing new freedoms for humans to develop complex societies, cultures, economies, and lifestyles. Eventually, we learned to use fossilized sunshine at industrial scale, creating even more freedoms. However, our continued liberation from daily necessities requires "energy slaves" (machines) powered by fossil fuels. Continuing the story of progress and freedom will require that we acknowledge just how dependent on our fragile climate we are.

So reframing climate change as an idea is a first step to acknowledging that the advantages gained by a few for a short period of time have required the sacrifice of other people, non-humans, and ecosystems, leading ironically to our own enslavement to our "energy slaves."

Tracing the consequences of our progress to the structures of systemic racism, genocides, extinctions, collapsing ecosystems, and destabilized climate can do two things: one, it can enable us to take an honest look in the mirror and see some things that we have long tried to avoid; two, it can give us the opportunity to ask what kind of world we would like to have: how can we have freedom without sacrificing others? Some argue that "only a revolution in human consciousness can summon the political will needed" to transform the human–nature relationship (Falk 2016, 96). Scholarship in the Environmental Humanities is ideally positioned to reimagine freedom as a state in which all living beings in an interdependent system can achieve their fullest potential (Bookchin 2005, Haraway 2008). It's going to require practical, imaginative people to pioneer Civilization 2.0.

Figure 2.6 This "Knowledge is Power" mosaic is featured at the US Library of Congress.

Image credit: The Library of Congress (Wikimedia Commons).

Reflection 2.3 Scholar-activism

Can you create change in your community? Where and how do you start?

First, inventory your skills and knowledge: do you write and communicate well? Speak multiple languages? Understand the power of art? Read densely reasoned, abstract prose? Analyze complex patterns of thought? Understand historical context?

Second, train yourself in resilience thinking and complex systems analysis. Learn the basic science. Read *Resilience Practice* (Walker and Salt 2012) in the Annotated Bibliography and look at the Stockholm Resilience Centre and Post-Carbon Institute under Weblinks. Take a seminar.

Third, work in the networks you already have: family, friends, school. These networks can be powerful if organized—remember Greta Thunberg. If you got a group of friends and family together, and they got friends and family to join, you would have enough organized power to negotiate with community and institutional leaders. As Naomi Klein (2017) argues, social movements succeed when they unite imaginative vision with organized people power.

Fourth, look for local needs. Are there activist groups in your area? How could you apply your skills and knowledge to their needs and objectives? How can you partner with churches, libraries, community centers, downtown development groups, child-care, and other volunteer groups to build resilience and reduce fossil fuel dependency?

The second thing that students of the Environmental Humanities can do right now is become "scholar-activists." To date, scholars have preferred to stay out of political-activist causes, thinking that they would preserve the critical distance necessary to "speak truth to power." That's still necessary, but honesty means you *live* the truth you speak. Scholar-activists in the Environmental Humanities can enter partnerships with local groups who want to arm themselves with evidence in their fight against climate change.

How do you do this? Research, critical analysis, documentation, bearing witness, telling stories, filming, portraying, writing, drawing on multicultural know-how, attentive listening, rhetorical study of language, logical dissection of argument, ethical and spiritual evaluation of actions, mediating legal documents and official discourse for local needs and ordinary people—all of the things at which humanities and social science scholars excel. This is the difficult, daily work by which we reinvent the story of progress and freedom for a world in which we are one species among billions, who together co-create the planet on which we depend.

Chapter summary

This chapter has reviewed some of the basic science of climate change, showing the almost unanimous scientific consensus on the fact that the climate is changing faster than at any time in human history, and is caused by burning fossil fuels to drive modern society. We pointed out that, despite scientific agreement, the public still perceives disagreement. This is due to our cultural ideas of climate, ultimately our deeply held belief that humans are

exceptions to laws that govern the rest of nature. Our anthropocentrism, stories of progress, and overemphasis on individualism have to be retired if we are to deal with climate change. We also covered the social inequality and injustice that climate change exposes. We described the Environmental Humanities as a critical force that can challenge anthropocentrism, false narratives of progress, and the injustice that are the necessary corollaries to burning fossil fuels. We concluded with some ideas for how the Environmental Humanities-inspired scholar-activism can help communities transition to a more just, sustainable, and vibrant version of "the Good Life."

Exercises

1. How would you engage different groups of people on the topic of climate change? You could start by finding out what their perceptions of climate change are. The Yale School of the Environment has a short quiz you can use to compare data from your school with national averages: https://climatecommunication.yale.edu/about/projects/global-warmings-six-americas/. Once you figure out what your audience believes about climate change, consider what kind of message campaign you would design to raise awareness. Develop an action plan and see if you can organize people to make some small change that would reduce GHG emissions. Or you could try mobilizing students at your university to petition administrators to sign onto Second Nature's Climate Leadership Network (https://secondnature.org/climate-action-guidance/network/) or to make a substantive mitigation commitment, such as divesting from fossil fuels (https://divested.betterfutureproject.org/). Extinction Rebellion offers many practical approaches to direct action (https://rebellion.global/).

2. What do you think about the claims for the "transformative power of storytelling"? Watch this video from the Stockholm Centre for Resilience and reflect on how stories can shape worldviews and actions: www.stockholmresilience.org/research/research-videos/2018-09-30-the-transformative-power-of-storytelling.html. Could you use stories to change people's attitudes toward their carbon emissions? What kind of stories and what kind of medium (music, art, theater, film, writing, multimedia, gaming)? Tell your own carbon-emissions story. Better yet, host a series of events—game night, open mic, poetry slam, improv theater, short films, story night—focused on student-created, narrative-based climate change projects. Use the IOES website under Weblinks for additional strategies and examples.

3. Take a look at IPCC or (if you live in the US) EPA predictions for your climate region. What kind of weather can you expect in thirty years? How do you think this will affect the kind of job you'll have, the house you'll live in, the family you'll have, and the community relationships you'll have? What kinds of adaptation will be necessary? Write a "report from the future" on what daily life is like in your hometown thirty years from now. Or, as a class project, create an issue of your school's newspaper written thirty years from now. See www.ipcc.ch/report/ar5/wg2/ "Part B: Regional Aspects" or https://nca2018.globalchange.gov/ "Report Chapters."

4. For a semester project or multi-year independent study in scholar-activism, conduct a climate change resilience assessment of the town where your university is. Dig into the history of human–environment relationships in the region. Use participatory research and other methods (see The Institute for Development Studies under Weblinks) to gain an understanding of the interdependent systems that define your town: economics, environment, waste, transportation, food, housing, governance, culture. Map systemic inequalities and vulnerabilities. Use systems theory to understand threat and adaptation across multiple scales. Present a synthesis to diverse community groups and ask for their help in developing the assessment. The key to working with citizen groups is not telling them what you think they should do—falling into the "expertise trap"—but engaging in a mutually respectful dialogue about what they need.

Annotated bibliography

Diamond, Jared. 2005. *Collapse: How Societies Choose to Fail or Succeed*. New York: Viking. This Pulitzer-prize winning social scientist provides historical case studies of the specific conditions that lead to civilizational collapse, including climate change, population explosion, and political discord.

Flannery, Tim. 2007. *The Weather Makers: How Man is Changing the Climate and What It Means for Life on Earth*. New York: Grove Atlantic. This readable history of climate change science explains what it will mean for life on earth.

Ghosh, Amitav. 2016. *The Great Derangement: Climate Change and the Unthinkable*. Chicago and London: University of Chicago Press. Ghosh completely rethinks how our governing assumptions and accepted methods in science, economics, politics, and literary art render climate change "unthinkable."

Hulme, Mike. 2017. *Weathered: Cultures of Climate*. London and New York: SAGE. One of the world's top climatologists explains the way the idea of climate shapes and is shaped by different human cultures.

Klein, Naomi. 2014. *This Changes Everything: Capitalism vs. the Climate*. New York: Simon and Schuster. This powerful, engaging assessment of how globalized capitalism drives climate change explains how exploited communities can organize to stop it.

Lerch, David, ed. 2017. *The Community Resilience Reader: Essential Resources for an Era of Upheaval*. Washington, DC: Island Press. Short chapters by leading experts in the field review the four main crises (Energy, Environment, Equity, Economy) facing human society and provide case studies and toolkits for addressing them at the community level.

Oreskes, Naomi and Eric Conway. 2010. *Merchants of Doubt: How a Handful of Scientists Obscured the Truth on Issues from Tabacco Smoke to Global Warming*. London: Bloomsbury. This impeccably researched book carefully traces how organized climate denial delayed action on climate change for more than two decades and furthered a neoconservative agenda for deregulation and corporate power.

Walker, Brian and David Salt. 2012. *Resilience Practice: Building Capacity to Absorb Disturbance and Maintain Function*. Washington, DC: Island Press. This practical handbook on resilience thinking includes case studies and models for applying resilience practices to any size system or institution.

Weblinks

Carbon Offsets to Alleviate Poverty. This site offers comparative data on carbon emissions around the world, carbon calculators, information about the relation between poverty and carbon emissions, with ideas for how to offset your own carbon emissions. https://cotap.org/per-capita-carbon-co2-emissions-by-country/

Climate Access. This non-profit organization offers education, blogs, networks, and toolkits for organizing communities to address environmental issues and advocate for sustainable solutions. https://climateaccess.org/

Climate Justice Alliance. This is a non-profit advocacy organization working for economic and social equality in adapting society to climate change. It focuses on organizing and empowering poor, minority, and indigenous communities that are most vulnerable to the twin impacts of climate change and globalization. https://climatejusticealliance.org/

Our World in Data. This Creative Commons project is designed to provide useful, reliable data for understanding and addressing the world's largest problems, including climate change. https://ourworldindata.org/co2-and-other-greenhouse-gas-emissions

Stockholm Resilience Centre. The Centre is a collaboration between Stockholm University and the Beijer Institute of Ecological Economics at the Royal Swedish Academy of Sciences. The site houses education programs, research, podcasts, seminars and other information on building a sustainable world, including guidance on how to do a resilience assessment of your community. www.stockholm-resilience.org

The Commonwealth Scientific and Industrial Research Organization. CSIRO is Australia's top association of scientists. They provide Oz-specific information, news, projects and data on climate change and climate change impacts. www.csiro.au/en/Research/Climate

The Fourth National Climate Assessment Report for the US. This report is prepared by the EPA and documents the threats, causes, likely impacts, and mitigation and resilience building efforts by region. https://nca2018.globalchange.gov/

The Institute for Development Studies. This is an independent research center based at the University of Sussex, UK. This site offers education and a toolkit for using participatory research methods, essential for most field work in community resilience assessment and town-gown partnerships. https://participatorymethods.org/task/research-and-analyse

The Intergovernmental Panel on Climate Change is commissioned by the UNFCCC to research climate change. This is where you'll find the Reports and other information collated from the world's top scientists. www.ipcc.ch

The Laboratory for Environmental Narrative Strategies, Institute of the Environment and Sustainability at UCLA. The Lab has ongoing research for how storytelling is an important tool to solve environmental problems. www.ioes.ucla.edu/lens/

The MIT Game Lab is dedicated to researching games for teaching about real world problems like climate change, with plenty of inspiring examples. http://gamelab.mit.edu/

The Nongovernmental International Panel on Climate Change. This denialist organization publishes reports designed to look deceptively identical to the IPCC reports in order to create confusion. It is sponsored by the Heartland Institute, a denialist organization funded by fossil fuel and neoconservative groups like Koch Industries. http://climatechangereconsidered.org/about-the-nipcc/

The Post Carbon Institute. An independent research center, this site offers information, resources, toolkits, seminars, and blogs by leading experts in environmental sustainability. Their vision is a post-carbon society that is fairer, just, healthy, and happy. www.postcarbon.org

The Transition Network. This international organization encourages and trains communities to self-organize in adapting to climate change. The Transition Network advocates for local empowerment, economic and social equality, and rethinking the human project. https://transitionnetwork.org/

The United Nations Framework Convention on Climate Change. This is the global governing body overseeing climate change research, negotiation, action, and regulation. 192 countries are members. https://unfccc.int/

The US Geological Survey. The Department of the Interior's staff of scientists supports public education on a range of environmental issues, including climate change. www.usgs.gov/science-support/osqi/yes/resources-teachers/college-global-change

The US National Oceanic and Atmospheric Administration (NOAA). The site provides information, news, and project-based learning ideas on climate and weather. www.climate.gov/taxonomy/term/3434

The Yale Climate Connections. An initiative of the Yale University Center for Environmental Communication, this non-partisan, multimedia service provides daily broadcast radio programming and original web-based reporting, commentary, and analysis on the issue of climate change. It is also dedicated to studies of climate change perception. www.yaleclimateconnections.org

References

Bookchin, Murray. 2005. *The Ecology of Freedom: The Emergence and Dissolution of Hierarchy*. Oakland: A. K. Press.

Carbon Offsets to Alleviate Poverty (COTAP). n.d. https://cotap.org/per-capita-carbon-co2-emissions-by-country/.

Dryzek, John S., Richard B. Norgaard, and David Schlosberg. 2011. "Climate Change and Society: Approaches and Responses." In *The Oxford Handbook of Climate Change and Society*, edited by John S. Dryzek, Richard B. Norgaard and David Schlosberg, 3–17. Oxford: Oxford University Press.

Dunlap, Riley E., and Aaron M. McCright. 2011. "Organized Climate Change Denial." In *The Oxford Handbook of Climate Change and Society*, edited by John S. Dryzek, Richard B. Norgaard and David Schlosberg, 144–160. Oxford: Oxford University Press.

Falk, Richard. 2016. "Scholarship as Citizenship." In *New Earth Politics: Essays from the Anthropocene*, edited by Simon Nicholson, Sikina Jinnah, Erik Assadourian, Frank Biermann, Wil Burns, Ken Conca, Peter Dauvergne, Daniel Deudney, Navroz Dubash and Richard Falk, 96–111. Cambridge: MIT Press.

Haraway, Donna Jeanne. 2008. *When Species Meet*. Minneapolis: University of Minnesota Press.

Hulme, Mike. 2009. *Why We Disagree About Climate Change: Understanding Controversy, Inaction and Opportunity*. Cambridge: Cambridge University Press.

Idso, C. D., R. M. Carter, and S. F. Singer, eds. 2013. *Executive Summary: Climate Change Reconsidered II: Physical Science*. Chicago: The Heartland Institute.

Intergovernmental Panel on Climate Change (IPCC). 2014. *Climate Change 2014: Synthesis Report. Contribution of Working Groups I, II, and III to the Fifth Assessment Report of the Intergovernmental Panel on Climate Change*. Geneva: IPCC.

Jamieson, Dale. 2011. "The Nature of the Problem." In *The Oxford Handbook of Climate Change and Society*, edited by John S. Dryzek, Richard B. Norgaard and David Schlosberg, 38–54. Oxford: Oxford University Press.

Jasanoff, Sheila. 2011. "Cosmopoliltan Knowledge: Climate Science and Global Civic Epistemology." In *The Oxford Handbook of Climate Change and Society*, edited by John S. Dryzek, Richard B. Norgaard and David Schlosberg, 129–143. Oxford: Oxford University Press.

Jay, A., D. R. Reidmiller, C. W. Avery, D. Barrie, B. J. DeAngelo, A. Dave, M. Dzaugis, M. Kolian, K. L. M. Lewis, K. Reeves, and D. Winner. 2018. *Impacts, Risks, and Adaptation in the United States: Fourth National Climate Assessment*, edited by US Global Change Research Program. Washington, DC.

Klein, Naomi. 2015. *This Changes Everything: Capitalism vs. the Climate*. London: Penguin Books.

Klein, Naomi. 2017. *When No is Not Enough: Resisting Trump's Shock Politics and Winning the World We Need*. Chicago: Haymarket Books.

National Oceanic and Atmospheric Administration (NOAA). n.d. *Climate.Gov: Science and Information for a Climate Smart Nation*. NOAA.

Norgaard, Kari Marie. 2011. "Climate Denial: Emotion, Psychology, Culture, and Political Economy." In *The Oxford Handbook of Climate Change and Society*, edited by John S. Dryzek, Richard B. Norgaard and David Schlosberg. Oxford: Oxford University Press.

Steffen, Will. 2011. "A Truly Complex and Diabolical Policy Problem." In *The Oxford Handbook of Climate Change and Society*, edited by John S. Dryzek, Richard B. Norgaard and David Schlosberg, 21–37. Oxford: Oxford University Press.

Yale Program on Climate Change Communication. 2020. "Global Warming's Six Americas." Accessed May 18, 2020. https://climatecommunication.yale.edu/about/projects/global-warmings-six-americas/.

3 The Anthropocene

A superhero species comes of age

Chapter objectives

- To explain how scientists have identified the Anthropocene as a new geological epoch
- To explain how the new epoch implies a particular understanding of "the human"
- To review debates about the causes of the Anthropocene, its meaning, and the implications of its name
- To define ways the Environmental Humanities uses the Anthropocene to raise awareness of the environmental impacts of different political, economic, ideological, and cultural systems

It is the dawning of the age of the human

In 2000, Nobel-prize winning atmospheric chemist Paul Crutzen and biologist Eugene Stoermer coined the term "Anthropocene" to "emphasize the central role of mankind in geology and ecology" (Crutzen and Stoermer 2000, 17). They theorized that, since the Industrial Revolution, human activities have so fundamentally altered planetary systems that they mark a new geological era. The defining markers include "the growth of human population and energy use, the accelerating emissions of greenhouse gases, as well as the ozone-destroying chlorofluorocarbons, deforestations, exhausted fisheries and nitrogen fertilizers," a list later researchers expanded to include mass extinctions, a total reshuffling of living organisms, radioactive elements, synthetic materials, and pure metals (Zalasiewicz et al. 2018, 178). As paleobiologist Jan Zalasiewicz reports, "We really are seeing a new world on the cusp of emerging" (Zalasiewicz et al. 2018, 181).

Waypoint 3.1 Marking the ages: the science of stratigraphy

To identify the beginning of the Anthropocene, scientists are looking for the distinctive human "fingerprints" in the lithosphere (rock-mineral layer), chemosphere, and biosphere.

Lithostratigraphists are looking for the appearance and global distribution of pure metals that require human smelting; "novel" rocks like brick, ceramic, and cement; and synthesized inorganic crystalline compounds, like tungsten carbide (ballpoint pens) and plastics.

Chemostratigraphists are looking for human changes to chemical cycles, like carbon, nitrogen, and phosphorous, and the appearance of long-lasting synthetic chemicals including DDT, aldrin, plutonium, and cesium.

DOI: 10.4324/9781351200356-3

> Biostratigraphic signals, "in many ways the most important of all, affecting as they do the living fabric of our planet…are also the most complex signals in time and place" (Zalasiewicz et al. 2018). They include human-caused species extinctions and biota redistributions, human development of new species (bioengineering), and global agriculture.

That's pretty exciting. Humans may have collectively created a new age in Earth's 4.5 billion year history, and we are witnessing its dawn (Sullivan 2017, 414). But that's also unnerving because it means we're sailing into an unknown reality. All the rules are changing: everything we think we know was "founded on the relative climatic stability of the Holocene" (Ghosh 2016, 21).

Can we feel that disruption in daily life? Well, only with some historical context because, in the past eighty years, constant disruption has become normalized. But change this rapid is actually a strange state of existence for us. For twelve millennia, we've adapted to the relatively stable conditions of the Holocene. Now, within three to four generations, we have upended that stability. Being upended is the new "normal."

As with climate change discussed in Chapter 2, the Anthropocene is both a physical phenomenon and an idea. As a physical phenomenon, the Anthropocene quantifies the effects of human activities on the substratum of Earth's crust. But if cumulative human activity has altered Earth's future as decisively as the Yucatán meteorite that marked the start of the Cenozoic Era, then we may have to start acknowledging that our species is as destructive as the meteorite that killed the dinosaurs. We like to think of ourselves as a superhero species, but can we still do that in the Anthropocene?

Reflection 3.1 Biostratigraphic markers

Did you know that domesticated animals ("morphospecies" created by selective breeding and now genetic engineering) vastly outnumber wild animals? 96% of all mammals are either domesticated or human; only 4% are wild. 70% of all birds are chickens (Bar-On et al. 2018). There are 300 million housecats versus 3,000 wild tigers (Zalasiewicz et al. 2018). Chicken and housecat fossils are major biostratigraphic signals of the Anthropocene. Rat fossils are another signal because humans helped them trans-migrate more widely than any other wild mammals. Rats, cats, and chickens may be humanity's most remarkable biostratigraphic achievement.

Other biostratigraphic signals are more complicated. Invasive bivalves (clams, mussels, oysters) have altered ecosystems in San Francisco and Lake Michigan because they filter the whole body of water in one to two days, extinguishing entire species of protoplankton and algae, the building blocks of life (Williams et al. 2018). That kind of extinction event could be an Anthropocene signal if it could be confirmed globally.

Another signal might be coral reefs, some of the most threatened ecosystems due to acidification and warming oceans. The Great Barrier Reef, visible from space, may become a bleached fossil in your lifetime, yet another signal of the Anthropocene.

What other biostratigraphic markers of the Anthropocene can you identify?

It's depressing to consider that humans, despite our great capacity for creativity, may also be an inherently destructive species. As products of natural evolution, our destructiveness could

be an evolved adaptation, just as natural as the destructions wrought by cyanobacteria, which precipitated the "Great Oxygenation Event," exterminating most other life forms and triggering an ice age 2.5 billion years ago. Like worms, algae, and some plants, we may qualify as a "keystone bioturbator," a species that decisively alters the biosphere as an outcome of its nature.

Some social scientists point out that human bioturbation cannot be compared to that of worms and algae. Unlike those species, humans evolved big brains with the power to reflect on our actions and govern our collective behavior. Because our nature is different, it means that we can choose to be less destructive (Lewis and Maslin 2015). We could use our superpowers—our big brains—to change the way we alter environments.

What is our nature? This is one of the big questions suggested by the Anthropocene, which disrupts the idea that humans are evolution's crowning achievement—the "Superhero Species." Environmental humanists, those who study what it means to be human in relation to our non-human and more-than-human partners, are well placed to address it (see Chapter 1).

For example, literary scholar Timothy Clark posits that *Homo sapiens* are naturally evolved to ignore anything that happens on geological scales of time and global scales of space (Clark 2015). Environmental historian Richard Kerridge (2017, xiv) points out that our most destructive bioturbation is either microscopic (as in microplastics entering the food chain through plankton) or macroscopic (plastic garbage covering an area in the Pacific the size of Europe). In both cases, we are blind to our impact because it is too small, too vast, or too distant from the actions that caused it. The Anthropocene forces us to see our actions on multiple scales simultaneously, not just as an individual action, but also as part of the cumulative actions of a species. If we could evolve the ability to think beyond our narrow self-interest, that might be a silver lining. Can we evolve a more mature consciousness fast enough to save ourselves and others?

Case Study 3.1 The Pacific garbage patch

In the US, only 8% of plastics are recycled and many other countries are far lower. Plastics are generally unrecyclable, as the petrochemical industry knew for decades (see Weblinks). After just a few times, the material becomes too contaminated to be reformed. Because it releases toxins when burned and is so bulky, neither incinerators nor landfills are good options. And so, much of our discarded plastics ends up in the ocean where it is pushed by currents into massive garbage patches, slowly breaking down into micro-particles that enter the food chain and water cycle. Sometimes larger chunks are eaten by birds, fish, and marine mammals, who mistake the colorful plastic for food. Photographer Chris Jordan has documented some of the impacts of plastic on these creatures (see Figure 3.1 and search ChrisJordan.com for more images).

So how massive are these garbage patches? Some estimates suggest the size of Europe. However, NOAA warns that measuring by square kilometers is misleading because most of the plastic resembles flecks of pepper floating in the water column, not miles of densely packed yogurt cups. A lot of the plastics in our water come from washing our fleece and using body scrubs that contain plastic microbeads. Drinking microplastic integrates it into our bodies. By one estimate, each US citizen consumes between 74,000 and 121,000 particles of microplastic annually (Editors 2019).

Some cities, states, and nations have banned single-use plastic, but its production is predicted to double by 2050. What is your experience with plastic, a key chemostratigraphic marker of the Anthropocene?

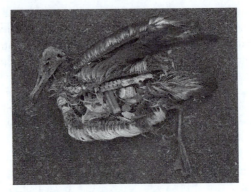

Figure 3.1 Albatross at Midway, Atoll Refuge.

Image credit: Chris Jordan (Wikimedia Commons).

In contrast to Clark and Kerridge, Indian novelist Amitav Ghosh (2016) argues that humanity's current destructiveness, of radically greater magnitude than any previous bioturbation, is specific to our present culture, not a natural trait of all *Homo sapiens*. History shows that only an extremely small, marginal, and historically recent group of people—whose emergence coincides with early Anthropocene signals—behave at a globally destructive scale (see Chapter 2's discussion of Western, Educated, Industrialized, Rich, Democratic cultures and climate change). Other cultures do not, or have not, destroyed their environments at this scale. Ghosh theorizes that our destructiveness is due to modern, western culture's unique "way of thinking that deliberately excludes things and forces (externalities) that lie beyond the horizon of the matter at hand: it is a perspective that renders the interconnectedness of Gaia unthinkable" (Ghosh 2016, 56). From this perspective, the Anthropocene disrupts the idea that all *Homo sapiens* are the same and our destructiveness is just natural. Instead, we're very different and destructiveness looks like a cultural, or learned, behavior.

Many environmental humanists turn to the Anthropocene for its potential for telling stories about *Homo sapiens* that can teach us to see ourselves and our world more clearly. One story is of a superhero species tragically misusing its power, falling victim to its own hubris. Another story is of a superhero coming of age, awakening to a true understanding of its responsibilities to an interdependent relationship with other living and nonliving things. An effective story of the Anthropocene could be like a mirror helping us reflect on who "we" really are. Another kind of Anthropocene story could be like a lens that can bring into focus the thick mesh of co-species with whom we share Earth. Which story will we write? How will it end?

As with climate change, environmental humanists first need to understand the science behind the Anthropocene and then consider some of the debates about the term, its dating, and the new Earth histories it tells. Then we can look at critical and creative ways that the Anthropocene is "good to think with."

What is the Anthropocene?

Stratigraphy is a branch of geology that measures the way rocks, chemicals, and organisms are layered in Earth's crust. Its goal is to reconstruct Earth's history by marking changes in the type and distribution of rocks, chemicals, and organisms, and tell a story of how Earth and everyone on it came to be. Earth scientists divide the planet's 4.5-billion-year history into eons, eras, periods, epochs, and so forth—like chapters, sections, paragraphs, and sentences in a story, though some chapters are millions of years long. Any new chapter must identify

evidence ("signals") from all three areas that coincide in the same time-strata across the entire Earth. And they must be perceptible for millions of years. The International Commission on Stratigraphy (ICS) oversees this story, approves its sections, and arbitrates dating. New data suggests new dates for beginning different eons, eras, periods, epochs, and ages (Macdougall 2011).

We live the Cenozoic Era, which began about 66 million years ago when an asteroid collided with Earth, blanketing the atmosphere with dust, freezing the planet, killing the

EON	ERA	PERIOD	EPOCH		Ma
Phanerozoic	Cenozoic (Neogene/Paleogene)	Quaternary	Holocene		0.011
			Pleistocene	Late	0.8
				Early	2.4
		Tertiary	Pliocene	Late	3.6
				Early	5.3
			Miocene	Late	11.2
				Middle	16.4
				Early	23.0
			Oligocene	Late	28.5
				Early	34.0
			Eocene	Late	41.3
				Middle	49.0
				Early	55.8
			Paleocene	Late	61.0
				Early	65.5
	Mesozoic	Cretaceous	Late		99.6
			Early		145
		Jurassic	Late		161
			Middle		176
			Early		200
		Triassic	Late		228
			Middle		245
	Paleozoic	Permian	Early		251
			Late		260
			Middle		271
			Early		299
		Pennsylvanian	Late		306
			Middle		311
			Early		318
		Mississippian	Late		326
			Middle		345
			Early		359
		Devonian	Late		385
			Middle		397
			Early		416
		Silurian	Late		419
			Early		423
		Ordovician	Late		428
			Middle		444
			Early		488
		Cambrian	Late		501
			Middle		513
			Early		542
Precambrian	Proterozoic	Late	Neoproterozoic (Z)		1000
		Middle	Mesoproterozoic (Y)		1600
		Early	Paleoproterozoic (X)		2500
	Archean	Late			3200
		Early			4000
	Hadean				

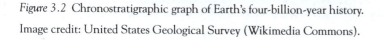

Figure 3.2 Chronostratigraphic graph of Earth's four-billion-year history.

Image credit: United States Geological Survey (Wikimedia Commons).

dinosaurs, and halting photosynthesis (Macdougall 2011). That's what stratigraphers call a "golden spike" or "a global marker of an event in stratigraphic material, such as rock, sediment, or glacier ice" (Lewis and Maslin 2015, 173). "Golden spikes" (Global Boundary Stratotype Section and Point-GSSP) are the preferred boundary markers between geological moments of time because they are so precise—like a period at the end of a sentence.

The Cenozoic Era is divided into three periods; ours, the Quarternary, began 2.6 million years ago (Lewis and Maslin 2015). The Quarternary is characterized by a lot of temperature and climactic variation: four major "Glacial Periods," popularly known as "Ice Ages," when it was more than 20°C below our current global average, interspersed by "Interglacials," all of which were cooler than the current Interglacial Epoch, the Holocene, which began 11,650 years ago (Zalasiewicz 2019).

In the Holocene, Earth warmed and the climate stabilized comparatively quickly, a GSSP documented in ice cores and fossils (Steffensen n.d.). For 12,000 years, the temperature has barely changed, an unprecedented "state of equilibrium between the living world and the geophysical world, creating resource abundance that is vital to the survival of humankind as we know it today" (Iyengar 2017, 51). This long equilibrium makes the Holocene a remarkable, though incredibly short, epoch by geological standards: for just a blink of an eye in 4.2 billion years, it was a climate you could count on.

For the human story, the Holocene is remarkable because that's when settled agricultural civilization began. For some 200,000 years, humans wandered the globe in small groups following food sources, temperate ecosystems, and avoiding predators. But within a few centuries of the beginning of the Holocene, a large number of *Homo sapiens* living in many different places suddenly and simultaneously took up an entirely different way of life (McNeill and Engelke 2014, 1). As sustainability expert, Leena Iyengar (2017), writes, it is "the only state of the planet we know that can support modern societies, and a world population of more than 7 billion people" (51). We don't know if human civilization can exist in any other conditions.

The Anthropocene may mark the start of a new epoch in which the state of equilibrium so favorable to us has been irreversibly disrupted. As the stratigraphers on the Anthropocene Working Group write, "the human reign has been geologically brief—but then so was the meteorite impact that likely ended the world of the Cretaceous and ushered in the Cenozoic Era. In this case, we collectively are (in effect) the meteorite" (Zalasiewicz et al. 2018, 181).

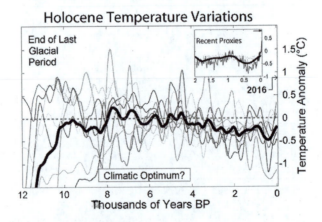

Figure 3.3 Holocene temperature variations.

Image credit: CC BY-SA 3.0 (Wikimedia Commons).

Case Study 3.2 Who's to blame? The Industrial Revolution, the Great Acceleration, or colonialization?

At stake in dating the Anthropocene is how we tell the human story of progress. Historians J. R. McNeill and Peter Engelke (2014) note that we can divide human history into two main energy phases: organic and fossil. Fossil fuels, they say, gave humans access to 500 million years of photosynthesis, "frozen sunshine," which powers not just the technological and economic revolutions of the modern period, but also unprecedented population growth. Britain, Western Europe, and the US would be principally to blame.

But industrialization developed slowly and locally. Not until the "The Great Acceleration" did population and fossil fuel use change the biogeochemical functioning of the planet in the ways stratigraphers measure (see Waypoint 3.1). A more logical choice for the "golden spike" is 1945 when the first layer of radioactive plutonium was laid down across Earth's entire surface. We'd have to blame advanced Western nations, particularly the US.

But some say that the biological signals are more important than the chemical, and thus date the Anthropocene's GSSP to the "Columbian Exchange" of plants, animals, and diseases during European colonization (Williams et al. 2018, 189). Starting in 1610, the biostratigraphical signature can be seen in ice cores, fossils, and global temperature records. Early-modern European imperialist nations are to blame.

In truth, only a tiny fraction of people have perpetrated the actions considered "golden spikes" (Opperman 2018, 4). Yet, the name, "Anthropos," falsely implies "all mankind." This is a big debate in the Environmental Humanities.

Before we get to the implications, let's look at how scientists have measured "the first appearance of a clear synchronous signal of the transformative influence of humans on key physical, chemical, and biological processes at the planetary scale" to mark the GSSP between the Holocene and the Anthropocene (Waters et al. 2018, 380).

Humans have long preferred to reshape their environments to suit their convenience. Neolithic humans extinguished most of the large mammals in Australia, the Americas, Africa,

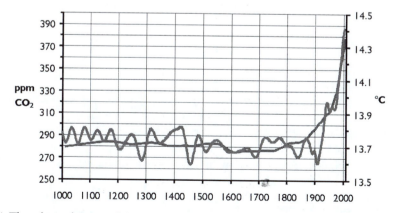

Figure 3.4 The relation between CO_2 concentrations and global temperature over the last 1,000 years. Image credit: D.M. Etheridge, L.P. Steele, R.L. Langenfelds and R.J. Francey (Wikimedia Commons).

and Eurasia, and used fire to reshape landscapes, leaving distinctive biostratigraphical markers of human impact on the biosphere that go back into deep time. Yet these markers lack the time precision necessary to define the Anthropocene (Williams et al. 2018). Until the modern period, there just were not enough people with powerful enough tools to leave a clear, synchronous, global fingerprint. At the beginning of the Holocene, there were only about 6 million people on Earth, roughly equivalent to the current population of Greater Sydney (Jamieson 2017, 14–15). Now there are 7.5 billion, most of whom appeared in the last 200 years. Exponentially more people have correspondingly more intensive and extensive bioturbation.

Waypoint 3.2 The start of the Anthropocene

Compare Figure 3.4's correlation between atmospheric CO_2 concentrations and recent temperature. Note the spike in global average temperatures, higher in the last 100 years than during the entire last 1,000. The change in chemostratigraphy, caused by humans burning fossil fuels, is one of the principal "golden spikes" considered for marking the beginning of the new epoch.

But it is not just masses of humans that leave a clear, synchronous signal on Earth systems; it is masses of humans acting in powerfully disruptive ways. Until British capitalists invented industrial economies that organized humans at mass scale and unleashed a technological explosion, the species did not have the power to disrupt the Holocene's equilibrium. Thus many people, including Paul Crutzen and Eugene Stoermer, point to 1776 when coal first powered James Watt's steam engine to drive industrial economies (Crutzen 2002). Using fossil-fueled machines not only affects atmospheric GHG concentrations, but also makes possible technologies and projects that were simply unimaginable with the kind of power (animal, human, wood) available to earlier civilizations.

However, industrialization spread gradually and did not have global effects for more than a century, meaning that it does not fit the criteria of clear, synchronous, global change necessary to qualify as a "golden spike" (Lewis and Maslin 2015, 176). Only after 1945, when industrial capitalism spread to the rest of the world, is there evidence of "an extensive, variably interconnected suite of physical, chemical, and biological changes to the Earth System" (Waters et al. 2018). While the dating is still under formal review by the ICS, they recently indicated that the "Great Acceleration" starting in 1945 is the most likely "golden spike" (Subramanian 2019).

Case Study 3.3 Geoengineering: Plan B or "arrogant ignorance"?

Geoengineering refers to large-scale modification of Earth systems to solve problems such as global warming, acidification of the oceans, drought, or desertification. As climatologist Will Steffen (2011) explains, climate change has turned attention to geoengineering as "plan B" for the planet (29).

There are two basic types, Carbon Dioxide Removal (CDR) and Solar Radiation Management (SRM). CDR means using natural or mechanical means to remove CO_2 (the leading greenhouse gas) from the atmosphere. Schemes include planting

more forests (afforestation), more trees (reforestation), or fertilizing soil or oceans to enhance their carbon absorption. The "engineering" boosts nature's process of removing carbon, and that seems safe except that there are significant land, water, and economic costs, plus long delays before noticeable amounts of carbon are removed.

A more high-tech form of CDR uses machines to suck air across a chemical filter that binds carbon while emitting water. Mechanical CDR does not require much land or water, can run on renewable energy, and can suck substantial carbon from the air immediately. While the IPCC notes that mechanical CDR has high cost and "considerable implementation challenges," all of its mitigation models assume CDR will complement the transition to all-renewable energy and reduced consumption. Thus, CDR still requires a painful recalibration of modern lifestyle expectations.

The second type of geoengineering, solar radiation management (SRM), promises to reduce global temperatures without changing current lifestyle expectations. In one scheme, aerosols block incoming sunlight, much like adjusting the blinds on your windows. In other schemes, oceans seeded with chemicals absorb more carbon; reflectors floated on ocean surfaces enhance the albedo effect; mirrors arrayed in space block sunlight from entering Earth's atmosphere. Life can go on as usual. We could pump a lot more carbon into the atmosphere without increased warming.

No one knows if SRMs will work until we try them. They might work too well, accidentally creating an ice age, or not work at all. Even if they work as expected, most computer models show the entire southern hemisphere entering severe multi-decade drought: is that acceptable collateral damage? Who decides? Nor do SRMs address any of the other Anthropocene problems: extinction, biodiversity loss, pollution, inequality—all caused by the same exploitive practices that created a climate crisis. Finally, and most problematic, once the world adopts geoengineering at this scale, we are committed to controlling the climate for the foreseeable future: we can't stop and we can't make mistakes. Some have argued that being better stewards of our homelands is the alternative to playing God (Steffen et al. 2011). What do you think?

What does the Anthropocene mean?

From an Environmental Humanities perspective, the precise date is less important than the fact that humans have affected the planet's biogeochemical structure in ways that can be compared to tectonic drift, the tilt of Earth's axis, and asteroid collisions. What that means, who is responsible, and what should be done now are key debates in the field.

Some debate is centered on what name to call this new epoch. Some sneer that naming an epoch for ourselves displays as much anthropocentrism as what got us into the mess in the first place. Others hope that the name reminds us of the need to take responsibility for our actions (Jamieson 2017, 14, LeManager 2017, 473, Heise 2017, 4). Historian Dipesh Chakrabarty (2009) speculates that the name may help unify humanity around the "shared catastrophe that we have all fallen into" (218).

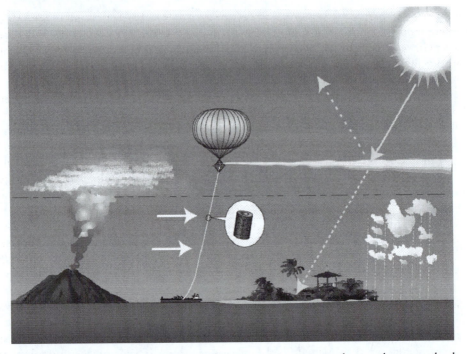

Figure 3.5 This picture shows an example of SRM using water vapor, similar to volcanos or clouds, to reflect incoming solar radiation.

Image credit: Hughhunt (Wikimedia Commons).

Reflection 3.2 What's in a name?

The **Anthropocene** is criticized for generalizing responsibility for trashing the planet to the whole human species. Here are some other proposed names:

The **Capitalocene** names the exploitive, extractive relationships of capitalism as the cause of planetary destruction. Industrial scale capitalism produces the wastes that stratigraphers use to identify these "golden spikes."

The **Plantationocene** names the slave-dependent plantation system as the cause of planetary destruction, an older form of capitalism's exploitive, extractive relationships. The plantation system was essential to European empire-building and the "Columbian Exchange," thus connecting it to another proposed "golden spike."

The **Chthulucene**, a term invented by biologist Donna Haraway, rebrands the age with an aspirational identity, naming the ethical, co-creative relationships that will be necessary to cultivate (see our Annotated Bibliography).

The **Gynocene**, the **Homogenocene** and the **Symbiocene** (Chapter 14) are other proposed names. Look them up and consider which one best fits the conditions of the new geological epoch. Does it matter what we name it? What are the consequences of one name or another?

Others warn that "Anthropocene" implies that we're all in this together, concealing differences in responsibility, guilt, power, risk, and vulnerability. Powerful, wealthy elites, particularly in the West, bear most of the responsibility, have benefited the most, and will be

least harmed by consequences. Justice and accuracy require scholars to measure not only the planetary scale of the human fingerprint, but also match the fingerprints to the specific people who disturbed the substratum of life on which we all depend. In trials for war crimes and genocide, we distinguish those responsible for making the decisions from followers, victims, and others.

Can that same distinction be applied to those whose decisions caused the Anthropocene? Did they act with enough consciousness? Who are "they"?

Beyond the issue of justice, environmental humanists are interested in leading reflection on behavioral and cultural change. If self-consciousness distinguishes our species and we (roughly) know the catastrophic consequences of our actions, then we can also ask whether our actions are necessary (like algae oxygenating) or just one of many options for achieving our needs—indeed, whether we are acting on *wants*, not *needs*. Can we redesign a civilizational structure that radically reduces destructive bioturbation while meeting genuine quality of life needs for all?

That is probably the most complicated and contentious question we can ask in the Anthropocene because it revolves around the issue of whether we can control our power. Looked at one way, humans are the new superhero species, boldly altering vast planetary systems; looked at another way, we are the sorcerer's apprentice, helpless before the vast powers we've unwittingly released and making matters worse with each new intervention. Incredibly powerful; utterly helpless. This is why Richard Kerridge says that the Anthropocene reveals humanity as a "duck-rabbit" paradox (Kerridge 2017, xiv–xv).

Having destabilized planetary systems, we now must manage them, but even with the most advanced supercomputer modeling, we cannot predict exactly how we will affect those systems, which are complex, adaptive, multi-scalar, and dynamic, with feedback loops and tipping points. We have a terrible track record of foreseeing the consequences of our actions: the Covid-19 pandemic, recent mass shootings, global financialization of risk, increasing power

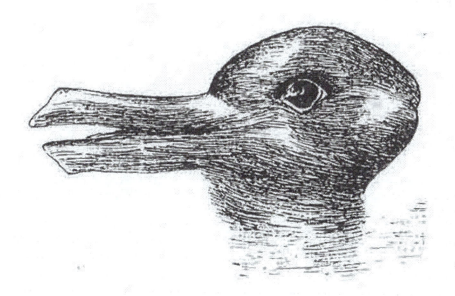

Figure 3.6 The duck-rabbit visual paradox.

Image credit: Wikimedia Commons.

of technology elites, and popular agitation, all demonstrate the unpredictability of human-scale events. Any attempt to manage environmental systems at global levels of scale seems like preposterous hubris.

And yet, as techno-futurist and former publisher of the famous *Whole Earth Catalogue*, Stewart Brand, has recently proclaimed, "we are as gods and *have* to get good at it" (see The Edge, The Reality Club under Weblinks). The statement will strike many as the essence of hubris, but Brand's perspective is pragmatic—we have transformed the entire Earth, which implies god-like superpowers. Therefore, practically speaking, we ought to accept our super-hero status and learn how to do the job well. If we could figure out how to be good agents of change, then the Anthropocene could turn out well. Maybe naming the age after ourselves *will* motivate us to take responsibility, evolve the necessary technologies, institutions, ethical relationships, and self-awareness to solve the problems we created.

This is not nearly as easy as Brand makes it sound. We're talking about the rapid evolution of the whole species toward a collective consciousness of our interdependence with other species. We'd have to learn how to give other species a "say" in the future of the planet because no one, individual or species, is more important for the sustained life of this planet.

Such a reckoning makes the Anthropocene into a "philosophical wrecking ball" for modern Western culture's most cherished belief: individualism. The doctrine of self-interest is the idea driving all the Anthropocene's "golden spike" events and central to the industrial-capitalist system. In the Western story of progress, a few elites convinced all of us that the pursuit of self-interest is a social good and a law of nature. Yet the pursuit of self interest was generally regarded as anti-social by previous civilizations and they established ethics, religion, arts, and culture to contain it. Individualism is contrary to what evolutionary biology and ecology tells us about the advantage of collaboration over competition for long-term species success. Individuals, no matter how much money they have, cannot survive the 6°C global warming predicted if "business as usual" continues (Jay et al. 2018, 41). The Anthropocene shows us that must cooperate or die.

What the Environmental Humanities contributes

If the Environmental Humanities uses the idea of the Anthropocene to attack the Western myths of progress, anthropocentrism, and toxic individualism, it also contributes to building a counter culture (Heise 2017, 8). Australian scholars, Deborah Bird Rose and Thom van Dooren, advocate a seemingly simple "attentiveness to the diverse living beings and forms of liveliness that constitute our world" (Rose and Van Dooren 2017, 120). Without attentiveness to the other, we suffocate within the confines of our own egotism. We can think of no more powerful way to counter the current culture of toxic individualism, which is the very root of our environmental crises, than cultivating attentiveness. Perhaps climate change, species extinction, and attention deficit disorder (ADD) are all related symptoms of the Anthropocene culture.

Rose and van Dooren also encourage the "arts of witness"—acknowledging, recording, and memorializing the lives and deaths in the world around us. This can take the form of oral histories, non-fiction nature writing, and multimedia arts. The work of the Climate Change Theater is exemplary: see our suggested websites and Case Study 12.4. Later chapters on ecoart, literature, journalism, history, and theater will provide other, specific ways you can apply Environmental Humanities knowledge and skills to Anthropocene crises.

Reflection 3.3 Attention! Achtung! Attenzione! Atencion!

How would you rate your attention span? Are you Instagramming, Snapchatting, tweeting, texting, and Facebooking while you read this? Listening to Spotify, streaming live feeds of stupid pet tricks, and checking football stats (American, European, or Australian)? There are plenty of demands on our attention and we've developed a capacity to multitask (though the research is clear that multitasking produces sloppy work). But what's lost when we channel surf through our day? When is the last time you sat alone, unplugged, in a quiet place for thirty minutes?

Recent research into contemplative practices (mindfulness, meditation, yoga) shows that developing attentiveness produces calm, clarity, and peace, reducing anxiety and depression. In *The Spell of the Sensuous*, philosopher David Abram (2012) points out that attentiveness discloses a world of creatures who are paying attention to us. That's an opportunity to escape narcissism, but also recognize that the world is a living community inviting our participation. Deep attention is also essential for thinking through complexity, surely a vital skill for navigating the Anthropocene.

Philosopher Simone Weil suggested that attention is the greatest gift you can give another because it's how you are fully present to others, able to respond authentically. What are some ways you can cultivate attentiveness? As you experiment, track the effects on yourself and others.

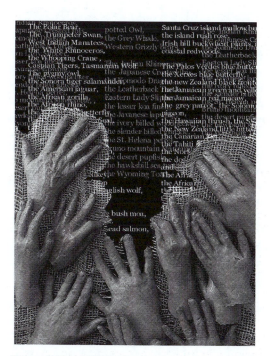

Figure 3.7 From "Spider Woman's Hands" (2007).

Image credit: Lauren Raine (Wikimedia Commons).

In addition, environmental humanists can support environmental and social justice (Johnston 2017). Using our powerful skills of research, writing, and art and our understanding of history, communication, and culture, we can investigate how power and risk are distributed in a community, asking who makes decisions, who profits, and who risks exposure to environmental hazard. For example, you can record or celebrate the adaptive capacity of those living in sacrifice zones while tracing the destruction back to the distant boardrooms, stock markets, banks, legislators, and executives whose decisions determined who gets to sacrifice so others can profit. *Days of Destruction, Days of Revolt*, by Chris Hedges and Joe Sacco, is an exceptionally powerful model: See Annotated Bibliography.

Reflection 3.4 Art and the Anthropocene

Arts of witness and memorial to the mass extinctions occurring in the Anthropocene take all forms, from installation, kinetic, and graphic design to digital art, mixed media experimentation, and film. Theater, literature, and music also thematize the human impact on Earth systems. In Figure 3.7, the artist has emphasized the impact literally, with human hands superimposed on lists of species predicted to go extinct or that have become extinct. What's its effect on you? For more on this topic, see Chapter 9.

The challenge of Anthropocene art is to make visible and tangible something that is abstract and conceptual. How would you visualize some of the concepts we've discussed in this chapter? Do some research and find out what others have done. If possible, try to visit a gallery that is showing Anthropocene art.

Finally, environmental humanists can trace histories of settlement, domestication, and place-making and how they are represented in arts and culture: how, where, when, and why do we create a home in a particular place? What does "home" mean? How is place-making related to belonging, identity and purpose? Consider that the Anthropocene's "golden spikes" center on changes in human settlement patterns—settled agriculture, colonization, industrialization, globalization. Those changes required force to dispossess and displace what—and who—came before. The Environmental Humanities is uniquely designed to ask questions about power: "'who is imagined to belong in this place?' and 'who (or what) has been excluded to make this place?'" (Emmett and Nye 2017, 25).

A study of place-making reveals the *inhumanity*—the thoughtlessness and presumptuousness—of many human settlement practices. Stewart Brand claims that the Anthropocene requires us to recognize that "we are as *gods* and have to get good at it." But maybe the Anthropocene—the *"human age"*—requires something simpler: "we are *humans* and have to get good at it." This means using our superpower—our big brains—with humility. The Environmental Humanities is where that project will take place.

Waypoint 3.4 Solastalgia in the Sacrifice Zone

Solastalgia: Coined by Glenn Albrecht, Australian professor of sustainability, solastalgia defines the complex emotions felt when one experiences profound and irreversible change to one's homeland: nostalgia, loss, distress, and confusion resulting from a loss of familiar landscapes of belonging and identity. People who see their ancestral homes bulldozed for a coal mine would feel solastalgia, but so might suburbanites who lose their neighborhoods to a strip mall, highway expansion, or climate-fueled wildfire (see Chapter 14).

Sacrifice Zone: The term originally identified places where nuclear testing was carried out. It has since been applied to environments that industry degrades in the process of extracting resources, processing materials, or disposing of waste, all of which are necessary for modern, industrial culture. They are places such as Gary IN, Flint MI, "Cancer Alley" LA, Bhopal India, the area around Chernobyl, some Native American reservations, Fort McMurray Alberta, Wittenoom, Western Australia, and many others around the globe. Sacrifice Zones showcase the environmental injustice and racism that results from globalization. Those residing in "sacrifice zones" suffer traumatic levels of "solastalgia."

Chapter summary

This chapter has defined the Anthropocene as a new geological age characterized by the human influence on Earth systems and described the way scientists have determined when it began. It has also described the Anthropocene as an idea about human–nature relations. Environmental humanists use this idea to interrogate the category of "human," breaking down the monolithic idea of one species into historically and culturally specific groups who reshaped Earth in geologically important ways. This work is central to rethinking human agency and calling civilization to account. Environmental humanists are using the Anthropocene to encourage a new evolution of human civilization, away from destructive anthropocentrism and toward sustainable symbiosis with our fellow earthlings.

Exercises

1. From coral reefs to mountaintops, from cities to rural farms, environments are being altered and destroyed with dizzying speed. Where have you personally witnessed the wounds of the world? What were your emotions? Have you experienced "solastalgia" for a place you care about? In a short documentary film, photo series, or creative non-fiction, bear witness to the environmental loss on a landscape you care about: how will you visualize the loss? Who is your audience?

2. Reducing net anthropogenic carbon emissions by 45% by 2030 is the IPCC's recommendation for keeping temperature increases below 1.5°C, which is the threshold for preventing catastrophic impacts. Pitch a plan to meet this goal to a climate change denier. What arguments would you use? What evidence would you cite? If you are speaking to a denier, you'll have to think of reasons to reduce carbon emissions other than the fact that they destabilize the climate system. You might start with these two articles: Burt, Orris, and Buchanan. 2013. "Scientific evidence of health effects from coal use in energy generation." Chicago and Washington, DC: School of Public Health, University of Illinois and Health Care Without Harm; and Markandya and Wilkinson. 2007. "Electricity generation and health." *Lancet* 370: 979–990; but also consider US EPA. 2013. "How people are exposed to mercury," www.epa.gov/hg/exposure.htm.

3. Return to Reflection 3.1 and read the references cited there about biostratigraphic markers of the Anthropocene. Write down a list of the top ten markers that scientists have identified. Like our "cat, rat, and chicken" signals, which ones could be used in a graphic or literary satire of the Anthropocene? Using Jonathan Swift's (1729) *A Modest Proposal* (www.gutenberg.org/files/1080/1080-h/1080-h.htm) or Gary Larson's *The Far Side* comic strip (www.thefarside.com) as a model, create a short essay illustrated with graphic sketches.

4. Identify an environmentally risky industry in your area and try to find out why it was located there, who makes money from it, who is put at risk, and who makes the decisions. Research your local zoning laws to find out about permitting, liability, environmental impact studies, regulation, and risk management. Contact local action groups and agencies to consider how this research could be useful to local action groups and agencies trying to preserve their communities and lands.

Annotated bibliography

Diamond, Jared. 1997. *Guns, Germs, and Steel: The Fates of Human Societies*. New York: W. W. Norton. This Pulitzer-Prize-wining book examines the competitive and environmental advantages that allowed European societies to expand its influence across the globe.

Ellis, Erle C. 2018. *The Anthropocene: A Very Short Introduction*. New York and Oxford: Oxford University Press. Written by a professor of geography and environmental systems, this book provides an accessible review of the geological debates and a discussion of how humans are shaping the future of the planet.

Haraway, Donna. 2016. *Staying with the Trouble: Making Kin in the Chthulucene*. Durham: Duke University Press. In this challenging book by founding post-humanist thinker, Haraway proposes that we learn the kind of symbiotic thinking that will enable us to build a more livable future with Earth's family of species—a critical reframing of our crisis epoch as an opportunity to evolve *Homo sapiens*, great potential.

Kolbert, Elizabeth. 2014. *The Sixth Extinction: An Unnatural History*. New York: Henry Holt and Co. A story-driven tale of humanity's encounter with extinction, and the slow recognition that our species is probably causing the next great extinction event in geological history. Science journalism at its best.

McNeill, J. R. and Peter Engelke. 2014. *The Great Acceleration: An Environmental History of the Anthropocene since 1945*. Cambridge: The Belknap Press of Harvard University. The book offers a readable examination of the causes and consequences of the Anthropocene, paying particular attention to energy systems, climate change, urbanization, consumerism, and population. The authors engage with important debates in stratigraphy, geology, economics, geography, and demographics.

Wilson, E. O. 2016. *Half-Earth: Our Planet's Fight for Life*. New York: Liveright. A two-time Pulitzer Prize-winning Harvard biologist examines the human impact on biodiversity and the prospect of survival in the Anthropocene—essential for understanding the relation between biodiversity and human thriving.

Weblinks

Climate Change Theater Action. This is a global collaboration of several theater companies that stage plays thematizing climate change and human impact on the planet; its educational outreach mission assists schools and other groups free of charge with creating their own climate change theater. www.climatechangetheatreaction.com

Haus der Kulturen der Welt. This is an international forum for art, music, literature, and debate about how we think about the Anthropocene, with webcasts, podcasts, performances, webinars, educational exchanges, book reviews, and more. www.hkw.de/en/index.php

PBS Frontline and NPR does investigative journalism on environmental topics such as plastic pollution and industry collusion. This site is a starting point that will lead you to other reports on plastics. www.npr.org/2020/09/11/897692090/how-big-oil-misled-the-public-into-believing-plastic-would-be-recycled

Stratigraphy, The International Stratigraphic Commission. This is the association of scientists overseeing the chronostratigraphic chart and maintaining the standards of measuring and describing Earth history. www.stratigraphy.org

The Anthropocene, Future Earth. This journalistic enterprise is dedicated to science literacy and sustainable innovation. www.anthropocenemagazine.org

The *Anthropocene* Journal. This is a leading scholarly journal publishing peer-reviewed interdisciplinary research on the nature, scope, scale, and significance of human impacts on Earth systems. www.journals.elsevier.com/anthropocene

The Anthropocene Project. This multidisciplinary work by a group of artists integrates film, visual art, multimedia, and science to examine the human impact on planetary systems. See their recent, award-wining film, *The Anthropocene: The Human Epoch*, 2018. https://theanthropocene.org/

The Anthropocene Review. This is a scholarly journal publishing peer-reviewed research from the social and natural sciences and the humanities on the causes, history, nature, and implications of a world in which human activities are integral to the functioning of the Earth system. https://journals.sagepub.com/home/anr

The Center for Humans and Nature. This organization shares ideas about a socially and ecologically interconnected world through a forum, a blog, and a journal. The following issue addresses art in the Anthropocene. www.humansandnature.org/art-in-the-anthropocene-1

The E. O. Wilson Foundation. This website, named after the great Harvard biologist and dedicated to preserving biodiversity through education, advocacy, dialogue, and support of various projects around the world, offers blogs, book reviews, news, videos, education toolkits, and other programming. https://eowilsonfoundation.org/

The Edge, The Reality Club. This is an online forum of conversations with the world's most brilliant, innovative thinkers, on a wide range of topics, including this interview with the Stewart Brand. www.edge.org/conversation/stewart_brand-we-are-as-gods-and-have-to-get-good-at-it

References

Abram, David. 2012. *The Spell of the Sensuous: Perception and Language in a More-Than-Human World*. New York: Vintage.

Bar-On, Yinon M., Rob Phillips, and Ron Milo. 2018. "The Biomass Distribution on Earth." *PNAS* 115 (25): 6506–6511.

Chakrabarty, Dipesh. 2009. "The Climate of History: Four Theses." *Critical Inquiry* 35 (2): 197–222.

Clark, Timothy. 2015. *Ecocriticism on the Edge: The Anthropocene As a Threshold Concept*. London: Bloomsbury.

Crutzen, Paul J. 2002. "Geology of Mankind." *Nature* 415 (3): 23.

Crutzen, P. J., and E. F. Stoermer. 2000. "The Anthropocene." *IGBP Newsletter* 41: 17–18.

Editors. 2019. "Findings." *Harper's Magazine* 339 (2031): 96.

Emmett, Robert S., and David E. Nye. 2017. *The Environmental Humanities: A Critical Introduction*. Cambridge: MIT Press.

Ghosh, Amitav. 2016. *The Great Derangement: Climate Change and the Unthinkable*. Chicago: University of Chicago Press.

Heise, Ursula K. 2017. "Introduction: Planet, Species, Justice—and the Stories we Tell about Them." In *The Routledge Companion to the Environmental Humanities*, edited by Ursula K. Heise, Jon Christensen and Michelle Neimann, 1–10. London and New York: Routledge.

Iyengar, Leena. 2017. "The Environmental Crisis: The Needs of Humanity versus the Limits of the Planet." In *The Community Resilience Reader: Essential Resources for an Era of Upheaval*, edited by Daniel Learch, 45–63. Washington, DC: Island Press.

Jamieson, Dale. 2017. "The Anthropocene: Love it or Leave it." In *The Routledge Companion to the Environmental Humanities*, edited by Ursula K. Heise, Jon Christensen and Michelle Niemann, 13–20. London and New York: Routledge.

Jay, A., D. R. Reidmiller, C. W. Avery, D. Barrie, B. J. DeAngelo, A. Dave, M. Dzaugis, M. Kolian, K. L. M. Lewis, K. Reeves, and D. Winner. 2018. *Impacts, Risks, and Adaptation in the United States: Fourth National Climate Assessment*, edited by US Global Change Research Program. Washington, DC.

Johnston, Barbara Rose. 2017. "Action-Research and Environmental Justice: Lessons from Guatemala's Chixoy Dam." In *The Routledge Companion to the Environmental Humanities*, edited by Ursula K. Heise, Jon Christensen and Michelle Niemann, 174–184. London and New York: Routledge.

Kerridge, Richard. 2017. "Foreword." In *Environmental Humanities: Voices from the Anthropocene*, edited by Serpil Oppermann and Serenella Iovino, 13–17. London and New York: Rowman & Littlefield.

LeManager, Stephanie. 2017. "The Humanities After the Anthropocene." In *The Routledge Companion to the Environmental Humanities*, edited by Ursula K. Heise, Jon Christensen and Michelle Niemann, 473–481. London and New York: Routledge.

Lewis, Simon L., and Mark A. Maslin. 2015. "Defining the Anthropocene." *Nature* 519 (7542): 171–180.

Macdougall, J. D. 2011. *Why Geology Matters: Decoding the Past, Anticipating the Future*. Berkeley: University of California Press.

McNeill, John Robert, and Peter Engelke. 2014. *The Great Acceleration: An Environmental History of the Anthropocene Since 1945*. Cambridge: The Belknap Press of Harvard University Press.

Opperman, Serpil. 2018. "The Scale of the Anthropocene: Material Ecocritical Reflections." *Mosaic* 51 (3): 1–17.

Rose, Deborah Bird, and Thom van Dooren. 2017. "Encountering a More-than-Human World: Ethos and the Arts of Witness." In *The Routledge Companion to the Environmental Humanities*, edited by Ursula K. Heise, Jon Christensen and Michelle Niemann, 120–128. London and New York: Routledge.

Steffen, Will. 2011. "A Truly Complex and Diabolical Policy Problem." In *The Oxford Handbook of Climate Change and Society*, edited by John S. Dryzek, Richard B. Norgaard and David Schlosberg, 21–37. Oxford: Oxford University Press.

Steffen, Will, Asa Persson, Lisa Deutsch, Jan Zalasiewicz, Mark Williams, Katherine Richardson, Carole Crumley, Paul Crutzen, Carl Folke, Line Gordon, Mario Molina, Veerabhadran Ramanathan, Johan Rockström, Marten Scheffer, Hans Joachim Schellnhuber, and Uno Svedin. 2011. "The Anthropocene: from Global Change to Planetary Stewardship." *Ambio* 40 (7): 739.

Steffensen, Jorgen Peder. n.d. "*What Caused the End of the Ice Age?*". Niels Bohr Institute. Accessed August 28, 2019. https://www.nbi.ku.dk/english/sciencexplorer/earth_and_climate/golden_spike/video/spoergsmaal_svar1/.

Subramanian, Meera. 2019. "Anthropocene Now: Influential Panel Votes to Recognize Earth's New Epoch." *Nature*.

Sullivan, Heather I. 2017. "Material Ecocriticism and the Petro-Text." In *The Routledge Companion to the Environmental Humanities*, edited by Ursula K. Heise, Jon Christensen and Michelle Niemann, 414–423. London and New York: Routledge.

Waters, Colin N., Jan Zalasiewicz, Colin Summerhayes, Ian J. Fairchild, Neil L. Rose, Neil J. Loader, William Shotyk, Alejandro Cearreta, Martin J. Head, James P. M. Syvitski, Mark Williams, Michael Wagreich, Anthony D. Barnosky, Zhisheng An, Reinhold Leinfelder, Catherine Jeandel, Agnieszka Gałuszka, Juliana A. Ivar Do Sul, Felix Gradstein, Will Steffen, John R. McNeill, Scott Wing, Clément Poirier, and Matt Edgeworth. 2018. "Global Boundary Stratotype Section and Point (GSSP) for the Anthropocene Series: Where and How to Look for Potential Candidates." *Earth-Science Reviews* 178: 379–429.

Williams, Mark, Jan Zalasiewicz, Colin Waters, Stephen Himson, Colin Summerhayes, Anthony Barnosky, and Reinhold Leinfelder. 2018. "The Palaeontological Record of the Anthropocene." *Geology Today* 34 (5): 188–193.

Zalasiewicz, Jan, ed. 2019. *The Anthropocene as a Geological Time Unit: A Guide to the Scientific Evidence and Current Debates*. Cambridge and New York: Cambridge University Press.

Zalasiewicz, Jan, Colin Waters, Colin Sumerhayes, and Mark Williams. 2018. "The Anthropocene." *Geology Today* 34 (5): 177–181.

4 Indigenous cultures and nature

Past, present, and future

Chapter objectives

- To become familiar with the complex relationship between Indigenous cultures and their environments
- To appreciate the contributions of Indigenous peoples around the world to contemporary debates regarding environmental sustainability
- To acquire a foundation for working with Indigenous communities in Environmental Humanities research projects

Contacting the sentinelese

On November 17, 2018, members of a tribe known as the Sentinelese killed 26-year-old American missionary John Allen Chau with arrows. Consisting of a small population of about 100, the Sentinelese live on North Sentinel Island, an isolated 20-square-mile (52-square-kilometer) island between India and Myanmar (Burma) in the Bay of Bengal (Figure 4.1). According to anthropologists, the people have occupied the island for over 30,000 years, surviving mainly by hunting and gathering. Chau had to recruit local fishermen to smuggle him to North Sentinel. He hoped to convert the residents to Christianity. And so it happened that the global spotlight came to shine on one of the most isolated, misunderstood, and vulnerable Indigenous communities on the planet (Safi 2018).

There is a history of Sentinelese resistance to strangers. As one of the "last uncontacted tribes," they hold a place in the global imagination (Wallace 2011). The Italian explorer Marco Polo never visited North Sentinel but, in 1296, described the people unflatteringly as "Idolaters" (or heathens) and "no better than wild beasts" (Polo 1875, 292). In the 1960s, anthropologists arrived, bearing gifts, but peacemaking was abandoned a decade later, after the near misses of far too many arrows. On August 2, 1981, *Primrose*, a freighter en route to Australia from Bangladesh, ran aground with a load of poultry feed. The stranded men were airlifted to safety after a harrowing week spent dodging spears on an otherwise idyllic beach (Goodheart 2000).

Evident in this history is the Sentinelese's desire to be left alone amid a modern world that seems bent on assimilating them. Environmental humanists recognize that assimilation would constitute the loss of cultural practices for living sustainably in the world. After all, the Sentinelese have been living on a small island for 30,000 years; they must be doing something right! A respect for Indigenous knowledge and culture has been foundational for the development of Environmental Humanities and the field tracks in parallel to the global Indigenous rights movement.

DOI: 10.4324/9781351200356-4

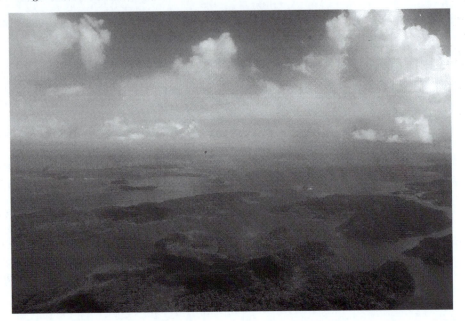

Figure 4.1 In addition to the Sentinelese, India's Andaman Islands are home to the Jarawas, Jangil, Onge, and other Indigenous groups.

Image credit: Venkatesh K. (Wikimedia Commons).

Reflection 4.1 The ethics of first contact

The term *first contact* refers to encounters with members of Indigenous societies who have not previously been exposed to the industrialized world. Aired in the United Kingdom, the documentary *First Contact: Lost Tribe of the Amazon* presents first meetings with the Txapanawa of Brazil (MacQueen 2016). The people relate shocking stories of massacres, illegal mining, logging, drug smuggling, and other threats to their future. Some Indigenous rights activists argue that uncontacted people should be left completely alone. Other advocates support limited contact as a means to record communities in transition and enhance cultural survival. What do you think? Should the world's last uncontacted people remain just that: *uncontacted*?

Indigenous cultures and the Environmental Humanities

According to the United Nations, there are 370–500 million Indigenous people in the world belonging to 5,000 distinct cultural groups across 90 countries. Although they inhabit nearly every region of the planet—from the South Pacific to the Arctic—about 70% live in Asia. The Hmong, for instance, are found in parts of China, Vietnam, and Laos (Cha 2010). Indigenous people speak the majority of the world's 6,500–7,000 known languages. What's more, their traditional homelands contain up to 80% of the planet's imperilled biodiversity (Cultural Survival 2018b; UNESCO 2019). The urgent environmental issues of our present era—climate change, species loss, water pollution, and so on, as discussed in Chapter 3—are especially acute for Indigenous communities who depend on threatened ecosystems for their

livelihoods. While they constitute only 5% of the global population, Indigenous people represent 15% of the world's poor and 33% of the world's critically poor (Asia Pacific Forum of National Human Rights Institutions 2013, 3).

Over many millennia, Indigenous societies like the Sentinelese have learned to live in sustainable balance with environments. In another example, recent excavations at a rock shelter in northern Australia indicate that human occupation of the continent began 65,000 years ago (Clarkson et al. 2017). When the first inhabitants of Australia arrived during an interglacial period of the Middle Pleistocene, woolly mammoths roamed across North America and Eurasia. While respecting Indigenous societies that have survived, in some cases, many thousands of years longer than Chinese, Indian, or Roman societies, the Environmental Humanities seeks neither to romanticize Indigenous people nor to suggest that their interactions with the land have been without impacts. The field, instead, acknowledges the deep cultural histories of Indigenous people. To be sure, ecologists have begun to examine the application of traditional ecological knowledge—or TEK—of Indigenous societies in developing approaches to environmental problems (Nelson and Shilling 2018). Indigenous knowledge of flora, fauna, weather, and seasons could shed light on the problems facing humans and more-than-humans in the Anthropocene (Raygorodetsky 2017). Moreover, Indigenous knowledge is our only access to social adaptations from before the Holocene, when Earth's climate was as variable and uncertain as it is predicted to be in the Anthropocene (see Chapter 3).

Case Study 4.1 Indigenous Weather Knowledge project

Launched in 2002, the Indigenous Weather Knowledge (IWK) project is a partnership between Indigenous communities and the Bureau of Meteorology in Australia. The website (www.bom.gov.au/iwk/) includes information about the traditional calendars of fourteen Aboriginal groups. IWK aims to preserve the knowledge of environment and culture embedded within seasonal calendar systems. One of the groups featured in the project is the Banbai, the traditional owners of the Wattleridge Indigenous Protected Area of New South Wales (Australian Government n.d.). The Banbai recognize six seasons, including "Wildfire time" from November to March during which frogs breed, beetles swarm, trees fruit, and soaring temperatures trigger bushfires.

IWK is an example of *ethnometeorology*. Crossing between anthropology and meteorology, this field examines people's beliefs about weather and seasons. The Indigenous people of Australia recognize a variety of influences on weather, including the activities of ancestral beings associated with the Dreaming, or Dreamtime, during which the world was created. Understanding meteorological patterns has been central to the adaptation of Indigenous societies to environmental change over long expanses of time. As anthropologist and botanist Philip Clarke comments, "The way of life for Aboriginal people demanded a detailed knowledge of the relationships between weather and the landscape, enabling them to observe and forecast its constant changes" (Clarke 2009, 79).

Why is Indigenous knowledge of weather and seasons important? If you live in a country that has displaced Indigenous weather and seasonal knowledge with the imported knowledge of colonial powers, see if you can recover some of the Indigenous knowledge. Which flowers, birds, and ecological events are important to the Indigenous cultures of your country, region, or area?

Case Study 4.1 raises the crucial question of which terms to use to refer to the people who inhabited a place prior to colonization by Europe, Japan, China, the United States, and other imperial powers. Descriptive language varies widely according to cultural and historical contexts. However, generic adjectives—"Indigenous" and "Aboriginal" are common—conceal important distinctions between cultural groups. Where possible, it is preferable to employ precise names such as "Banbai" rather than "Aboriginal Australian"; "Hmong" rather than "Indigenous Vietnamese"; and "Cherokee" rather than "Native American." When working with Indigenous people, make sure to consult ethical guidelines beforehand. If you are in doubt about which terms are suitable, just ask the people themselves.

The Australian Institute of Aboriginal and Torres Strait Islander Studies (AIATSIS), for instance, recommends "Indigenous Australians"—usually capitalized—to encompass both Aboriginal and Torres Strait Island people. In Australia, an Indigenous person is one whose relatives are Indigenous; regards herself or himself as Indigenous; and is acknowledged as such by members of the community (AIATSIS 2015, 11–12). The AIATSIS statement reflects the United Nations (UN) working definition of an Indigenous person as one who self-identifies as Indigenous and belongs to an Indigenous community (Asia Pacific Forum of National Human Rights Institutions 2013, 6).

In this chapter, we use the adjective "Indigenous" to refer to the original inhabitants of different regions of the world. We recommend the noun "Indigenous people" over "Indigenes," a term that has increasingly become outdated. Our linguistic choice here reflects the language employed in the UN Declaration of the Rights of Indigenous Peoples (United Nations 2007). Numerous competing terms, however, can complicate the matter of choosing the most respectful language when studying, researching, or working with Indigenous communities within an Environmental Humanities framework. In the United States, the use of identity labels is a highly controversial area. Michael Yellow Bird, a member of the Sahnish (Arikara) and Hidatsa First Nations, characterizes "American Indian" and "Native American" as "the most common racial and ethnic labels used to identify the general population of Indigenous Peoples in the United States" (Yellow Bird 1999, 1). It is important to bear these debates in mind as you progress through your studies of the Environmental Humanities. Let's take a look at Waypoint 4.1 for a summary of common labels, some of which are more culturally respectful than others.

Waypoint 4.1a Identity labels

- *Aboriginal people*: refers to the Indigenous people of Australia as a whole but can be used for the original inhabitants of other countries; preferred over the dated term *Aborigines* (AIATSIS 2015, 12, Clarke 2011)
- *Ethic group*: describes a group of people sharing the specific characteristics of a culture, such as history, homeland, and dialect. However, exercise care with this term because not all ethnic groups are Indigenous (Barth 1998)
- *First Nations*: came into popular use in the 1970s in reference to the Indigenous people of Canada south of the Arctic circle; replaced *Indian*, which some view as insensitive and degrading (Government of Canada 2012)
- *Indian*: originated in Columbus' misguided notion that he had discovered a route to India; often refers to American Indian, or Amerindian, people; enshrined in institutional monikers such as the Bureau of Indian Affairs (BIA) (Warrior 2014)

Waypoint 4.1b Continued—Identity labels

- *Native American*: emerged in the 1960s out of respect to American Indians and Native Alaskans but has expanded to include all the Indigenous people of the United States and its territories (Native American Rights Fund n.d.)
- *Original inhabitants*: reflects an historical understanding of Indigenous people as those who occupied a particular place prior to settlement by an outside power (Samson and Gigoux 2017)
- *Traditional Owners*: appeared first in the *Aboriginal Land Rights (Northern Territory) Act* of 1976 in reference to Indigenous Australians with "common spiritual affiliations to a site on the land" (Edelman 2009, 4)
- *Tribal people*: derives from the discipline of cultural anthropology to denote a social group consisting of multiple families or generations and sharing particular connections to a homeland (Bodley 2011)

Reflection 4.2 Thinking critically about identity labels

Which terms do you prefer from Waypoint 4.1, and why? Are there any Indigenous peoples in your community or university? What is/are the specific name(s) of their cultural group(s)? If you don't know the answer yet, how could you learn more? If your state or country practices bilingualism with an Indigenous culture, you might examine the language choices for official signs and events. Or perhaps your state or country has a formal ceremony at the beginning of all meetings and events to recognize traditional owners of the land. What do you think of these linguistic efforts at inclusion?

Indigenous cultures and EH: Historical perspectives

The evolution of ethnobiology is a landmark within studies of Indigenous peoples' relationships to the environment, as examined within the Environmental Humanities. Ethnobiology includes the more specialized fields of ethnobotany (plants), ethnozoology (animals), ethno-entomology (insects), ethnomycology (fungi), ethnomedicine (natural healing agents including herbs), and ethnoecology (whole ecosystems). Ethnobotany, for instance, crosses between anthropology, archaeology, history, religion, literary studies, botany, medicine, and pharmacology. Ethnobotanists are interested in how Indigenous people process, use, classify, and think about plant life. In the late 1800s, ethnobotany took shape in North America through an emphasis on Native American peoples' interactions with plants. Botanist John Harshberger coined the term in 1895 to describe "the use of plants in primitive societies" (where "primitive" today would be considered patronizing) (Schultes 1995, 11). Pioneering ethnobotanist Richard Evans Schultes explained that the field studies "human evaluation and manipulation of plant materials, substances, and phenomena, including relevant concepts, in primitive or unlettered societies" (Schultes 1995, 11–12).

Reflection 4.3 Ethnobotany around town

Ethnobotanists study plants, people, and culture. In particular, they research Indigenous societies' uses of plants for food, medicine, fiber, decoration, ceremonial objects, and other purposes. Choose a plant near your house, office, or campus. It can be a tree, bush, shrub, herb, or small flower. What is the name of the plant? Is it edible, medicinal, or fragrant? What do you know about the traditional uses of the plant? Jot down your impressions.

Case Study 4.2 Amazonian Bioprospecting

The Amazon rainforest encompasses about 2,700,000 square miles (7,000,000 square kilometers) located mostly in Brazil, Peru, and Columbia (Figure 4.2). (For the sake of comparison, the lower 48 states of the United States cover roughly 3,120,000 square miles). With an estimated 30,000 species, Amazonian forests harbor the greatest diversity of plants in the world (compared to 17,000–18,000 plant species in the entire United States). As a result, Amazonia has been likened to El Dorado, the fabled city sought by the Spanish empire. Yet, rather than gold, Amazonian wealth consists of lucrative medicines derived from plants and used for millennia by Indigenous people such as the Yanomami. The term *bioprospecting* refers to "the characterization of living organisms (e.g., plant species) in respect to the presence of commercially valuable chemical compounds" (Skirycz et al. 2016, 783).

The Convention on Biological Diversity addresses the rights of Indigenous communities to benefit from the use of their traditional ecological knowledge. Signed in 1992 at the UN Conference on Environment and Development (the Rio de Janeiro Earth Summit, discussed in Chapter 1), the Convention has three main objectives: (1) to conserve biodiversity; (2) to enhance the sustainable use of biodiversity; and (3) to ensure the equitable sharing of benefits resulting from genetic resources. Adopted in 2010, the Nagoya Protocol protects Indigenous communities from the exploitation of their knowledge. The Protocol aims to "enhance the contribution of biological diversity to sustainable development and human wellbeing" (Secretariat of the Convention on Biological Diversity 2011, 1).

What kinds of benefits should Indigenous people receive from the commercialization of their traditional ecological knowledge (TEK)? What are some of the risks associated with bioprospecting? How many current pharmaceuticals come from Amazonia? To get started, you can refer to the UN website for information on bioprospecting: https:// globalpact.informea.org/glossary/bioprospecting.

In the 1990s and 2000s, the "Ecological Humanities" emerged in Australia in close dialogue with Indigenous beliefs and values. A key work is anthropologist Deborah Bird Rose's *Dingo Makes Us Human* (1992), a study of the Yarralin people of the Northern Territory of Australia. Rose's method was classically "ethnographic" (see Waypoint 4.2). She participated in conversations with Yarralin people about their cultural stories, or Dreaming, including traditional ecological knowledge and ideas of human kinship with other living beings. Rose later published the book *Nourishing Terrains* (1996), narrating Indigenous peoples' connections to their ancestral homelands, or Country (spelled in Australia with a capital "C").

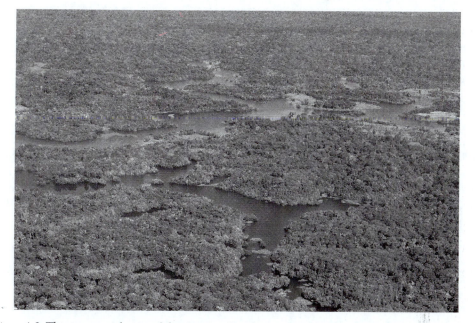

Figure 4.2 This is an aerial view of the Amazon Rainforest, near Manaus, the capital of the Brazilian state of Amazonas.

Image credit: Neil Palmer/CIAT (Wikimedia Commons).

Authored with Libby Robin, her influential article "The Ecological Humanities in Action: An Invitation" (Rose and Robin 2004), furthermore, calls attention to Indigenous Australian philosophies as essential to the development of the field. Indigenous knowledge systems are described as intricate, ethical, and localized. The final section of the article, "Indigenous Ecological Knowledge," proposes what Rose and Robin call a *connectivity ontology* in which "connections are what matter" (see Reflection 4.4).

Reflection 4.4 What is a connectivity ontology?

Rose and Robin (2004) discuss the idea of a *connectivity ontology*, drawn from Indigenous Australian worldviews, in which all living and non-living things are related. The authors contrast this idea to a Western ontology that splits mind from matter and nature from culture. *Ontology* is the philosophical study of being and is concerned "with what exists" (in other words, with *everything*) (Blackburn 2005, 261). In Chapter 7, we will explore the field of environmental philosophy in detail. In the meantime, consider how a *connectivity ontology* (a sense that everything that exists is connected) contributes to the aims of environmental sustainability?

Connectivity ontology is one of many concepts that Environmental Humanities has borrowed from Indigenous studies, a parallel discipline in the social sciences and humanities. Other examples include the ideas of kinship with non-humans and animism as a worldview the recognizes all things as alive. The academic study of Indigenous cultures evolved alongside the global Indigenous rights movement. As Indigenous knowledge and culture became more respected as a mainstream study, Indigenous people slowly gained acceptance for their

right to exist separately from modern nation-states. In principle, modern nations are willing to acknowledge the history of colonization and the increased vulnerability of Indigenous peoples, cultures, and languages. They are also coming to value Indigenous knowledge, beliefs, practices, and rituals, particularly in relation to local ecologies. Yet, this has been a long, continuing struggle, and rights are too often ignored when they conflict with the state's economic interests.

One starting point for this global history is the meeting in the 1920s between Iroquois (or Haudenosaunee) Chief Deskaheh and Māori leader Tahupōtiki Wiremu Rātana. They petitioned the League of Nations (the UN's predecessor) on behalf of Indigenous people. The Indigenous and Tribal Populations Convention (established in 1957, revised in 1989) then provided a standard for ensuring Indigenous rights (Danver 2015, 865–870). The convention of 1957 was followed by the UN Declaration of Indigenous Peoples of the World, presented on June 7, 1992 at the Global Forum for Indigenous Peoples in Rio de Janiero (Danver 2015, 870–871). The Declaration opens with this collective statement:

> We the Indigenous Peoples of the world, manifest our concern at this moment, when people from the whole planet are gathered here in Rio to discuss the direction of our lives, our planet Mother Earth and the future of our children and grandchildren.
>
> United Nations (2007, 871)

Adopted in 2007, the UN Declaration on the Rights of Indigenous Peoples reasserted the right to self-determination called for in previous documents (United Nations 2007).

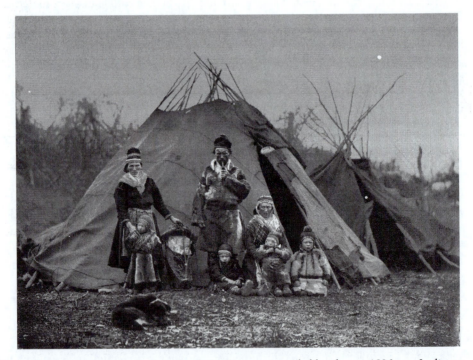

Figure 4.3 This photograph of a Sami family in Norway was probably taken in 1896 near Lødingen. Image credit: Wikimedia Commons.

Case Study 4.3 Indigenous activism in the Philippines

The Philippines archipelago is home to approximately 110 Indigenous groups such as the Bicolano, Ibanag, Kapampangan, and Visayan. The International Work Group for Indigenous Affairs estimates that 10–15% of the population is Indigenous (Asia Indigenous Peoples' Pact 2010, 5). The people of northern Philippines are known as *Igorots*, which in Tagalog (the national language) means "mountain people." The Igorots include the people of six provinces (Abra, Apayao, Benguet, Ifugao, Kalinga, and Mountain) located in Cordillera Central, a mountain range in the north-central part of the island of Luzon (Figure 4.4). Each language group has a distinct set of beliefs and practices connected to the natural world (Finin 2005).

Igorot activists and human rights defenders in the Cordillera have opposed mining, logging, and other large-scale development in the region. Yet, their resistance has come with grave risks, ominously, extrajudicial killings. Rafael Markus Bangit, a leader of the Malbong people of Kalinga, was murdered in 2006 (Cordillera Peoples Alliance 2006). James Balao, founder of the Cordillera Peoples Alliance, disappeared in 2008, presumably abducted by the state (Asia Indigenous Peoples' Pact 2010, 13, Cultural Survival 2018a). More broadly, the issue of Indigenous land rights in Southeast Asia has received less attention from the international community than debates in Australia, New Zealand, and the Americas (Xanthaki 2003).

Is it possible to protect Indigenous rights while altering the land through mining, clearcutting, and other activities? What sorts of measures might ensure that Indigenous Southeast Asian voices are heard by the global community? Base your argument on some of the forty-six Articles in the UN Declaration on the Rights of Indigenous Peoples, available here: www.un.org/development/desa/indigenouspeoples/wp-content/uploads/sites/19/2018/11/UNDRIP_E_web.pdf.

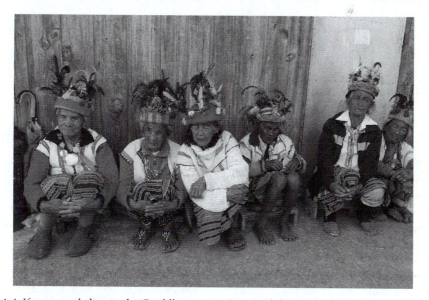

Figure 4.4 Ifugao people live in the Cordillera region, Luzon, Philippines.

Image credit: Yves Picq (Wikimedia Commons).

Indigenous cultures and EH: Current directions

There are different ways of thinking about the relationship between Indigenous cultures and the Environmental Humanities. Let's outline three. The first is Indigenous interactions with the environment as *models for sustainable environmental practices* in the future. The traditional ecological knowledge of Indigenous societies provides a basis for developing solutions to local, regional, and global problems. A good example is the adoption of traditional low-intensity—or mosaic—burning practices by land managers in Australia to reduce the likelihood of catastrophic bushfires while, at the same time, enhancing animal and plant diversity (Bliege Bird et al. 2018, Gammage 2011). The second is research that applies an Environmental Humanities framework to *examine Indigenous issues* (e.g., land rights, resource use, or bioprospecting) or *incorporate Indigenous perspectives* into Environmental Humanities analyses of modern culture (e.g., the idea of a connectivity ontology). The third is Environmental Humanities research that *includes Indigenous people directly as participants* and *integrates ethical principles* in order to protect their traditional knowledge. An illustration of the third point is Jessica Weir's study *Murray River Country: An Ecological Dialogue with Traditional Owners* (2009), which involved conversation and collaboration with the Indigenous communities of the Murray-Darling Basin of Australia.

Reflection 4.5 Indigenous cultures and EH

We have outlined three ways of understanding the relationship between Indigenous cultures and the Environmental Humanities:

- Indigenous interactions with the land are used as models for developing sustainable practices
- Indigenous issues and/or perspectives are incorporated into EH research or programs
- Indigenous people are included as participants in EH research or programs that integrate ethical principles

Consider these three points. What are the key differences and similarities between them?

A spate of recent publications highlights the increasing importance of studies of Indigenous cultures to the development of the Environmental Humanities. In the edited volume *The Routledge Companion to the Environmental Humanities*, for example, Neshnabé (Potawatomi) scholar-activist Kyle Powys Whyte observes that Indigenous people continue to put into practice traditional knowledge of the natural world in response to the urgent ecological challenges of the Anthropocene. Whyte offers the examples of sturgeon, wild rice, and water restoration projects that include public programs, bringing Indigenous and non-Indigenous people together to learn more about human entanglements with other species (Whyte 2017). A special issue of the journal *Humanities*, moreover, calls attention to the intersection of Indigenous studies and the Environmental Humanities. The editors highlight the potential of these two interdisciplinary fields to collaborate further in devising approaches to ecological and cultural quandaries (Thornber 2016).

Waypoint 4.2 Four research methodologies

- *Ethnography*: involves observing, participating in, and representing Indigenous cultures; developed historically out of the social sciences and tends to make use of interviews, focus groups, and/or questionnaires (Harrison 2018)
- *Archival Studies*: focuses on the analysis of data collected by other parties and stored in physical or digital repositories; the US National Archives, for example, contains Native American records from as early as 1774 (Jackson 2008, 87-88)
- *Textual Analysis*: centers on the interpretation of *texts* (books, documents, films, magazines, cartoons, clothing, tattoos, and so forth) in order to understand the ways in which a culture makes sense of the world (McKee 2005, 1)
- *Discourse Analysis*: studies how meaning is produced and messages communicated in everyday life; also examines popular representations of Indigenous people that circulate in the media (Johnstone 2018)

Case Study 4.4 Dakota Access Pipeline protests

The Dakota Access Pipeline is a 1,172-mile (1,886-kilometer) underground pipeline transporting crude oil from North Dakota, through South Dakota and Iowa, to Illinois. At a cost of US$3.8 billion, construction took place between December 2014 and April 2017. The project was completed, despite strong resistance from Native American communities and environmental activists, especially between April 2016 and February 2017 (Sammon 2016). The route crosses under the Missouri River (Mni Sose) and traverses land adjacent to the Standing Rock Sioux (Hunkpapa Lakota, Sihasapa Lakota, and Yanktonai Dakota) and Fort Berthold (Mandan, Hidatsa, and Arikara) reservations. Opponents stressed that the pipeline threatens water sources and disturb culturally important sites (Nicolescu 2018).

In 2016, Indigenous activists led by Standing Rock Sioux Elder LaDonna Brave Bull Allard established Sacred Stone Camp on the construction grounds of the pipeline (Figure 4.5). By November 2016, the camp grew to more than 400 people representing 90 Indigenous nations. A second camp, Oceti Sakowin, accommodated a steady influx of activists from around the world (Estes 2019, 57). Protesters were subjected to pepper spray, guard dogs, cannon blasts, and other forms of violence. Although the pipeline was eventually finished, the protests constitute one of the most significant Native American grassroots movements in history. The camps brought together diverse Indigenous voices opposed to the degradation of Native American land and culture.

Visit the website Standing with Standing Rock (https://standwithstandingrock.net). What were the key features of the protests? How did Indigenous peoples use their moral authority as traditional owners with rights given by US treaties to gain legal standing? What does this example illustrate about the power that Indigenous peoples can bring to environmental activism?

Figure 4.5 The Dakota Access Pipeline protest took place at the Sacred Stone Camp near Cannon
Ball, North Dakota.

Image credit: Tony Webster (Wikimedia Commons).

Summary

Chapter 4 has explored the role of Indigenous cultures in the Environmental Humanities.
TEK is the precious culmination of thousands of years of Indigenous peoples' lived experiences in places. Our discussion has encouraged you to begin to think critically about the connections between Indigenous cultures, the natural world, and contemporary concerns such
as land clearance and bioprospecting. Indigenous practices have indeed become increasingly
vital to humanistic approaches to environmental justice and sustainability. Nonetheless,
this emphasis comes with ethical and moral questions regarding the use—and misuse—of
Indigenous knowledge. Environmental Humanities research often seeks to engage directly
with Indigenous communities as partners in projects designed to address ecological problems,
enhance human wellbeing, and protect more-than-human species.

Exercises

1. Learn about the TEK of local Indigenous people in relation to plants, forests, animals,
 fungi, soil, water, and/or whole ecosystems. How does this compare with modern scientific knowledge? Can the two forms of knowledge be integrated?
2. Identify an Indigenous culture in a region different from where you live or grew up. For
 instance, if you live in Europe, find out about an Indigenous Southeast Asian culture.
 Summarize the TEK of the culture you choose. Does this help you understand your home
 ecology in a new way?
3. Locate a story in the media about an Indigenous community. It could about a campaign for land rights or an initiative to preserve an endangered language. Describe
 how the community is represented in the story. Pay particular attention to the identity
 labels used.
4. Climate change is a serious issue affecting Indigenous people around the world. Consult
 one of more of these resources to learn more about the issues: www.kcet.org/shows/
 tending-nature/the-disproportionate-impact-of-climate-change-on-indigenous-communities; www.nature.com/articles/palcomms201785; www.un.org/development/desa/indigenouspeoples/climate-change.html. Outline a research project to examine the effects of

climate change on these communities. Apply one or more of the approaches outlined in Waypoint 4.2.

5. A multinational pharmaceutical company has arrived in town to commercialize traditional knowledge of plants. As an advocate working on behalf of Indigenous people, outline the steps you will take to ensure that their rights will be observed and protected.

Annotated bibliography

Albuquerque, Ulysses Paulino, and Rômulo Romeu Nóbrega Alves, eds. 2016. *Introduction to Ethnobiology*. Heidelberg: Springer. The highly accessible textbook offers a concise overview of ethnobiology, an interdisciplinary field that studies the interactions between people and the environment.

Benterrak, Krim, Stephen Muecke, and Paddy Roe. 1984. *Reading the Country: Introduction to Nomadology*. Fremantle: Fremantle Arts Center Press. This is a seminal example of a work that crosses fluidly between Indigenous studies and the Ecological Humanities in Australia. The collaborative and multimedia book includes songs, narratives, conversations, photographs, and paintings focused on the Indigenous cultures of the Kimberley region of Western Australia.

Danver, Steven, ed. 2015. *Native Peoples of the World: An Encyclopedia of Groups, Cultures, and Contemporary Issues*. London: Routledge. The three-volume sourcebook provides a valuable introduction to the Indigenous cultures of all regions of the world as well as issues of agriculture, climate change, colonialism, globalization, mining, racism, revitalization, and social discrimination.

Geniusz, Wendy Makoons, ed. 2015. *Plants Have So Much To Give Us, All We Have To Do Is Ask*. Minneapolis: University of Minnesota Press. This is a superb example of an ethnobotanical work by Indigenous (Anishinaabe) writers, artists, and healers who use stories to pass on traditional knowledge of herbal plants from generation to generation.

Lennox, Corinne, and Damien Short, eds. 2016. *Handbook of Indigenous Peoples' Rights*. London: Routledge. The handbook comprises eight parts: Indigeneity; Rights and Governance; Indigenous Women's Rights; Development and the Environment; Mobilization for Indigenous Peoples' Rights; Justice and Reparations; International Monitoring and Mechanisms for Indigenous Peoples' Rights; and Regional Case Studies.

Monani, Salma, and Joni Adamson, eds. 2016. *Ecocriticism and Indigenous Studies: Conversations from Earth to Cosmos*. New York: Routledge. The edited volume offers insight into the convergence of ecocriticism (or environmental literary studies) and Indigenous studies through an emphasis on film, performance, literature, and multimedia productions.

Weblinks

American Indian Records in the National Archives, Native American Heritage. The National Archives of the United States contains millions of historical records relating to Native American heritage from 1774 to the mid-1990s. www.archives.gov/research/native-americans

Cordillera Peoples Alliance. This is the website of an independent grassroots organization that works on behalf of the Indigenous communities of the Cordillera region of the Philippines. www.cpaphils.org

Forest Peoples Program. This UK-based human rights organization works with Indigenous people around the world on land rights and livelihoods. www.forestpeoples.org

Indigenous Environmental Network. This US-based network focuses on environmental justice and land preservation. www.ienearth.org/home2

Indigenous Weather Knowledge project. This is a collaboration between Indigenous Australians and the Bureau of Meteorology. The website provides details about the traditional calendars of fourteen Indigenous cultures. www.bom.gov.au/iwk

Man in Search of Man. Available on YouTube, this film from 1974 depicts the Indigenous people of the Andaman and Nicobar islands in the Bay of Bengal. www.youtube.com/watch?v=wSkGqTPzsTM

Native American Ethnobotany. The website is one of the earliest online archives specialized in the plant-based food, medicines, dyes, and fibers of Native Americans. http://naeb.brit.org

Survival International. The organization works in partnership with Indigenous communities in South America, Australia, Asia, and elsewhere. Watch this three-minute film to learn about the importance of protecting the last uncontacted people of the world from ecogawking. www.survivalinternational.org

United Nations. The UN works to preserve Indigenous culture, language, and artefacts. This link includes information about international law and treaties. https://en.unesco.org/indigenous-peoples

References

AIATSIS. 2015. *Guidelines for the Ethical Publishing of Aboriginal and Torres Strait Islander Authors and Research From Those Communities.* Canberra: Aboriginal Studies Press.

Asia Indigenous Peoples' Pact. 2010. *ASEAN's Indigenous Peoples.* Chiang Mai: International Work Group for Indigenous Affairs.

Asia Pacific Forum of National Human Rights Institutions. 2013. *The United Nations Declaration on the Rights of Indigenous Peoples: A Manual for National Human Rights Institutions.* Sydney: Asia Pacific Forum of National Human Rights Institutions.

Australian Government. n.d. "*Wattleridge Indigenous Protected Area.*" Accessed March 10, 2019. https://www.niaa.gov.au/indigenous-affairs/environment/wattleridge-ipa-and-rangers.

Barth, Fredrik, ed. 1998. *Ethnic Groups and Boundaries: The Social Organization of Culture Difference.* Long Grove: Waveland Press. Original edition, 1969.

Blackburn, Simon. 2005. *The Oxford Dictionary of Philosophy.* 2nd ed. Oxford: Oxford University Press.

Bliege Bird, Rebecca, Douglas W. Bird, Luis E. Fernandez, Nyalanka Taylor, Wakka Taylor, and Dale Nimmo. 2018. "Aboriginal Burning Promotes Fine-Scale Pyrodiversity and Native Predators in Australia's Western Desert." *Biological Conservation* 219: 110–118. doi: 10.1016/j.biocon.2018.01.008.

Bodley, John H. 2011. *Cultural Anthropology: Tribes, States, and the Global System.* Lanham: AltaMira Press.

Cha, Ya Po. 2010. *An Introduction to Hmong Culture.* Jefferson: McFarland & Company.

Clarke, Philip. 2009. "Australian Aboriginal Ethnometeorology and Seasonal Calendars." *History and Anthropology* 20 (2): 79–106. doi: 10.1080/02757200902867677.

Clarke, Philip. 2011. *Aboriginal People and Their Plants.* Kenthurst: Rosenberg Publishing.

Clarkson, Chris et al. 2017. "Human Occupation of Northern Australia by 65,000 Years Ago." *Nature* 547 (7663). doi: 10.1038/nature22968.

Cordillera Peoples Alliance. 2006. "*CPA Factsheet: Killing of Rafael Markus Bangit.*" Accessed March 12, 2019. http://www.cpaphils.org/FACT%20SHEET%20MAKOY_june%209htm.htm.

Cultural Survival. 2018a. "*Help Put Pressure On the Government of the Philippines to Find Indigenous Activist James Balao.*" Accessed March 12, 2019. https://www.culturalsurvival.org/news/help-put-pressure-government-philippines-find-indigenous-activist-james-balao.

Cultural Survival. 2018b. "*The Issues.*" Accessed March 6, 2019. https://www.culturalsurvival.org/issues.

Edelman, David. 2009. "*Broader Native Title Settlements and the Meaning of the Term 'Traditional Owners'.*" AIATSIS Native Title Conference, Melbourne.

Estes, Nick. 2019. *Our History Is the Future: Standing Rock Versus the Dakota Access Pipeline, and the Long Tradition of Indigenous Resistance.* London: Verso.

Finin, Gerard. 2005. *The Making of the Igorot: Ramut Ti Panagkaykaysa Dagiti Taga Cordillera (Contours of Cordillera Consciousness).* Manila: Ateneo de Manila University Press.

Gammage, Bill. 2011. *The Biggest Estate on Earth: How Aborigines Made Australia.* Crows Nest: Allen & Unwin.

Goodheart, Adam. 2000. "The Last Island of the Savages." *The American Scholar* 69 (4): 13–44. https://theamericanscholar.org/the-last-island-of-the-savages/#.XIl2dLgpCM8.

Government of Canada. 2012. "*Terminology*." Accessed March 10, 2019. https://web.archive.org/web/20130114030734/http://www.aadnc-aandc.gc.ca/eng/1100100014642/1100100014643.

Harrison, Anthony Kwame. 2018. *Ethnography: Understanding Qualitative Research*. Oxford: Oxford University Press.

Jackson, Sherri. 2008. *Research Methods: A Modular Approach*. Belmont: Thomson Higher Education.

Johnstone, Barbara. 2018. *Discourse Analysis*. 3rd ed. Hoboken: John Wiley & Sons.

MacQueen, Angus. 2016. *First Contact: Lost Tribe of the Amazon*. London: Channel 4.

McKee, Alan. 2005. *Textual Analysis: A Beginner's Guide*. London: SAGE.

Native American Rights Fund. n.d. "Frequently Asked Questions." Accessed March 10, 2019. https://www.narf.org/frequently-asked-questions/.

Nelson, Melissa, and Dan Shilling, eds. 2018. *Traditional Ecological Knowledge: Learning from Indigenous Practices for Environmental Sustainability*. Cambridge: Cambridge University Press.

Nicolescu, Ionut. 2018. "Cases of Equality: Idle No More and the Protests at Standing Rock." *Canadian Journal of Urban Research* 27 (2): 1–13.

Polo, Marco. 1875. *The Book of Ser Marco Polo, the Venetian, Concerning the Kingdoms and Marvels of the East*. Translated by Henry Yule. 2nd ed. Vol. 2. London: John Murray.

Raygorodetsky, Gleb. 2017. *The Archipelago of Hope: Wisdom and Resilience from the Edge of Climate Change*. New York: Pegasus Books.

Rose, Deborah Bird. 1992. *Dingo Makes Us Human: Life and Land in an Aboriginal Australian Culture*. Cambridge: Cambridge University Press.

Rose, Deborah Bird. 1996. *Nourishing Terrains: Australian Aboriginal Views of Landscape and Wilderness*. Canberra: Australian Heritage Commission.

Rose, Deborah Bird, and Libby Robin. 2004. "The Ecological Humanities in Action: An Invitation." *Australian Humanities Review* 31–32. http://australianhumanitiesreview.org/2004/04/01/the-ecological-humanities-in-action-an-invitation/.

Safi, Michael. 2018. "American Killed By Isolated Tribe On North Sentinel Island in Andamans." *The Guardian* November 22. https://www.theguardian.com/world/2018/nov/21/american-killed-isolated-indian-tribe-north-sentinel-island

Sammon, Alexander. 2016. "A History of Native Americans Protesting the Dakota Access Pipeline." *Mother Jones* September 9. https://www.motherjones.com/environment/2016/09/dakota-access-pipeline-protest-timeline-sioux-standing-rock-jill-stein/.

Samson, Colin, and Carlos Gigoux. 2017. *Indigenous People and Colonialism: Global Perspectives*. Cambridge: Polity Press.

Schultes, Richard Evans. 1995. "Preface." In *Ethnobotany: Evolution of a Discipline*, edited by Richard Evans Schultes and Siri Von Reis, 11–14. Portland: Dioscorides Press.

Secretariat of the Convention on Biological Diversity. 2011. *Nagoya Protocol on Access to Genetic Resources and the Fair and Equitable Sharing of Benefits Arising from their Utilization to the Convention on Biological Diversity: Text and Annex*. Montreal: United Nations Environmental Programme.

Skirycz, Aleksandra, Sylwia Kierszniowska, Michaël Méret, Lothar Willmitzer, and George Tzotzos. 2016. "Medicinal Bioprospecting of the Amazon Rainforest: A Modern Eldorado?" *Trends in Biotechnology* 34 (10): 781–790. doi: 10.1016/j.tibtech.2016.03.006.

Thornber, Karen. 2016. "Humanistic Environmental Studies and Global Indigeneities." *Humanities* 5 (52): 1–8. doi: 10.3390/h5030052.

UNESCO. 2019. "*Indigenous Peoples*." Accessed March 6, 2019. https://en.unesco.org/indigenous-peoples.

United Nations. 2007. *Declaration on the Rights of Indigenous People*. New York: United Nations.

Wallace, Scott. 2011. *The Unconquered: In Search of the Amazon's Last Uncontacted Tribes*. New York: Crown Publishing.

Warrior, Robert. 2014. "Indian." In *Keywords for American Cultural Studies*, edited by Bruce Burgett and Glenn Hendler, 130–132. New York: New York University Press.

Weir, Jessica K. 2009. *Murray River Country: An Ecological Dialogue with Traditional Owners*. Canberra: Aboriginal Studies Press.

Whyte, Kyle Powys. 2017. "Our Ancestors' Dystopia Now: Indigenous Conservation and the Anthropocene." In *The Routledge Companion to the Environmental Humanities*, edited by Ursula Heise, Jon Christensen and Michelle Niemann, 206–215. London: Routledge.

Xanthaki, Alexandra. 2003. "Land Rights of Indigenous Peoples in South-East Asia." *Melbourne Journal of International Law* 4 (2): 467–496.

Yellow Bird, Michael. 1999. "What We Want To Be Called: Indigenous Peoples' Perspectives on Racial and Ethnic Identity Labels." *American Indian Quarterly* 23 (2): 1–21.

5 Environmental anthropology, cultural geography, and the geohumanities

Space and place

Chapter objectives

- To introduce the relationship between space, place, and people in the Environmental Humanities
- To explain the contribution of environmental anthropology, cultural geography, and the geohumanities to the Environmental Humanities
- To enable you to appreciate your own experiences of space and place in your everyday life
- To stress the idea that place is home, or the space with which one becomes familiar and from which one derives the resources to live.

Razing the amazon

The Brazilian Amazon is burning. The country's National Institute for Space Research recorded 93,000 individual fires between January and September 2019—an 85% rise from 2018 and the highest number in a decade. Analysts attribute the significant spike in fires to land clearance for cattle ranching (Figure 5.1). The burning, moreover, corresponds to a sharp decrease in the prosecution of environmental crimes under the politically conservative presidency of Jair Bolsonaro who assumed office earlier in the year (BBC 2019). In response to the crisis—and Bolsonaro's lukewarm commitment to halting it—the European Union has proposed a ban on Brazilian imports of beef and leather (Kauranen 2019).

The razing of the precious Amazon provokes important questions about truth and myth in media coverage of the environment. The Amazon, for instance, is commonly described as "the lungs of the planet." However, for ecologists such as Michael Coe of the Woods Hole Research Center in Massachusetts, this characterization falls short. According to Coe and other Earth system scientists, Amazonia's real value is its biodiversity (Zimmer 2019). Burning the forests will transform it into a less biodiverse savanna-like landscape, radically diminishing the ecological complexity on which global sustainability depends. This profound ecological shift, in turn, will destabilize the Indigenous communities that have depended on the ecosystem for generations. This is in addition to turning the Amazon from a carbon sink to a carbon producer as burning releases carbon dioxide, and deforested areas have reduced capacity to remove carbon from the atmosphere.

If we stop imagining the Amazon as the "lungs of the planet" and start seeing it as the world's most fragile, biodiverse ecosystem, essential to maintaining civilization's ideal climate, we have started to characterize it as a place worthy of consideration and protection. How we define the place will shape the actions we take in that place. Understanding how

DOI: 10.4324/9781351200356-5

Figure 5.1 Smoke from Amazon wildfires depicted on August 20, 2019 using Visible Infrared Imaging. Image credit: Wikimedia Commons.

humans turn vague geographical space into detailed, meaningful places that we care about is the general focus of environmental anthropology and cultural geography.

Reflection 5.1 Infrared imaging

Figure 5.1 was created with a new technology known as Visible Infrared Imaging Radiometer Suite (VIIRS) employed in weather satellites, aircraft, and drones. This radiometer collects imagery and measures electromagnetic radiation to produce detailed visualizations of land, atmosphere, and oceans. In the Environmental Humanities, imagery is essential to understanding space and place from various perspectives across different scales. Yet, while satisfying the need for abstract knowledge, different kinds of images also engender feelings. What emotional responses does Figure 5.1 provoke for you? List a few now. As an alternate exercise, try looking at images of melting glaciers in Alaska: https://climate.nasa.gov/news/2939/ice-in-motion-satellites-capture-decades-of-change/. What emotional response do these provoke?

Space and place in the Environmental Humanities

Space and place are cornerstones of the Environmental Humanities. These interdependent concepts enable us to approach, understand, and formulate solutions to complex socio-ecological issues including the razing of the Amazon. Studies of space and place shed light on human–environment relations beyond the rigid division between *our* social world, on the one hand, and *their* natural order, on the other. Space lays the groundwork for place. In his influential study *Space and Place: The Perspective of Experience*, geographer Yi-Fu Tuan (1977)

suggests that "'space' is more abstract than 'place'. What begins as undifferentiated space becomes place as we get to know it better and endow it with value" (6). In other words, place emerges as we—and other creatures—experience space directly through our cognitive and sensory faculties. Space becomes place becomes home.

We will now consider the importance of space and place in the three fields at the center of this chapter: *environmental anthropology*, *cultural geography*, and *the geohumanities*. Whereas environmental anthropology and cultural geography are relatively established fields, the geohumanities is an emerging area that shares much common ground with the Environmental Humanities.

To begin with, environmental (or ecological) anthropology has played a leading role in the evolution of the Environmental Humanities. A focus area within the broad field of anthropology, environmental anthropology foregrounds human–environment interactions of the past, the present and—particularly in response to climate change and the Anthropocene—the future (Shoreman-Ouimet and Kopnina 2011, 1). Environmental anthropologists study a range of topics—from human behavior, ecological perception, community environmentalism, and societal collapse to natural disasters, biological diversity, urban gardening, and Indigenous knowledge. Although an academic specialization rife with theory (and the abstraction that necessarily comes along with it), environmental anthropology is also an applied, policy-driven field motivated by ecological concern and interested in presenting avenues for action. Environmental anthropologists hope to contribute to global conservation but generally focus on local solutions.

Case Study 5.1 Easter Island and ecocultural collapse

Easter Island is a classic case study of the relationship between environmental degradation and societal collapse. Also known as Rapa Nui, Easter Island is the most remote inhabited island on the planet. Located in the south-eastern Pacific Ocean, the Polynesian island is known for its colossal, large-headed statues, or *moai*, carved by the Rapa Nui people between the twelfth and seventeenth centuries (Figure 5.2). Venerated for their otherworldly powers, *moai* depict ancestors and are regarded as *aringa ora*, or "living faces," rather than celestial deities (Arnold 2000, 23–24). Despite the grandeur of the more than 900 *moai*, the construction of the statues may have severely altered the ecology of the island and the culture of the Rapa Nui people, according to one theory popularized by geographer Jared Diamond.

Trees were felled to make fires and build canoes to transport the *moai*. The loss of forest cover resulted in erosion, triggering a chain of calamities including lower food production, hunger, starvation, conflict, war and, eventually, the decline of the human population. According to some environmental anthropologists and other researchers, this process of societal breakdown was not immediate but instead took three centuries to materialize (Boersema 2011, 1–2). In *Collapse: How Societies Choose To Fail or Survive*, Diamond (2004) cites Easter Island as iconic of the perils of ecological exploitation and the exhaustion of a place over time. Diamond urges humankind to avoid replicating the history of Rapa Nui elsewhere in the world. Diamond's theory transforms Easter Island into a place symbolizing humanity's self-destructive relation to a fragile, limited ecosystem.

Research theories of Easter Island's demise and consider what different characterizations of the island suggest for human–nature relations generally. Can you think of other places that stand for certain moral truths? How can "making a place" be used, for good or ill, as an environmental object lesson?

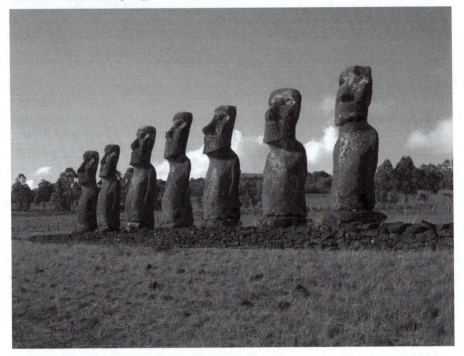

Figure 5.2 These Ahu Akivi are the only *moai* that face the ocean.

Image credit: Ian Sewell (Wikimedia Commons).

 Like environmental anthropology, cultural geography has considerably influenced the growth of the Environmental Humanities. A specialization within human geography, the field investigates human interactions with space and place in order to cast light on the ways in which we inhabit and affect the world as well as the various meanings and values we ascribe to our experiences. On a globalized planet ever more characterized by change at all levels, cultural geography grapples with themes of alienation, mobility, relations, transience, and transition. Holistic in approach, the field approaches politics not solely as electoral processes and class dynamics but broadly as power relations between humans, other humans, and more-than-humans (see Waypoint 1.3). Questions of how we derive knowledge and interact with nature are fundamental to cultural geography (Oakes and Price 2008, 1–2).

Reflection 5.2 From space to place

Space and place are foundational to the Environmental Humanities. Much research on these concepts has been done in environmental anthropology and cultural geography, both of which focus on human–nature relations but from different disciplinary perspectives. We have suggested that space (abstract) *becomes* place (tangible) through experience, memory, meaning, and value. In the case of Easter Island, the people of Rapa Nui transformed the physical space of the island into an ancestral place significantly through the carving of *moai*. Diamond and other environmental anthropologists then transformed the island into an object lesson in a moral allegory about human responsibility to the places on which they depend. In their rendering, Earth itself became a place we should care about. Reflect on an experience of arriving somewhere unfamiliar (a space) and making it become meaningful (a place). How did you go about transforming space into place?

Focused on interaction between the humanities and geography, the geohumanities has emerged recently in response to global technological and social shifts. Geographer Tim Cresswell (2015) defines the field as an "interdisciplinary endeavor with space and place at its heart that links decades of critical thought following the spatial turn [in the discipline of geography] to new developments in our digital capabilities" (7). The phrase the "spatial turn" refers to greater emphasis on space in geographical theory and practice. The geohumanities reflects conceptual and technical developments—such as geocoding—that enable innovative approaches to data processing and underlie the production of new representations of space and place. The geohumanities emphasizes space and place as unquestionably vital to all forms of knowledge production. After all, all action takes place in a "place." It is thus informed by the actor's perception of the space as a "place" for her actions. What we come to know or believe derives from our perceptions and actions in a specific place. As an example of the geohumanities in action, the Welikia Project aimed to reconstruct, in digital form, the original landscape of New York City circa 1609 when Dutch settlers first arrived. Studying this reproduction can give us an understanding of what the first European settlers perceived and how their actions turned that space into a meaningful place for themselves. For more information on the endeavor, see this chapter's Weblinks section.

Waypoint 5.1 Keywords in space and place studies

- *Bioregionalism*: the design of community structures according to bioregions usually defined by the boundaries of watersheds
- *Globalization*: the global-scale, capital-driven, free market economy in which economic, commercial, political, and other activities no longer adhere to national boundaries
- *Livelihood*: a concept outlined by cultural theorist Raymond Williams that opposes the nature–culture opposition and encourages a sustainable approach to making a living from the physical world
- *Mobility*: the ways in which humans, more-than-humans, technologies, ideas, and ideologies move between spaces and places
- *Non-place*: a concept proposed by anthropologist Marc Augé to describe places of excessive information and space, such as supermarkets, airports and motorways
- *Place*: the space that someone identifies with as meaningful and imbued with memories shared by individuals and communities
- *Placelessness*: a term coined by geographer Edward Relph to refer to the substitution of places of character with homogenized landscapes that lack identity, such as malls
- *Sense of place*: the distinctive feeling we have for particular places as experienced through our senses, bodies, minds, and memories; a sense of place is essential for a sense of belonging and identity
- *Space*: a location that lacks social connection, value, and meaning, and thus remains a geometric abstraction, or a featureless blank
- *Topography*: the spatial arrangement of the physical features of a place, including landforms and watercourses
- *Topophilia*: a strong attachment to place marked by feelings of affection and love; theorized by geographer Yi-Fu Tuan and philosopher Gaston Bachelard
- *Transience*: the short-term inhabitation of a place by certain populations, often connected to migration, diaspora, and refugeeism

Space and place: historical perspectives

The concepts of space and place occupied the earliest Western thinkers, poets, and scientists. In the fourth century BC, for instance, Aristotle developed a theory of place in his collection of treatises called *Physics*. The Greek philosopher conceptualized place in terms of time, motion, and locomotion (or what he referred to as *change of place* and we describe as *mobility*). For Aristotle, place provides form and shape to bodies within its dimensions of length, breadth, and depth (Barnes 1991, 52). In his own words, place is "the boundary of the containing body at which it is in contact with the contained body" (57). According to this view, place exists only with respect to the body—or bodies—it encloses within three-dimensional geometric space. Philosophers describe this understanding of place as *phenomenological*—or engaging human sensory perception of the world's complex phenomena.

This relationship between bodies, spaces, and places has been central to environmental anthropology since the emergence of the field in the early to mid-twentieth century. As a case in point, during the 1930s, anthropologist Julian Steward (1902–72) developed the influential idea of cultural ecology, focused on long-term human adaptations to environments. Steward's concept emphasizes the role of culture in how humans adapt to environments and live within ecological limits. Cultural ecology seeks "to explain the origin of particular cultural features and patterns which characterize different areas" (Steward 1972, 36). In his studies of the Shoshone, the anthropologist detailed the technologies used to procure natural resources as well as the social structure of subsistence activities. Steward's theory, indeed, reminds us that the transformation of space into place depends on cultural beliefs, values, and practices.

Case Study 5.2 *Balinese rice terraces and the Subak System*

Bali, Indonesia, is a densely populated volcanic island in Southeast Asia that is also a popular tourist destination. The cultural ecology of the island is dominated by five spectacular rice terraces and their water temples covering about 19,500 hectares (48,200 acres) (Figure 5.3). Designated a UNESCO World Heritage Cultural Landscape in 2012, the terraced landscape produces rice using neither fertilizers nor pesticides. Canals channel water from springs and rivers through temples and into paddies, making cultivation possible on the steep terrain. The temples have been the focal point of a cooperative water management system known as *subak* dating back at least to the eleventh century. The system reflects the Balinese principle of *Tri Hita Karana*, integrating human, natural, and spiritual realms into a harmonious whole (UNESCO World Heritage Centre 2012).

For more than one-thousand years, the *subak* network has been an integral part of the spiritual life of Balinese people. Now it is under threat from globalization and local pressures. *Subaks* compete with hotels for water and other resources as Bali becomes more urbanized. Farmers struggle to pay land taxes as national policy keeps the price of rice artificially low. Better paying employment in the tourism sector attracts the children of farmers. Between 2005 and 2009, about 1,000 hectares annually (2,470 acres) of *subak* terraces were appropriated for other uses. What's more, several *subaks* lacking the UNESCO cultural landscape designation, especially those located near the sprawling capital city of Denpasar, collapsed in the face of encroaching development (Windia et al. 2017, 195).

Allowing development to impact the cultural ecology of islands such as Bali risks transforming place into "non-place": replacing distinctive human–nature adaptive

systems into cookie-cutter resorts. Are there any places you know that have been subject to similar "devolution"? What strategies could be implemented to achieve balance between the demands of tourism and the needs of heritage in Bali and elsewhere?

Ideas of space and place have similarly been pivotal to the history of cultural geography as a subfield of human geography. In particular, the work of Carl O. Sauer (1889–1975) gave rise to cultural geography as a discrete area of practice and theory. Sauer harshly criticized the theory of geographical determinism. Prevailing in the late nineteenth and early twentieth centuries, the theory maintains that the environment controls the developmental patterns of a person, group, or society. For Sauer, geographical determinism generalizes the complex exchanges between culture and ecology over time, erasing the variation of different cultural groups within similar environments; it moreover positions humankind as embroiled in a constant uphill struggle against the impositions of nature. The environment is not a single entity restricting human progress, but rather the composite energy of all living beings striving to reproduce within their geophysical place. Life makes the environment and is shaped by its diverse action.

In contrast to environmental determinism, Sauer proposed the idea of cultural landscape as basic units of geographical analyses (see, for example, Case Study 5.2 on Balinese rice terraces). His book *Agricultural Origins and Dispersals* (Sauer 1952) encouraged geographers to take an interest "in discovering related and different patterns of living as they are found over the world—culture areas" (1). Sauer's life-long emphasis on these patterns would influence subsequent cultural geographers including Yi-Fu Tuan, Edward Relph, and Denis Cosgrove, all of whom have contributed significantly to our contemporary understandings of space and place.

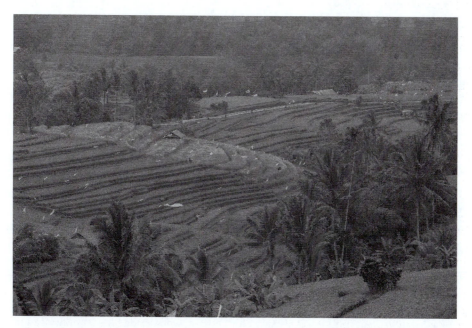

Figure 5.3 Jatiluwih Rice Terraces in Bali, Indonesia, are part of a UNESCO World Heritage Cultural Landscape.

Image credit: Thomas Fuhrmann (Wikimedia Commons).

Reflection 5.3 Are you a determinist or possibilist?

Geographical, or environmental, determinism is the position that individuals are constrained by their environment and especially their climate. In this model, physical geographies set the absolute boundaries for what social behaviors and structures can evolve. In contrast, environmental possibilism says that the level of inventive opportunism of living organisms in a place can expand or contract the set of possible social behaviors and structures. Determinism leads to Neomalthusian ideas of "carrying capacity": the resources of a place can only support so many people before the system crosses a threshold and collapses, much like Easter Island after a certain percentage of trees were cut. Possibilism leads to cornucopian ideas of human innovation and creativity solving problems like resource scarcity. On the one hand, it seems true that our sense of what's possible depends on our imaginative capacity. How many times have you reimagined a place and discovered that it offered more than you thought? On the other hand, we can acknowledge that geophysical systems have absolute limits, thresholds, tipping points, and feedback loops. Although not common in the Environmental Humanities today, Sauer's term *culture area* shares ground with the idea of an *ecoculture* as the entanglement of nature and culture in a specific place. Which model corresponds to your understanding of reality: determinism or possibilism? What are some of the advantages and limitations of each?

Unlike environmental anthropology and cultural geography, the geohumanities has taken shape only in the last decade in response to the proliferation of spatial technologies like Google Earth, GIS, and Geotracking. The young field has a dedicated journal called *GeoHumanities*, published since 2015, as well as a handful of edited books (Cresswell 2015; Dear et al. 2011). In approaching the historical trajectory of the geohumanities, then, it is potentially more illuminating to familiarize ourselves with the diverse technologies adopted by researchers. After all, technologies are based on social values and, accordingly, can be read as cultural texts themselves. For instance, a common platform in the geohumanities is geographical information science (GIScience), geared toward the processing and representation of large volumes of data. As a case in point, the Stanford Literary Lab uses this technology—and many others—to map ideas of race and ethnicity in American fiction between 1789 and 1964. See this chapter's Weblinks section for more information on the project.

Waypoint 5.2 Making place from the five (and more) senses

The process of perceiving geographical space with our senses conjures the idea that we call "a sense of place." Imagine a "non-place" like a dorm or hotel room; once you start perceiving yourself in that space, it becomes "your place"—a mashup of reality, perception, and imagination. Here are some key terms for classifying the different senses you use to perceive "place":

- *Vision*: sense of sight, strongly correlated to the acquisition of intellectual knowledge in Western philosophy (except for Diderot, who derided it as the "most superficial" of the senses)

- *Audition*: sense of hearing, unique, like vision, among the senses for its capacity to function across distances; thus known among theorists as a *distal sense*
- *Somatosensation*: sense of touch but also the idea of being touched, as in being moved or affected in a positive way; *hypoesthesia* is reduced sensation whereas *paresthesia* is abnormal sensation
- *Olfaction*: sense of smell, sharing a powerful connection with memory and emotion, both of which are processed in the amygdala of the brain's limbic area; *anosmia* is the loss of the ability to smell
- *Gustation*: sense of taste, involving the five basic modes of sweet, sour, salty, bitter, and *umami* or savory; *ageusia* is the total loss of taste
- *Proprioception*: detection and awareness of the movement, balance, and orientation of one's body in space
- *Thermoception*: sense of heat, cold, and temperature patterns
- *Nociception*: perception of pain, closely linked to touch
- *Magnetoception*: sense of direction and navigation according to magnetic fields; common among birds and, possibly, flying insects

Space and place: current trends and future prospects

This chapter has called attention to space and place as essential concepts in the fields of environmental anthropology, cultural geography, and the geohumanities. In the Anthropocene, current approaches to space and place underscore the urgency of learning to think in both local and global terms (Figure 5.4).

Two prevailing frameworks in studies of space and place are *bioregionalism* (local) and *ecocosmopolitanism* (global). Bioregionalism involves the design of human activities and community structures—politics, economics, architecture, and so forth—within the limits of bioregions. These natural regions are typically defined by the boundaries of watersheds and the characteristics of topographies. For example, the Cascadia bioregion stretches from Southern Alaska to Cape Mendocino, California. The bioregional movement emerged in the 1970s through the writings of Allen Van Newkirk, Peter Berg, Raymond Dasmann, Kirkpatrick Sale, Gary Snyder, and others. Berg (2002) defined the term *bioregion* as "the overall pattern of natural characteristics that are found in a specific place" comprising the factors of terrain, climate, seasons, landforms, soils, plants, animals, and insects (para. 2). Bioregional thinking has significantly influenced the American environmental, wilderness, and sustainability movements. For instance, it is central to Murray Bookchin's vision of "libertarian municipalism": decentralized, semi-autonomous city-states integrated within commonly managed natural resource regions.

In response to the predominance of bioregionalism and place-based discourse, environmental humanist Ursula K. Heise elaborates on the idea of ecocosmopolitanism in her book *Sense of Place and Sense of Planet* (2008). Emphasizing networks and exchanges, ecocosmopolitanism represents "an attempt to envision individuals and groups as part of planetary 'imagined communities' of both human and nonhuman kinds" (Heise 2008, 61). By *imagined*, Heise does not mean *imaginary* as in fantasy or make-believe. In contrast, she is calling upon the power of the human imagination to envision—and indeed empathize with—those creatures and communities in other parts of the world who are necessary co-creators of global ecosystems. For Heise and other theorists, space and place in an era of climate change should be grounded in the local yet also oriented toward the global. In other words, as the saying goes, *think globally, act locally.*

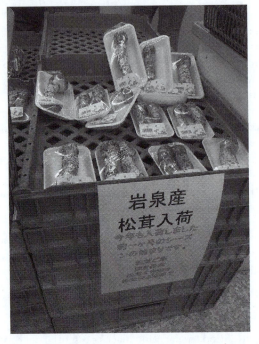

Figure 5.4 Plastic-wrapped matsutake mushrooms at a Japanese market symbolize the relationship between the local and global at the heart of the geohumanities.

Image credit: Hajime Nakano (Wikimedia Commons).

Case Study 5.3 The global plastic waste crisis

Case Study 3.1 explored the global problem of plastic waste through the example of the Great Pacific Garbage Patch. This crisis exemplifies Heise's concept of ecocosmopolitanism as thinking the local in relation to the global, and vice versa. As of January 2018, in an effort to rejuvenate the environment and promote the sustainable use of resources, the Chinese government completely banned the import of plastic waste. For nearly thirty years, China imported more than half of the world's recyclable plastic (McNaughton and Nowakowski 2019). Other developing Asian nations quickly followed suit by directing shipping containers loaded with plastic waste back to the United States, Canada, Australia, and European countries. No longer willing to serve as dumping grounds for Western trash, and also burdened with their own domestic waste, the Philippines, Cambodia, Indonesia, Malaysia, and Sri Lanka all returned significant amounts of plastic to their countries of origin in 2018 and 2019.

The current annual production of plastic worldwide is well over 300 million tons, 90% of which is not recyclable and ends up either in landfills or in the environment as pollutants (McNaughton and Nowakowski 2019). Plastic production accounts for 6% of global oil consumption and is projected to grow to 20% by 2050. Not only an

ecological contaminant, however, plastic is a major health concern. Microplastics, or plastic pieces smaller than five millimeters, have infiltrated every corner of the planet, sea, land, and air, as well as our own bodies. A recent study suggests that Americans consume between 39,000 and 52,000 microplastic particles annually. When the inhalation of the particles is considered, the estimate increases to 74,000 and 121,000 (Cox et al. 2019). Although the exact implications of microplastics for human health are unclear, researchers postulate negative effects on the immune and digestive systems.

What might Heise's concept of ecocosmopolitanism reveal about the global plastic crisis? What practical steps can you take to reduce your everyday use of plastic products?

Research on space and place in environmental anthropology is trending more and more towards *engaged anthropology*, a scholarly area that prioritizes advocacy, activism, collaboration, interaction with the public and long-term commitment to the subjects of research (Kirsch 2018). Engaged anthropology is defined by an overarching "commitment to mobilizing anthropology for constructive interventions into politics" (1). Examples include "participation in social movements, collaborating with activists and nongovernmental organizations, advising lawyers, writing affidavits, and producing expert reports" (1). These practices are meant to enhance and expand the conventional—i.e., detached—ethnographic paradigm by stimulating new directions for research in which practical, social, and environmental benefits are conferred to the communities being studied. And they respond to the understandable desire on the part of researchers to alleviate suffering for the people they study.

Yet, this desire to intervene conflicts with the scientific origins and aspirations of the field—criteria of objectivity, repeatability, and documentation. Additionally, intervention can be culturally destructive by projecting the researcher's values and visions on local people. Journalists face the same conflict: do you remain detached or try to help? An interesting resolution of these conflicts can be seen in anthropologist Stuart Kirsch's work with the Indigenous Yonggom people of Papua New Guinea. For nearly two decades, Kirsch supported the community in their opposition to Ok Tedi, a multinational copper and gold mining project that contaminated local rivers and disrupted traditional forms of livelihood (Kirsch 2007).

In cultural geography, intersections with studies of law are opening up unprecedented possibilities for documenting movements to establish the legal standing of ecosystems and more-than-humans. In 2017, the settlement of decades-long litigation between Māori communities and the New Zealand government resulted in the Te Awa Tupua, or Whanganui River Claims Settlement. The Whanganui River is the longest navigable river in New Zealand (Figure 5.5). The Act recognizes the river and its surroundings as a living entity bearing legal rights enforceable by Indigenous guardians. In declaring the personhood of the Whanganui, the legislation acknowledges the physical and spiritual significance of the river for Māori people (Rodgers 2017). What is more, an area of scholarship known as *human–plant geography* examines the relations between people and flora, including issues of ethics, dignity, and rights (Head and Atchison 2008). In 2008, the Swiss government declared "arbitrary harm caused to plants to be morally impermissible" (Federal Ethics Committee on Non-Human Biotechnology 2008, 20). (See Chapter 7 for a discussion of plant ethics.) The field of cultural geography, thus, is poised to bring studies of space and place into greater dialogue with emerging approaches to understanding animals, plants, and other beings.

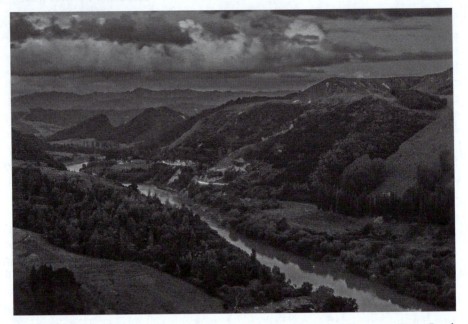

Figure 5.5 The Whanganui River of New Zealand as seen from along the Whanganui River Road.
Image credit: Jacqui McGowan (Wikimedia Commons).

Within the geohumanities, an intriguing area of specialization is *geopoetics*, located at the crossroads of geography, poetry, and creative expression. While representing the momentum toward greater transdisciplinarity in space and place research, geopoetics also harks back to the ancient root of geography as "earth-writing" or "earth-description" (Magrane 2015, 87). Research in geopoetics involves the creation of literary narratives of place informed by geographical thought (Springer 2017, 1). These narratives ideally enable us to move "past questions of subjectivity-objectivity, art-science [to] imagine and enact other ways of inhabiting the world" (Magrane 2015, 98). For example, geographer Tim Cresswell's debut collection, *Soil* (2013), includes the poems "Rare Metallophytes" and "Human Geography I." (A metallophyte is a plant that can tolerate heavy metals.) Cresswell is part of a long tradition of "locodescriptive" writers, such as William Wordsworth, who broke into "the spontaneous overflow of powerful feelings," in response to local geographies, producing some of the most important English-language poetry of place and a famous touring guide to the Lake District (UK) (see Chapter 10). In Canada, geographer James Wreford Watson penned the collection *Of Time and the Lover* (1950), replete with geographical references. Robert Macfarlane's *Landmarks* (2015) and *The Lost Words* (2017) show how local vernacular dialects make possible specific human–nature relationships. Like Cresswell, he illustrates a neo-Wordsworthian concern for the imaginative possibilities of language for our sense of place. As such, geopoetics can be considered a revamped tradition that predates the emergence of the geohumanities in the past decade.

Chapter summary

Chapter 5 provided an introduction to studies of space and place within the Environmental Humanities through an elaboration of the fields of environmental anthropology, cultural geography, and the geohumanities. Space is a geographical abstraction that becomes lived

place as humans—and other creatures—confer value, meaning, and significance to it. Place is home—the space with which one becomes familiar and from which one derives a livelihood. Place, therefore, is a spatial as well as a cultural phenomenon. This chapter encouraged you to appreciate your own experiences of space and place in your everyday life. To be certain, one of the ways in which we make place from space is through our senses. Although we often think about the five senses, there are in fact multiple senses that relate to perceiving and navigating the world. Chapter 5 concluded with a discussion of bioregionalism and ecocosmopolitanism. Scholars argue that the Anthropocene demands new approaches to space and place that take into consideration the interaction between the local and the global.

Reflection 5.4 Geography and poetry? Are you kidding me?

Geopoetics is a growing area of the geohumanities that examines the interconnections between geography and poetry. On the face of it, geography (the natural and social sciences) and poetry (the humanities and liberal arts) might seem like incompatible domains of knowledge. After all, poetry deals with emotions, feelings, experience, and all things subjective. But a good poem, something like William Wordsworth's "Lines Written a Few Miles above Tintern Abbey" or Derek Wolcott's "Becune Point," can render a place in a rich texture of associated meaning that no GIS image can match.

What might poetry bring to the study of space and place? What might geography bring to the writing of poetry? Carry out some preliminary research and try to identify a geographer of the past or present who also published poetry. What subjects do his or her poems deal with?

Exercises

1. Identify the name of the bioregion in which you live. Use your five (and more) senses to investigate your bioregion. What unique sights, sounds, textures, tastes, and smells figure into your sense of place? What memories do you have of your bioregion?
2. Make a list of the spaces you move through on a daily basis. In what ways do these spaces become places invested in meaning and value for you? Or are some of these *non-places*? If so, why?
3. The effects of climate change and the Anthropocene are especially evident on islands. Consider an island located near you or which you once visited. Do additional research. What environmental threats, hazards, and vulnerabilities do the human and more-than-human inhabitants of the island face?
4. Design a plastic waste reduction campaign for your community that does not rely on recycling. What approaches would you use to increase public awareness of the ecological and health-related risks of microplastics? You can also make use of visual material such as sample designs of flyers, advertisements, websites, and social media platforms.
5. Explore the Mannahatta Project (https://welikia.org) in which an interdisciplinary team of geographers, cartographers, historians, and archivists visually reconstructed the landscape of present-day New York City as it was circa 1609. Propose an approach to visualizing the place where you live as it appeared in the seventeenth century. What technical skills would you need to acquire to do this? What specialists would you need to work with? You are welcome to include visual content such as drawings, sketches, and photographs.

Annotated bibliography

Augé, Marc. 2008. *Non-Places: An Introduction to Supermodernity*. London: Verso. French anthropologist Marc Augé develops the concept of supermodernity to describe the proliferation of non-places, or places of excessive information and space, such as city centers, supermarkets, shopping malls, airports, train stations, hotels, and the digital realm. Augé claims that non-places profoundly shift human consciousness yet are only perceived to a partial extent.

Bachelard, Gaston. 1994. *The Poetics of Space*. Boston: Beacon Press. Published in French originally in 1957. This classic study by French philosopher Gaston Bachelard employs a phenomenological approach to analyze lived experiences of architectural spaces. In particular, Bachelard investigated the role of the imagination and emotions in how humans construct meaning in domestic places.

Dear, Michael, Jim Ketchum, Sarah Luria, and Douglas Richardson, eds. 2011. *GeoHumanities: Art, History, Text at the Edge of Place*. London: Routledge. This trailblazing work explores the potential of the geohumanities through sections on creative places, spatial literacies, visual geographies, and spatial histories. The editors develop four key terms—geocreativity, geotext, geoimagery, and geohistory—of high interest to researchers at the junction of geography and the humanities.

Duncan, James S., Nuala C. Johnson, and Richard H. Schein, eds. 2008. *A Companion to Cultural Geography*. Hoboken: Blackwell Publishing. This edited collection featuring contributions from leading scholars in cultural geography provides a concise introduction to key theories, approaches, and frameworks such as historical materialism, feminisms, poststructuralism, psychoanalytic approaches, performativity, nationalism, social class, sexuality, public memory, and transnationalism.

Kopnina, Helen, and Eleanor Shoreman-Ouimet, eds. 2017. *Routledge Handbook of Environmental Anthropology*. London: Routledge. This valuable introduction to current trends in this rapidly diversifying field includes sections on the development of environmental anthropology; the new sub-fields of enviromateriality, historical ecology, architectural anthropology, and relational ecology; ecological knowledge, belief, and sustainability; climate change, resilience, and vulnerability; justice, ethics, and governance; health, population, and environment; and environment and education.

Relph, Edward C. 1976. *Place and Placelessness*. London: Pion. Published over four decades ago, Canadian geographer Edward Relph's landmark study is a phenomenological analysis of human experience of place. Articulating the importance of sense of place, the book postulates that the idea of place is rapidly changing as a result of climate change and economic disparities.

Seddon, George. 1972. *Sense of Place: A Response to an Environment, the Swan Coastal Plain, Western Australia*. Nedlands: University of Western Australia Press. Australian geographer George Seddon's study was the first to address sense of place in Australia. Seddon details the plants, animals, soils, and landforms of the biodiverse Swan Coastal Plain of Western Australia where the city of Perth is located.

Williams, Raymond. 1973. *The Country and the City*. New York: Oxford University Press. In this seminal text, cultural studies pioneer Raymond Williams analyzed representations of rural and urban life in English literature since the sixteenth century. Williams argued for the need to trace through history the dualistic opposition between country and city at the center of modern thought. His *Keywords* extends some of this thinking.

Weblinks

Beyond Mannahatta: The Welikia Project. This offers a fascinating example of the geohumanities in practice. A team of researchers spent ten years uncovering and reconstructing the original ecology and topography of Manhattan. https://welikia.org

GeoHumanities: Alliance of Digital Humanities Organizations. This is a Special Interest Group (SIG) of the Alliance of Digital Humanities Organizations focusing on spatial, spatio-temporal, and "placial" approaches in the digital humanities. You can subscribe to the mailing list. www.geohumanities.org

GeoHumanities: Space, Place and the Humanities. This academic journal explores key debates in geography and the humanities, including longer articles and shorter creative pieces. www.aag.org/cs/publications/journals/gh

Native Land. This mapping project is based on the importance of territory acknowledgement as a means of recognizing Indigenous inhabitation and land rights. The map depicts the traditional territories of Indigenous cultures in North America, South America, the Pacific Islands, Australia, and New Zealand. https://native-land.ca

Placeness, Place, Placelessness. Curated by geographer Edward Relph, this website offers a wide-ranging overview of concepts of place, sense of place, spirit of place, placemaking, placelessness, and non-place. www.placeness.com

Stanford Literary Lab. An outstanding example of the geohumanities, this research lab applies computational methods to the study of literature. https://litlab.stanford.edu

Visualizing Urban Geographies. This project aims to enable researchers to use digitized and georeferenced maps to enrich historical understandings. http://geo.nls.uk/urbhist/index.html

References

Arnold, Caroline. 2000. *Easter Island: Giant Stone Statues Tell Of a Rich and Tragic Past*. New York: Clarion Books.

Barnes, Jonathan, ed. 1991. *The Complete Works of Aristotle*. Princeton: Princeton University Press.

BBC. 2019. "Amazon Fires: Fines for Environmental Crimes Drop Under Bolsonaro." *BBC News* August 24. https://www.bbc.com/news/world-latin-america-49460022.

Berg, Peter. 2002. "*Bioregionalism: An Introduction*." Accessed September 17. http://www.planetdrum.org/bioregion_bioregionalism_defined.htm#Bioregionalism.

Boersema, Jan. 2011. *The Survival of Easter Island: Dwindling Resources and Cultural Resilience*. Translated by Diane Webb. Cambridge: Cambridge University Press.

Cox, Kieran, Garth Covernton, Hailey Davies, John Dower, Francis Juanes, and Sarah Dudas. 2019. "Human Consumption of Microplastics." *Environmental Science and Technology* 53 (12): 7068–7074. doi: 10.1021/acs.est.9b01517.

Cresswell, Tim. 2013. *Soil*. London: Penned in the Margins.

Cresswell, Tim. 2015. "Space, Place and the Triumph of the Humanities." *GeoHumanities* 1 (1): 4–19.

Diamond, Jared. 2004. *Collapse: How Societies Choose to Fail or Succeed*. New York: Viking Press.

Federal Ethics Committee on Non-Human Biotechnology. 2008. *The Dignity of Living Beings With Regard to Plants*. Berne: Federal Ethics Committee on Non-Human Biotechnology.

Head, Lesley, and Jennifer Atchison. 2008. "Cultural Ecology: Emerging Human–Plant Geographies." *Progress in Human Geography* 33 (2): 1–10. doi: 10.1177/0309132508094075.

Heise, Ursula K. 2008. *Sense of Place and Sense of Planet: The Environmental Imagination of the Global*. Oxford: Oxford University Press.

Kauranen, Anne. 2019. "Finland Urges EU To Consider Banning Brazilian Beef Over Amazon Fires." *Reuters* August 23. https://www.reuters.com/article/us-brazil-politics-eu-beef/finland-urges-eu-to-consider-banning-brazilian-beef-over-amazon-fires-idUSKCN1VD17R.

Kirsch, Stuart. 2007. "Indigenous Movements and the Risks of Counterglobalization: Tracking the Campaign Against Papua New Guinea's Ok Tedi Mine." *American Ethnologist* 34 (2): 303–321. doi: 10.1525/ae.2007.34.2.303.

Kirsch, Stuart. 2018. *Engaged Anthropology: Politics Beyond the Text*. Oakland: University of California Press.

Macfarlane, Robert. 2015. *Landmarks*. London: Hamish Hamilton.

Macfarlane, Robert. 2018. *The Lost Words*. Toronto: House of Anansi Press.

Magrane, Eric. 2015. "Situating Geopoetics." *GeoHumanities* 1 (1): 86–102. doi: 10.1080/2373566X.2015.1071674.

McNaughton, Sean, and Kelsey Nowakowski. 2019. "How China's Plastic Waste Ban Forced a Global Recycling Reckoning." *National Geographic*. Accessed September 17. https://www.nationalgeographic.com/magazine/2019/06/china-plastic-waste-ban-impacting-countries-worldwide/.

Oakes, Timothy, and Patricia Price. 2008. "Introduction." In *Cultural Geography Reader*, edited by Timothy Oakes and Patricia Price, 1–8. London: Routledge.

Rodgers, Christopher. 2017. "A New Approach to Protecting Ecosystems: The Te Awa Tupua (Whanganui River Claims Settlement) Act 2017." *Environmental Law Review* 19 (4): 266–279. doi: 10.1177/1461452917744909.

Sauer, Carl O. 1952. *Agricultural Origins and Dispersals*. New York: The American Geographical Society.

Shoreman-Ouimet, Eleanor, and Helen Kopnina. 2011. "Introduction: Environmental Anthropology of Yesterday and Today." In *Environmental Anthropology Today*, edited by Helen Kopnina and Eleanor Shoreman-Ouimet, 1–33. London: Routledge.

Springer, Simon. 2017. "Earth Writing." GeoHumanities 3 (1): 1–19. doi: 10.1080/2373566X.2016.1272431.

Steward, Julian. 1972. *Theory of Culture Change: The Methodology of Multilinear Evolution*. Urbana: University of Illinois Press. Original edition, 1955.

Tsing, Anna Lowenhaupt. 2015. *The Mushroom at the End of the World: On the Possibility of Life in Capitalist Ruins*. Princeton: Princeton University Press.

Tuan, Yi-Fu. 1977. *Space and Place: The Perspective of Experience*. Minneapolis: University of Minnesota Press.

UNESCO World Heritage Centre. 2012. "Cultural Landscape of Bali Province: The *Subak* System as a Manifestation of the *Tri Hita Karana* Philosophy." *UNESCO World Heritage List*. Accessed September 10. https://whc.unesco.org/en/list/1194/.

Watson, J. Wreford. 1950. *Of Time and the Lover*. Toronto: McClellan and Stewart.

Windia, Wayan, Gede Sedana, Therese de Vet, and J. Stephen Lansing. 2017. "The Local Wisdom of Balinese *Subaks*." In *Indigenous Knowledge: Enhancing its Contribution to Natural Resources Management*, edited by Paul Sillitoe. Boston: CABI.

Zimmer, Katarina. 2019. "Why the Amazon Doesn't Really Produce 20% of the World's Oxygen." *National Geographic*. Accessed April 20, 2021. https://www.nationalgeographic.com/environment/article/why-amazon-doesnt-produce-20-percent-worlds-oxygen.

6 Environmental history

The story of coevolution

Chapter objectives

- To examine the emergence, significance, and relevance of environmental history (EVH) and its contributions to the Environmental Humanities
- To summarize methods of researching and writing environmental history
- To review main subjects and themes that environmental historians have addressed
- To consider emergent areas of inquiry in the field

Virus cultures

Are viruses natural or human-made? Surely, they must be natural—microbes, the building blocks of all life, are the oldest organisms, emerging 3.5 billion years ago. Humans are walking ecosystems of microbes (like viruses, bacteria, and fungi) whose symbiotic work enables us to eat, breathe, eliminate, fight diseases, and even think. *Humans* don't *make* microbes; microbes make humans.

Actually, some viruses are human-made, in the sense that people make the environmental conditions for novel microbes to evolve. When we domesticated animals and plants 8,000 to 10,000 years ago and began living in cities about 4,000 to 6,000 years ago, we created the conditions for our most familiar epidemic diseases: measles, tuberculosis, smallpox (from cows), influenza (from pigs and ducks), malaria (from chickens), and plague (from rabbits) (Diamond 1999, 195–210). Note that all of these diseases come from animals we eat. The novel SARS coronavirus-2 also came from bats via one or two intermediary animals people eat. So human culture does make possible these microbes' evolution.

These microbes are classified as "zoonotic" diseases because they originate in wild animal populations (all our domestic animals were once wild) and jump to humans. It's not easy for a microbe to do that. It has to evolve the skills to overcome our immune system, and that requires precise environmental conditions, like proximity and duration of contact.

Those conditions were not widespread prior to settled agriculture and urban society. Hunter-gatherer-fisher peoples (H-G-F) moved around too frequently and their contact with animals was limited to hunting (or being hunted). But when the Holocene climate allowed settled agriculture, we found it convenient to capture some of our wild animal food and pen it near our shelters, eventually replacing diverse wild ecosystems with a few species of domesticable animals and plants. These conditions "invited the development of disease epidemics by providing high densities of genetically uniform hosts": horses, pigs, cows, chickens, sheep, goats, ducks, rabbits (Penna 2015, 328).

DOI: 10.4324/9781351200356-6

Agriculture is a much more efficient means of extracting calories from the land, so early farmers could support a much larger population with their efforts. That led to long-term settlements, concentrating microbe hosts (us and our animals). Increased proximity and duration of cross-species contact opened all the pathways of microbial transmission: blood, milk, feces, skin, saliva, breath. Also, insects, delighted by the concentration of food sources, become vectors in human–animal transmission of microbes.

Case Study 6.1 The Black Death

The Black Death, caused by the Bubonic plague (Y. *pestis* bacterium), killed half of the world's population between 1346 and 1353 and recurrent outbreaks kept the population low for the next 300 years. The microbe utterly transformed everyone's life.

A zoonotic virus, Y. *pestis* evolved in rabbit species during the last Ice Age. It jumped to humans in central Asia after the agricultural revolution 6,000 years ago (Demeure et al. 2019). Y. *pestis* moved around by rat hosts whose populations exploded with the new food sources provided by agriculture, afflicted early city-states in North Africa, India, the Middle East, and Asia, but needed help to become a global pandemic. It got just what it needed during the unusually warm Medieval Climactic Anomaly (950–1250). Warm weather stimulated huge crop yields which were stored in urban granaries, attracting rats bearing fleas carrying Y. *pestis*. Excess food also attracted more people, overcrowding those cities. Once the Y. *pestis*-infected rats died, the fleas jumped to humans. Trade, military adventurism, and people fleeing plague outbreaks quickly spread Y. *pestis* across Eurasia and North Africa. Urban design, population densities, inequality, trade, and geopolitics "made" Y. *pestis* into The Black Death.

This invisible killer then remade society, causing social collapse, extremism, and violence. Medieval citizens scapegoated Jewish people and shunned even their own family-members. Kate Rigby speculates that epidemics expose "the limits of hospitality" (2015, 59), the ethic fundamental to social cohesion. The politics of fear continue to shape our response to pandemics (Ghebreyesus 2020).

Research the history of pandemics (and also consult Chapter 14). Consider how they are "hybrid disasters": shaped by civilizations and reshaping those civilizations. Also consider how pandemics expose public health inequalities and environmental injustices.

This concentration of people and animals made early cities into petri dishes for microbes learning how to be communicable diseases. Disease epidemics meant that the "health, physique, and life-expectancy" of agriculture-based urbanites declined compared to their H-G-F ancestors, even as they were able to have more children and enjoy greater food security (Hughes 2009, 25). As cities became hubs within networks of production, trade, knowledge, power, culture, and wealth, everything flowed into and out of cities—and still does, including civilization's epidemic microbes.

Without cities and agriculture, most of the pathogens that afflict humanity would not exist. Without trade networks and geopolitical conflict, they wouldn't be epidemic. Those microbes are *anthropogenic*, a fancy term for human-made.

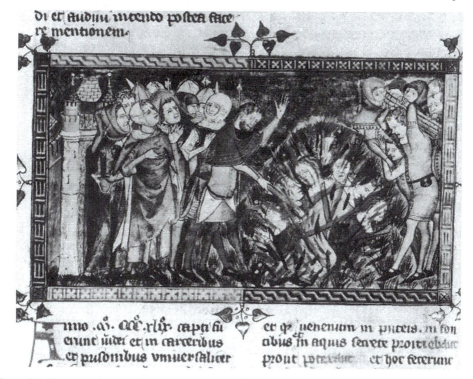

Figure 6.1 Europeans burning Jewish people whom they scapegoated for causing the Black Death. Who is scapegoated for causing Covid-19?

Image credit: H. H. Ben-Sasson 1976 (Wikimedia Commons).

Kate Rigby (2015) argues that "'disasters spring from the nexus where environment, society, and technology come together'…Occurring 'at the interface of vulnerable people and physical hazards,' no disaster is ever purely 'natural'" (15). They are caused by "social systems generat[ing] the conditions that place people, often differentiated along axes of class, race, ethnicity, gender, or age [and we would add, dis/ability], at different levels of risk from the same hazard" (14).

The latest coronavirus research bears out this theory. In the south-eastern region of Asia where the disease first emerged, "a subtropical to tropical climate; dense, growing and rapidly urbanizing populations of people; a high degree of poultry and livestock production; and other factors which may promote cross-species transmission and disease emergence" (Latinne et al. 2020, no page) created opportunities for the microbe to learn how to infect humans made vulnerable by urban design, population density, and inequality. Trade, travel, geopolitical conflict, and international supply chains rapidly spread the virus around the world. But many, including WHO Director General Tedros Ghebreyesus, say that without national leadership failures and political divisions, the virus would never have reached pandemic status. Thus, contrary to what some political leaders are telling us, the Covid-19 pandemic is a human-made disaster, not a "natural" disaster.

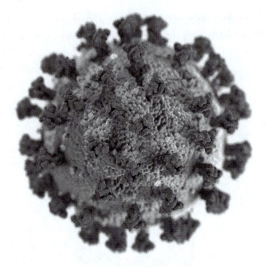

Figure 6.2 Covid-19 microbe.

Image credit: Alissa Eckert, MS and Dan Higgins, MAM, Centers for Disease Control and Prevention (Wikimedia Commons).

Naturalizing this disaster allows us to ignore the way globalized systems of exploitation have, over many decades, made this region particularly vulnerable to zoonotic microbe transmission: the lack of agricultural regulation, urban planning, and health care combined with massive environmental disturbance, extreme poverty, and repressive, corrupt regimes increases exposure and encourages risk factors. Western demand for cheap products from this region encouraged exploitive, unregulated development. If we think of Covid-19 as natural, we will not address the global sociopolitical and economic conditions that are the underlying cause of this pandemic.

This is true of other so-called "natural" disasters from the last several hundred years, almost all of which are fully preventable. Take the 2012 tsunami that slammed into Japan: the disaster was not the tsunami, but the vulnerabilities of a population exposed to the Fukushima Daiichi meltdown. Since the Middle Ages, it was well known that this was a high-risk area for tsunamis (Ghosh 2016, 55). Modern engineers created the disaster when they sited a nuclear reactor in the path of an obvious hazard.

What if we viewed these disasters as urgent warnings about a maladaptive culture? By placing pandemics or tsunamis in the total context of humans and nature coevolving, environmental history teaches us to hear those warnings and develop adaptations.

Environmental history

History is the humanities discipline devoted to telling the story of how things change over time. That story usually focuses on social history: how humans change and have been changed by their social, political, economic, and cultural contexts.

Nature is traditionally excluded from the story. The reason goes back to Plato and Aristotle's division of knowledge: scientists study nature; humanists study humans. But it also has to do with the fact that, until the late-eighteenth century, people assumed nature didn't change. As Isaac Newton argued, God created nature according to certain laws, such as "every object persists in its current state until compelled to change by other forces." As Newton's First Law of Motion implies, nature is an object that is moved "by other forces,"

ultimately God, the Prime Mover; nature is the object of His agency. As God's chosen proxies on Earth, humans also had agency. Like God, we can make conscious decisions and cause things to happen. So that's the main reason human histories didn't include nature—nature doesn't do anything. Stories are about actors and their actions, not about passive objects.

That idea began to change in the eighteenth century thanks to the Anglo-German Romantic movement (see Chapter 10), the theory of organicism (see Chapter 7), and scientific field work. The new thinking posited that nature did change and had agency (though different from human agency) and was far older and more diverse than previously thought.

Early geologists from 1795–1832, studying glaciation, rock formation, and fossils, discovered that Earth's sedimented layers tell a story of very slow change over millions of years, sometimes punctuated by catastrophic change. Alexander von Humboldt discovered that interactions between species, landscape, climate, and elements constantly change the function and appearance of all members in the system. A few decades later, with the help of "the two Charles"—geologist Charles Lyell and biologist Charles Darwin—the evolution of nature through "deep time" and by means of its own agency became a subject worthy of history.

Case Study 6.2 The Columbian Exchange—rewriting imperial destiny

Social historians liked to tell the story of Columbus discovering the New World in 1492 followed by its swift conquest. If you only look at the human context, that conquest may seem inevitable, part of "the story of progress": a superior, enlightened civilization demonstrating its manifest destiny.

Alfred Crosby (2003) kicked that version of history to the dust bin when he wrote that European success was "largely the result of conscious and unconscious 'teamwork' between materialistic humans and the aggressive 'portmanteau biota'—plants, animals, and pathogens—they carried with them" (Mosley 2006, 921). According to Tim Griffiths, "The agricultural revolutions of the Old World … had bred humans who were familiar with crowd diseases and a biota that was already disturbed, domestic and opportunistic, well adapted to colonizing and competing" (Griffiths and Robin 1997, 4). European invaders were so surprised by their success that they assumed God must have chosen them. In truth, it was just a dynamic, unpredictable mix of microbes, plants, animals, and humans evolving interdependently over time.

Reading environmental histories of imperialism can make you rethink what you've been told about national destinies and progress. Take a look at Crosby, Griffiths and Robin, Jared Diamond (1999), or Mark Fiege's (2012) book in the Annotated Bibliography section of this chapter. How do you see your nation differently by placing it in a long-term environmental context?

Meanwhile, imperialist states sent botanists, foresters, and agronomists into regions where humans and natural environments had evolved in dynamic interdependence. Their introduction of non-native species, extractive industries, and intensive agriculture, particularly in places like the tropics or Australia (Sörlin and Warde 2009), profoundly disrupted those regional ecosystems. Deforestation caused flooding; intrusion into wild lands exposed humans to new microbes and insect vectors; irrigation and flood control caused salinization in arid lands, destroying agriculture; intensive monoculture farming destroyed soil fertility and created dust storms; introduced species eliminated natives, destroying ecosystems. From studying

their mistakes and bad science, a few of these colonial scientists began rewriting their assumptions about nature as an unchanging, infinite resource that can be controlled for human purposes. Archeological work around the Mediterranean showed how ancient civilizations disrupted their environments through overdevelopment, propelling their own collapse.

Yet historians largely ignored what the scientists were doing, focusing instead on the story of empires, nations, and leaders rising and falling. Founders of the modern discipline, Giambattista Vico (1688–1744) and Edward Gibbon (1737–94), reasoned that you can't tell a story about what simply "is" (nature); you can only tell a story about what is made and who makes it (human civilization and humans). For 200 years, history focused on what humans had done and left nature to the scientists.

Environmental history (EVH), therefore, starts by asserting that we need to change the way history is written (Worster 1993, Grove and Damodaran 2009). EVH treats nature as an active agent in dynamic relation with human agents changing the world we experience. Humans are not exceptional, but one species among many, and not always the most important agent of change. Revising the definitions of nature and humankind means that social history's traditional scale is too narrow. Ecosystems evolving in dynamic relation to societies have to be included in the story. Instead of a fairly short, uniform story of progress, EVH tells a much longer story of complex, uneven, indeterminate, often contingent change across multiple scales and for multiple reasons. Some changes can be beneficial to certain organisms and orders; others can be threatening. These four revisions to the basic assumptions of history (agency, exceptionalism, scale, and change) have revolutionized the discipline.

The stories that EVH tells always include humans—that's what keeps it in the humanities—but the context has been radically expanded to include everything that acts on and reacts to human action (Adamson et al. 2016, 133). For historians, context is everything; for environmental historians, everything is the context.

But this expansion of context doesn't just mean "more quantity"; it also means a qualitatively different understanding of change, one that appreciates the coincidence of multiple, simultaneous, contradictory processes and rates of change. EVH draws from ecology the idea that the Earth is a self-regulating system, with its own agency, even as members of the system are themselves agents of change in pursuit of their own self-regulation. Species are some of the most important agents, but no species or individual ever acts alone, always in relation to others. This reciprocity is essential to the evolution of all species. The more they interact with each other, the more dependent on each other they become for the stimulus to act. This interdependence drives evolution, more properly considered "coevolution."

Sometimes humans change things too much too fast. When that happens, ecosystems, societies, civilizations, and species collapse, transform, or go extinct. One of the most important questions EVH asks is how to interpret and understand the balance of coevolution that prior and current civilizations achieved. The goal is not to prescribe any particular balance, but to tell the most accurate story of the human part in disturbance and coevolution. This is how EVH has redefined the history discipline (Worster 1994b, 8).

Reflection 6.1 "Those who cannot remember the past are condemned to repeat it"

You've probably heard George Santayana's famous aphorism before. But is it true? Historian William Cronon thinks not: "Santayana was probably wrong in implying that those who study the past can avoid repeating it, because in fact the past never

repeats" (1993, 17). Ian Simmons asserts that "the world is in a physiological state (in terms of its species mix and gaseous levels) which has no past analogy: there never was a time when it was like this" (2008, 19). For this reason, the past might be a bad guide if we assume that what will happen is going to be the same as what has happened.

So what *do* you learn by remembering the past? Cronon proposes that we learn the historical "habit of mind": the ability to see things in their larger context and understand that change is caused by multiple agents, including non-human, with many complex unintended consequences.

For Carolyn Merchant (2011), history helps you acknowledge how difficult it is to live within the limits set by our environment. Societies that survived learned by trial and error to restrain greed and self-interest: "they made rules, lots and lots of them" (Worster 1994b, 13). Those societies that have balanced personal liberty with equality in free, open democracies were more likely to live within limits (Worster 2007).

What do you think the value and relevance of history is? Do you think our civilization needs more rules limiting personal freedom? What's your evidence?

Many observers say that EVH, influenced by the environmental and civil rights, anti-war, and anti-nuclear movements sweeping the globe since the 1950s, formally began in 1972. In that year, the *Pacific Historical Review* dedicated a special issue to environmental history and several field-defining works, including Alfred Crosby's *The Columbian Exchange* (2003, originally 1972), were published. Five years later, US historians founded the American Society for Environmental History (ASEH), along with its flagship journal, *Environmental History*. Shortly thereafter, a number of significant works, like Donald Worster's *Nature's Economy* (1994), Carolyn Merchant's *The Death of Nature* (1980), Stephen Pyne's *Fire in America* (2017), and Keith Thomas' *Man and the Natural World* (1983), helped consolidate the field. Since the 1990s, the field has grown exponentially, taking the discipline of history by storm (Worster 1993, McNeill 2003).

Other historians point out that this origin story is far too Ameri-Anglo-Euro-centric, ignoring the important work of Indians, Latin Americans, Chinese, and Australians. Some say the dating ignores earlier environmental histories, like George Perkins Marsh's *Man and Nature* (2003, originally 1864), Fredrick Jackson Turner's "The Significance of the Frontier in American History" (1893), and Walter Prescott Webb's *The Great Plains* (1959, originally 1931). Still others argue that there was plenty of environmental history being written in the late 1950s and early 1960s; scholars just didn't think of themselves as a distinct subdiscipline yet (McNeill 2003, Hersey and Vetter 2019).

Pioneering environmental historians integrated the sciences, particularly anthropology, human geography, and ecology, into their story of humans and nature coevolution. As Donald Worster puts it, "to do environmental history really well, one must have some familiarity with, if not advanced training in, more scientific fields than many scientists would venture to acquire" (Worster 1993, 2), including soil and atmospheric chemistry, botany, zoology, ecology, geology, virology, anthropology, archeology, forestry, and their paleo-versions (McNeill 2003, 9). Economics, sociology, and psychology are also important.

Borrowing from the sciences also means using systems-thinking and complexity theory to model change across multiple, linked systems, human and natural. Additionally, it means borrowing terms such as "metabolism" to think about how matter and energy flow through

societies and their environments, and "entropy" to talk about the way human energy use accelerates degradation (Adamson et al. 2016, 133).

The knowledge required to fully contextualize the human story can be daunting, so let's look at how to do it.

Telling it like it is

In contrast to Earth history, which studies the geological formation of the planet over 4 billion years, EVH studies the last 250,000 years, "that portion of environmental history occurring in human history, both affecting and being affected by human agency, and the human ability to accelerate or substantially alter biophysical, chemical, and genetic processes occurring in the rest of the natural world" (Adamson et al. 2016, 133). In doing so, EVH gives "a fuller sense of the environmental and social costs that arise as a culture attempts to survive biologically on the planet" (Mosley 2006, 916). Just going about the daily business of living means that people, like all species, are going to do things that disrupt landscapes and environmental functioning (Worster 1994b). EVH tells the story of that disruption, searching for who changed a place, when, how and why.

Waypoint 6.1 Is nature "natural"?

Were the fires of Australia's "Black Summer" (2019–20) natural? Were Hurricanes Sandy (2012) and Harvey (2017) natural disasters? Environmental historians say no. What we see is a product of humans and natural forces working together. Humans have disturbed environments on regional and continental scales since they first used fire to clear forest understories, improve soil fertility, herd game animals, and select desired plant species. Now that modern industrial society has harnessed fossil fuels, the scale of disturbance is global. Environments disturbed by humans adapt, collapse, or transform, meaning that all landscapes are now human-shaped. A storm or fire may seem like it originates "out there," caused by purely natural forces (low pressure, water cycles, lightening), but if those forces are just the "equal and opposite reaction" to prior human actions, isn't it more accurate to think of them as civilization's hurricanes and fires?

National parks are also human-made. When Europeans first saw the Kimberley, Serengeti, Yellowstone, and Banff, they thought they were seeing "pure," "original" nature as created by God. They didn't understand that Indigenous peoples had shaped them with fire for millennia. When Europeans turned them into national parks, they tried to preserve their "original wilderness" state. To them, that meant expelling Indigenous communities and suppressing fire. The massive, out of control fires we now have are the reaction of a landscape acclimated to fire being prevented from burning by modern human civilization: "culture-fires" not "wild-fires."

Consider the lands you live in and trace the history of their human management: how does it change the way you see those lands?

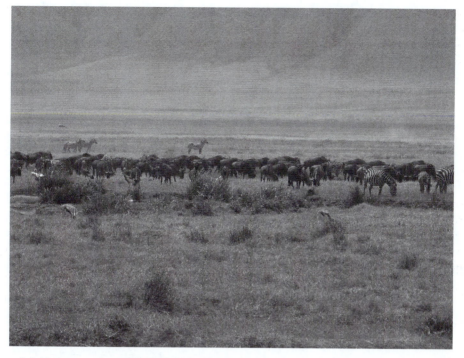

Figure 6.3 Nature or culture? UNESCO World Heritage Site, Serengeti National Park.

Image credit: Marc Patry (Wikimedia Commons).

EVH uses a wide variety of sources to answer these questions. The environment itself, Roderick Nash proposes, is "an historical document. Rightly seen, it revealed a society's culture and traditions as surely as did a novel or a newspaper or a Fourth of July oration" (1972, 363). Reading the landscape takes a disciplined eye and knowledge from at least some of the historical sciences: climatology, geology, plant, animal and microbial ecology, pollen records, paleontology, ice cores, archeology, and geography. That context helps you identify some of the agents of change as well as key events over time. You'll also need to gather various human records and artifacts, including literature, journalism, law and policy, diaries, myths and legends, and public records (Worster 1988). Historians are the eager beavers of research.

Your sources will likely reveal conflicting evidence for who did what to a place at a certain time for certain reasons. To navigate the complexity, historians:

> interpret their sources by comparing and contrasting them and then locating and explaining the most likely meaning that is presumed to exist in them. This meaning is widely understood as being the most likely narrative that is presumed to exist in the series of the causally connected past events that are examined.
>
> Munslow (2012, 2)

Let's say you want to know why you came to be sitting in a chair in your college dorm room reading this chapter. Right away, you can tell that there are a lot of human agents and

institutions at play—there's your decision to be there taking a course, the decisions the college has made to offer the course, the decisions your professor made in assigning the reading, and our decisions in writing this textbook. But there are also networks of related institutions and their human agents to consider: the companies and people who built your chair, college doom room, and college; Routledge, the publishing company; the history profession that determines how your professor is qualified.

But that only addresses some human reasons for why you're here now. What non-human agents, forces, and networks are involved? How about the carbon cycle? Water, potassium, sunlight, climate. Unless each one of those is perfectly keyed, there's no "you" (or "us"). There is also a history of energy—the fossil fuels that power your lights, HVAC, and are embodied in the material structures around you. And what about those materials? Where did they come from and how were they produced? Since this level of abstraction may short circuit your brain, consider the method of food production on which you depend for all that synapse firing. "Ecological history must always begin," writes Donald Worster, "with hunger and food, with filling people's bellies" (1993, 42). And while we're thinking about food, what about the fact that you are sitting here, reading, and not out foraging your next meal? That gets us into the economy, specifically the globalized flow of goods and services that sustains the relationships you (and we) depend on for "surviving biologically on the planet." What are the environmental and social costs that arise from coordinating these human–natural agents and forces for this moment, right here, right now, to exist?

Reflection 6.2 Is microbiology relevant if I'm a history major?

You've probably asked that question, or one like it, at least once in your life. We admit to asking it ourselves—as an aspiring English major, Andrew was sure that math was a waste of his time.

But can we really afford to be so hyper-specialized in this incredibly complex, interconnected world? Covid-19 and the likelihood of increasingly frequent zoonotic pandemics in the future is as good an argument for knowing the basics of microbiology as we can think of—it's a matter of survival. And if you want to understand anything about why this all happened and how it will fundamentally alter civilization, then you'll need courses in economics, politics, group psychology, sociology, anthropology, climatology, urban planning, ecology, and business. Geography, the history of science and technology, Asian studies, and systems theory are important too.

The great nineteenth-century educator, Matthew Arnold (1882), said, "all knowledge is interesting to a wise man." But we recognize that some knowledge is more useful. But which? Is there a competitive advantage to learning broad, interdisciplinary knowledge, like the kind encouraged in the Environmental Humanities, compared to the narrow specializations in our current system of academic majors?

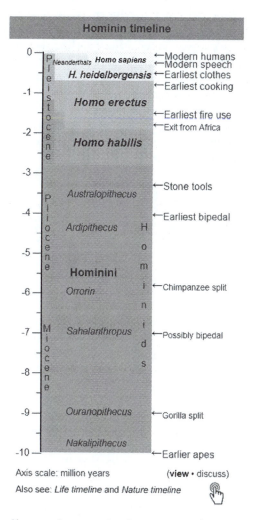

Figure 6.4 The evolution of humans from apes, by chronostratigraphic era.

Image credit: D. R. Bogdan (Wikimedia Commons).

Case Study 6.3 Ideas of nature

Historians say that the idea of nature in Britain changed substantially between Shakespeare's time and Darwin's (1580–1880).

In Shakespeare's time, nature was thought to be unchanging and eternal, passive and subordinate to humans. Humans were rational, ensouled beings, though with an "animal" body; animals were organic machines. Humans could exploit nature for their own purposes.

This idea of nature informs racism, sexism, and classism. Non-whites, women, and the lower classes were "brutes," and "bestial," having less reason and more animal nature. They were "naturally" suited to their lower status and made better when kept there (Thomas 1983).

In the late eighteenth century, some people began to redefine nature as an "Arcadian" paradise of harmony, equality, and peace. The Arcadian idea of nature suggested that humanity's existential alienation originated with the attempt to dominate nature with technology: losing nature, man lost himself (Worster 1994a).

According to Worster, these two main ideas of nature still inform modern views. Deep ecologists and environmentalists tend to believe in Arcadian nature while technocratic capitalists, economists, and political leaders believe in dominating nature in order to fill civilizations' transcendent destiny.

Many ecologists fall in the middle, understanding humans and nature as complex, self-organizing systems operating at multiple, semi-autonomous scales. Proper care of nature means not exploiting the system beyond its tipping point. In this idea, nature is constantly changing, and humans are both causing disturbance and victims of disturbance.

What ideas of nature do you have? What ideas of nature do you encounter in various media, literature, and classes? Consult Gilbert F. Lafreniere (2008), *The Decline of Nature*, in the Annotated Bibliography section to trace the history of these ideas.

If you take EVH seriously, seemingly simple questions like "why am I here?" start to look extremely complicated. That's because they actually are. Trying to understand the full context for any single moment in time and space eventually connects you to every other moment.

Historians rarely try to manage all that context when they tell their stories of how human–habitat relationships over time account for what the present looks like. Instead, they select a main study area, scale, subject, and theme.

The main study areas are:

1. the dynamics of natural ecosystems over time in relation to human activity
2. interactions of natural ecosystems, socioeconomic systems, and technology
3. the evolution of cultural ideas, values, and beliefs about nature (Mosley 2006, Worster 1993, 48–49, McNeill 2013, 6).

In the first area, you would emphasize biological and physical changes in order to explain the structure and distribution of natural environments and how they affect human societies (McNeill 2003).

In the second area, you would emphasize the evolution of certain tools and economic modes of production and their consequences—intended and unintended—on human habitats. Carolyn Merchant notes, human relationships to the land are intimately tied to our means for producing and reproducing life, whether that be hunting-gathering-fishing or globalized capitalism (2011, 24).

But economies and technologies are shaped by "perceptions, ideologies, ethics, laws, and myths": the ideas we have about nature and ourselves (Worster 1993, 48–49). So the third area concerns the histories of ideas such as "nature," "environment," "wilderness," and "man."

Choosing a scale helps you figure out what level of specificity you'll need: local, regional, continental, hemispheric, or global. To tell the story of how you are here now, you'd probably choose the local level and focus on your personal decisions. Yet, as we noted above, even those have an environmental context operating at other scales. You can argue that it is reasonable to exclude current El Niño conditions as too marginal to the story of why you are here now. Of course, your reader might disagree, but that's okay—you've left her space to add her two cents. EVH is cumulative and revisionary, building on prior work. You don't have to do it all.

Subjects can include any natural or human formation: forests, agriculture, grasslands, desert, natural parks, automobiles, religion, rural or urban built environments, oceans, lakes, rivers, mountains, pollution and sanitation, glaciers, students studying Environmental Humanities textbooks in their college dorm rooms. Recent studies have examined the way urban-rural regions function like an organism, united by metabolic flows of raw materials, provisions, waste, and energy. Sustainability and resilience are central themes to this subject (McNeill 2003).

A subject of current importance is the history of climate science. Climate science is extremely expensive, energy intensive, and vitally important to a range of powerful industries and governments. EVH describes how powerful interests shape conditions in the field, library, lab, and region of the world where knowledge is developed. It asks:

> does the work of science, in trying to discover the truth of how nature works, further democracy, freedom, equality, justice, civil rights and local empowerment? Or does it enhance, even inadvertently, the control of nature by powerful elites with ambitions to subjugate both nature and humans? How do we extend knowledge without creating the conditions for further exploitation?
>
> Hersey and Steinberg (2019, 435–438)

Themes include discussions of sustainability and resilience, race, class, gender, structures of knowledge and power, and forms inequality, privilege or disadvantage. A current theme in environmental history is the question of whether exploitive economic practices reduce biological and social diversity simultaneously. Do the same forces that sustain systemic racism in Europe and "settler societies" (US, Canada, Australia, New Zealand, South Africa) also threaten biodiversity though land development, extractive industries, and intensive agriculture? (Dunlap 1999). What mutual reinforcements exist when a society with a single, dominant culture imposes monocultural plantations on biodiverse rainforests in Brazil and Indonesia? At a smaller scale, one could ask how the uniformity of race, class, gender, nationality, and education in the board rooms of the major mining corporations is related to values of uniformity, discipline, and mechanization inherent to management structure and practices: what effect does the bureaucratic culture and decision-making process have on species extinction from habitat loss and climate change?

Environmental justice themes are particularly important in environmental history, with historians examining the parallels between the unequal distribution of goods and services, environmental risks, power, and populations. In examining study areas and subjects, historians ask questions like, who gets to decide the environmental conditions someone else has to live with? The disproportionate Covid-19 impacts on race and class demographics offer a current example of environmental justice history. In analyzing your own history, you might ask, what structures of knowledge and power that shape your university reading environment, here, now?

The goal of these choices is to tell a coherent story of change over time. "History is a narrative enterprise" (Sorlin and Warde 2009, 12), and "narrative is the only vehicle we have for explaining how and why things happened" (Munslow 2012, 5). Narrative is humanity's oldest and most effective technology for organizing a set of actions into a logical sequence of cause and effect, with agents creating conflict and a clear arc toward a resolution when it all makes sense (Worster 1993). Without an ability to arrange actions into this kind of logical sequence, everything would appear completely random.

But narrative is a tricky technology that can shape the knowledge it produces. Are we relating a sequence of cause and effect that actually exists, or are we imposing cause and effect with our narration? Consider the story of an unfortunate bike crash: "moments after a black cat crossed in front of my bike, I crashed into the curbstone." Narrative links these

sequential coincidences into a cause-and-effect relationship. But in identifying the *cause* of his bike crash as a black cat crossing his path, has the speaker confused correlation with causation? While history is a narrative-based discipline, its value depends on its practitioners being rigorous enough to check their facts, cross-reference, and, like a scientist, try to *disprove* their conclusions: could there be other causal agents? How direct, indirect, or speculative is the causal attribution? Are you using the past to predict the future, pretending that you can see where the narrative arc is heading (Cronon 1993)?

Historians have spent a lot of time reflecting on the way their tools and perspectives construct their stories (Grove and Damodaran 2009, 12). Ideally, EVH navigates the two poles of constructivism (which says that nature is just something humans imagine) and environmental determinism (which says that humans are just the unwitting pawns of natural forces like genetics, microbes, and climate) (see also Chapter 5). Generally, it's "both/and": we construct the world we see with our tools, but the world determines our tools and how we use them.

The great challenge is to tell a coherent story about a fabulously complex process: how all 8 billion of us act independently and jointly affecting planetary evolution, and how all the planet's subsystems and species act independently and jointly to affect human evolution. Historians solve this by selecting "case studies" that provide local and specific detail of a trend and then generalizing those trends in a larger narrative (Hughes 2009, 3).

History for the future

While history never repeats, it can provide lessons to inform decisions about the future (Sörlin and Warde 2009, 2). Donald Worster encourages historians to consider:

> culture as a mental response to opportunities or pressures posed by the natural environment. In other words, culture can be defined as a form of 'adaptation'...In the case of culture-making organisms like humans, adaptation can involve acquiring new information, learning new rules, and altering one's behavior.
>
> Worster (2010, 30)

What if you examined the history of your own culture—whether that's family, peer group, community, or nation—for its adaptive capacity to specific environmental conditions, partly shaped by your group's culture-making? Then you could assess its value for adapting to the coming changes in human–nature environments. How would your culture need to evolve in order to sustain its adaptive capacity?

By adopting this metaphor from evolutionary biology, you can assess other societies too and learn from their successes and failures. For example, which societies have survived the longest? What adaptive advantages did they have—religion, ethics, laws, myths, stories, ideas, governments? How did they define nature and imagine their relation to nature?

Consider the economic culture represented by global capitalism: is it "a form of evolutionary adaptation"? If so, then "the maladaptive aspects of this economic culture need to be examined as carefully as its triumphs" (Worster 2010, 32). An environmental history of global capitalism would identify maladaptive ideologies and practices that jeopardize our survival.

Studying consumer culture is another important, new area of study. How did today's unsustainable consumerism become ingrained in our culture? Many define personal freedom as buying what you want when you want without thinking of consequences. But what kinds of conflict, displacement, and inequality does that belief generate and conceal? What idea of human–nature relations does it assume? You might focus on specific industries, supply chains, companies, or practices (Mosley 2006, 920).

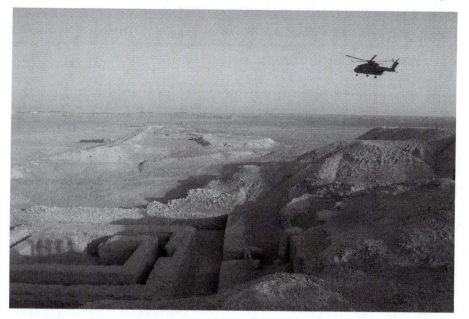

Figure 6.5 The world's oldest city, Uruk, in present-day Iraq, victim of deforestation, salinization, and other consequences of urbanization.

Image credit: SAC Andy Holmes-RAF (Wikimedia Commons).

The history of urban environments is another important new area, especially in postcolonial regions (Holmes and Goodall 2017). EVH treats cities as "a structured human relationship with the natural environment ... part of the ecosystems within which they exist, although they make extensive changes within them" (Hughes 2009, 30). Sing C. Chew (2001) demonstrates that for 5,000 years, urbanization, accumulation, and population growth told the same story: rising inequality, deforestation and soil depletion, loss of biological and social diversity, resource exhaustion, increased vulnerability—inevitably overshoot and collapse. Why hasn't humanity learned its lesson from history? Chew blames overconfident elites who choose short-term wealth maximization combined with the willingness of people to deny reality (Hughes 2016, 91). A history of cities might show us how to circumvent those two causes of collapse.

An environmental history of the body also deserves more attention (Nash 2006, 8). The human body is an environment moving through other environments, a nexus of social-environmental relationships shaped by culturally specific beliefs. What we believe about our bodies—and the bodies of other humans and non-humans—reveals assumptions about our relations to the natural world. As we think about how race, class, and gender are organized and imposed on bodies, we also have to think about how environments are organized and controlled along racial, class, and gender lines. Do women belong in the domestic sphere? Why are the "right" and "wrong" sides of town divided according to class and race? How are racial and ethnic minorities and majorities "placed" in and displaced from environments? Environmental histories of the body can address nutrition and food, endemic disease and environmental regulations, freedom of movement and zoning laws. In these ways, EVH can confront the environmental injustice that often conditions social oppression (Armiero 2016).

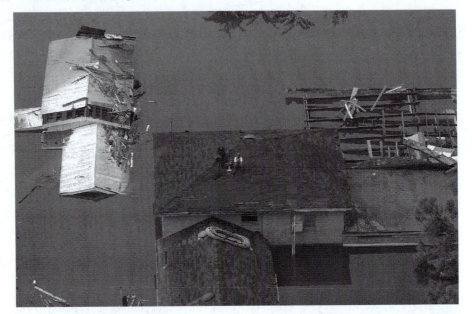

Figure 6.6 Flooding after Hurricane Katrina disproportionately affected New Orleans' African American residents because zoning, tax structures, funding and development policies embedded racism into the urban environment.

Image credit: Jocelyn Augustino-FEMA (Wikimedia Commons).

"Every environmental struggle is, at its foundations, a struggle among interests about power" (Hughes 2009, 9). From an environmental perspective, those power struggles continually redefine the relationships of interdependency that add up to the complex system supporting life on Earth. They do not change the fact of interdependency, but they decidedly change the patterns of interdependency (Worster 1994a, 429). What we take to be "true" about nature is "a product of forces which work to legitimize some ideas and repress others" (Simmons 2008, 14). These legitimated "truths" inform our ethical and legal systems, those rules that govern our relationships with nature. "We are facing a global crisis today, not because of how ecosystems function but rather because of how our ethical systems function" (Worster 1993, 27). EVH can cut through these power struggles to tell the history of *humanature* coevolution, helping our species accept the profound fact that "*we are all in this together*" (Cronon 1993, 19, emphasis added). In telling these stories, EVH can inspire reform of human behavior, values, and beliefs causing global crises.

Chapter summary

In this chapter, we reviewed the origins and influences of EVH or environmental history. While the subdiscipline was formally organized in 1972, inspired by environmental and civil rights movements, important preliminary work was published in the 1950s and 1960s. Geography, anthropology, evolutionary biology, and ecological science provide essential models of change and theories for the interrelationship between humans and nature. From its interdisciplinary perspective, EVH challenges traditional histories to expand the context for the human story to include all living and nonliving agents of change. The field also narrates a more complex process of change. The most important work today relates to how modern civilization has arrived at its

current moment of global environmental crisis. EVH aspires to provide historical perspectives on how human ethics, beliefs, values, ideas, and ways of living coevolve with the living Earth.

Exercises

1. Find a local place that has clear geographical boundaries and a documented human history, for example, a piece of river-frontage, field, house, city block or park. Tell the environmental history of that place using scientific and human documentation. What disturbances altered that place and who were the agents of change? Consult your local historical society for oral histories and "folk" knowledge of the place. Consider how different types of knowledge provide different histories of place.

2. Using a camera, document the relationship between race (or gender or class) and environment shaping a public place on your campus or in your community. Who has access? Who belongs? Who doesn't? How has the environment structured relationships between different groups of people and non-humans? Who controls the environment and what power struggles are visible in its geography? Where do you fit in, particularly with your observational privilege? Accompany your photojournalism with a short essay that speculates on how the environment organizes and reinforces power relations.

3. What is your idea of history? What ideas do your friends and family have? Trace those ideas to literature, science, and philosophy using one or more of the following texts: Donald Worster's *Nature's Economy*; Keith Thomas' *Man and the Natural World*; Carolyn Merchant's *The Death of Nature* (see the References section). In *Global Environmental History* I. G. Simmons (2008) lists eleven dominant ways of thinking about nature (4–5). What advantages and disadvantages does your idea of nature have for living in sustainable relation to the environment? Describe those in terms of adaptive capacity.

4. Research a historical pandemic and compare it to the Covid-19 pandemic. What patterns can you identify? Make a case for these pandemics as humanature hybrid disasters.

5. Compose a multimedia history of an ordinary, daily behavior: eating, showering, dressing, communicating, working, shopping. Detail the way this behavior is distinctly expressive of you, personally and culturally. Where does this behavior originate? Who taught it to you? What values and beliefs does it embody? How does the behavior link you to energy and material flows in your society, including technologies and economies? What kind of relationship to the natural world does it imply? Is that relationship adaptive or maladaptive?

Annotated bibliography

Bennett, Brett M. and Ulrike Kirchberger. 2020. *Environments of Empire: Networks and Agents of Ecological Change*. Chapel Hill: University of North Carolina Press. Nine transnational, comparative case studies from non-British empires challenge assumptions about the causes, consequences, and networks of biological and ecological change resulting from imperialism.

Fiege, Mark. 2012. *The Republic of Nature: An Environmental History of the United States*. Seattle: University of Washington Press. The book retells the story of America as a coevolution with its environment and is particularly relevant for its race, class, and gender analysis of environmental justice.

Headrick, Daniel R. 2020. *Humans versus Nature: A Global Environmental History*. Oxford: Oxford University Press. Synthesizing vast knowledge of how human-driven environmental changes are interwoven with larger global systems, the book explains humanity's impact on the planet and the planet's influence on the human future.

Hughes, J. Douglas. 2016. *What is Environmental History?* Cambridge and Malden: Polity Press. A short, schematic introduction to the field from one of its most respected practitioners, the book is a wealth of resources for doing EVH at any scale, local to global.

Lafreniere, Gilbert F. 2008. *The Decline of Nature: Environmental History and the Western Worldview.* Salem: Oak Savanna Publishing. This account of Western civilization's ecological impact upon the planet reflects on the dominant ideas that have helped bring us to the brink of environmental, social and economic collapse.

Pyne, Stephen. 2012. *Fire: Nature and Culture.* London: Reaktion Books. The world's leading fire historian offers a succinct survey of fire's long coevolution with humanity, showing how it has defined human culture and is necessary to our survival.

Weblinks

Environmental History, ASHE. This is the field's leading journal, with essays, news, links, and book reviews from top scholars doing cutting-edge, interdisciplinary and international research. https://environmentalhistory.net/

Environmental History on the Internet, Carolyn Merchant, UC Berkeley. Maintained by one of the most respected scholars in the field, this website lists the best environmental history websites. https://nature.berkeley.edu/departments/espm/env-hist/eh-internet.html

Environmental History Resources, Jan Oosthoek. Managed by an Australian environmental historian, the website offers blogs, videos, bibliographies, essays, reviews, links and other resources that are international in scope and cater to many interests, from student to expert. www.eh-resources.org

Environmental History, Timeline and Historical Insights, Bill Kovarik, Radford University. This is an independent, not-for-profit project focusing on American environmental policies and politics, but links and details provide a broad perspective, particularly for contemporary history. http://environmentalhistory.org/

H-Environment, Pennsylvania State University. This is a general resource, including book reviews, conference announcements, a course syllabus library, and a survey of films. https://networks.h-net.org/h-environment

The American Society for Environmental History (ASEH). The Society advances understanding of human interactions with the natural world through teaching, research, annual conferences, awards, online discussions, public outreach, and a peer-reviewed journal, *Environmental History*. https://aseh.org/

The International Consortium of Environmental History Organizations (ICEHO). The Consortium unites history organizations from around the world to foster awareness, understanding, and consideration of the historical dimensions of the human/environment relationship. www.iceho.org

References

Adamson, Joni, William A. Gleason, and David N. Pellow. 2016. *Keywords for Environmental Studies.* New York: New York University Press.

Armiero, Marco. 2016. "Environmental History Between Institutionalization and Revolution: A Short Commentary with Two Sites and One Experiment." In *Environmental Humanities. Voices from the Anthropocene*, edited by Serenella Iovino and Serpil Opperman, 45–59. London: Rowman & Littlefield.

Arnold, Matthew. 1882. "Literature and Science." *The Nineteenth Century and After: Monthly Review* 12 (66): 216–230.

Ben-Sasson, H. H., ed. 1976. *A History of the Jewish People.* Cambridge: Harvard University Press.

Chew, Sing C. 2001. *World Ecological Degradation: Accumulation, Urbanization, and Deforestation, 3000 BC–AD 2000.* Lanham: AltaMira Press.

Cronon, William. 1993. "The Uses of Environmental History." *Environmental History Review* 17 (3): 1–22.

Crosby, Alfred W. 2003. *The Columbian Exchange: Biological and Cultural Consequences of 1492.* Vol. 2. Praeger: Westport. Original edition, 1972.

Demeure, Christian E., Olivier Dussurget, Guillem Mas Fiol, Anne-Sophie Le Guern, Cyril Savin, and Javier Pizarro-Cerdá. 2019. "*Yersinia Pestis* and Plague: An Updated View on Evolution, Virulence Determinants, Immune Subversion, Vaccination, and Diagnostics." *Genes & Immunity* 20 (5): 357–370.

Diamond, Jared M. 1999. *Guns, Germs, and Steel: The Fates of Human Societies.* New York: W. W. Norton.

Dunlap, Thomas R. 1999. *Nature and the English Diaspora: Environment and History in The United States, Canada, Australia, and New Zealand: Studies in Environment and History.* Cambridge: Cambridge University Press.

Ghebreyesus, Tedros Adhanom. 2020. *WHO Director-General opening remarks at the Member State Briefing on the COVID-19 pandemic evaluation, July 9, 2020.* Geneva: World Health Organization.

Ghosh, Amitav. 2016. *The Great Derangement: Climate Change and the Unthinkable.* Chicago: University of Chicago Press.

Griffiths, Tom, and Libby Robin. 1997. *Ecology and Empire: Environmental History of Settler Societies.* Seattle: University of Washington Press.

Grove, Richard, and Vinita Damodaran. 2009. "Imperialism, Intellectual Networks, and Environmental Change: Unearthing the Origins and Evolution of Global Environmental History." In *Nature's End: History and the Environment*, edited by Sverker Sörlin and Paul Warde, 23–49. Basingstoke & New York: Palgrave Macmillan.

Hersey, Mark D., and Jeremy Vetter. 2019. "Shared ground: Between Environmental History and the History of Science." *History of Science* 57 (4): 403–440.

Hersey, Mark D., and Theodore Steinberg. 2019. *A Field on Fire: The Future of Environmental History.* Tuscaloosa: University of Alabama Press.

Holmes, Katie, and Heather Goodall. 2017. *Telling Environmental Histories: Intersections of Memory, Narrative and Environment.* Basingstoke & New York: Palgrave Macmillan.

Hughes, J. Donald. 2009. *An Environmental History of the World: Humankind's Changing Role in the Community of Life.* 2nd ed. London: Routledge.

Hughes, J. Donald. 2016. *What is Environmental History?* Hoboken: John Wiley & Sons.

Latinne, Alice, Ben Hu, Kevin J. Olival, Guangjian Zhu, Libiao Zhang, Hongying Li, Aleksei A. Chmura, Hume E. Field, Carlos Zambrana-Torrelio, Jonathan H. Epstein, Bei Li, Wei Zhang, Lin-Fa Wang, Zheng-Li Shi, and Peter Daszak. 2020. "Origin and Cross-Species Transmission of Bat Coronaviruses in China." *BioRxiv*: no page.

Marsh, George Perkins. 2003. *Man and Nature.* Seattle: University of Washington Press. Original edition, 1864.

McNeill, John R. 2003. "Observations on the Nature and Culture of Environmental History." *History and Theory* 42 (4): 5–43.

McNeill, John R. 2013. *Global Environmental History: An Introductory Reader.* Edited by Alan Roe, *Rewriting histories.* New York: Routledge.

Merchant, Carolyn. 1980. *The Death of Nature.* London: Wildwood House.

Merchant, Carolyn. 2011. *Major Problems in American Environmental History.* Boston: Cengage Learning.

Mosley, Stephen. 2006. "Common Ground: Integrating Social and Environmental History." *Journal of Social History* 39 (3): 915–933.

Munslow, Alun. 2012. *Authoring the Past: Writing and Rethinking History.* London & New York: Routledge.

Nash, Linda. 2006. *Inescapable Ecologies: A History of Environment, Disease, and Knowledge.* Riverside: University of California Press.

Nash, Roderick. 1972. "American Environmental History: A New Teaching Frontier." *The Pacific Historical Review* 41 (3): 362–372.

Penna, Anthony N. 2015. *The Human Footprint: A Global Environmental History.* 2nd ed. Hoboken: Wiley Blackwell.

Pyne, Stephen J. 2017. *Fire in America: A Cultural History of Wildland and Rural Fire.* Seattle: University of Washington Press.

Rigby, Catherine E. 2015. *Dancing With Disaster: Environmental Histories, Narratives, and Ethics for Perilous Times*. Charlottesville: University of Virginia Press.

Simmons, Ian G. 2008. *Global Environmental History: 10,000 BC to AD 2000*. Edinburgh: Edinburgh University Press.

Sörlin, Sverker, and Paul Warde. 2009. *Nature's End: History and the Environment*. Basingstoke: Palgrave Macmillan.

Thomas, Keith. 1983. *Man and the Natural World: A History of the Modern Sensibility*. New York: Pantheon Books.

Turner, Frederick Jackson. 1893. *The Significance of the Frontier In American History*. London: Penguin.

Webb, Walter Prescott. 1959. *The Great Plains*. Vol. 766. Lincoln: University of Nebraska Press. Original edition, 1931.

Worster, Donald. 1988. "Doing Environmental History." In *The Ends of the Earth: Perspectives on Modern Environmental History*, edited by Donald Worster and Alfred W. Crosby. Cambridge: Cambridge University Press.

Worster, Donald. 1993. *The Wealth of Nature: Environmental History and the Ecological Imagination*. Oxford: Oxford University Press.

Worster, Donald. 1994a. *Nature's Economy: A History of Ecological Ideas*. 2nd ed. Cambridge: Cambridge University Press.

Worster, Donald. 1994b. "Nature and the Disorder of History." *Environmental History Review* 18 (2): 1–15.

Worster, Donald. 2007. "Nature, Liberty, and Equality." In *American Wilderness: A New History*, edited by Michael L. Lewis, 263–272. Oxford: Oxford University Press.

Worster, Donald. 2010. "Historians and Nature." *Current* (523): 29.

7 Environmental philosophy

Thinking about nature

Chapter objectives

- To introduce readers to the four main areas of Western environmental philosophy: environmental ethics, radical ecology, ecofeminism, and ecoaesthetics
- To contextualize the field of environmental philosophy within the growth of the Environmental Humanities
- To impart an understanding of current directions in environmental philosophy including animal, plant, food, and geoengineering ethics
- To build appreciation of non-Western environmental philosophies through case studies

Luminescing flora

In James Cameron's *Avatar* (2009), the warbonnet fern—known among the Na'vi humanoids as *eyaye*—is distinctive for its shimmering blue leaves. The fern is one of the several bioluminescent, or glow-in-the-dark, plants that inhabit the futuristic landscape of Pandora. The popular sci-fi film invites viewers to imagine a world in which radiant flora supply organic sources of light, replacing light bulbs and electrical circuits. With the aid of emerging genetic technologies, Cameron's far-fetched idea may not be too far off. In the 1980s, scientists engineered the first bioluminescent plant by splicing a firefly gene into a tobacco specimen. The malevolently named *luciferase* gene, derived from fireflies, encodes an enzyme that catalyzes the production of light (Ow et al. 1986).

Three decades later, the Glowing Plants project launched a campaign on the crowdsourcing platform Kickstarter to fund the genetic engineering of bioluminescent flora, described as "self-powered phototonics" (Kwak et al. 2017, 7951). The group hypothesized that light-emitting trees could one day be used as streetlamps for reducing global energy consumption. Although ceasing activities in 2017, the Glowing Plants initiative helped to popularize the field of *synthetic biology*, entailing the manipulation of organisms to promote novel features. What's more, the project provoked debates about *botanical nanobionics*, the embedding of microscopic particles into the cells of plants, which are then transformed into vegetable light sources, natural infrared devices, and green sensors. Sometimes *truth* is stranger than *science fiction*.

Reflection 7.1 The ethics of bioengineering

Despite its enthusiastic public reception, the Glowing Plants Kickstarter became the target of criticism concerning the ethical, legal, and environmental implications of

DOI: 10.4324/9781351200356-7

genetically modified organisms (GMOs), defined as species that have been engineered in a laboratory. One of the roles of philosophers, ethicists, and other critical environmental thinkers is to appraise the potential long-term effects of biotechnologies. Consult the Glowing Plants website: www.kickstarter.com/projects/antonyevans/glowing-plants-natural-lighting-with-no-electricit. Next, research some of the online media coverage of the project. What sorts of criticism did the initiative attract? Do you think the potential benefits of plant nanobionics outweigh the risks?

Ecophilosophy as a pillar of the Environmental Humanities

What is nature? Is it an abstract notion or tangible object? Does it have worth beyond its use or economic value? Is humankind entitled to consume a large proportion of the globe's natural resources? Are we morally obliged to conserve rainforests? Is it justifiable to cull feral species in order to protect their native counterparts? Is a flower less beautiful if it is known to invade wetlands and suffocate vulnerable plants? Is a restored landscape inferior to the original, unspoiled environment? Is it morally right to engineer transgenic species?

Such questions are integral to environmental philosophy, a branch of philosophy that emerged in the late 1960s and early 1970s as an outgrowth of the environmental movement. This chapter concentrates on Western, or Occidental, environmental philosophy developed in Europe, Australasia, and the Americas as distinct from Eastern, or Oriental, ecophilosophy evolving from Asian countries. Despite this emphasis, we will present case studies that we hope will engender in readers an appreciation of the plurality of environmental thinking in non-Western contexts. We suggest that—in its commitment to the more-than-human world and advocacy of ecological justice—environmental philosophy has been formative to the maturation of the Environmental Humanities.

Since its emergence, specialists have approached environmental philosophy in different ways. Moral philosophers, phenomenologists, aestheticians, epistemologists, logicians, metaphysicians, ecofeminists, radical ecologists, and deep ecologists—some of whom will be discussed in this chapter—navigate according to particular philosophical compasses. Nevertheless, there are commonalities across definitions and interpretations of the field and its practitioners that are important to note. On the whole, environmental philosophers interrogate conceptions of nature, human–environment interactions, and ecological problems such as climate change, pollution, biodiversity loss, habitat destruction, development, resource use, and bioengineering. Ecophilosophers believe that the transformation of our thinking about the natural world can promote positive environmental values, beliefs, and actions—from conservation, preservation, and restoration to appreciation, empathy, and emotional identification.

In his groundbreaking paper "Is There a Need for a New, an Environmental, Ethic?", Australian logician Richard Sylvan (née Routley) called for a radical philosophical framework "setting out people's relations to the natural environment" (Routley 1973, 205). Summoning conservationist Aldo Leopold's land ethic, Routley declaimed that "human interests and preferences are far too parochial to provide a satisfactory basis for deciding on what is environmentally desirable" (210). In other words, ecological issues cannot be addressed as long as the human is invested in purely human—or *anthropocentric*—concerns. Routley categorized social and cultural prejudice against the more-than-human as "species bias" (209). His paper

implores the international philosophy community to leverage the field's strengths in creative thinking and conceptual analysis to ameliorate environmental problems. As such, in Routley's view, an *environmental* philosophy would deliver a conceptual basis for *decentering* human interests by placing value on individual animals and plants, on the one hand, and environmental wholes and collectives—species, genera, habitats, and ecosystems—on the other (Callicott 1993, 5).

As Sylvan's early publication suggests, environmental philosophy examines our *moral duty* to nature and the *inherent worth* of the environment. These two key concepts recur in explications of the field. *Moral duty* refers to the responsibility to act in accordance with ethical obligations to the environment. Also described as intrinsic or non-instrumental value, *inherent worth* signifies the value of nature in its own right regardless of its use as a means to some other end (Brennan and Lo 2014, 10). The inherent worth of a plant, for example, lies its value beyond its usefulness to humans as a food, fiber, medicine, tool, ornament, symbol, or object of study. The American theorist Michael E. Zimmerman (2001), accordingly, defines environmental philosophy as "an effort to examine critically the notion that nature has inherent worth and to inquire into the possibility that humans have moral duties to animals, plants, and ecosystems" (3). For Indian-American philosopher Sahotra Sarkar (2012), moreover, environmental philosophy investigates questions of biodiversity, climate change, ecological integrity, sustainability, and non-human life in terms of moral duty, intrinsic value, human–nature reciprocity, and other frameworks (2–4). Note how different this is from the usual anthropocentric, utilitarian argument that biodiversity loss or climate change is bad because it harms humans. Before we introduce the major specializations within the field, let's consider a case study on non-Western ecophilosophy, that of Green Islam. In Islamic ecological thought, the first human being, Adam, served as *khalifa* or guardian of the planet; all men and women thus inherit the moral duty to steward the Earth and its life forms (Rizk 2014).

Figure 7.1 This aerial view depicts Pondok Pesantren in Central Sulawesi, Indonesia.

Image credit: Hendri Wigiarto (Wikimedia Commons).

Case Study 7.1 Islamic environmental philosophy

There are between 1.4 and 1.8 billion Muslim people worldwide, about one-fifth of humankind. The Qur'an is the main source of Islamic philosophies about the natural world. The three founding pillars of Islamic ecophilosophy are *tawhid* (unity, balance, and harmony), *khalifa* (trusteeship or stewardship), and *akhirah* (the hereafter). According to these principles, each human generation should maintain the wellbeing of the land by avoiding resource depletion and biological degradation (Saniotis 2012).

Notwithstanding Islam's ecological foundation, studies reveal low levels of environmental awareness, ethics, and behavior in Muslim majority countries (for example, Foltz 2005). The situation, however, may be changing in nations such as Indonesia, the world's most populous Muslim country and one which, since 1996, has lost 2 million hectares (5 million acres) of forests annually to land clearance. More than 1,000 *pesantren* (traditional religious boarding schools) in Indonesia have implemented eco-friendly waste, water, and energy practices (Figure 7.1). The eco-*pesantren* movement reinterprets mainstream Islamic ideas in terms of contemporary ecological sustainability (Gade 2019).

In another example of Green Islam, farmer-activist Iskandar Waworuntu founded Bumi Langit, a permaculture farm near Yogyakarta, Indonesia, committed to the realization of *tawhid* and *khilafah* as well as *thoyyib* (wholesomeness) and *asah-asih-asuh* (teaching-loving-caring).

Visit the Bumi Langit website (www.bumilangit.org) then, locate three online media stories of pro-environmental behavior in Indonesia. What are some of the other aims of Indonesian Islamic ecophilosophy? What is your view of the general relationship between religion, philosophy, and environmental sustainability? Is an ecotheology *necessary* to an ecophilosophy? We will explore the last two questions in more detail in Chapter 8.

Philosophers split environmental philosophy into various specializations. The four main areas of that we present in this chapter are *environmental ethics*, *radical ecology*, *ecofeminism*, and *ecoaesthetics* (Zimmerman 2001). There are also specializations in ecophenomenology (the pursuit of how human beings discover meaning through interaction with the environment), ecometaphysics (exploring the beingness of the non-human), ecolinguistics (stressing the connection between language and environment), bioregionalism (privileging the ecoregion as the basic unit of social organization), philosophy of science (focusing particularly on the biological and conservation sciences), and others that a semester-long course in environmental philosophy should cover.

Environmental philosophy is often regarded as interchangeable with environmental ethics, the critique of anthropocentric (human-centered) ethics and the extension of moral consideration to the natural world. However, such a conflation, we suggest, risks skimming over the gamut of approaches to—and interpretations of—the field.

To begin with, *environmental ethics* makes use of structured reasoning to assign moral status to nature and devise frameworks regarding what constitutes a virtuous life within the limits of the biosphere. Ethicists often critique the philosophical paradigm of positivism, which has separated mind and matter in Western thought by asserting the primacy of scientific validation and the irrefutability of mathematical evidence. Interested in establishing nature's intrinsic rights, ethicists discern between good/right and bad/wrong environmental

behaviors. They understand eco-virtue as a means to becoming ecologically good, conscious, and responsible (Traer 2020, 1–68). Evolving initially from theories of animal liberation and rights, this branch of ecophilosophy formulates approaches to individual organisms (oaks, pines, camels, kangaroos) as well as whole ecological communities (deserts, mountains, rainforests, coral reefs). Aldo Leopold's land ethic, as a case in point, exemplifies a holistic approach to environmental ethics.

A recurring debate in environmental ethics is *anthropocentric* versus *biocentric* rationales for moral considerability (Boylan 2014, 115). The anthropocentric position determines value according to the environment's usefulness to people; one's obligations to nature therefore are prudential and self-interested. The "future generations" argument represents an anthropocentric environmental ethic. Along these lines, the conservation of nature is imperative only insofar as it might promote the welfare of future human communities. In contrast, biocentrism is life-centered ethical theory. The biocentric position asserts that each species or organism contributes to ecosystemic health and, therefore, should be able to continue living free of undue human interference (Boylan 2014, 115).

Reflection 7.2 Anthropocentric versus biocentric ethics

The 2019–20 Australian bushfire season was one of the worst on record. By January 2020, 10.7 million hectares (26 million acres or 41,000 square miles) were burned. That's larger than the state of Maine; fourteen times the area burned in the 2018 California fires; and twelve times that of the 2019 Amazon fires (see Chapter 5). At the time of writing, the fires had killed 28 people and destroyed over 6,000 buildings, including 2,200 homes. An estimated 1 billion animals perished. Climate change was cited as a major cause of the catastrophe. Review some of the media coverage of the fires. What sorts of *anthropocentric* and *biocentric* ethical debates are evident in the media stories?

Comprising both deep ecology and social ecology, *radical ecology* is commonly associated with countercultural movements. Radical ecophilosophers assert that their analytical approaches reveal the conceptual, social, cultural, and historical underpinnings of the environmental crisis. From their perspective, only a fundamental social revolution or cultural transformation will help humankind avert long-term ecological disaster. They critique political and other reforms as superficially dealing with the symptoms, rather than the causes, of environmental decline (Zimmerman 2001).

Norwegian philosopher Arne Næss (1973) differentiated between the *shallow* and *deep long-range* ecology movements. Shallow ecology emphasizes short-term changes within developed nations preoccupied with issues of pollution and resource consumption. In contrast, deep ecology aims to reconfigure Western societies' worldviews. Deep ecologists highlight the interrelatedness of ecosystems; egalitarianism between species (or biocentrism); respect for diversity and complexity; and the value of local economies and decentralized governance. In contrast to deep ecology, social ecology regards the history of human domination of others, including the more-than-human, as the primary deterrent to natural and social evolution. Social ecologists call into question the commodification of the environment and the predominance of patriarchal-authoritarian values. A pioneer of social ecology was American political philosopher Murray Bookchin (1921–2006), whose early writings on the field are presented in the next section of this chapter (Clark 1993, 346).

Since the late 1970s and early 1980s, *ecofeminism* (or ecological feminism) has brought the feminist, peace, anti-nuclear, and animal rights movements into dialogue with environmentalism. This branch of environmental philosophy claims that the natural world is a feminist concern—and that the domination of women is closely linked to the domination of nature. Ecofeminism encompasses a variety of philosophical positions that illuminate woman-nature interconnections. Ecofeminist practitioners maintain that recognizing these linkages is essential to all forms of feminism, environmentalism, and ecophilosophy (Warren 1993a). As German sociologist Maria Mies and Indian author-activist Vandana Shiva write, "the liberation of women cannot be achieved in isolation, but only as part of a larger struggle for the preservation of life on this planet" (Mies and Shiva 2014, 16). Ecofeminism understands *patriarchy* as an ideology that legitimizes oppression by creating a sense of self separated from—rather than connected to—all life. This disconnected sense of self, for ecofeminists, underlies the ecological crisis and all forms of oppression (Gaard 1993, 2). Recent work in ecofeminism reasserts the value of compassion and empathy while cautioning against the longstanding Western dualisms of reason-emotion, cognition-feeling, and knowledge-embodiment that position the body perilously in opposition to the mind. This recent approach in ecofeminism is known as *embodied materialism*.

The fourth branch, *ecoaesthetics* (or environmental aesthetics), deals with the aesthetic perception of the natural world as beautiful, picturesque, sublime, uncanny, ugly, repulsive, or displeasing (Figure 7.2). Ecoaesthetics emerged in the late 1960s in response to increasing political and popular focus on environmental degradation. Ecoaestheticians call attention to the distinction between the appreciation of artworks, on the one hand, and natural environments, on the other. In an early essay, for instance, Scottish philosopher Ronald Hepburn (1963) contended that an environmental spectator—in contrast to an appreciator of art—becomes more deeply immersed in the object of perception.

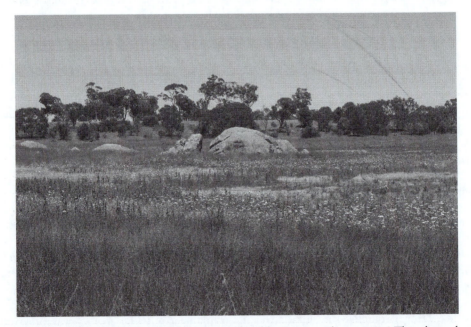

Figure 7.2 Is a landscape less beautiful if it is populated by invasive plant species? This photo shows Racecourse Swamp, Uralla, New South Wales, Australia.

Image credit: J. C. Ryan.

The natural environment provokes a wider range of sensory feedback—seeing, hearing, touching, smelling, and even tasting what is apprehended. Through direct experience, the environmental spectator is transformed into an ecological agent. As she or he moves through a place, the dichotomy between human subject and natural object disintegrates. Moreover, traditional artworks (paintings, illustrations, sketches, sculptures) are intentionally framed or positioned in a manner that landscapes and natural objects are not. Unlike artworks, meaning in nature is independent of an artist or designer. A major debate in environmental aesthetics is the distinction between *cognitive* and *non-cognitive* frameworks. In the cognitive mode, scientific knowledge of the natural object is a precondition for its appreciation whereas, in the non-cognitive mode, experience, metaphor, and imagination are sufficient. The field of applied ecoaesthetics investigates the function of aesthetic appreciation in environmental conservation policy and in promoting sustainability in the public domain.

Waypoint 7.1 Keywords in Environmental Philosophy

- *Agency*: the capacity of a natural being or object to act with intention or self-directedness within its environment
- *Anthropocentrism*: literally "human-centeredness"; the belief that humankind is the principal bearer of moral status and that other beings can be exploited freely for human use
- *Biocentrism*: an ecoethical framework that confers intrinsic value to the biosphere (to animate beings only)
- *Biophilia*: the love of life, or "the innate tendency to focus on life and lifelike processes" (Wilson 1984, 1)
- *Ecocentrism*: an ecoethical framework that imparts value to the ecosphere (to all animate beings and inanimate things)
- *Embodied materialism*: an ecofeminist perspective that grounds justice in the materiality of the everyday world
- *Environmental justice*: the equitable distribution of ecological benefits and hazards in addition to meaningful engagement in environmental decision-making processes
- *Intrinsic (or inherent) value*: the value of nature in its own right, independent of its instrumental use
- *Picturesque*: an ecoaesthetic category involving a pleasing visual prospect extending, oftentimes, over rolling hills; usually associated with pastoral landscapes
- *Sentientism*: an ecoethical framework that confers intrinsic value to sentient beings, or those with the potential to experience pain and pleasure
- *Speciesism*: a bias or prejudice against members of particular species that often underlies ecological injustices
- *Sublime*: an ecoaesthetic category in which the magnitude of nature (e.g., a mountain or ocean) overwhelms the human subject, producing a simultaneously discomfiting and exhilarating response

Historical developments and key texts in environmental philosophy

The work of nineteenth-century American writer and naturalist Henry David Thoreau, particularly his classic *Walden* (1910, originally 1854), laid the foundation for modern environmental philosophy. A staunch critic of anthropocentrism, Thoreau recognized virtue in the natural world, advocated the protection of wildlands, and asserted that human flourishing entails much more than capitalist gluttony. In his interactions with mammals, birds, insects, plants, and waterbodies, Thoreau displayed an acute sense of empathy and care for more-than-human wellbeing (for more on Thoreau's contribution to the Environmental Humanities, see Chapter 1). Ralph Waldo Emerson's *Nature* (2003, originally 1836) and John Muir's *My First Summer in the Sierra* (2004, originally 1911) also influenced the germination of environmental philosophy as a field of inquiry emphasizing humankind's moral duty to the environment and nature's intrinsic rights.

In the mid-twentieth century, Aldo Leopold's persuasive proposal for a land ethic in *A Sand County Almanac* (1949) and Rachel Carson's compelling narration of the linkage between human and environmental health in *Silent Spring* (1962) inspired the fuller emergence of environmental philosophy as a response to the environmental movement. Leopold (1949) wrote famously, "A thing is right when it tends to preserve the integrity, stability, and beauty of the biotic community. It is wrong when it tends otherwise" (201). Following Leopold and Carson, ecologist Garrett Hardin's "The Tragedy of the Commons" (1968) and biologist Paul Ehrlich's *The Population Bomb* (1968) both warned of the hazards of overpopulation and resource depletion. Likewise, the report *The Limits to Growth* (Meadows et al. 1972) predicted a decline in human population and industrial capacity by the late twenty-first century. These debates gave rise to the first peer-reviewed academic journal in the field, *Environmental Ethics*, appearing in 1979 under the editorship of philosopher Eugene C. Hargrove.

The previous section of this chapter alluded to Richard Routley's rejection of species bias and human chauvinism in his seminal paper from 1973. Two years later, philosopher Holmes Rolston III would scrutinize the relationship between environmental ethics and ecological science, arguing for a transdisciplinary synthesis of knowledge: "The topography is largely uncharted; to cross it will require the daring, and caution, of a community of scientists and ethicists who can together map both the ecosystem and the ethical grammar appropriate for it" (Rolston 1975, 109). Rolston advocated an ethical framework informed by the latest ecological understanding, such as the concept of homeostasis (stable equilibrium between elements); in his view, omitting science from ethics would prove foolhardy. In addition to the publications by Routley and Rolston, Hardin's work on population dynamics, carrying capacity, and sovereignty helped to energize the rise of environmental ethics. Known for his "ethics of a lifeboat," Hardin (1974) built on the idea that the land available to each nation globally has a finite carrying capacity. An ethical crossroads is reached when a rich "lifeboat," such as the United States, encounters a poor nation "treading water" outside the boat and "calling for help." If the poor nation is allowed on board, the boat becomes swamped, and all passengers perish. Controversially, Hardin argued that, in order to preserve the safety margin, no additional passengers should be allowed to board. Hardin's dire ethical metaphor demonstrates that the greater good requires policy-makers to strictly regulate populations and resources in order to maintain balance. Good governance, Hardin believed, avoided the circumstances of "lifeboat ethics," even if that meant restricting personal liberties, reproduction rights, and capitalist enterprise.

The animal rights and liberation movement has also figured prominently into the fruition of environmental ethics. Ruth Harrison's *Animal Machines* (1964) exposed the cruelties of industrial poultry and livestock farming. The essay collection *Animals, Men, and*

Morals (Godlovitch et al. 1971), additionally, outlined moral arguments for animal liberation. The book was inspired by novelist Brigid Brophy's article "The Rights of Animals" published six years earlier. Australian philosopher Peter Singer's "Animal Liberation" (1996, originally 1973), an essay appearing initially in the *New York Review of Books*, asserted that animals' ability to feel pain (sentience) is enough to warrant their ethical consideration. Knowledge of animals' biological commonalities with humans should afford satisfactory evidence that they suffer.

As sentient organisms, animals have interests that merit our attention. Singer invoked nineteenth-century English philosopher Jeremy Bentham's provocation, "The question is not, Can they *reason?* nor Can they *talk?* but, Can they *suffer?*" (Singer 1996, 9). He maintained that the experience of pain is unrelated to the faculty of language: "There seems to be no reason at all to believe that a creature without language cannot suffer" (10). The animal movement counters the speciesist logic most evident in clinical testing on non-humans conducted for human benefit (12). Singer suggests that the instrumental, utilitarian value of animal life is culturally ingrained; thus, animal liberation requires values of altruism and identification because non-humans cannot protest their own mistreatment (although certainly the cry of a wounded animal, such as the koalas rescued from the 2019–20 Australian bush fires, can be understood as a pained expression of protest).

Case Study 7.2 Buddhist environmental ethics

About 8% of the human population, or 600 million people, practice Buddhism worldwide. The fundamental beliefs underlying all Buddhist thinking include *kamma* (the consequences resulting from actions), *saṃsāra* (endless cyclicality), and *dukkha* (bodily pain, psychological anguish, and unrealized desires). Buddhist doctrines do not set human beings in opposition to nature but, instead, highlight the capacity of humankind to act compassionately toward other living beings. For instance, in the Pāli Canon of Theravada (the dominant form of Buddhism in Cambodia, Laos, Myanmar, Sri Lanka, and Thailand), monks and nuns practice an ethic of non-violence toward sentient beings such as plants by not cutting down trees and avoiding harm to grasses (Findly 2002). India's emperor Ashoka (304–232 BC), furthermore, used Buddhist ethics to encourage people to grow medicinal trees, protect animals, and adhere to tenets of non-violence.

Phrakhru Somkit Jaranathammo is a Buddhist monk from Nan Province, Northern Thailand (Figure 7.3), who promotes what he calls *dhammic agriculture*. Dhamma means "truth." Somkit uses a Buddhist perspective to identify the fundamental causes of local environmental problems and devise creative solutions that merge practical strategies and community participation with spiritual ideals. He interprets the ancient Buddhist idea of "Right Livelihood" as one that enables farmers to increase their income and self-sufficiency while taking care of the environment. The forward-thinking monk works with about fifty farmers within an agricultural cooperative, growing local varieties of vegetables for export around Thailand. A mix of food crops and animal husbandry recreates an ecological system in which the forest is an essential component. Somkit has also restored acres of grasslands and forests previously burned and cleared for monocrop agriculture.

Read Somkit's inspiring story here (www.mdpi.com/2077-1444/10/9/521) as detailed by Susan M. Darlington in her article. Summarize the features of his Buddhist environmental ethics.

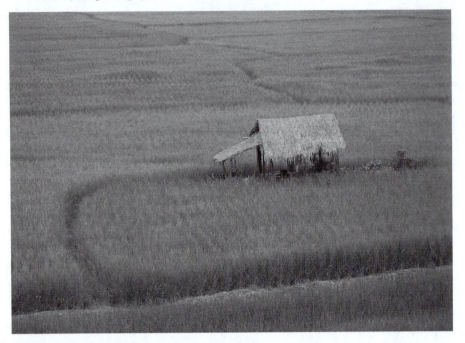

Figure 7.3 Phrakhru Somkit Jaranathammo is a Buddhist monk who works on environmental sustainability in Nan Province, Northern Thailand, pictured here.

Image credit: Takeaway (Wikimedia Commons).

In 1973, Arne Næss coined the term *deep ecology* to refer to a movement recognizing "organisms as knots in the biospherical net or field of intrinsic relations" (1973, 95). Næss was influenced by Buddhist principles of self-realization as well as the ideas of Dutch philosopher Baruch Spinoza (1632–77) and Indian ethicist Mahatma Gandhi (1869–1948). Countering anthropocentrism, Næss proposed *biospherical egalitarianism* as the equal right to prosper across species and organisms. From a deep ecological perspective, diversity and symbiosis represent the ability of organisms to coexist in complex—but not complicated—relations. Deep ecology adopts an anti-class posture involving diversity, local autonomy, decentralization, and self-governance. In particular, deep ecologists use the term *ecosophy* to denote a philosophical framework in which ethical action is informed by Earth wisdom or, in other words, "a philosophy of ecological harmony or equilibrium" (Næss 1973, 99). Ten years later, while hiking in Death Valley, California, with fellow philosopher and deep ecologist George Sessions, Næss outlined eight principles of the movement, beginning with the assertion that "the well-being and flourishing of human and non-human life on Earth have value in themselves (synonyms: intrinsic value, inherent worth). These values are independent of the usefulness of the non-human world for human purposes." (To read all eight points, see Næss 1993, 197, originally 1983.) Deep ecology later influenced the formation of the radical environmental activist groups Earth First! (in 1980) and Deep Green Resistance or DGR (in 2011) as well as anarcho-primitivism, a movement that questions the purpose of civilization and forwards rewilding—the returning of places and people to their natural or feral state.

> ## Reflection 7.3 Anarcho-primitivism and the ecology-society nexus
>
> *Anarchists* reject the state in support of small-scale political formations. *Anarcho-primitivists* call for industrial technology to be abandoned and group subsistence to be adopted. Despite his grounding in anarchist thought, Bookchin criticized the anti-civilization and anti-technology stance of anarcho-primitivism. He developed "libertarian municipalism" and communalism, which integrated social ecology into civil rights.
>
> How central to environmental degradation are social inequalities? Find a current case study from the media that illustrates how social justice can enhance ecological flourishing. Or examine the United Nation's Sustainable Development Goals (https://sdgs.un.org/goals): how do these seventeen goals encourage synergies between ecological restoration and social uplift? How does this conflict with the way development is usually framed? Also consider whether the UN defines the value of sustainability anthropocentrically or biocentrically. Does it matter whether sustainability acknowledges the intrinsic worth of all life, or do the ends justify the means?

As the second major form of ecoradicalism, social ecology shares ground with both deep ecology and ecofeminism. Murray Bookchin (1982) called for "a consistently radical social ecology: an ecology of freedom" (1). He argued that the human domination of nature arises from social inequalities. In response, social ecology proposes a free and harmonious society—one without hierarchies and domination—founded on ecological principles. A decentralized society makes use of renewable energies, organic farming methods, and pollution reduction measures but also deals with the social relations and political structures that underlie the inequalities that obstruct flourishing for people and nature. Elsewhere, Bookchin described social ecology as concerned with the ecological problems arising from deeply rooted social issues. Put differently, environmental quandaries cannot be resolved without confronting social problems. In somewhat utopian terms, Bookchin envisioned a new society "in which human beings intervene in natural evolution with their best capacities—their moral sense, their unprecedented degree of conceptual thought, and their remarkable powers of communication" (1993, 370).

In 1974, Francoise d'Eaubonne gave the name *l'écoféminisme* (ecofeminism) to the body of philosophical work that brings feminist and ecological ideas into conversation. A year later, Rosemary Radford Ruether's essay collection *New Woman, New Earth* (1975) became one of the first ecofeminist publications. Ruether called attention to a link between the subjugation of women and the degradation of the Earth. She critiqued the hierarchies that split feminized nature from masculinized culture in Western thought. Carolyn Merchant's *The Death of Nature* (1980), moreover, contends that a mechanistic worldview, originating in the Scientific Revolution, underlies the exploitation of the environment and subordination of women. Following a similar analysis, Karen J. Warren's "The Power and Promise of Ecological Feminism" (1993b), argued that ecofeminism supplies a unified ethical framework to confront the entangled repression of women and the Earth. In recent years, ecofeminism has turned to the Global South from which strands such as postcolonial ecofeminism have emerged to address the subjugation of women and nature in South Asia, Southeast Asia, Africa and elsewhere. In this context, Vandana Shiva's work on "Earth democracy" has been an important contribution.

Ecoaesthetics—the analysis of the aesthetic appreciation of natural environments—arose in the 1970s and 1980s in response to aesthetic philosophy's emphasis on art rather than nature as well as rising public concerns over ecological degradation. In particular, Ronald Hepburn's essay "Contemporary Aesthetics and the Neglect of Natural Beauty" (1966) gave momentum to the emergence of ecoaesthetics in the late twentieth century. Hepburn examines the question of why nature fell out of favor among philosophers of aesthetics. Contemporary humankind, Hepburn argues, has become estranged from nature, in part, due to the scientific rationalization of embodied sensory experience. The environment, nevertheless, always remains an object of appreciation in its own right and not something to be confused with an object of art (painting, drawing, sculpture, etc.). In nature, "we have not only a mutual involvement of spectator and object, but also a reflexive effect by which the spectator experiences *himself* [or *herself*] in an unusual and vivid way; and this difference is not merely noted, but dwelt upon aesthetically" (Hepburn 1966, 289). Hepburn's assessment sparked renewed interest in the aesthetics of nature and prompted the emergence of contemporary environmental aesthetics.

As elaborated in Reflection 7.4, ecoaesthetic approaches are grouped as *cognitive, concep-*

Reflection 7.4 Cognitive versus non-cognitive ecoaesthetics

You are sitting in an old-growth forest in the Pacific Northwest of the US. You *reflect* on the vast age of the ecosystem and marvel at the unseen fungi that help trees communicate with each other. You *reach* into the thick moss as the cool, wet, and musky soil squishes between your fingers. The first mode of appreciation (*reflecting*) represents a cognitive ecoaesthetics whereas the second mode (*reaching*) is non-cognitive, a difference we will consider below. Now call to mind a natural place you enjoy visiting. Do you believe knowledge and information are necessary to appreciating that place? Or are your feelings and emotions sufficient? Consider these two questions in relation to the place you have selected. Experiment with the two modes by experiencing the actual place. Jot down your conclusions.

tual, and *narrative*, on the one hand, and *non-cognitive, non-conceptual*, and *ambient*, on the other. The distinction between the two categories rests on the function of knowledge in environmental aesthetic appreciation in comparison to the influence of physical engagement, emotion, and imagination. Allan Carlson, for instance, propounds the cognitive view. He argues for the centrality of natural history and natural science to ecoaesthetic appreciation. Knowledge of the object renders aesthetic judgement either true or false: "for significant aesthetic appreciation of nature, something like the knowledge and experience of the naturalist is essential" (Carlson 1981, 25). Carlson lavishes praise on John Muir, John Ruskin, John James Audubon, and Aldo Leopold as "not only appreciators of nature but also accomplished naturalists" (25). In contrast to Carlson, philosopher Arnold Berleant (1991) articulates a non-cognitive stance in which the appreciator becomes immersed in the object of appreciation. Berleant's "aesthetics of engagement" encourages appreciators to close the physical and psychological distance between themselves and the natural environment with which they

interact, experiencing the full range of emotions and senses. Note how these philosophers deepen the "sense of place" theories from Chapter 5.

Waypoint 7.2 Other radical environmental philosophies

- *Animal liberation*: a movement that seeks to end the subjugation of animals as disposable objects of research, consumption, and entertainment; divided into *rights* and *utilitarian* camps
- *Bioregionalism*: a philosophy of naturally bounded areas, or bioregions, emphasizing local ecologies, economies, and politics
- *Earth liberation*: a loosely anarchistic ideology that seeks to liberate the Earth from industrial capitalism by any means necessary; it emphasizes ecocentrism and biophilia
- *Ecofascism*: a philosophical paradigm centered on totalitarian governance in which individuals must forgo their needs and desires for the common biospheric good
- *Ecopsychology*: a movement that investigates the psychological processes that create affection for, and detachment from, nature
- *Eco-Marxism*: an ecophilosophical framework incorporating the traditional Marxist critique of production, property, and labor
- *Eco-minimalism*: a worldview that aligns sustainable living with the minimal consumption of resources and production of waste
- *Green anarchy*: or eco-anarchism; a counter-authoritarian philosophy that promotes self-governing statelessness as a social basis for addressing environmental problems
- *Green libertarianism*: or eco-libertarianism; a counter-authoritarian political philosophy integrating green values with libertarianism toward the preservation of autonomy and freedom
- *Neo-Paganism*: a contemporary religious system that melds pre-modern pagan beliefs (polytheism, animism, the sacredness of nature) with ecocentric principles and practices
- *Plant liberation*: a movement that sets out to counter "plant blindness," the widespread social marginalization of vegetal life
- *Queer ecology*: an ecophilosophy that upsets heteronormative concepts of activism, environment, biology, gender, and sexuality
- *Sexecology*: or ecosexuality; a radical environmental orientation based on Earth fetishism in which nature is treated as a lover

Current trends and future prospects in environmental philosophy

In response to the popularization of the Anthropocene concept over the past two decades, environmental philosophy has further diversified into studies of plant, food, and climate ethics, including climate engineering, Anthropocene feminism, and sustainability aesthetics. This section introduces a handful of examples of recent and potential directions in the field

as scholars seek to apply the methods of philosophical inquiry to confronting the planetary environmental crisis and redressing the degradation of the biosphere.

Plant—or vegetal—ethics is an evolving specialization within environmental ethics, although "a free-standing ethics of plants is at best embryonic" (Kallhoff et al. 2018, 1) (see Chapter 14 for a discussion of critical plant studies). Discussed in passing by environmental philosophers over the years, plants are usually generalized as "living beings" and seldom studied in detail from a humanistic perspective. In comparison, animals have received considerably more philosophical treatment, as shown by the animal rights and liberation movement. Nonetheless, scientific research is revealing that plants are much more than part of the furniture. They exhibit a range of intelligent behaviors, including learning by association, recognizing the self, correcting errors in judgement, communicating with kin, remembering interactions with animals, and blocking traumatic memories to ensure the survival of themselves and subsequent generations.

This relatively new area of ecoethics grapples with plant-focused questions pertaining to breeding technologies, agricultural robotics, genetically modified varieties, and laboratory experimentation. Some philosophers regard plants as ethical subjects insofar as they are valuable to sentient beings. But such a position reflects an anthropocentrism that denies sentience to plants. Other philosophical approaches emphasize the human practices that depend on plants. There are also ethical frameworks that acknowledge the values—for instance, abundance, flourishing, and regeneration—associated with botanical life.

A notable development related to plant ethics is food ethics. This ethical paradigm probes questions of food consumption, food policy, and food systems: What impacts do our food choices have on the environment? Should we eat animals, plants, or both? Do vegetarianism and veganism offer important interventions? What are the ecological implications of fad diets? Should we be omnivores, locavores, or opportunivores (professional dumpster divers)? Should we consume genetically modified livestock and crops? Should rich nations help confront global malnutrition? Food ethicists pay attention to local and global *food systems*, defined as the intricate networks of people, processes, and products that generate food for human delectation.

Reflection 7.5 The ethics of climate engineering

Many climate engineering strategies have been proposed. A technique called *ocean fertilization* involves bolstering the ocean's iron content to increase phytoplankton production, which in turn decrease CO_2. *Carbon sequestration* entails removing CO_2 from the atmosphere by burying it underground. *Planetary cooling* promises to mitigate tropical cyclones, drought, heatwaves, and flooding by reducing the temperature of the Earth. *Solar geoengineering* is accomplished by spraying sulfur dioxide into the atmosphere, which then reflects the sun's heat.

Do some research into two or three other geoengineering proposals: see Case Study 3.3 for more discussion. Are these ideas valuable, or do they distract from the *real* work of reducing CO_2 emissions from vehicles and industry?

When environmental ethics emerged as a field in the 1960s and 1970s, climate change was not an important concern for society or philosophers. Flash forward fifty years, and the situation has morphed drastically. The global climate catastrophe is making headlines on a

daily basis. The debate, for instance, became central to the disastrous Australian bush fire season of 2019–20 that took place during the writing of this book. In this context, philosopher Stephen M. Gardiner (2010) writes that "climate change is fundamentally an ethical issue" (3). Climate ethics thus interrogates the ethical complexities of climate change and ideas of climate justice (see Chapter 2). Specifically, climate change asks questions about *distributive justice*—defined as the equitable distribution of the advantages and burdens of climate policy. Climate engineering, or geoengineering, intervenes in the planetary system in an effort to counteract the negative impacts of climate change.

Furthermore, a recent trajectory in ecofeminism is Anthropocene feminism. This new area of ecofeminist theory and practice draws attention to the ways feminism can provoke alternative perspectives on the Anthropocene. As indicated by the geoengineering examples discussed above, the Anthropocene and climate change are dominated by approaches that privilege science and technology. Anthropocene feminism reaffirms feminism's historical emphasis on the effects of human-centeredness on women and nature but directs those concerns to the current geological context. This cousin of ecofeminism asks what feminism contributes to the Anthropocene debate and, conversely, how the Anthropocene is transforming feminist thought in the twenty-first century (Grusin 2017). In this light, the Australia-based project Hacking the Anthropocene develops an ecofeminist critique of anthropocentrism while proposing alternatives for a viable future (see the Exercises section at the end of this chapter).

Case Study 7.3 Traditional Chinese *yijing* aesthetics

Philosopher Yuriko Saito observes that ecoaesthetics is shifting from its original focus on spatial environments (landscapes, habitats, ecosystems, places, structures) toward everyday objects, materials, activities, and human–nature interactions. Saito's claim is evident not only in Western environmental aesthetics, increasingly concerned with ecological decline in the Anthropocene, but also in longstanding Eastern traditions being reinvented in countries such as China. For thousands of years, for instance, the ancient aesthetics known as *yijing* has played a crucial role in Chinese philosophy, literature, and art (Figure 7.4). Comparable to Arnold Berleant's "aesthetics of engagement," previously discussed, *yijing* connects the emotional world to external objects and scenes.

This aesthetic model accordingly can promote emotional identification with the more-than-human world in a time of global crisis. The Xiamen Island Ring Road greenbelt is an example of *yijing* aesthetics in practice. The road offers a slow circuitous mode of travel, highlighting the urban, cultural, and natural dimensions of the metropolitan area. Walking paths allow pedestrians to appreciate sculptures, exercise areas, and coastal habitats at close-range. The greenbelt also provides viable habitat for the many bird species that migrate through Xiamen during the year. *Yijing* aesthetics have also been applied at Mount Lushan National Park in Jiangxi Province, a popular tourist attraction that manifests an interplay of natural, historical, spiritual, and visual elements.

In what ways are aesthetic values important to environmental sustainability? We'll also consider this question in Chapters 9 and 10.

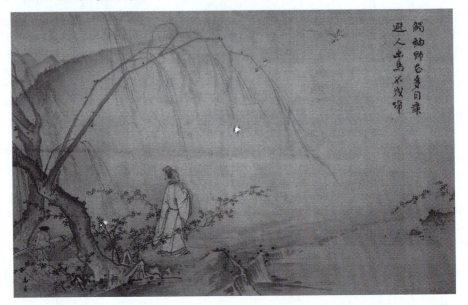

Figure 7.4 "Walking on a Mountain Path in Spring" by Song Dynasty Artist Ma Yuan (1160–1225) exemplifies the integration between human appreciator and natural environment essential to traditional Chinese *yijing* aesthetics.

Image credit: National Palace Museum (Wikimedia Commons).

Chapter summary

This chapter has maintained that environmental philosophy has powerfully influenced the emergence of the Environmental Humanities. We have introduced readers to the field's four main specializations: environmental ethics, radical ecology (deep and social ecologies), ecofeminism, and ecoaesthetics. Environmental philosophy develops arguments for the intrinsic value of nature; calls the paradigm of anthropocentrism into question; critiques the subject-object dualisms that place nature in opposition to humankind; and establishes the moral duties of humans to care for, protect, and conserve the environment. This integration of cultural (human) and natural (ecological) worlds is similarly a central preoccupation of the Environmental Humanities. What's more, environmental philosophers and environmental humanists alike contemplate the role of the scientific paradigm in addressing the urgent issues of the Anthropocene and developing pathways to attaining ecological justice. Finally, the work of many environmental philosophers has become part of the Environmental Humanities literature. Ecofeminist Val Plumwood's *Environmental Culture* (2002), as a case in point, has contributed greatly to the growth of the Environmental Humanities in Australia and elsewhere. In understanding the evolution of interdisciplinary fields, such as environmental philosophy, we are better positioned to appreciate the transdisciplinary Environmental Humanities.

Exercises

1. Imagine you are a member of an Environmental Humanities research team charged with investigating human responses to wildfires in Australia, California, and the Amazon. The team wants to know how human victims use creative practices (drawing, painting, writing, journaling, performance, etc.) to deal with the grief and loss caused

by catastrophes of this kind. How would you advise your colleagues about using environmental philosophy frameworks within the research project? Remember to consider the four areas we have covered: ethics, radical ecology, ecofeminism, and aesthetics.

2. View the YouTube video "A Plant's World: The Intelligence of Plants" (www.youtube.com/watch?v=fKS-uFYGjt0) or a related video on plant intelligence. List some of the sensitive attributes of plants. Do you think they are intelligent? Should they accordingly be subjects of moral consideration? How might an ethical view of the plant world transform human society for the better?

3. Select three radical environmental philosophies from Waypoint 7.2. Gather more information from the "Radical Environmentalism" entry in the *Encyclopedia of Religion and Nature*. Then examine (a) their coverage in the media and, conversely, (b) media works (films, documentaries, websites, etc.) created by practitioners of the philosophies you've selected. What kinds of messages do these radical philosophies promote? How are they represented by mainstream media outlets?

4. Visit the "Hacking the Anthropocene" website: https://hackingtheanthropoceneiv.wordpress.com. What are the main goals of the project? How do the researchers go about achieving their aims? In what ways do ecofeminist scholars critique the Anthropocene concept?

5. Design an environmental protection campaign that involves ecoaesthetics. Select a place that is meaningful to you but threatened by development. Address the two main ecoaesthetic modes: *cognitive* (knowledge and information about nature) and *non-cognitive* (feelings, emotions, experiences, and imagination).

Annotated bibliography

Gade, Anna M. 2019. *Muslim Environmentalisms: Religious and Social Foundations*. New York: Columbia University Press. Gade employs an Environmental Humanities perspective to understand environmental traditions in Muslim cultures. This pioneering study is essential to appreciating environmental thought outside the Western mainstream.

Kallhoff, Angela, Marcello Di Paola, and Maria Schörgenhumer, eds. 2018a. *Plant Ethics: Concepts and Applications*. London: Routledge. This edited collection introduces readers to the emerging area of plant ethics. The text redresses the longstanding neglect of plant life in environmental philosophy.

Næss, Arne. 1973. "The Shallow and the Deep, Long-Range Ecology Movement. A Summary." *Inquiry* 16 (1–4): 95–100. doi: 10.1080/00201747308601682. For nearly fifty years, deep ecology has influenced Western ecological thinking. Næss' essay is essential reading for anyone interested in radical environmentalism.

Plumwood, Val. 2002. *Environmental Culture: The Ecological Crisis of Reason*. London: Routledge. Plumwood argues for "(re)situating humans in ecological terms and non-humans in ethical terms" (8). Her approach in this study exemplifies the contribution of environmental philosophy to the Environmental Humanities, particularly in overcoming the human–nature divide.

Salleh, Ariel. 2005. "Moving to an Embodied Materialism." *Capitalism, Nature, Socialism*. 16 (2): 9–14. Embodied materialism is a complex theoretical position increasingly adopted by ecofeminists as a means to restore attention to the materialities of everyday life. The work of Salleh has advanced this area considerably.

Traer, Robert. 2019. *Doing Environmental Ethics*. 3rd ed. New York: Routledge. This comprehensive and accessible introduction to applied environmental ethics covers moral philosophy, ethics and science, ethics and economics, duty, character, virtue, empathy, integrity, rights, policy, and other areas pivotal to the field.

Williston, Byron. 2019. *The Ethics of Climate Change: An Introduction*. London: Routledge. Williston's overview affords readers a glimpse into the complexities of climate change ethics, an emergent area of ecophilosophy that enlarges continually in response to the urgencies of the planetary crisis.

Weblinks

Center for Environmental Ethics and Law. The mission of the center is to apply the frameworks of environmental ethics and environmental law to inform local, regional, national, and international decision-making. www.environmentalethicsandlaw.org

Earth First! This radical environmental activist organization was founded in 1980 in the United States and now has branches across the globe. www.earthfirst.org

Environmental Ethics: An Interdisciplinary Journal. The first journal dedicated to the field of environmental philosophy. The index on the journal website lists all issues published between 1979 and 2017. www.cep.unt.edu/enethics.html

Foundation for Deep Ecology. The mission of the organization is to support campaigns and other activities of value to the future of nature and people. www.deepecology.org/index.htm

Glossary of Terms in Environmental Philosophy. Like other academic fields, environmental philosophy uses a specialized lexicon. This website provides a comprehensive list of terms frequently appearing in philosophical debates about the environment. www.uwosh.edu/facstaff/barnhill/490-docs/thinking/glossary

Institute for Social Ecology. A pioneer of ecological approaches to food, technology, and community, this institute offers training programs, intensives, gatherings, and other resources on social ecology. http://social-ecology.org

International Association for Environmental Philosophy. The association organizes academic conferences and disseminates information of interest to scholars in the field. https://environmentalphilosophy.org

International Society for Environmental Ethics. The organization promotes education and research in environmental ethics. Membership is available. https://enviroethics.org

References

Berleant, Arnold. 1991. *Art and Engagement.* Philadelphia: Temple University Press.

Bookchin, Murray. 1982. *The Ecology of Freedom: The Emergence and Dissolution of Hierarchy.* Palo Alto: Cheshire Books.

Bookchin, Murray. 1993. "What Is Social Ecology?" In *Environmental Philosophy: from Animal Rights to Radical Ecology*, edited by Michael Zimmerman, J. Baird Callicott, George Sessions, Karen J. Warren and John Clark, 354–373. Englewood Cliffs: Prentice Hall.

Boylan, Michael. 2014. "Anthropocentric Versus Biocentric Justifications." In *Environmental Ethics*, edited by Michael Boylan, 115–118. Chichester: John Wiley & Sons.

Brennan, Andrew, and Y. S. Lo. 2014. *Understanding Environmental Philosophy.* London: Routledge.

Callicott, J. Baird. 1993. "Introduction." In *Environmental Philosophy: From Animal Rights to Radical Ecology*, edited by Michael Zimmerman, J. Baird Callicott, George Sessions, Karren J. Warren and John Clark, 3–11. Englewood Cliffs: Prentice Hall.

Carlson, Allen. 1981. "Nature, Aesthetic Judgment, and Objectivity." *The Journal of Aesthetics and Art Criticism* 40 (1): 15–27.

Carson, Rachel. 1962. *Silent Spring.* Boston: Houghton Mifflin.

Clark, John. 1993. "Introduction." In *Environmental Philosophy: From Animal Rights to Radical Ecology*, edited by Michael Zimmerman, J. Baird Callicott, George Sessions, Karen J. Warren and John Clark, 345–353. Englewood Cliffs: Prentice Hall.

Ehrlich, Paul. 1968. *The Population Bomb.* New York: Sierra Club and Ballantine Books.

Emerson, Ralph Waldo. 2003. *Nature and Other Writings.* Edited by Peter Turner. Boston: Shambhala. Original edition, 1836.

Findly, Ellison Banks. 2002. "Borderline Beings: Plant Possibilities in Early Buddhism." *Journal of the American Oriental Society* 122 (2): 252–263.

Foltz, Richard, ed. 2005. *Environmentalism in the Muslim World.* Hauppauge: Nova Science Publishers.

Gaard, Greta. 1993. "Living Interconnections with Animals and Nature." In *Ecofeminism: Women, Animals, Nature*, edited by Greta Gaard, 1–12. Philadelphia: Temple University Press.

Gardiner, Stephen M. 2010. "Ethics and Global Climate Change." In *Climate Ethics: Essential Readings*, edited by Stephen M. Gardiner, Simon Caney, Dale Jamieson, and Henry Shue, 3–28. Oxford: Oxford University Press.

Godlovitch, Stanley, Roslind Godlovitch, and John Harris, eds. 1971. *Animals, Men, and Morals: An Inquiry into the Maltreatment of Non-Humans*. London: Grove Press.

Grusin, Richard. 2017. "Anthropocene Feminism: An Experiment in Collaborative Theorizing." In *Anthropocene Feminism*, edited by Richard Grusin, 7–19. Minneapolis: University of Minnesota.

Hardin, Garrett. 1968. "The Tragedy of the Commons." *Science* 162 (3859): 1243–1248.

Hardin, Garrett. 1974. "Living on a Lifeboat." *BioScience* 24 (10): 561–568.

Harrison, Ruth. 1964. *Animal Machines: The New Factory Farming Industry*. London: Vincent Stuart Publishers.

Hepburn, Ronald. 1963. "Aesthetic Appreciation of Nature." *British Journal of Aesthetics* 3 (3): 195–209.

Hepburn, Ronald. 1966. "Contemporary Aesthetics and the Neglect of Natural Beauty." In *British Analytical Philosophy*, edited by Bernard WIlliams, and Alan Montefiore, 285–310. London: Routledge and Kegan Paul.

Kallhoff, Angela, Marcello Di Paola, and Maria Schörgenhumer. 2018b. "Introduction." In *Plant Ethics: Concepts and Applications*, edited by Angela Kallhoff, Marcello Di Paola, and Maria Schörgenhumer, 1–9. London: Routledge.

Kwak, Seon-Yeong, Juan Pablo Giraldo, Min Hao Wong, Volodymyr B. Koman, Tedrick Thomas Salim Lew, Jon Ell, Mark C. Weidman, Rosalie M. Sinclair, Markita P. Landry, William A. Tisdale, and Michael S. Strano. 2017. "A Nanobionic Light-Emitting Plant." *Nano Letters* 17 (12): 7951–7961. doi: 10.1021/acs.nanolett.7b04369.

Leopold, Aldo. 1949. *A Sand County Almanac: And Sketches Here and There*. Oxford: Oxford University Press.

Meadows, Donella, Dennis Meadows, Jørgen Randers, and William Behrens. 1972. *The Limits to Growth*. Falls Church: Potomac Associates.

Merchant, Carolyn. 1980. *The Death of Nature: Women, Ecology, and the Scientific Revolution*. New York: HarperCollins. Original edition, 1980.

Mies, Maria, and Vandana Shiva. 2014. *Ecofeminism*. London: Zed Books. Original edition, 1993.

Muir, John. 2004. *My First Summer in the Sierra*. Mineola: Dover Publications. Original edition, 1911.

Næss, Arne. 1993. "The Deep Ecological Movement: Some Philosophical Aspects." In *Environmental Philosophy: From Animal Rights to Radical Ecology*, edited by Michael Zimmerman, J. Baird Callicott, George Sessions, Karen J. Warren, and John Clark, 193–212. Englewood Cliffs: Prentice Hall. Original edition, 1983.

Ow, David, Keith Wood, Marlene DeLuca, Jeffrey De Wet, Donald Helinski, and Stephen Howell. 1986. "Transient and Stable Expression of the Firefly Luciferase Gene in Plant Cells and Transgenic Plants." *Science* 234 (4778): 856–859.

Rizk, Riham. 2014. "Islamic Environmental Ethics." *Journal of Islamic Accounting and Business Research* 5 (2): 194–204. doi: 0.1108/JIABR-09-2012-0060

Rolston III, Holmes. 1975. "Is There an Ecological Ethic?" *Ethics* 85 (2): 93–109.

Routley, Richard. 1973. "Is There a Need for a New, an Environmental, Ethic?" *XVth World Congress of Philosophy* September 17–22, 1973, Varna, Bulgaria.

Ruether, Rosemary Radford. 1975. *New Woman, New Earth: Sexist Ideologies and Human Liberation*. New York: Seabury Press.

Saniotis, Arthur. 2012. "Muslims and Ecology: Fostering Islamic Environmental Ethics." *Contemporary Islam* 6 (2): 155–171. doi: 10.1007/s11562-011-0173-8.

Sarkar, Sahotra. 2012. *Environmental Philosophy: From Theory to Practice*. Malden: John Wiley & Sons.

Singer, Peter. 1996. "Animal Liberation." In *Animal Rights: The Changing Debate*, edited by Robert Garner, 7–18. Basingstoke: Macmillan.

Thoreau, Henry David. 1910. *Walden*. New York: Thomas Y. Crowell. Original edition, 1854.

Traer, Robert. 2020. *Doing Environmental Ethics*. 3rd ed. New York: Routledge.

Warren, Karen J. 1993a. "Introduction." In *Environmental Philosophy: From Animal Rights to Radical Ecology*, edited by Michael Zimmerman, J. Baird Callicott, George Sessions, Karen J. Warren, and John Clark, 253–267. Englewood Cliffs: Prentice Hall.

Warren, Karen J. 1993b. "The Power and Promise of Ecological Feminism." In *Environmental Philosophy: From Animal Rights to Radical Ecology*, edited by Michael Zimmerman, J. Baird Callicott, George Sessions, Karen J. Warren, and John Clark, 320–341. Englewood Cliffs: Prentice Hall.

Wilson, Edward O. 1984. *Biophilia: The Human Bond with Other Species*. Cambridge: Harvard University Press.

Zimmerman, Michael. 2001. "General Introduction." In *Environmental Philosophy: From Animal Rights to Radical Ecology*, edited by Michael Zimmerman, J. Baird Callicott, George Sessions, Karren J. Warren, and John Clark, 1–5. Englewood Cliffs: Prentice Hall.

8 Ecological religious studies
Faith in nature

Chapter objectives

- To review a comparative history of religious teachings about human–nature relations
- To examine the major religious traditions' relation to God's Creation
- To trace recent significant shifts in religious teachings about the environment
- To detail scholarly and practical ways people can address current ecological problems from religious and spiritual positions

Religion versus environment

If you had asked Andrew in 1976 whether religion encouraged people to care for nature, he would have said, "no way!" That's because, every Sunday, he got dragged to church where he sat inside, bored, looking out the windows, longing to be outside. Church was about being quiet, reflecting on the state of your soul and your relationship to God. It made being out-doors, active in the world God made, somehow less holy. Some of the teachings even made it seem as though wanting to be in nature was sinful—the wilderness was where Satan tempted Christ. More discouragingly, Andrew's good Presbyterian elders warned that physical pleas-ures would take him to hell. Basically, Andrew got the standard Christian doctrine: nature was given to Adam to use for his needs. It had no value of its own.

What Andrew didn't know was that this doctrine was being vigorously debated. In 1967, medieval historian Lynn White Jr. blasted Christianity as:

> the most anthropocentric religion the world has seen ... [it] not only established a dual-ism of man and nature but also insisted that it is God's will that man exploit nature for his proper ends ... We shall continue to have a worsening ecological crisis until we reject the Christian axiom that nature has no reason for existence save to serve man.
>
> White, Jr. (1967, 1206)

White is credited with starting a revaluation of the relation between religion and ecology. Over the previous century, it was becoming increasingly clear that humanity was not just subduing but destroying Creation. Cold War doomsday scenarios challenged religious people in the Abrahamic traditions (the three monotheistic religions—Judaism, Christianity, and Islam—that claim Abraham as a prophet) to square humanity's destructive power with God's commandments—surely God had not intended man to destroy His Creation? Wouldn't that be "playing God," the ultimate sin?

DOI: 10.4324/9781351200356-8

Some, like White, said the human license to subdue and dominate was unsupported by the original Christian (or Qur'anic or Judaic) teachings, but rather a consequence of medieval reinterpretation of scripture compatible with the development of powerful technologies for subduing Creation for human purposes. White traced a late medieval shift in emphasis from Genesis 2.15's command to "till and keep" God's Creation to Genesis 1.28's "replenish the earth and subdue it," which medieval theologians interpreted to mean "level the woods, till the soil, drive off the predators, kill the vermin, plough up the bracken, drain the fens" (Thomas 1983, 14–15).

This doctrine, "Heavenism," focused religious practice on ascetic renunciation of this world. Renunciation of the world opens the door to callous use of nature as a resource to fulfill human desire. In extreme cases, the emphasis on Heaven has coincided with environmental destruction. To name one notorious example, Pope Alexander VI's *Inter Ceatera* Bull of 1493 declared that it was God's will for Spanish conquistadors to exploit the Americas. They brought priests from the Spanish Inquisition who blessed their genocidal, biocidal invasion, a catastrophe so momentous that it left a fossil record of increased global extinction rates in the Earth's crust (see Case Study 3.2).

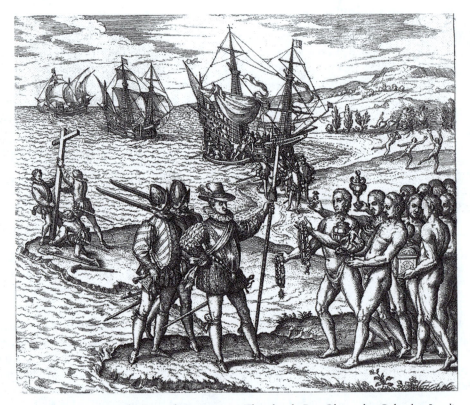

Figure 8.1 No one expects the Spanish Inquisition! Theodor de Bry, *Christopher Columbus Landing on Hispaniola* (1592) with Spanish Priests in background.

Image credit: Wikimedia Commons.

In the eighteenth and nineteenth centuries, the Protestant version of Heavenism is credited with fueling industrial capitalism with all its carbon consequences (Weber 2013). Consequently, some have described Christianity as handmaiden to climate change and the Anthropocene. Nor should Christianity be singled out; examples of religiously sanctioned environmental destruction are common to all major faiths.

And yet, we must remember that some of the most ardent environmentalists are religious leaders. Moreover, a fuller study shows that sometimes religious doctrine provides the most stringent environmental protections in the world societies. How can religion be the source of both environmental disdain and reverence?

The answer underlies the reason that the field of religious studies is one of the most interesting areas of the Environmental Humanities right now. Lynn White Jr.'s thesis forced many religious scholars and practitioners to question their doctrine. They concluded that "there is nothing inherently anti-ecological or environmentalist about religion and spirituality" (Pellow and Guo 2017, 242). Taking a more global view shows that "ecological problems are not peculiar to the West, for soil erosion, deforestation and the extinction of species have occurred in parts of the world where the Judeo-Christian tradition had no influence" (Thomas 1983, 24). What matters is how religion is interpreted and applied.

Case Study 8.1 Ministering to the Earth

Christian missionary work often gets a bad rap for cultural insensitivity, aiding imperialism, and ignoring social injustice. But here are some successes: abolition of the slave trade in Britain (led by Evangelical Anglicans); the Underground Railroad (led by Quakers); abolition of slavery in the US (led by many Protestant sects); Civil Rights (led by a broad interfaith coalition); and civil rights, Indigenous rights, and anticorruption work in Central America (led by Catholic Liberation Theologians). Although he was assassinated by a Hindu nationalist, Gandhi's Hindu faith provided the strategy and strength for uniting India against the British. Anglican Archbishop Desmond Tutu was instrumental in defeating South African Apartheid. Engaged Buddhists and the Buddhist Peace Fellowship use non-violence to resist militarism.

Social justice has long been part of religious ministry. How does it translate into Creation care and ecojustice? Well, as some believers witness the spiritual despair that results from environmental degradation, they are connecting traditional ministry to environmentalism. As Pope Francis puts it, you can't have spiritual health without social justice, and you can't have social justice without healthy ecosystems.

Today, there are thousands of religious organizations dedicated to Earth Care. Here are a few: Earth Ministry, The Eco Church, The World Council of Churches, Interfaith Power & Light, and The Indigenous Environmental Network.

Additionally, many congregations now find themselves drawn into battles over land development, pollution, climate change threats, and extractive industries. Sometimes, these galvanize inspiring examples of religious unity, such as in 2018, when Hindu monks from Yogaville, an ashram in North Carolina, joined with a local African American Pentecostal church in opposition to Dominion Energy's gas pipeline and compressor station. The concept of "Sacred Place" has helped unite many religious and

Indigenous spiritual groups to protect sacred places threatened by climate change: Jerusalem, Rome, Mecca, the Himalayas, Mt. Fuji, Uluru.

What ecojustice religious organizations are active in your area? See the Weblinks section and read the "about" tabs of websites listed there. Try bringing speakers to your campus. Ask them if they can identify a sacred place worth defending. What is their reasoning?

If religion is not the cause of environmental destruction, what is? And how can religion be part of the solution?

Consider today's deep despair about civilization's future in the Anthropocene, what Mike Hulme (2011) refers to as "the West's loss of confidence in the future" (265). More than technological and scientific solutions (of which we have plenty, by the way), humans living in the Anthropocene need faith, hope, and love—the three things taught by all world religions and spirituality. Thinkers from Lynn White Jr. to Pope Francis, Gary Snyder to Seyyed Hossein Nasr argue that religion has the resources to "awaken a new reverence for life" and "other ways of envisioning the future ... [in which] human creativity, imagination and ingenuity will create radically different social, cultural and political worlds" (Hulme 2011, 266). We might posit that, without a reverence for life, we have no reason to stop exploiting the environment.

In this chapter, we'll ground you in the history and debates of ecoreligion and show you some of its most interesting future directions. We'll focus on mainstream Abrahamic religions, particularly Christianity, because of its importance to the debate in English-speaking countries, but we'll reference other traditions so you can explore further. Along the way, we'll look at some of the practical uses of religious ritual and spirituality in addressing the unique spiritual and ethical problems of being human in the Age of the Human. Sackcloth and ashes optional.

Religion or ecology

Religion can be defined as:

> those cosmological stories, symbol systems, ritual practices, ethical norms, historical processes, and institutional structures that transmit a view of the human as embedded in a world of meaning and responsibility, transformation and celebration. Religions connect humans with a divine presence or numinous force.
>
> Tucker (2006, 399)

Religion tells us "how to think about and relate to everything on earth that we did not make ourselves" (Gottlieb 2006, 3). Through ritual and story, it codifies the reverence and awe we feel living in a meaningful world.

If religions evolved as means of explaining nature's existence, our relation to and purpose within it (Grim and Tucker 2014b, 2), science has taken over that role for modern people, and for good reason: science is an empirical, evidenced-based consensus process that ensures its theories are not just articles of faith or subjective impressions, but verifiable and correctable. Advanced math, computing, communication, and technologies for observing and measuring phenomena beyond the capacities of unaided human senses have led to science becoming a global, multigenerational enterprise, something no previous attempt to understand nature could ever have been.

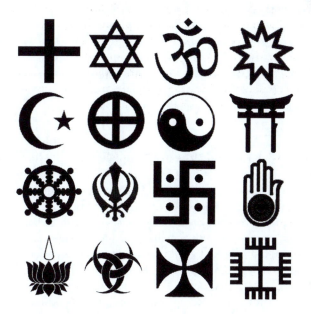

Figure 8.2 Religious symbols.

Image credit: Ratomir Wilkowski (Wikimedia Commons).

Nonetheless, the observations of local environments by early humans was, as a matter of survival, acute, precise, and detailed, and their precariousness taught daily lessons in reverence and respect for nature. Their collected wisdom, called traditional environmental knowledge (TEK), would have informed not only practical decisions such as when to hunt, plant or harvest, but also the best ways to attune human behavior, emotions, and thoughts to the demands and rhythms of the local place with the proper wonder, awe, and thankfulness (see Chapter 4). Thus, "insofar as religion is involved in how people inhabit and interpret their world, it is involved in ecologies" (Jenkins 2017, 23). Science can complement, but not replace, religious TEK, particularly its multigenerational empirical testing and intimate understanding of relationships in localized systems. TEK's importance to understanding issues like climate change is enshrined in the 2015 Paris Accord.

TEK is embedded in the early civilizations that developed the world's major religions during the First Axial Age, about 3,000 years ago (Jaspers 1948). As these agricultural societies shifted from local, pragmatic worship to globally defined metaphysics, cosmology, and ethics, they reorganized TEK into the "cosmological stories, symbol systems, ritual practices, ethical norms, historical processes, and institutional structures" governing the use of natural resources, relationships to animals, and the treatment of living creatures, all essential knowledge for survival over time (Hillel 2006). Although some of the sacred texts can sound strange to modern ears, read within their specific historical and ecological context, they can be regarded as place-based practices for managing a sustainable society (Jenkins 2011). Perhaps the rituals of purity encoded in the Torah, the Bible, the Qur'an, the Five Classics of Confucianism, Bhagavad Gita, and other scriptures are "not the cause of our ecological crisis but a treasure of environmentally sound ideas" (Tirosh-Samuelson 2006, 56).

That said, the Axial Religions—those religions that trace their origins to a "pivotal age" of civilization's development 3,500 years ago: Judaism, Islam, Christianity, Confucianism, Hinduism, Daoism—all did something that some scholars regard as profoundly anti-environmental: anti-environmental. They divided reality into physical nature and the metaphysical,

spiritual world (Szerszynski 2017). The Abrahamic religions are unique in being monotheistic, with a creator-God who stands apart from His Creation. All three traditions are crystal clear on their difference from pantheistic "pagans" who believe that their gods (plural) are *in* nature; in other words, their gods are everywhere, in everything. By separating God from Nature, the Abrahamic traditions declared that nature was not sacred, and worship of it was sinful. This dualistic cosmology, Heavenism, created a new ambiguity—what kind of reverence for the non-human is permitted? Is nature just a thing?

Waypoint 8.1 Stewardship in the Anthropocene, or "The God Question"

Stewardship is a central concept in religious treatments of nature: God called man to be an active steward or manager of His Creation. Stewardship is also a central concept in geoengineering plans (see Case Study 3.3): humans have disturbed the natural functioning of planetary systems, so now humans have a responsibility to steward them.

Geoengineering stewardship is forward-looking, trying to rescue planetary systems from total collapse so that future generations can survive. The complicated science and expensive technology mean that only a few, very powerful, highly trained people will play a "God-role" in determining "acceptable losses" among non-humans and impoverished human communities (Dean-Drummond et al. 2017). In contrast, religious stewardship is backward-looking, returning us to the original relationship Adam had with God. In respect to His wishes, all of the faithful work to preserve Creation in its "very good" state until He returns (Baumgartner 2017).

The Anthropocene's existential threats put people of faith into a double-bind: the faithful serve God, but to save Earth, they may have to usurp His position as the prime-mover. This is one reason many religious thinkers are developing the concept of "Creation Care" as envisioned in The Earth Charter: "Everyone shares a responsibility for the present and future well-being of the human family and the larger living world" (Earth Charter Commission 2000, 1).

The Charter represents interfaith, Indigenous, and secular humanist moral teachings, and while it does not regard nature as sacred, it does regard "the protection of the Earth's vitality, diversity, and beauty [as] a sacred trust." Other living beings have their own integrity, value, and interests apart from human interests.

Dig into The Charter (listed in Weblinks) and see if you can trace the different religious teachings. What vision of stewardship is described? Would you consider yourself a steward of Creation?

Let's take a closer look at the Abrahamic cosmology, keeping in mind its outsized influence on how human civilization has viewed the non-human world. Read the first chapter of the *Book of Genesis*. You'll see a fairly simple creation story, but three things stand out: one, what God creates is "not-God"; two, what God creates He declares "very good"; three, God gives Creation to man and woman, who, unlike the rest of Creation, are created in His image. It's a gift that man has a right to subdue for his sustenance. But are we authorized to damage the gift that God has deemed "very good"? Is that the etiquette of gift-receiving? The text offers no guidance, but perhaps the story a few chapters later, about Noah and the Flood, would shed light. God doesn't let us "subdue and dominate" His gift any way we want. We have to use his gift the way He expects, or He punishes us.

According to this cosmology, man has a special relationship to God, partly because of being formed in His likeness and partly because man gets to have dominion over God's creation with no stated restrictions. This cosmology's anthropocentrism and instrumental view of nature are what Lynn White Jr. (1967) attacked (1205).

But read over the second chapter of Genesis. Here you'll find what sounds like a second creation story. Indeed, that is how it has been described by biblical scholars. Look at some of the differences from the first story: less on the creation of earth, waters, fish, birds, and animals; instead, a description of the Garden of Eden, Adam, Eve, and a restriction of human desire. Adam is not made in God's image, but from dust that God inspirits with His breath. God creates Adam and Eve to "till and keep" the Garden and name all the animals. In return, they can eat the fruit of any tree, except the Tree of Knowledge. The third chapter explains what happened when Adam and Eve disobeyed: they were evicted from the Garden, had to suffer and work, and became subject to death.

What's interesting from an ecological perspective is the fact that, in the second cosmology, humans have duties and responsibilities to nature. More importantly, God restricts humanity's use of nature to what benefits our long-term health. There's the kernel of what later readers have extrapolated to the ethics of stewardship and creation care.

One of the most important and influential "later readers" is Pope Francis. His Encyclical, *Laudato Si* (2015), is subtitled "On Care for Our Common Home." As most commentators have recognized, this teaching transforms Christian doctrine and has the potential to change worldviews on a global scale. Why is this important? Because "humans live within worldviews" "that reflect and sanction the social, economic, political, and religious orders" (Eaton 2017, 126, 125). Worldviews determine how we see the world, a sort of permanent corrective lens that brings some things into focus and obscures others. Humans have worldviews because we use language, a system of symbols to think about, organize, and describe our experience of the world, and we swim in this sea of symbolized perception without noticing how it shapes our actions. But shape our actions it does.

This is the most important explanation for why religious studies is necessary to the Environmental Humanities. For at least 85% of humans, religion may be the most important shaper of worldviews. The cosmology described above shapes Abrahamic worldviews: do we see the world as an instrument to dominate or a gift to cherish? When Pope Francis calls for "an 'ecological conversion', whereby the effects of [Christians'] encounter with Jesus Christ become evident in their relationship with the world around them" (2015, 62), he is attempting to change the worldview of about 2.18 billion people, one-quarter of the global population.

Here's how momentous this is: Christians, along with believers from other Axial faiths, have always been called to care for other people—how and to what degree may be different, but "People Care" is fundamental. Sometimes, "People Care" has led to social justice work: the Liberation Theology that we might characterize as "Fair Share" makes sure everyone gets equal access to the basic requirements for a meaningful life.

But if "People Care" has always been a central religious tenet and "Fair Share" occasionally is, "Earth Care" has only been at the radical fringes of Catholic teaching. Pope Francis has changed that: for Christians, "living [the] vocation to be protectors of God's handiwork is essential to a life of virtue; it is not an optional or a secondary aspect of [the] Christian experience" (2015, 62). What's exciting is the fact that Pope Francis is joined by Greek Orthodox, Jewish, Protestant, Hindu, Muslim, Buddhist, Sikh, and Indigenous sects, all of whom have published similar statements in the last thirty years. At the level of official religion, we are in the midst of a transformation of worldviews, where the principles of People Care, Fair Share, and Earth Care are declared essential to living a righteous, Godly life.

Reflection 8.1 What's your worldview?

Worldview is your fundamental way of seeing the world, which is based on beliefs about the world, informed by experience, peer and social group norms, language, and identity factors. Everyone has one, but most people are unconscious of how they shape behavior. They act as general assumptions about what is true, mediating our perception, our knowing, our interpreting, and our decision-making.

Arlee Hochschilde says that worldviews give us "deep stories," the stories that explain why things are the way they are (Hochschild 2016). The "American Dream" and the "self-made man" are deep stories in American worldviews; the "lucky country," "punching above its weight," and the "tall poppy" are Australian deep stories.

What historical conditions, identity factors, and experiences shape your worldview? Do you have a "deep story" that you tell about yourself, your future, and your place in the world? Write down that story. What does it reveal about your belief system?

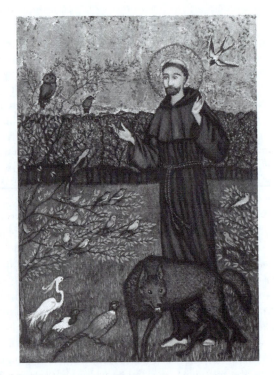

Figure 8.3 St. Francis of Assisi.

Image credit: Małgorzata (Wikimedia Commons).

Waypoint 8.2 The core beliefs and ecological potential of Abrahamic religions

Judaism: Founded by Abraham around 2000 BC; Monotheistic Creator-God; Chief Scriptures: Torah, Mishna, Talmud; 14 million adherents; Sects: Orthodox, Reform, Conservative, Reconstructionist, Humanist; Salvation: eternal life through following the Law, but afterlife not emphasized. Green potential: Torah outlines principles of sustainability in purity rituals; care of land necessary to maintain Israel as a place for God; Torah's ethics of virtue: humility, modesty, moderation, mercifulness counter behaviors that cause environmental destruction (Tirosh-Samuelson 2006).

Christianity: Founded by Jesus of Nazareth, first century AD; Antecedent: Judaism; Monotheistic Creator-God; Chief Scriptures: Bible (Old and New Testaments); 2.1 billion adherents; Main Sects: Greek Orthodox, Roman Catholic, Protestant; Salvation: redemption in Heaven. Green potential: commandment to universal love; care for the "wretched of the earth"; Good Samaritan parable; critique of money; a sacramental universe where all creatures have intrinsic value; stewardship/creation care (Hart 2006, Chryssavgis 2006, Santmire and Cobb Jr. 2006).

Islam: Founded by Muhammad, AD 622; Antecedents: Judaism-Christianity; Monotheistic Creator-Allah; Chief Scriptures: Qur'an, Sunna; 1.8 billion adherents; Main Sects: Sunni, Shia; Salvation: Eternity in heaven for living a life that pleases Allah. Green Potential: Interpreting "Tawhid" as "all inclusive"; Sufi mystical tradition; laws emphasizing compassion for non-human life; Qua'ranic instructions to humans to maintain balance in all things; judgements against despoilers of the Earth and against wastefulness and overconsumption (Foltz 2006) (see Chapter 7).

Religion and ecology

If religion provides a way of understanding the non-human world just as ecology does, it offers both advantages and disadvantages in the questions it asks about the non-human world. The science of ecology describes how organisms interact with other organisms, energy, and matter in complex systems that determine the abundance and distribution of organisms. Religion asks what the value of those organisms is, why they exist, what their purpose is, and what duties they may owe each other or to an other-worldly Creator.

You can see how ecology is vital for providing an objective analysis of what exists and how it functions. But science generally doesn't give us much sense of existence's value, beyond mere functional utility. Using that rubric, you can log old-growth forests or harvest as many salmon as you want, as long as you don't cross a system tipping point.

By contrast, religion determines "the sacred," which cannot be harmed. If religion determines that nature is sacred, or a sacred trust, then humans must treat it with reverence—no more clear-cuts, no more factory trawlers. The sacred is the most powerful law governing human behavior. For this reason, Mary Evelyn Tucker and John Grim, "deans" of the religion and ecology movement, contend that "science and policy approaches are clearly necessary, [but] they are not sufficient in helping to transform human consciousness and behavior for a sustainable future … value and ethics, religion and spirituality [are] important in this transformation"(Tucker 2009a, 3).

Waypoint 8.3 Core beliefs and ecological potential of three Eastern Axial religions

Neo-Confucianism: Founded by Zhou Dunyi around AD 1050; Antecedents: Confucianism, Dao, Buddhism, Chinese traditions; Non-theistic; Chief Scriptures: Five Classics, Four Books; adherents uncounted; Main Sects: many schools of thought; Salvation: practicing Dao to become a sage. Green potential: Ecumenical; goal of self-cultivation is balance of self, earth, heaven; "Three Pillars" of thought: empathetic knowing, embodied acting and compassionate living; kinship with all life; nature is interdependent (Berthrong 2006, Tucker 2009b).

Hinduism: No founder, evolved from 5000 BC; Antecedent: Vedic traditions; Monotheistic: Brahma is an omnipresent formless "Absolute" who manifests in all physical things; Chief Scriptures: Vedas, Puranas, Upanishads; 900 million adherents; Main Sects: many; Salvation: Elimination of bad Karma, achievement of good Karma ends cycles of reincarnation. Green potential: "God is one and is everywhere present"; vegetarianism and prohibitions on causing suffering to all life; biocentric worldview; interpretations of Dharma and Karma can require ecospirituality and environmental ethics (Dwivedi 2006).

Buddhism: Founded by Gautama Siddhartha, Buddha, around 600 BC; Antecedent: Vedic traditions; Non-theistic; Chief Scriptures: Tripitaka, Mahayana Sutras; 376 million adherents; Main Sects: Mahayana Chinese, Japanese, Tibetan: Theravada; Salvation: Elimination of Karma ends cycle of reincarnation, release into Nirvana. Green Potential: Law of Karma shows interdependence of all life; Four Noble Truths counteract consumerism, animal abuse, and action that causes suffering (Kaza 2006) (see Chapter 7).

See www.webofcreation.org/religious-education/541-faith-based-groups for more ideas.

According to theologians and scholars, religions offer values that define the purpose and meaning of life in nonmaterialist ways. That's important, they say, because modern, secular values define the purpose and meaning of life as the accumulation of more stuff. Consider how GDP is used to rank nations on their achievement of "the good life." That metric quantifies the value of life according to how much stuff we consume, leading us to overconsume natural resources. As Tucker and Grim (2017) write, religion can provide an important critique of modern consumerism, the primary driver of the Anthropocene's environmental disasters, and an alternative vision of "the good life."

At its best, religion provides a "realm in which the pursuit of power, pleasure, and wealth is suspended in favor of … the most long-lasting and authentic values" (Gottlieb 2006, 12). For forty years, this logic has animated religionists with an interest in ecology to ask three basic questions:

1. How can traditional scriptures, teaching, rituals, and beliefs be reinterpreted to support an environmental ethic?
2. How can marginalized, apocryphal, and ignored texts and teachings that support an environmental ethic be restored to the canon?
3. How can new beliefs, values, and practices be developed, consistent with the religious tradition, that will support an environmental ethic?

We can call these three methods Reinterpretation, Recovery, and Revision. Scholars apply these methods to three study areas: how human relations with nature have historically been shaped by religion; how environmental crises raise fundamentally religious questions about human value, destiny, and purpose; and how the new Anthropocene nature is reshaping religion.

All of this makes religion seem like the perfect antidote to modernity and the environmental crisis brought about by two centuries of a globalized, industrial-capitalist, techno-scientific approach to the question of how to live well. This conclusion oversimplifies the matter on two counts: it ignores sectarian divisions within each religion and between formal leadership and believers; and it supposes that ideas automatically change the world, an example of Idealism. As Kate Rigby and Ronald Simkins explain, religions' new stories about human–nature relations will need to be combined with political, economic, and social transformations (Rigby 2017, 280, Simkins 2018). Religion is an important part of the solution, but it can't change the world alone, as Grim and Tucker (2014b) remind us.

Waypoint 8.4 The power of World religion

It is sometimes forgotten that religions wield real-world power: political, financial, and cultural. Here is a list of religion-power adopted from the Alliance of Religions and Conservation:

- Religions provide a cosmology which shapes worldviews
- They wield moral authority
- They reach and mobilize huge numbers of people
- They have enormous wealth in property, financial investments, and money
- They practice long-term thinking essential for sustainability
- They have guidelines for handling wealth in modest, just, and responsible ways
- They are rooted in specific social and cultural contexts
- They run many of the world's schools

Collectively, the world's religions can mobilize up to 85% of the world's population and around a twelfth of its wealth to influence a transformation of civilization's behavior toward the Earth (Gardner 2002). As with any power, it can be used for good or ill.

Religion and ecology futures

That said, there is an enormous amount of exciting, new work in this field as scholars, theologians, and practitioners realize the potential of ecologically informed religion to reframe environmental work. The final section of this chapter categorizes some of this work and encourages you to investigate what interests you, for example, reinterpreting doctrine, elaborating creation care ethics, deepening creation spirituality, or advocating ecojustice (Kearns 2011). No matter what your beliefs are, there are opportunities for a variety of personal interests, aptitudes, and styles.

Reflection 8.2 Do religions share a universal environmental ethic?

Environmental ethics is a "system of value guiding human treatment of and behavior in the natural world" (Taylor 2010, 597). In the last three decades, world religions have collaborated to synthesize their different traditions into a common set of principles. Here are a few from a list compiled by Kusumita Pedersen (cited in Grim and Tucker 2014b, 12):

- The natural world has intrinsic value and does not exist solely to serve human needs
- God/the cosmic order requires humans to apply moral consideration, such as justice, compassion, and reciprocity, to non-human others
- There are legitimate and illegitimate uses of nature; restraint and protection are commended; greed and destructiveness are condemned
- Humans are obliged to live in harmony with the natural world and should follow the specific practices for this prescribed by their traditions

The Earth Charter and The Council of World Religions also have lists of environmental ethics that you might compare.

If you have a faith tradition, does its doctrine support or conflict with these ethics? How do you feel about having a "universal ethic"? If you tried to live by it, what would you have to do differently?

Many religious scholars are working in an area called "*confessional* literature"—reinterpreting and reimagining the traditions and doctrine in answer to Anthropocene crises. Buddhist monk and activist Thich Nhat Hahn developed "engaged Buddhism," which includes the active pursuit of ecojustice. Catholic Thomas Berry combined the teachings of many different faiths with earth sciences, which he called "georeligion," an example of creation spirituality that emphasizes the miraculous wonder of Creation's accidental existence. Muslim Seyyed Hossein Nasr writes on Islam's creation care ethics.

"*Constructive* literature" is scholarship that assesses how different religions are responding to Anthropocene crises and how religious terms, like stewardship, migrate into general use. For example, some scholars investigate the way environmental changes shaped religions in the past, speculating about how climate change may shape religions in the future (Jenkins et al. 2018, Szerszynski 2017). Others evaluate the relation between doctrine and practice, such as how individual practitioners, congregations, or sects respond to the teachings coming out of elite centers like the Vatican and Council of World Religions, or from the Dali Lama. Still others study the way ecojustice and creation care produces new interfaith, ecumenical alliances. Finally, a few scholars consider how the Christian Right has developed doctrine to support an even more anti-environmentalist position (Kearns 2011, Ronan 2017). New study could consider how fundamentalist or nationalist interpretations of religious faiths serve anti-environmentalist action.

"Religious *activism*" is a third, wide-ranging area of interest. Since all faiths have some call to service, religious congregations have always been potent centers of community action. Scholars are interested in how defense of sacred lands, ecojustice, and other environmental causes are taken up by congregations: how do they define their call to this form of service? By

contrast, why do other congregations, particularly those threatened by pollution, industrial development, climate-change fueled flooding or fire, extractive industries, etc., avoid environmental activism?

Studying these three areas puts you in the position of reading about what others are doing. But once you've done some reading, what kinds of things could you personally do?

Norwegian professor of religious studies, Sigurd Bergmann, offers four practical ways to address environmental problems. First, you can use religious teachings and techniques to soothe, comfort and uplift people suffering the pain, violence, and loss now typical in the Anthropocene. You can pray, meditate, worship, sing, chant, or read sacred texts with them. Second, use your tradition's non-verbal methods to help people ground themselves in their place—ritualized physical movement, eating, gardening, meditation, music, and image-making. This is particularly helpful for displaced migrants and those suffering malaise induced by environmental change (see Waypoint 3.4). Third, you can remind your faith community about your religious tradition's prohibitions on worshipping or abusing money, reminding them that consumerism is a direct cause of our environmental crises. Fourth, you can study your religion's wisdom and tools for learning how to "be-at-home-in-the-world" (Bergmann 2017).

Do you have to be part of an organized religion or a scholar to do this work? Not necessarily. Nonetheless, to develop spiritual practices that address ecological problems, it is useful to consult the traditions people have been using for thousands of years. Why reinvent the (dharma) wheel?

For example, learning to "be-at-home-in-the-world" addresses a central human experience in the modern age: displacement or alienation. Climate change, petrochemical and other industrial disasters, land development, warfare, mining, forestry, agriculture, and other aspects of globalized modernity force millions of people to migrate. Predictions are that by 2050, there could be around 200 million displaced people—that's one in every forty-five people—defining displacement as the Anthropocene norm (Brown 2008). In addition to forced displacement, modern people expect to be displaced for work, education, and health; few people can stay in the community in which they grew up. Many argue that these displacements—effects of the modern, globalized economy—cause spiritual alienation and emptiness. Now that we are all experiencing such rapid change, ecological stress disorder and other emotional "displacements" result.

The wisdom of religious traditions directly addresses the existential crisis of alienation from "home," and provides stories, consolation, and hope for the act of reinhabitation. A sense of home is perhaps the most important way we ground our existence in the world and understand how we belong here and why we care about our fellow earthlings (see Chapter 5). Without a "home," we are an alien, invasive species.

Non-religious people can join environmental justice, or ecojustice, actions led by interfaith, ecumenical religious organizations. From Lutheran Joseph Sittler to Catholic Liberation priests like Leonardo Boff, Indigenous shamans, and Jainist and Buddhist monks, religious people have put their lives on the line for vulnerable people who are threatened by disproportionate environmental, industrial, and military hazards. As Black Liberation theologist James Cone explains, "the fight for justice cannot be segregated but must be integrated with the fight for life in all its forms" (Cone 2014, 329). Secular ecojustice insists on a legal right to environmental and public health for all people. Some extend this to a universal human right to a sustainable environment. Spiritual teaching takes this to the next level, identifying the intrinsic value of all life and the "integral ecology" of Creation (Pellow and Guo 2017). To be in the presence of a religious ecojustice leader is to witness a powerful force for change.

Consider the ways that states and industries threaten religious minorities by compromising the ecological and symbolic functioning of sacred lands. The Israel-Palestine conflict is the best-known example, but China has a long record of deploying environmental injustice to oppress religious minorities—Tibetans and Uighurs, for instance. Brazil has been developing Amazonia in order to force Indigenous minorities to leave their traditional lands, and the US, Canada, and Australia used (and still use) environmental desecration to subjugate their Indigenous people. Extirpating sacred lands and touchstones of cultural identity can be a method of cultural genocide. Many oppressed religious groups are reinventing in real time how religion can fight environmental injustices, offering inspiring lessons for the future (see Case Studies 4.4 and 4.5).

Ecotheology today teaches that Earth is a home we share with a "'democracy of all creatures' ... joined in praise for the Creator" (Rigby 2017, 286). Being at home on Earth gives us the capacity for full expression of our being. Whether we call our home *sacred* and those practices that are destroying it *evil* are central questions for all faiths. Shalom.

Chapter summary

This chapter has reviewed how religion has helped define the way humans relate to the natural world, comparing different religions and spiritual traditions. It has addressed the way Abrahamic and other religions fed anti-environmental activity, and how recent religious study has focused on recovering more ecologically accurate interpretations of scripture and doctrine. An analysis of *The Book of Genesis* reveals how an ecological cosmology informs the Abrahamic religions and identifies Pope Frances' 2015 Encyclical as the most influential religious teaching to do so. Three areas of current and future work include confessional,

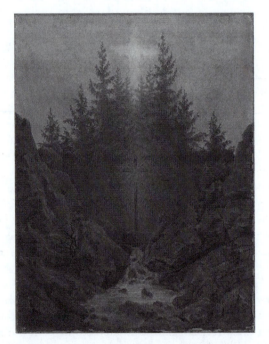

Figure 8.4 "The Cross in the Forest" (1813) by Caspar David Friedrich.

Image credit: Staatsgalerie Stuttgart, Online-Katalog (Wikimedia Commons).

constructive, and activist applications of spiritual traditions. Faith groups, particularly ecumenical, interfaith groups, are joining Indigenous and other activists to support ecojustice. The chapter concludes with an overview of how religion and spiritual practices can be applied to the practical needs of the world's environmentally displaced, including awareness training in how to be "at-home-in-the-world."

Exercises

1. Find a story from the Bible, Torah, Qur'an, or other scripture. Analyze what it says about the human relation to nature or nature's value. What ecological wisdom can you draw from it? Rationalize your answer with textual reference and logical inference. You could also look the passage up and see how others have interpreted it. Does your ecotheology conflict with how others have read it? How or how not? What is the importance of this?
2. Pick an Eastern religion and a Western religion and study their core beliefs. How do they compare? What are the strengths and weaknesses in relation to an ethic of Earth Care? Use Case Study 8.2 and the references below to get started.
3. Using one of the interfaith websites below, investigate the organization's ecological creed. What position do they take on stewardship, ecojustice, and Creation spirituality? What scriptural justification do they cite? Do you agree with how they have interpreted the scripture?
4. How have religions participated in the climate justice movement? Have they been effective? If not, what could be more effective? Consider some of the examples in the suggested websites below.
5. Compare these two statements:

> **We affirm** that godly human dominion over the Earth means men and women, created in the image of God, laboring freely and lovingly together to enhance Earth's safety, fruitfulness, and beauty, to the glory of God and the benefit of our neighbors.
> (Beisner 2015)

See the full text here: https://cornwallalliance.org/landmark-documents/the-biblical-perspective-of-environmental-stewardship-subduing-and-ruling-the-earth-to-the-glory-of-god-and-the-benefit-of-our-neighbors/.

> Judaeo-Christian thinking, on the basis of the Genesis account which grants man 'dominion' over the earth (cf. Gen 1:28), has encouraged the unbridled exploitation of nature by painting him as domineering and destructive by nature. This is not a correct interpretation of the Bible as understood by the Church. Although it is true that we Christians have at times incorrectly interpreted the Scriptures, nowadays we must forcefully reject the notion that our being created in God's image and given dominion over the earth justifies absolute domination over other creatures. The biblical texts are to be read in their context, with an appropriate hermeneutic, recognizing that they tell us to "till and keep" the garden of the world (cf. Gen 2:15).
> (Francis 2015, 20)

See the full text here: https://laudatosi.com/watch.

Are both interpretations of the same scripture valid? What does the Pope mean by "read in context and with the correct hermeneutic"? Does Beisner follow that method? For a longer project, compare the two full statements and research the debate over "correct hermeneutic" and "context." Then consider how Beisner and the Pope would apply their doctrine to strip mining, offshore oil drilling, fracking, clearing the Amazon for cattle ranching, and other extractive industries. What justifications do they give?

Annotated bibliography

Bauman, Whitney A., Bohannon, Richard R. II, and O'Brien, Kevin J. 2011. *Grounding Religion: A Field Guide to the Study of Religion and Ecology*. London and New York: Routledge. Divided into three sections, Religion, Ecology, and Key Issues, this accessible collection of essays is a great starting point for investigating the intersections and tensions between religion and ecology.

Berry, Thomas. 1999. *The Great Work: Our Way into the Future*. New York: Random House. The masterwork of this highly influential "geotheologist" fuses science and ecumenical theologies into a vision of a sacred Earth that calls humans to evolve a new ecoconsciousness and ecospirituality.

Berry, Wendall. 2010. *What Matters? Economics for a New Commonwealth*. New York: Counterpoint. This collection of essays redefines economics through principles of Christian stewardship, reverence for Creation, and sustainability.

Grim, John and Tucker, Mary Evelyn. 2014. *Ecology and Religion*. Washington, DC: Island Press. This book explores the history of many religious traditions and the environment, illustrating how religious teachings and practices both promoted and at times subverted sustainability.

Palmer, Joy and Cooper, David. eds. 2001. *50 Key Thinkers on the Environment*. London and New York: Routledge. Entries describe some of the most influential environmentalist thinkers, including St. Francis of Assisi, Buddha, Chuang Tzu, Black Elk, and Mahatma Gandhi.

Taylor, Bron, ed. 2005. *The Encyclopedia of Religion and Nature*. 2 vols. London and New York: Thoemmes Continuum. This is a go-to text for thousands of entries on important people, places, ideas, symbols, rituals, terms, events, and art written by the top scholars in the field.

Weblinks

Interfaith Power and Light is a US-based interfaith environmentalist organization sponsoring political advocacy, social assistance, community projects, with toolkits for individuals, congregations and other faith groups. www.interfaithpowerandlight.org/

The Earth Charter is a secular-religious collaboration that unites many philosophical and spiritual teachings in a call for comprehensive earth care, economic justice, and democratic reform. https://earthcharter.org/

The Indigenous Environmental Network is an international coalition dedicated to protecting "Mother Earth" and defending sacred lands. www.ienearth.org

The Parliament of World Religions is one of the most respected global, multifaith, ecumenical organizations dedicated to political, economic, and environmental justice from a spiritual perspective. https://parliamentofreligions.org/

The Yale Forum on Religion and Ecology, Yale University houses the most important religion and ecology website, containing news, references, videos, links to other works, multifaith scholarship, and other information central to the field. http://fore.yale.edu/

References

Baumgartner, Christoph. 2017. "Transformations of Stewardship in the Anthropocene." In *Religion in the Anthropocene*, edited by Celia Dean-Drummond, Sigurd Bergmann and Markus Vogt, 53–66. Eugene: Cascade Books.

Beisner, E. Calvin. 2015. *The Biblical Perspective of Environmental Stewardship: Subduing and Ruling the Earth to the Glory of God and the Benefit of Our Neighbors*, edited by The Cornwall Alliance. https://cornwallalliance.org/landmark-documents/the-biblical-perspective-of-environmental-stewardship-subduing-and-ruling-the-earth-to-the-glory-of-god-and-the-benefit-of-our-neighbors/.

Bergmann, Sigurd. 2017. "Developments in Religion and Ecology." In *Routledge Handbook of Religion and Ecology*, edited by Willis Jenkins, Mary Evelyn Tucker and John Grim, 13–21. London and New York: Routledge.

Berthrong, John. 2006. "Motifs for a New Confucian Ecological Vision." In *The Oxford Handbook of Religion and Ecology*, edited by Roger S. Gottlieb, 236–258. Oxford and New York: Oxford University Press.

Brown, Oli. 2008. *Migration and Climate Change*. IOM migration research series no. 31. Geneva: International Organization for Migration.

Chryssavgis, John. 2006. "The Earth as Sacrament: Insights from Orthodox Christian Theology and Spirituality." In *The Oxford Handbook of Religion and Ecology*, edited by Roger S. Gottlieb, 92–114. Oxford and New York: Oxford University Press.

Cone, James. 2014. "Whose Earth Is It, Anyway?" In *Religions and Environments: A Reader in Religion, Nature and Ecology*, edited by Richard Bohannon, 329–336. London and New York: Bloomsbury.

Dean-Drummond, Celia, Sigurd Bergmann, and Markus Vogt. 2017. "The Future of Religion in the Anthropocene Era." In *Religion in the Anthropocene*, edited by Celia Dean-Drummond, Sigurd Bergmann and Markus Vogt, 1–15. Eugene: Cascade Books.

Dwivedi, O. P. 2006. "Hindu Religion and Environmental Well-Being." In *The Oxford Handbook of Religion and Ecology*, edited by Roger S. Gottlieb, 160–183. Oxford and New York: Oxford University Press.

Earth Charter Commission. 2000. *The Earth Charter*, edited by Earth Charter Commission.

Eaton, Heather. 2017. "The Challenges of Worldview Transformation: 'To Rethink and Refeel Our Origins and Destiny'." In *Religion and Ecological Crisis: The 'Lynn White Thesis' at Fifty*, edited by Todd LeVasseur and Anna Peterson, 121–136. London and New York: Routledge.

Foltz, Richard C. 2006. "Islam." In *The Oxford Handbook of Religion and Ecology*, edited by Roger S. Gottlieb, 207–219. Oxford and New York: Oxford University Press.

Francis, Pope. 2015. *Laudato Si: On Care For Our Common Home*. Vatican City: Libreria Editrice Vaticana.

Gardner, Gary. 2002. *Invoking the Spirit: Religion and Spirituality in the Quest for a Sustainable World*. New York: Worldwatch Institute.

Gottlieb, Roger S. 2006. "Introduction: Religion and Ecology—What Is the Connection and Why Does It Matter?" In *The Oxford Handbook of Religion and Ecology*, edited by Roger S. Gottlieb, 3–21. Oxford and New York: Oxford University Press.

Grim, John, and Mary Evelyn Tucker. 2014b. *Ecology and Religion*. Washington, DC: Island Press.

Hart, John. 2006. "Catholicism." In *The Oxford Handbook of Religion and Ecology*, edited by Roger S. Gottlieb, 65–91. Oxford and New York: Oxford University Press.

Hillel, Daniel. 2006. *The Natural History of the Bible: An Environmental Exploration of the Hebrew Scriptures*. New York: Columbia University Press.

Hochschild, Arlie Russell. 2016. *Strangers in Their Own Land: Anger and Mourning on the American Right*. New York and London: The New Press.

Hulme, Mike. 2011. "Reducing the Future to Climate: A Story of Climate Determinism and Reductionism." *Osiris* 26 (1): 245–266.

Jaspers, Karl. 1948. "The Axial Age of Human History." *Commentary* 6: 430.

Jenkins, Willis. 2011. "Sustainability." In *Grounding Religion: A Field Guide to the Study of Religion and Ecology*, edited by Whitney A. Bauman, Richard Bohannon and Kevin J. O'Brien, 96–112. London and New York: Routledge.

Jenkins, Willis. 2017. "Whose Religion? Which Ecology? Religious Studies in the Enviroinmental Humanities." In *Routledge Handbook of Religion and Ecology*, edited by Willis Jenkins, Mary Evelyn Tucker and John Grim, 22–32. London and New York: Routledge.

Jenkins, Willis, Evan Berry, and Luke Beck Kreider. 2018. "Religion and Climate Change." *Annual Review of Environment and Resources* 43: 85–103.

Kaza, Stephanie. 2006. "The Greening of Buddhism: Promise and Perils." In *The Oxford Handbook of Religion and Ecology*, edited by Roger S. Gottlieb, 184–206. Oxford and New York: Oxford University Press.

Kearns, Laurel. 2011. "The Role of Religions in Activism." In *The Oxford Book of Climate Change and Society*, edited by John S. Dryzek, Richard B. Norgaard and David Schlosberg. Oxford and New York: Oxford University Press.

Pellow, David N., and Pengfei Guo. 2017. "Environmental Justice." In *Routledge Handbook of Religion and Ecology*, edited by Willis Jenkins, Mary Evelyn Tucker and John Grim. London and New York: Routledge.

Rigby, Catherine E. 2017. "Religion and Ecology: Towards a Communion of Creatures." In *Environmental Humanities: Voices from the Anthropocene*, edited by Serpil Opperman and Serenella Iovino, 273–294. London and New York: Routledge.

Ronan, Marisa. 2017. "American Evangelicalism, Apocalypticism, and the Anthropocene." In *Religion in the Anthropocene*, edited by Celia Dean-Drummond, Sigurd Bergmann and Markus Vogt, 218–231. Eugene: Cascade Books.

Santmire, H. Paul, and John B. Cobb, Jr. 2006. "The World of Nature According to the Protestant Tradition." In *The Oxford Handbook of Religion and Ecology*, edited by Roger S. Gottlieb, 115–146. Oxford and New York: Oxford University Press.

Simkins, Ronald A. 2018. "Religion, Environment, and Economy: Living in a Limited World." *Journal of Religion and Society* Supplement 16: 165–178.

Szerszynski, Bronislaw. 2017. "From the Anthropocene Epoch to a New Axial Age: Using Theory-Fictions to Explore Geo-Spiritual Futures." In *Religion in the Anthropocene*, edited by Celia Dean-Drummond, Sigurd Bergmann and Markus Vogt, 35–52. Eugene: Cascade Books.

Taylor, Bron Raymond. 2010. *Encyclopedia of Religion and Nature*. New York: Oxford University Press.

Thomas, Keith. 1983. *Man and the Natural World: A History of the Modern Sensibility*. New York: Pantheon Books.

Tirosh-Samuelson, Hava. 2006. "Judaism." In *The Oxford Handbook of Religoin and Ecology*, edited by Roger S. Gottlieb, 25–64. Oxford and New York: Oxford University Press.

Tucker, Mary Evelyn. 2006. "Religion and Ecology: Survey of the Field." In *The Oxford Handbook of Religion and Ecology*, edited by Roger S. Gottlieb, 398–418. Oxford and New York: Oxford University Press.

Tucker, Mary Evelyn. 2009a. "Preface." In *Ecology and the Environment: Perspectives from the Humanities*, edited by Donald K. Swearer and Susan Lloyd McGarry, 1–7. Cambridge: Harvard University Press.

Tucker, Mary Evelyn. 2009b. "Touching the Depths of Things: Cultivating Nature in East Asia." In *Ecology and the Environment: Perspectives from the Humanities*, edited by Donald K Swearer and Susan Lloyd with McGarry, 49–64. Cambridge: Harvard University Press.

Tucker, Mary Evelyn, and John Grim. 2017. "The Movement of Religion and Ecology: Emerging Field and Dyanimc Force." In *Routledge Handbook of Religion and Ecology*, edited by Willis Jenkins, Mary Evelyn Tucker and John Grim, 3–12. London and New York: Routledge.

Weber, Max. 2013. *The Protestant Ethic and the Spirit of Capitalism*: London and New York: Routledge.

White, Jr., Lynn 1967. "The Historical Roots of Our Ecologic Crisis." *Science* 155 (3767): 1203–1207.

9 Environmental art

Creativity, activism, and sustainability

Chapter objectives

- To introduce the field of environmental art (abbreviated as ecoart), including visual, sculptural, multimedia, site-specific, land-based, ecodigital, performative, and participatory art
- To highlight the overlays between art, activism, sustainability, climate change, and environmental degradation within ecoart
- To present some of the ways in which the Anthropocene is transforming creative practices by inspiring collective, community responses to ecological issues
- To familiarize readers with emerging areas of ecoart, including environmental arts therapy as a set of concepts and practices oriented toward personal and planetary healing

The art of vegetating

When does the planting of wheat and trees become art? Where should the line be drawn between art, agriculture, and activism? On these questions, let's consult Hungarian-American artist Agnes Denes.

A pioneer of environmental art, Denes (born in Budapest, Hungary, in 1931) has been warning humankind, for over five decades, about the perils of neglecting nature and the importance of restoring degraded places. In 1968, she created her first artwork, *Rice/Tree/Burial*, bringing together "philosophical concepts and ecological concerns" (Denes 1993, 388). At a site in rural Sullivan County, New York, she planted rice to signify vitality, chained trees together to represent human disruption of natural processes, and buried haiku poems to symbolize how the land inspires human creativity. For her 1982 piece *Wheatfield—A Confrontation*, with the help of volunteers, she painstakingly hand-planted a two-acre wheatfield in Manhattan, one block from Wall Street and within view of the Statue of Liberty, on "dirty landfill full of rusty metals, boulders, old tires, and overcoats" (Denes 1993, 390). After four months, the rehabilitated land yielded 1,000 pounds of wheat, which she then distributed globally as seed to people in twenty-eight cities through the exhibition *The International Art Show for the End of World Hunger*.

Located in Ylöjärvi, Finland, her site-based project *Tree Mountain: A Living Time Capsule* (1992–) is a forest of 11,000 silver fir trees planted by 11,000 people at a former gravel pit (Figure 9.1). Designed according to mathematical principles, the forest will be protected by the Finnish government for 400 years, at which time—that is, around 2392—the ecosystem will have reached mature, or old-growth, status. As the artist comments, "the trees live on through the centuries—stable and majestic, outliving their owners or custodians who created the patterns and the philosophy but not the tree[s]" (Denes 1993, 391).

DOI: 10.4324/9781351200356-9

Figure 9.1 Agnes Denes' *Tree Mountain* installation is located in Ylöjärvi, Pirkanmaa, Finland.
Image credit: Strata Suomi (Wikimedia Commons).

Reflection 9.1 Environmental art as time capsule

Early in her career, Denes decided that painting was too limiting for her ambitious philosophical, artistic, and community aims. Her massive earthworks, indeed, address complex ecological, social, cultural, and political concerns at local, regional, and global scales. On the whole, her work exemplifies the conceptual, open-ended, participatory, multimedia, socially engaged, activist, and site-based features of many contemporary environmental art projects.

Read the following interview with Denes published in the online magazine *Apollo*: www.apollo-magazine.com/agnes-denes-the-shed-interview. Why does she characterize her artworks as time capsules? What kinds of ecological ethics underpin her creative practices? What do you think about art's ability to set in motion pro-environmental behaviors?

Environmental art: from representation to relation

As we have shown so far in the book, the Environmental Humanities is a steadily evolving, strikingly diverse, and radically inclusive field of transdisciplinary scholarship and activism. Following that theme, this section introduces key terms, concepts, and case studies in Indigenous art, environmental visual art, environmental sculpture, land-based and site-specific art, ecological art, and ecofeminist art. New developments in the field—specifically ecodigital art,

climate change art, multispecies art, and environmental arts therapy—will be addressed later in the chapter. Moreover, environmental theater and cinema will be covered in Chapters 11 and 12, respectively. Due to limitations of space, however, important genres—environmental music, environmental photography, and botanical art stand out among many others—will lamentably be excluded from our overview. We nevertheless encourage readers to explore these areas according to their own interests.

In the age of rapid ecological decline known as the Anthropocene (covered in Chapter 3)—in which science tends to be upheld as *the* authoritative voice—what is the role of painting, printmaking, photography, illustration, sculpture, performance, music, installation art, multimedia work, and other creative forms? Can a song inspire progressive action on behalf of nature? Can a sculpture promote public awareness of the vulnerability of ecosystems? Can a photograph instill empathy for animals, plants, fungi, or rivers? Can a painting galvanize a global environmental movement? Can a theater performance enable a community to grieve the loss of a local wetland?

These are the kinds of questions pivotal to the study of environmental art. Certainly, art has always enjoyed a close relationship to the environment and more-than-human life. From the materials employed (wood, plants, minerals, animal products, water) to the scenes depicted (forests, mountains, oceans) and, in more recent years, to the manner in which particular works propound environmental values, art engages the natural world in diverse and, sometimes, surprising ways. Environmental art is also closely related to the study of ecoaesthetics, or the aesthetics of nature, discussed in Chapter 7. Environmental artists create works of keen interest to many ecoaesthetic philosophers.

Philosopher of art, Nicolas J. Bullot, defines *environmental art* as "all works of art that address environmental topics, regardless of the medium, style, and position advocated by the artist" (2014, 511). Other theorists define the term as a genre that encompasses works either (a) representing the environment pictorially as an image, scene, or landscape; or (b) demonstrating a *non-representational, performative,* or *participatory* approach to the natural world (Thornes 2008, 391). Agnes Denes' *Tree Mountain* and other pieces exemplify performative environmental art based on evolving interactions between the artist, human participants, and other-than-human agents (mountains, soil, trees, wheat, rice, and so forth). For more about the difference between representational and nonrepresentational environmental art forms, see Waypoint 9.2.

For millennia, Indigenous people globally have been creating environmental art (as introduced in Chapter 4). We suggest that the Indigenous art forms of the Americas, Oceania, Africa, Asia, and elsewhere constitute the first traditions of environmental art. Aboriginal Australian art, for instance, comprises rock paintings and wood carvings of animals, birds, plants, land forms, water bodies, celestial events, and human–nature interactions through practices of hunting, fishing, and gathering. In fact, some megafaunal species shown in rock paintings—including the thylacine (also known as the Tasmanian tiger) and the fat-tailed kangaroo—are tragically now extinct. Other Australian rock art depicts the first arrival of European ships and other colonial-era events.

On the north-west coast of Western Australia, the Dampier Rock Art Precinct contains the densest concentration of rock drawings—or petroglyphs—in the country. Ranging from 4,000 to 30,000—or more—years in age, approximately 1 million petroglyphs can be seen on rocks and massive boulders throughout the area (Gregory 2009). Despite its local and global significance—the site is far more extensive than the famous Paleolithic cave paintings at Lascaux, France—the Dampier Rock Art Precinct is threatened by the impacts of ongoing resource extraction, particularly natural gas (see Reflection 9.2).

Reflection 9.2 Activism and Indigenous environmental art

The Dampier Rock Art Precinct contains the Burrup Peninsula, or Murujuga, a place of cultural significance for the area's Traditional Owners. Since the 1950s, following the discovery of an offshore gas deposit, the Burrup has become a site of environmental and cultural activism aimed at protecting the ancient rock paintings from industrial pollution.

Read this article by the Conservation Council of Western Australia (CCWA): https://chuffed.org/project/save-murujuga-rock-art. Why should the Burrup be protected? Is it possible to balance cultural heritage protection and natural resource extraction in the Burrup and elsewhere?

The Dampier rock paintings are some of the earliest known examples of *environmental visual art*. We define this term very broadly to include paintings, drawings, illustrations, etchings, photographs, prints, textiles, sculptures, and other works that visually depict the environment, more-than-human life, people-land relations, ecological issues, and sustainable futures. The extensive Western and Eastern traditions of landscape painting fall within the scope of environmental visual art. Included in our discussion of non-Western ecoaesthetics in Chapter 7, Chinese landscape painting tends to portray nature's sublime power. Considered the oldest extant Chinese landscape painting, Zhan Ziqian's ink composition "Strolling About in Spring," from the late sixth century AD, depicts diminutive human forms subsumed within a rugged alpine habitat (Figure 9.2).

Western Medieval and Renaissance artists, by contrast, largely favored pastoral scenes. However, Pieter Bruegel the Elder's oil painting "The Triumph of Death" (c. 1562), departs distinctly from the pastoral ideal (Figure 9.3). Whereas the painting's bottom

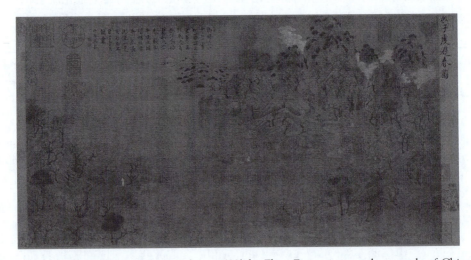

Figure 9.2 "Strolling About in Spring" (c. AD 600) by Zhan Ziqian is an early example of Chinese environmental visual art.

Image credit: Wikimedia Commons (Public Domain).

half is crowded with skeletons, corpses, coffins, and terrorized people attempting to flee death's proximity, the upper half features an ecologically ravaged scene of blackened trees, scorched hills, and fires illuminating the distance. Since Bruegel's dystopian composition, landscape painting has radically diversified and now includes the work of contemporary artists Georgia O'Keeffe (1887–1986) in the United States, Sidney Nolan (1917–92) in Australia, Zhang Bu (b. 1934) in China, and numerous other ecologically aware visual artists throughout the world.

Another prominent kind of environmental art—known as *environmental sculpture*—can be interpreted in at least three ways (Blanc and Benish 2017, 19–20). To begin with, the term can refer to sculptures depicting the environment, more-than-human beings, or cultural-natural systems. In the Indigenous societies of Southeast Alaska and British Columbia, for instance, totem poles carved with images of ravens and whales can be understood as environmental sculptures. In another sense, the term calls attention to sculptures designed to memorialize, harmonize with, or intensify a particular place. An example is British artist Antony Gormley's fifty-one sculptures created in 2003 at Lake Ballard in the arid Goldfields region of Western Australia (Figure 9.4). Thirdly, the term signifies a large-scale sculpture that immerses the observer and produces a sort of architectural microhabitat. Created by sculptor Harvey Fite over thirty-seven years, for instance, *Opus 40* is a 6.5-acre environmental sculpture located in Saugerties, New York. Meandering through the all-encompassing labyrinthine structure, the visitor experiences sudden changes of air temperature, visual perspective, sound patterns, and bodily orientation.

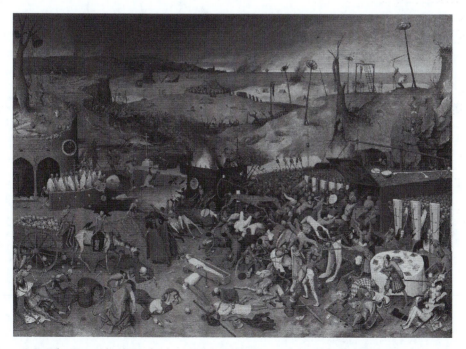

Figure 9.3 "The Triumph of Death" (c. 1562) by Pieter Bruegel the Elder features scenes of ecological catastrophe.

Image credit: Wikimedia Commons (Public Domain).

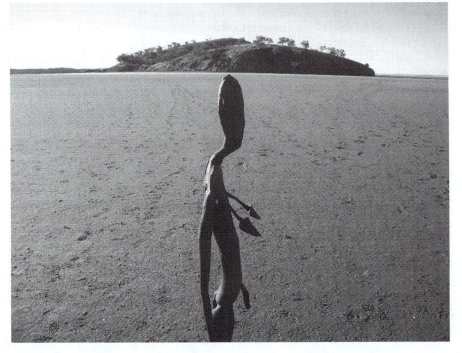

Figure 9.4 This image depicts one of the fifty-one statues at Lake Ballard, Western Australia, installed by Antony Gormley in 2003 as part of a site-based environmental sculpture.

Image credit: J. C. Ryan.

Waypoint 9.1 Overview of environmental art genres and movements

- *Anthropocene Art*: responds to the ecological crises of the Anthropocene, particularly the role of humans as planetary agents
- *Arte Povera*: emerged in Italy in the 1960s as a political art movement that approached nature in terms of transformation
- *Botanical Art*: develops accurate depictions of plants in drawings, sketches, illustrations, photography, and other media
- *Climate Change Art*: aims to enable viewers to relate emotionally to scientific ideas of climate disturbance and planetary warming
- *Destination Art*: refers to site-based environmental installations that become national and international tourist destinations
- *Earthworks*: uses natural media to create large-scale, site-based monuments and sculptures; synonymous with Earth and Land Art
- *Ecofeminist Art*: advocates the importance of collaborative, non-patriarchal values to the regeneration of the biosphere
- *Ecological Art (Ecoart)*: situates creative practices within ecological patterns, processes, systems, relations, and ethics
- *Ecological Justice Art*: focuses on ecological justice issues, including the socioeconomic dimensions of environmental racism

- *Environmental Architecture*: seeks to enhance sustainability through the efficient use of materials, energy, and space
- *Environmental Music*: promotes ecological values through music and/or engages nature directly in music and ambient sound
- *Environmental Sculpture*: comprises sculptures that represent nature, enhance a place, or immerse the spectator in a site
- *Environmental Visual Art*: depicts nature, other-than-human life, people-land relations, ecological issues, and sustainable futures
- *Indigenous Environmental Art*: reflects Indigenous cultures, traditions, and values, especially ancestral respect for nature
- *Landscape Painting and Photography*: represents the main aesthetic features of landscapes, namely, color, form, and proportion
- *Plant Art*: engages plants as responsive participants in artworks and recognizes more-than-human agencies in creative process

The third sense of environmental sculpture—as a physically immersive earthwork that involves the viewer as a participant—provides a segue into the complex world of contemporary land-based and site-specific art. Also known as Earth art or earthworks, *land art*—sometimes capitalized as Land Art—employs natural materials usually acquired onsite. The Tate, a major British museum of international modern and contemporary art, defines *land art* as "art that is made directly in the landscape, sculpting the land itself into earthworks or making structures in the landscape using natural materials such as rocks or twigs" (Tate n.d., para. 1). One of the earliest and most widely known land art works is American artist Robert Smithson's *Spiral Jetty*, an earthwork composed of mud, salt, and rock built in 1970 on the shore of Utah's Great Salt Lake, the biggest saline lake in the Western Hemisphere. (To view Smithson's thirty-two-minute film documenting the art work's construction, see the Weblinks section at this chapter's end.) *Spiral Jetty* moreover is an example of *site-specific art*, a genre that emphasizes the "inextricable, indivisible relationship between the work and its site [and demands] the physical presence of the viewer for the work's completion" (Kwon 2002, 12).

Case Study 9.1 Andy Goldsworthy's environmental sculptures

Andy Goldsworthy (b. 1956) is a British environmental artist known for his detailed site-specific installations using rocks, pebbles, leaves, branches, petals, snow, ice, and other scavenged natural materials. Most of his creations are ephemeral, or short-lived, eventually decaying or completely disappearing over time. His preferred locations are forests, shorelines, fields, and other outdoor settings. Inspired by Robert Smithson and the Land Art movement of the 1960s and 1970s, Goldsworthy takes photographs of his transient earth sculptures. The images then appear in books with pithy titles such as *Stone*, *Wood*, *Arch*, *Enclosure*, and *Time*. Goldsworthy comments: "Nature, for me, isn't just pastoral and therapeutic. It's those things, but it's deeply disturbing and challenging and threatening and brutal and raw as well as beautiful" (quoted in Nakhnikian 2018, para. 9).

Located at Grizedale Forest in England's Lake District, Goldsworthy's "Taking a Wall for a Walk," also known as "Wall That Went for a Walk," from 1990 is a stone wall measuring 450 feet long and five feet wide (Figure 9.5). Unlike most utilitarian stone

walls constructed in an efficiently linear fashion, Goldsworthy's wall snakes across the wooded landscape and curves around trees. Rather than intruding upon and disrupting the environment, the artwork attempts to harmonize with the particular features of the place. Over time, old trees have toppled into the wall, collapsing parts of the artwork, while saplings have grown up around it. Sections of the work have even been ploughed over by local farmers, further altering its original form.

Despite Goldsworthy's serious interest in ephemerality, some of his recent pieces are more playful and performative. In "Hedge Walk," shown in his documentary *Leaning into the Wind* from 2017, the artist "swims" inside an Edinburgh hedge, contorting his body as he moves through the unstable interior terrain of the urban plant.

In addition to site-specific art, land art, environmental sculpture, and environmental visual art, there is ecological art—abbreviated as *ecoart* or *eco-art*. Moving beyond a focus on the aesthetic representation of natural forms, ecoart situates creative practices deeply within ecological patterns, systems, and ethics. In this way, art becomes ecological in its very character. As a contemporary evolution of environmental art, ecoart brings environmental consciousness to bear on artistic practices by addressing the sociopolitical forces that impact the natural world. Art critic Ruth Wallen (2012) characterizes ecoart as "grounded in an ecological ethic and systems theory, addressing the web of interrelationships between the physical, biological, cultural, political, and historical aspects of ecosystems" (235). For Wallen, ecological artists inspire respect for the environment by shunning anthropocentric

Figure 9.5 "Taking a Wall for a Walk" (1990) by Andy Goldsworthy is an example of environmental sculpture.

Image credit: C. D. Uglow (Wikimedia Commons).

values and nurturing processes of renewal. As evident in the work of Agnes Denes, discussed at this chapter's opening, ecological art typically demands that detached viewers become active participants. Here are six key ecoart features:

- emphasis on ecological relationships;
- dialogue with scientific concepts, principles, and methods;
- engagement with natural elements of water, air, rocks, and soil;
- restoration of degraded habitats, as exemplified by Denes' *Wheatfield—A Confrontation*;
- commitment to educating the public about ecological issues through art; and
- formulation of new possibilities for interspecies ethics, community transformation, urban sustainability, and personal healing (Kagan 2012, 20).

In many examples of ecological art, the work itself *becomes* a self-regenerating ecosystem, as we see in *Living Water Garden* referenced in Reflection 9.3.

Reflection 9.3 Ecological art and habitat restoration

Completed in 1998 in Chengdu, China, American artist Betsy Damon's *Living Water Garden* is a 5.9-acre public park that purifies contaminated water from the Fu Nan River using constructed wetlands. Filtering about 50,000 gallons of water per day, the park has inspired a range of environmental revitalization projects in China. *Living Water Garden* was even replicated in Beijing for the 2008 Olympics.

Considering Damon's example, list at least five social, cultural, community, and/or environmental benefits of ecological art.

Emerging from developments in ecofeminist philosophy in the 1970s (see Chapter 7), ecofeminist art advocates the importance of non-patriarchal values to the regeneration of the biosphere. Ecofeminist art is "an artistic response to feminist and ecological concerns," specifically the oppression of women and the subjugation of nature (Mathew 2001, 10). Deborah Mathew describes the genre as "an art of social change [that] creates a healthy web of inter-relationships between humans and others" by countering dualisms and promoting respect for the Earth (11). According to art critic Gloria Feman Orenstein (2003), ecofeminist art focuses on healing environmental trauma through "direct, hands-on, aesthetic, and scientific collaborations with the earth *herself*" (104, emphasis original). Attuned to the relationship between ethics, aesthetics, and ecology—and thus sharing ground with ecological art, discussed previously—ecofeminist artists collaborate with the regenerative cycles of nature and aspire to nurture sustainable Earth systems. As shown in Damon's *Living Water Garden* (Reflection 9.3), "hands-on" ecofeminist artistic practices range from water purification and land regeneration to species conservation and environmental education. Prominent ecofeminist artists include Agnes Denes, Natalie Jeremijenko, Eve Mosher, and Shai Zakai.

Waypoint 9.2 Key characteristics of environmental art

- *Ecological*: based in natural processes, systems, and relations
- *Ephemeral*: exists for a short duration and then vanishes
- *Immersive*: encompasses the viewer physically and emotionally

- *Impermanent*: resists ideals of permanence and durability
- *Interactive*: engages the spectator through embodied participation
- *Multispecies*: involves other-than-human species as co-creators
- *Non-representational*: shifts emphasis away from the realistic depiction of natural forms to symbolic, abstract meaning or formal properties
- *Participatory*: requires human and non-human involvement and feedback
- *Relational*: decenters the role of the individual artist in favor of the artwork's network of relations
- *Representational*: depicts something more or less as it appears naturally to perception
- *Restorative*: revitalizes degraded habitats and abused landscapes
- *Scientific*: incorporates scientific ideas and practices
- *Site-Specific*: requires connections to specific sites to achieve meaning
- *Sustainable*: implements the aims of the sustainability movement in achieving balance and equity between nature and culture
- *Temporal*: reflects the passage of time and processes of decay
- *Transformative*: engages ecological transformations in order to inspire positive social change
- *Urban*: recognizes the ecologies of cities; situates art outside of pastoral, rural, and wilderness contexts

Historical and theoretical contexts in environmental art

The previous section introduced Indigenous art, environmental visual art, environmental sculpture, land-based and site-specific art, ecological art, and ecofeminist art. Waypoint 9.1 offers a synopsis of environmental art genres—including several that are not treated in our book yet have been vital to the evolution of the field as a whole. As demonstrated by the rock paintings at Burrup, the cave paintings at Lascaux, and the earthworks at Stonehenge, art has been connected deeply to the natural world for ages. Since the 1960s and 1970s, however, environmental artists have become intensely concerned with ecological degradation, Indigenous peoples' rights, biocultural heritage loss, plant and animal ethics, more-than-human agency, and the Anthropocene's profound, long-term effects on both nature and culture.

Reflection 9.4 Other characteristics of environmental art?

In Waypoint 9.2, are there any characteristics of environmental art that we forgot to mention? If so, list them on a separate page. Additional characteristics may become apparent as you continue through this chapter. Onward!

This section will present key historical developments and theories in environmental art with special attention to the ecoart movement of the last fifty years. In what ways does contemporary environmental art reflect broader developments in the Environmental Humanities, especially in the fields of geography (Chapter 5), history (Chapter 6), philosophy (Chapter 7), theology (Chapter 8), and literary studies (Chapter 10)? How do environmental artworks enhance ecological awareness and advance sustainable values? What is the *place* of art in the Anthropocene and, more specifically, in response to climate catastrophe?

A number of artistic, cultural, social, and environmental developments in the 1960s and 1970s—principally in North America, Europe, and Oceania—led to the emergence of contemporary environmental art. To begin with, many early environmental artists—Agnes Denes, Mary Miss, and Robert Smithson, among others—were significantly influenced by the radical experimentalism of post-World War II avant-gardism. In the United States, this movement included prominent figures associated with Black Mountain College in North Carolina, including poet Charles Olson, architect Buckminster Fuller, painter Dorothea Rockburne, and composer John Cage. Avant-garde practitioners sought to blur the distinctions between artistic and ordinary objects, urban and rural landscapes, and artists and audiences. Transdisciplinary in outlook, avant-gardists worked seamlessly across the conventional boundaries between art forms; Cage, for instance, was both a minimalist composer exploring ambient soundscapes and an abstract painter (Kastner and Wallis 1998). Environmental artists also drew inspiration from mid-twentieth century currents in Minimalism (concerned with the essence of forms) and Conceptualism (primarily focused on concepts and ideas).

Although the avant-garde and other artistic movements contributed to the advent of environmental art, they were far from the only factors. In the post-war decades, the environmental consequences of rapid industrialization and widespread suburbanization galvanized a new awareness of the natural world among the public. Appearing in 1962, Carson's *Silent Spring* voiced grave concerns over the contamination of ecosystems and, eight years later, the first Earth Day celebrations took place in American cities (see Chapter 1). Growing environmental consciousness cross-fertilized the psychedelic movement, finding expression in popular music. Around this time, as well, academic specializations in environmental education, history, and philosophy began to appear. Accordingly, in response to post-war environmentalism, counterculturalism, and experimentalism, environmental art acquired distinctly ecological, political, and ethical orientations.

As we find in Smithson's *Spiral Jetty*, many early ecoart monuments acquired meaning and significance in relation to their places of production. Artists regarded environmental elements as vital to the lifecycles of their creations; nature was regarded as a participant and collaborator. Works were conceptualized as organisms—thus as able to undergo stages of conception, gestation, and birth followed by maturation, decay, and death. A forerunner of Denes' *Wheatfield—A Confrontation*, Dennis Oppenheim's transient piece *Directed Seeding—Cancelled Crop* (1969) involved the artist sowing and harvesting wheat according to specific visual patterns, which he then documented in aerial photographs. Comparably, for the urban artwork *Vacant Lot of Cabbages* (1978), Barry Thomas illegally planted 180 cabbage seedlings in the shape of the word "CABBAGE." An example of public ecoart with an anarcho-activist bent, the work endured—and incited debate—for about six months before fading into the urban landscape of Wellington, New Zealand. The Burning Man festivals are a more recent—though equally controversial—example of anarcho-environmental art.

Reflection 9.5 Public ecoart and Thomas' *Cabbages*

One of ecoart's aims is to bring environmentally-conscious, politically-driven creative work to the public. Thomas' urban garden constituted a kind of performative protest against the lack of green space in Wellington. The site was later planted with trees native to New Zealand.

Find an example of a recent public ecoart project in your city, state, or region. Does the artwork effectively communicate ecopolitical dissent? Has it brought about any positive environmental change? If so, in what ways?

Not all early environmental art, however, was wholly ephemeral, site-specific, and resistant to being exhibited indoors. Other works reconstituted natural materials within the spatial confines of galleries, museums, and collections. In October 1968, in the middle of the Vietnam War, Robert Smithson organized a group exhibition in Manhattan called *EARTHWORKS* with contributions from Herbert Bayer, Walter De Maria, Sol LeWitt, Dennis Oppenheim, and others (Boettger 2011, 127). The artists exhibited gallery-scale works created with soil and rocks, or photographs of large-scale outdoor pieces. One month prior to this landmark exhibition, De Maria completed *Munich Earth Room* in which he filled the interior of a German gallery with twenty-three inches—or 2,000 cubic feet—of loamy topsoil (127). A year later, Smithson's gallery piece *Chalk-Mirror Displacement* (1969) employed eight two-sided mirrors to partition a pile of quarried chalk into triangular compartments. The configuration produced an optical illusion in which the mirrors vanished and the chalk pile appeared undivided (Art Institute of Chicago n.d.).

Case Study 9.2 Walter De Maria's *The Lightning Field*

Walter De Maria (1935–2013) was an American sculptor, composer, and illustrator associated with the Land Art and Earthwork movements. In addition to *Munich Earth Room* and its permanent successor, *New York Earth Room*, he is known for *The Lightning Field*, built between 1971 and 1977. Located in the high desert of western New Mexico, De Maria's installation contains 400, two-inch-wide stainless steel poles positioned in a grid pattern and spaced 220 feet apart. Each pole, of course, has the potential to conduct electricity. The immersive sculpture changes appearance when viewed from various angles, wandered through, and visited over the seasons, although one should always keep an eye out for lightning!

De Maria (1980) described the site in this way: "The land is not the setting for the work but a part of the work" (52, italics original). Although neither ephemeral nor transient, *The Lightning Field* exhibits themes common to ecological artworks. First and foremost, the spectator becomes a participant. Far from cities, the work represents humanity's complex and, sometimes, conflicted relationship to technology. Harnessing natural energies, the poles intrude upon the landscape. The piece furthermore epitomizes the real-world challenges of site-based ecoart management. For instance, the entire installation was closed throughout 2020 due to Covid-19. Finally, the work exemplifies contradictions inherent between the environmentalist message of ecoart and its ecological impacts.

Search online for images and videos of *The Lightning Field*. What ecological values does the installation communicate? More than forty years after its completion, what does the work say now about the human relationship to the environment in the Anthropocene?

How do works of ecoart inspire social transformation and engender ecological values? Through what specific means do these works engage audiences without turning into empty propaganda or feckless politics? Indeed, artworks produce diverse effects in their creators, commissioners, audiences, participants, and environments (Bullot 2014, 511). The primary functions of environmental artworks, for Bullot, include tracking, broadcasting, emotions manipulation, cooperative action, environmental reflection, and art-science collaboration.

Whereas *tracking* refers to the recording of information—data—about a particular place over time, *broadcasting* signifies the public dissemination of this information. In De Maria's *The Lightning Field* (Case Study 9.2), tracking and broadcasting apply to the weather of the

lightning-prone New Mexican desert plateau. *Emotions manipulation* denotes an artwork's ability to induce empathetic feelings in audiences, resulting in *cooperative action* on behalf of ecosystems. Thomas' *Vacant Lot of Cabbages*, for example, prompted empathy for the communities—human and non-human, including citizens, soil, and cabbages—of Wellington, stimulating public participation in the artwork and longer-term political changes in the urban landscape. *Environmental reflection* highlights the appreciator's reflective processes. The term suggests the viewer's questioning of ecological issues and critiquing of the social assumptions underlying such issues. In this sense, Denes' *Tree Mountain* encourages audiences to reflect on humanity's ethical responsibilities to protect species other than our own, restore degraded ecologies, and ensure viable habitats for future generations. Requiring open dialogue between disciplines, *art-science collaboration* enhances viewers' awareness of scientific knowledge by bringing insights from the social and natural sciences to bear on the artwork and its interpretation (Bullot 2014) (see Reflection 9.6).

Reflection 9.6 Olafur Eliasson's *The Weather Project*

In 2003, *The Weather Project* was installed at Tate Modern, London. The artwork combines lighting, projection, haze machines, aluminum, and scaffolding to generate a climatic experience for viewers in the gallery.

Explore the project website listed in the Weblinks section at this chapter's end. How does the artwork reflect (or not reflect) Bullot's six functions of ecoart: tracking, broadcasting, emotions manipulation, cooperative action, environmental reflection, and art-science collaboration?

Other theorists call attention to *relationality* in describing ecoart's ability to address environmental concerns (see Waypoint 9.2). For Nathalie Blanc and Barbara L. Benish, environmental art participates "in a deeper transformation of our relationships to nature and the environment" (Blanc and Benish 2017, 204). The relationships essential to ecoart transpire on various levels, for instance, between the human and non-human, the local and global, and the material and digital. This important relational aspect further includes:

- the relationship of individuals *in-and-with* the environment;
- the relationship of communities *in-and-with* the environment; and
- the relationship between natural and cultural diversity (Blanc and Benish 2017, 210).

Ecoart's emphasis on relation—as well as associated qualities of change, metamorphosis, and process—lead to the formation of new modes of environmental ethics. Similarly, Katrina Brown et al. (2017) argue that ecoartistic practices contribute to knowledge of resilience, challenge social assumptions about the environment, and encourage fresh perspectives on ecological urgencies. Through art-science collaboration and rootedness in place—qualities also emphasized by Bullot—ecoart supplies a medium for reflecting on social and ecological futures.

Waypoint 9.3 Examples of environmental art theory

- *Affect*: examines the manifestation of emotion, feeling, and embodiment as individuals, communities, and ecologies interrelate
- *Corporeality*: considers the body and senses in perception and knowledge-acquisition; also known as embodied cognition

- *Ecocriticism*: approaches works of ecoart as environmental texts saturated with meaning, signification, and figurative force
- *Ecopsychology*: explores the ways in which an artwork influences the psychologies of human beings in direct contact with nature
- *Mimesis*: focuses on the realistic or naturalistic representation of the visual appearance of the environment in an artwork
- *Multispecies*: attends to the intermingling of diverse species, organisms, and life forms within an artwork
- *Narrativity*: signifies an artworks' capacity to tell the story of a place and human–nature entanglements over time
- *Performativity*: articulates the modes of performance used by an artwork to reinforce ecological values
- *Phenomenology*: investigates forms of experience and consciousness that create environmental awareness
- *Psychogeography*: calls attention to the effects of an artwork's geographical location on individuals' emotions and behaviors
- *Psychohistory*: highlights how art historically drives social behaviors toward environmental concern; related to ecopsychology
- *Reception*: emphasizes an audience's interpretation of an artwork in making meaning and forming values in response to nature
- *Resilience*: refers to an artwork's capacity to boost the resilience, or adaptability, of individuals and communities
- *Sustainability*: denotes the contribution of an artwork to the aims of environmental, social, and cultural sustainability
- *Systems*: positions an artwork within a group of interacting elements that cohere as a synergetic whole, or system

Current and future directions in environmental art

Environmental art is a burgeoning subfield of the Environmental Humanities that brings aesthetic concepts and creative practices into dialogue with ecological concerns. But, still, can an artist, artwork, or artistic movement protect species, halt climate change, and save the biosphere? In conjunction with the social and natural sciences—as well as with humanities specializations already covered in this book—*it just might*. For as artists, conservationists, and critics claim, art is essential to transforming cultural values and therefore to activating positive environmental change.

In their introduction to *Art in the Anthropocene*, Heather Davis and Etienne Turpin argue that art is

> central to *thinking with* and *feeling through* the Anthropocene ... To approach the panoply of complex issues that are aggregated within and adjacent to the Anthropocene, as well as their interconnections and intra-actions, it is necessary to engage with and encounter art.
> Davis and Turpin (2015, 3–4, emphasis added)

The previous section outlined theories relevant to the interpretation of ecoart and elaborated specific qualities of artworks—relationality, art-science dialogue, emotions manipulation, among others—that induce thinking, feeling, and engagement in audiences. We also discussed key artists, artworks, and events in the history of environmental art since its emergence—under the banner of ecoart—in the 1960s and 1970s.

This final section will introduce readers to current directions and future prospects in environmental art in the context of Anthropocenic change and climate catastrophe. These recent areas include *climate change art* (or *cli-art*), *ecodigital art* (or *environmental digital art*), *multispecies art* (particularly *plant art*), *environmental artivism*, and *environmental arts therapy*. Although we can't give contemporary Aboriginal art the attention it deserves, its abstract "overview" landscapes and representation of "Dreaming" narratives demonstrate how so many of the novel developments in environmental art hark back to the very old traditions, such as the Dampier petroglyphs, with which we started this chapter: see the Weblinks section and Chapter 4 for more information.

The call for novel art forms addressing climate change stems back to activist Bill McKibben's essay "What the Warming World Needs Now Is Art, Sweet Art" (2005). McKibben understands art as "one of the ways we digest what is happening to us, make the sense out of it that proceeds to action" (2005, para. 11). Since McKibben's appeal more than fifteen years ago, climate change art (or what we call *cli-art*) has blossomed into a vibrant area of environmental art—one geared toward edifying the public and inspiring transformation on many levels. Works produced between 2005 and 2015, in particular, established cli-art's capacity to enable "the public to rethink the role of human beings' everyday activities in irrevocably altering the climate system" (Nurmis 2016, 501). One of the main functions of cli-art is to impart meaning—cultural, social, emotional, spiritual, and so forth—beyond the limited reach of political and scientific discourses. To this effect, many works of cli-art use climate change data to impact audiences emotionally and to render abstract information accessible. For instance, artist-interventionist Eve Mosher's *HighWaterLine: Visualizing Climate Change* (2007–) enhances climate change resiliency through workshops and public art activities (see Reflection 9.7). An aim of the multifaceted project is "translating scientific data into information that resonates with the community" (Mosher n.d., para. 5). Studies of cli-art indeed suggest that works are more effective when presenting solutions, emphasizing interconnectedness, and bringing art into the public domain (Sommer and Klöckner 2019).

Reflection 9.7 *Eve Mosher's* HighWaterLine

In 2007, Mosher walked seventy miles in Manhattan and Brooklyn, tracing in blue chalk the areas that would be severely affected by climate change-related flooding. The work has since been replicated in Miami (2013), Philadelphia (2014), and elsewhere.

Visit the project website: www.highwaterline.org. What strategies does the artist implement to foster public engagement with the issue of climate change?

In its use of topographic maps and satellite data, Mosher's *HighWaterLine* also exemplifies ecodigital art—or environmental digital art—defined as ecoart that employs digital media centrally in the creation and reception of artworks. Ecodigital art is a mode of creative practice that crosses fluidly between art and technology, reflects an underlying environmental ethics, and effectively uses metaphor and narrative. With the increasing influence of new media, social media, and virtual reality on art over the last two decades, ecoart has proliferated. One outcome of ecodigital art is the transformation of public attitudes and behaviors toward humanity's troubled relationship to nature. As an inherently interactive art form, ecodigital art often invites the public to participate in works and thus offers a medium to disseminate ideas of sustainability. More specifically, ecodigital art investigates the ways in which data and digital media interact with "social positions, complex emotions, and embodied realities" (Houser 2020, 4). Case Study 9.3 on Joseph DeLappe's *Project 929: Mapping the Solar* (2013) offers a detailed example of an ecodigital artwork.

Figure 9.6 Yucca Mountain is the site of a major nuclear waste storage facility.

Image credit: Fastfission (Wikimedia Commons).

Case Study 9.3 Joseph DeLappe's *Project 929: Mapping the Solar* (2013)

American multimedia artist Joseph DeLappe integrates digital technologies into his artworks for purposes of ecopolitical activism. A prominent example is *Project 929: Mapping the Solar* (2013), a 460-mile, ten-day bicycle ride. During the performative ride, the artist dragged a large piece of chalk attached to the frame of his bike for the entire distance. The uninterrupted chalk line, viewed aerially, appeared as a faint trace on the desert floor. Resulting from DeLappe's physical progress across the arid landscape of the American West, the resulting form constituted a large-scale, site-based artwork promoting ecodigital ethics.

DeLappe encircled US government sites of nuclear testing and military exercises, including the notorious Area 51 (the Nevada Test and Training Range), Yucca Mountain (where a major nuclear waste storage facility is located) (see Figure 9.6), and Nellis Air Force Base. The work's title refers to the 928 nuclear explosions that occurred at the Nevada Test Site between 1951 and 1992. DeLappe's 929th "test" signifies a transition toward sustainable technologies to meet long-term energy needs with fewer side-effects than nuclear or oil-based sources. The area DeLappe traced could accommodate the world's largest solar facility for generating renewable energy for the American public.

How did DeLappe use digital technologies? A solar cell array mounted on his bicycle powered locative media (GPS), video recording, and live streaming. An augmented reality (AR) documentary tour also resulted from the ecodigital performance piece. Visit the project archive here: https://project929.tumblr.com/. What additional strategies (digital or otherwise) did the artwork use to encourage social and environmental change?

A dynamic area of ecoart is *multispecies art*—incorporating other species, organisms, and life forms as lively participants in artistic processes. In such pieces, more-than-humans are not degraded as experimental subjects but respected as active contributors and intelligent co-creators. Multispecies art certainly is related to—but distinct from—bioart projects that manipulate tissues, organisms, and processes through biotechnologies. As an example of multispecies art, *plant art* engages botanical life as an actant and co-conspirator. An early example is Laurent Mignonneau's and Christa Sommerer's *Interactive Plant Growing* (1992). The artists used common house plants as interfaces between gallery visitors, a computer system, and the digital artwork. Visitors generated three-dimensional images of virtual flora when they touched the real plants. The botanical visualization on the screen was controlled in real-time by human–plant contact. *Interactive Plant Growing* fostered a sense of dialogue between species. Audience members participated in the creative process through the organic media of living plants. The artwork engendered awareness of human–vegetal relations through the shifting organic patterns that resulted in the gallery (Sommerer et al. 2015) (see Reflection 9.8).

Reflection 9.8 Plant Art

Since Mignonneau's and Sommerer's *Interactive Plant Growing* (1992), plant art has enjoyed a heyday of sorts. Many contemporary artists are using live flora respectfully in their artworks in order to call attention to the vital importance of symbiosis between plants and people.

Find an example of plant art from the last ten years. What are the main organic and non-organic elements of the artwork? What does the artwork say about plant ethics?

Artivism is artistically informed activism. Emerging in the late 1990s among artists in Los Angeles and Chiapas, artivism fuses art and activism toward the realization of anti-capitalist and anti-globalist aims. Artivist strategies include subvertising (parodying corporate symbols), reverse engineering (transforming everyday objects into expressions of dissent), street art (placing unauthorized art in public places), and puppetry (Diverlus 2016). Within this subcategory, *environmental artivism* integrates art, activism, and ecology. Environmental artivism played a significant role in the 2015 protests at the United Nations Climate Change Conference (COP21 or CMP11) in Paris (Goris and Hollander 2017). Two days prior to the conference launch, for instance, the Brandalism project—in an example of subvertising—installed 600 posters in public areas across the city. Created by artists from nineteen countries, the posters addressed the corporatism of COP21, underscoring the links between climate catastrophe, advertising, and consumerism (Figure 9.7).

In addition to the other emerging areas of ecoart featured in this section— environmental artivism, multispecies art, ecodigital art, and climate change art—environmental arts therapy (EAT) employs creative approaches to working with people therapeutically in outdoor settings. Blending aspects of ecoart and ecopsychology, environmental arts therapy aims to enhance human health and well-being through (re)connection with the natural world (Heginworth and Nash 2020, 1). EAT encompasses a range of creative techniques, including dramatic performances, storytelling, sculpting with natural materials, and visual artworks depicting the processes of physical and psychological recovery in a place. As means of facilitating healing, such works are created *by*—rather than *for*—those

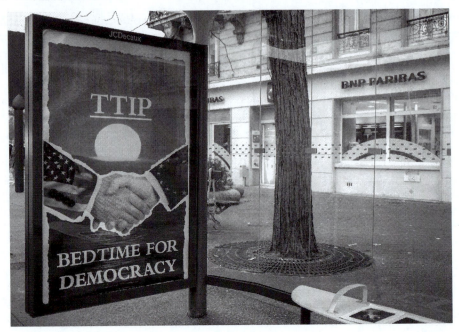

Figure 9.7 This example of street art in Paris featured in the Brandalism Project.

Image credit: Brandalism.org (Wikimedia Commons).

undergoing therapy. EAT "facilitates a deep personal connection between soul and soil, between the individual in therapy and the landscape in which the therapy takes place" (Heginworth 2020, 25). The EAT approach, furthermore, connects individual health to biospheric wellbeing.

Chapter summary

Over the millennia, artists have been fascinated with nature as both a subject to depict and a material to work with. Chapter 9 has explored the role of environmental art within the broad, encompassing sphere of the Environmental Humanities. Although environmental art continues to branch out—specifically in response to Anthropocenic change and climate alterations—this area of EH practice and theory has longstanding historical precedents in Indigenous art, environmental visual art, and environmental sculpture. This chapter summarized the primary genres of environmental art and provided an overview of recurring qualities in works, such as immersion, impermanence, and relationality. Since the 1960s and 1970s, environmental art has shifted increasingly away from aesthetic idealization of natural environments, for instance, as beautiful, picturesque, pleasing, harmonious, or balanced places. During the last fifty years, land-based and site-specific art, ecological art, and ecofeminist art have confronted complex environmental concerns. Environmental art therefore has become synonymous with ecoart. Recent specializations within ecoart—climate change art, ecodigital art, multispecies art, environmental artivism, contemporary Indigenous art, and environmental arts therapy—move fluidly across artistic boundaries, recognize the creative agencies of more-than-humans, develop ecopolitical critiques of social inequalities,

and involve the public as participants in the production of artworks. We conclude that—in ongoing dialogue with the natural sciences and technical research fields—art in the twenty-first century has the potential to catalyze enduring social, cultural, and environmental transformations.

Exercises

1. In the 1930s, French photographer Henri Cartier-Bresson rued, "The world is going to pieces and people like Adams and Weston are photographing rocks!" (quoted in Davis and Turpin 2015, 3). Cartier-Bresson was referring to American landscape photographers Ansel Adams and Edward Weston. Let's extend Cartier-Bresson's cynical appraisal of environmental photography to environmental art as a whole. What are the strengths of art in a world that is "going to pieces"? What are the limitations of art in addressing real-world ecological problems? Discuss at least *five* strengths and *five* limitations.
2. Design a site-based installation artwork that addresses *at least one* of the following five issues: (a) environmental racism; (b) air pollution; (c) species loss; (d) warming oceans; and/or (e) plastic waste. Referring to Waypoint 9.2, what qualities would the artwork incorporate? Where would it be located? Who would be involved? What would be its major themes? And what title would you select for the work? You are also welcome to sketch your proposed artwork.
3. Use *one or more* of the theories listed in Waypoint 9.3 to develop a critical analysis of architect Amanda Schachter and colleagues' *Harvest Dome 2.0* (2013), a massive floating orb constructed from old umbrellas and plastic bottles. View the project here at www.kickstarter.com/projects/481224446/harvest-dome-20 or elsewhere online. Which theories best describe how the artwork functions in communicating its environmental message?
4. Explore Naziha Mestaoui's light installation *1 Heart, 1 Tree*, projected during the United Nations Climate Change Conference (COP 21) in 2015: www.youtube.com/watch?v=0_Fa9w2YRPw. In what ways does the artwork adhere to—or depart from—Bullot's six functions of ecoart—tracking, broadcasting, emotions manipulation, cooperative action, environmental reflection, and art-science collaboration?
5. Devise an environmental arts therapy plan for climate change refugees who have been displaced from their homeland because of rising oceans and unprecedented storms. What kinds of therapeutic practices would you advise to enable them to express their grief, memorialize their homeland, and begin to connect with a new place?

Annotated bibliography

Casey, Edward S. 2002. *Representing Place: Landscape Painting and Maps*. Minneapolis: University of Minnesota Press. A well-known contemporary philosopher, Casey examines representations of the world and its diverse places. The study suggests that visual depictions of places often reflect a longing for embodied reconnection to the natural world.

Davis, Heather, and Etienne Turpin, eds. 2015a. *Art in the Anthropocene: Encounters among Aesthetics, Politics, Environments and Epistemologies*. London: Open Humanities Press. Downloadable as a free PDF, Davis and Turpin's edited collection is the most comprehensive source available on the subject of Anthropocene art. The book includes valuable contributions by critics and artists on technology, plastic, islands, plants, animals, and other current topics in the field.

Heginworth, Ian Siddons, and Gary Nash, eds. 2020a. *Environmental Arts Therapy: The Wild Frontiers of the Heart*. London: Routledge. This edited volume comprises five parts: contexts of environmental arts therapy; childhood, love, and attachment; femininity and masculinity; the cycle of the year and the seasons; and elderhood and death. The book is a must-have for readers interested in bringing ecoart into dialogue with environmental therapy.

Kastner, Jeffrey, and Brian Wallis, eds. 1998. *Land and Environmental Art*. London: Phaidon Press. This lavishly illustrated survey of contemporary environmental art focuses on site-specific installations around the world and details significant historical events. Including commentary by renowned critics and philosophers, the book covers Christo's *Running Fence*, Walter De Maria's *The Lightning Field*, and other seminal artworks.

Malpas, William. 2018. *Land Art: A Complete Guide to Landscape, Environmental, Earthworks, Nature, Sculpture, and Installation Art*. Maidstone: Crescent Moon Publishing. Originally published in 2003, this text introduces readers to significant land, environmental, and earthwork artists since the 1960s, including James Turrell, Michael Heizer, Robert Smithson, David Nash, Hamish Fulton, Alice Aycock, and others.

Sonfist, Alan, ed. 1983. *Art in the Land: A Critical Anthology of Environmental Art*. New York, Dutton. One of the earliest in-depth studies of the field, this book is an important reference for readers wanting to know more about the evolution of ecoart.

Weblinks

Agnes Denes Studio. This website provides an illuminating overview of Denes' biography, artworks, and writings over her remarkable fifty-year career. www.agnesdenesstudio.com

Brandalism. This international collective of artists resists the corporate domination of society, space, and ecology. http://brandalism.ch

Ecoart Network. Founded in 1999, this network brings together artists with interests in science and ecology. https://ecoartnetwork.org

EcoArt Project. Based in New York City, EcoArt Project organizes competitions, exhibitions, and salons. www.ecoartproject.org

Environmental Arts Therapy. Ian Siddons Heginworth's website provides a valuable introduction to the field. www.environmentalartstherapy.co.uk

Green Arts Web. This useful online resource lists key books and journals on environmental art. www.greenarts.org

Gugma Gaia. This environmental artivist collective is based in the Philippines but has global reach. https://gugmagaia.org

Japingka Aboriginal Art Gallery. This gallery in Freemantle, Western Australia is a center for contemporary Aboriginal fine arts and culture from across Australia, emphasizing ethical collecting, promotion of knowledge about Aboriginal culture, and support of community. https://japingkaaboriginalart.com/articles/understanding-aboriginal-art/

Lee, Shannon. "These 10 Artists Are Making Urgent Work about the Environment." Published on the Artsy website, this resource discusses Olafur Eliasson, Mary Mattingly, John Akomfrah, Agnes Denes, Tomás Saraceno, and other ecoartists. www.artsy.net/article/artsy-editorial-10-artists-making-urgent-work-environment

Mosher, Eve. *HighWaterLine: Visualizing Climate Change*. This is the main online resource for Mosher's ongoing ecoart project begun in New York City in 2007. http://highwaterline.org/about/

Smithson, Robert. *Spiral Jetty* (1970). This documentary is essential viewing for those interested in the impact of Smithson's *Spiral Jetty* on ecoart. www.youtube.com/watch?v=Dcw-llYF8_Q

Weather Project. This link provides key information on Olafur Eliasson's *The Weather Project*. www.tate.org.uk/whats-on/tate-modern/exhibition/unilever-series/unilever-series-olafur-eliasson-weather-project-0

References

Art Institute of Chicago. n.d. *"Chalk-Mirror Displacement."* Accessed September 1, 2020. https://www.artic.edu/artworks/93345/chalk-mirror-displacement.

Blanc, Nathalie, and Barbara Benish. 2017. *Form, Art, and the Environment: Engaging in Sustainability.* London: Routledge.

Boettger, Suzaan. 2011. "Earthworks." In *The Grove Encyclopedia of American Art*, edited by Joan Marter, 126–128. Oxford: Oxford University Press.

Brown, Katrina, Natalia Eernstman, Alexander Huke, and Nick Reding. 2017. "The Drama of Resilience: Learning, Doing, and Sharing for Sustainability." *Ecology and Society* 22 (2): 1–8.

Bullot, Nicolas. 2014. "The Functions of Environmental Art." *Leonardo* 47 (5): 511–512. doi: 10.1162/LEON_a_00828.

Davis, Heather, and Etienne Turpin. 2015b. "Art and Death: Lives Between the Fifth Assessment and the Sixth Extinction." In *Art in the Anthropocene: Encounters Among Aesthetics, Politics, Environments and Epistemologies*, edited by Heather Davis and Etienne Turpin, 3–29. London: Open Humanities Press.

De Maria, Walter. 1980. "The Lightning Field: Some Facts, Notes, Data, Information, Statistics, and Statements." *Artforum* 18 (8): 52–59.

Denes, Agnes. 1993. "Notes on Eco-Logic: Environmental Artwork, Visual Philosophy and Global Perspective." *Leonardo* 26 (5): 387–395.

Diverlus, Rodney. 2016. "Re/imagining Artivism." In *Artistic Citizenship: Artistry, Social Responsibility, and Ethical Praxis*, edited by David Elliott, Marissa Silverman and Wayne Bowman, 189–210. Oxford: Oxford University Press.

Goris, Yannicke, and Saskia Hollander. 2017. *Activism, Artivism and Beyond: Inspiring Initiatives of Civic Power.* Amsterdam: Partos.

Gregory, Jenny. 2009. "Stand Up for the Burrup: Saving the Largest Aboriginal Rock Art Precinct in Australia." *Public History Review* 16: 92–116. doi: 10.5130/phrj.v16i0.1234.

Heginworth, Ian Siddons. 2020. "Turning: The Emergence and Growth of Environmental Arts Therapy in the British Isles." In *Environmental Arts Therapy: The Wild Frontiers of the Heart*, edited by Ian Siddons Heginworth and Gary Nash, 9–26. London: Routledge.

Heginworth, Ian Siddons, and Gary Nash. 2020b. "Introduction by the Editors." In *Environmental Arts Therapy: The Wild Frontiers of the Heart*, edited by Ian Siddons Heginworth and Gary Nash, 1–5. London: Routledge.

Houser, Heather. 2020. *Infowhelm: Environmental Art and Literature in an Age of Data.* New York: Columbia University Press.

Kagan, Sacha. 2012. *Toward Global (Environ)Mental Change: Transformative Art and Cultures of Sustainability.* Berlin: Heinrich Böll Foundation.

Kwon, Miwon. 2002. *One Place After Another: Site-Specific Art and Locational Identity.* Cambridge: MIT Press.

Mathew, Deborah. 2001. "What is Ecofeminist Art? An Introduction to the WE Gallery." *Women and Environments International Magazine* 52/53: 10–11.

McKibben, Bill. 2005. "What the Warming World Needs Now Is Art, Sweet Art." *Grist* April 22.

Mosher, Eve. n.d. *"HighWaterLine: Visualizing Climate Change."* Accessed September 4, 2020. http://highwaterline.org/about.

Nakhnikian, Elise. 2018. "Interview: Andy Goldsworthy on Leaning into the Wind." *Slant Magazine.* Accessed August 30, 2020. https://www.slantmagazine.com/film/interview-sculptor-andy-goldsworthy-on-leaning-into-the-wind/.

Nurmis, Joanna. 2016. "Visual Climate Change Art 2005–2015: Discourse and Practice." *Wiley Interdisciplinary Reviews: Climate Change* 7: 501–516. doi: 10.1002/wcc.400.

Orenstein, Gloria Feman. 2003. "The Greening of Gaia: Ecofeminist Artists Revisit the Garden." *Ethics and the Environment* 8 (1): 102–111.

Sommer, Laura Kim, and Christian Andreas Klöckner. 2019. "Does Activist Art Have the Capacity to Raise Awareness in Audiences?—A Study on Climate Change Art at the ArtCOP21 Event in Paris." *Psychology of Aesthetics, Creativity, and the Arts* 13 (3): 1–16. doi: 10.1037/aca0000247.

Sommerer, Christa, Laurent Mignonneau, and Florian Weil. 2015. "The Art of Human to Plant Interaction." In *The Green Thread: Dialogues with the Vegetal World*, edited by Patrícia Vieira, Monica Gagliano, and John Ryan, 229–250. Lanham: Lexington Books.

Tate. n.d. "*Land Art.*" Accessed August 30, 2020. https://www.tate.org.uk/art/art-terms/l/land-art.

Thornes, John E. 2008. "A Rough Guide to Environmental Art." *Annual Review of Environment and Resources* 33: 391–411. doi: 10.1146/annurev.environ.31.042605.134920.

Wallen, Ruth. 2012. "Ecological Art: A Call for Visionary Intervention in a Time of Crisis." *Leonardo* 45 (3): 234–242.

10 Ecological literary studies

Imagining nature

Chapter objectives

- To assess the way literature and literary imagination build ecological awareness
- To review a history of how English-language literature imagines human–nature relations
- To demonstrate the process of analyzing literature from an ecological point of view
- To consider different methods and purposes for using literature to think about ecology and human–nature relations
- To describe the practical value of literature's lessons in how to dwell in the world

Can literature save the world?

Literary scholars and writers believe it can. The climate crisis, according to Indian novelist, Amitav Ghosh (2016), is a failure of imagination; a new environmental literature must train our imaginations to properly see anthropogenic climate change. American poet Brenda Hillman reasons that "the habits of mind learned from reading and engaging with poetry can counter a culture of greed, narcissism and blind destruction, and help the poetry reader to live with patience and attentiveness" (quoted in Fiedorczuk and Beltran 2015, 206). Literary scholar Lawrence Buell sums up the broad consensus when he proclaims that "The success of all environmentalist efforts finally hinges not on 'some highly developed technology, or some arcane new science' but on 'a state of mind': on attitudes, feelings, images, narratives" (Buell 2009, 1). Literature teaches knowledge, habits of mind, and empathy, necessary foundations for any real success in solving Anthropocene crises.

Reflection 10.1 "Poets are the unacknowledged legislators of the world"

Poet Percy Bysshe Shelley (1792–1822) was a great lyric and philosophical poet of the British Romantic period. His ideas about the power of literature are comparable to the statements of Ghosh, Hillman, Fiedorczuk, Beltran, and Buell. In "The Defence of Poetry," he wrote:

> A man, to be greatly good, must imagine intensely and comprehensively; he must put himself in the place of another and of many others; the pains and pleasures of his species must become his own. The great instrument of moral good is the imagination; and poetry administers to the effect by acting upon the cause. Poetry enlarges the circumference of the imagination by replenishing it with thoughts of ever new delight…Poetry strengthens that faculty which is the organ of the moral nature of man, in the same manner as exercise strengthens a limb.

> *"The Defence of Poetry," in Abrams and Greenblatt (2006, 844)*

DOI: 10.4324/9781351200356-10

Literature trains our sympathetic imagination so that we can think and feel altruistically, making us capable of acting ethically. This is obviously important if we are going to feel a moral obligation to animals, non-humans, and the environment. But literature is also the method humans have for synthesizing knowledge, allowing us to build new ideas. Shelley proposed that without literary imagination, we would drown in data. It's not just how we can see the forest from the trees, but how we can see the potential forest that could exist if we acted differently. Making something different means we first imagine it.

Literary critic Timothy Clark, on the other hand, is skeptical, arguing that the danger with equating literature's ability to change minds with social change is that it perpetuates "an illusion all too convenient for the destructive status quo" (2015, 21). For example, as ever-larger populations celebrate Earth Day each year, Australian officials have greenlighted the plan by Bravus Mining and Resources (previously known as Adani Australia) to develop the world's largest coal mine in the Galilee Basin of Queensland, Canada exploits the Tar Sands of Alberta, US leaders deny that fossil fuels cause climate change, and OPEC pumps more oil than ever. At one level, skeptics are right—stories and imagination are a poor defense against the organized power of multinational corporations and their government allies.

All true, and yet…

It is hard to think of a significant social transformation that has not combined hard-nosed pragmatism with inspiring stories, images, and ideas. Mass movements are created by appeals to imagination, not policy, facts, or reason. *But they are always combined with organizational muscle and the determination to confront powerful elites at every level* (Klein 2017). That second part is often missing from readers' and writers' idealist proclamations.

Case Study 10.1 Inspired by stories

Is the pen mightier than the bulldozer? In March 2017, the citizens' action group, Save Beeliar Wetlands, helped defeat Western Australia's conservative government (Gaynor et al. 2017). Against the advice of most impact studies and the will of local people, the government had rammed through a plan to build a road over one of Perth's last intact wetlands. Save Beeliar Wetlands united a broad coalition of Aboriginal and community resistance, but their efforts would have failed had they not sparked the imagination of voters across state and party lines. Success was a product, in equal measure, of brilliant organizing, strategic thinking, and popular storytelling, often right from the frontlines where bulldozers and police confronted peaceful, resolute citizens.

This is an example of what Naomi Klein calls "Blockadia": popular resistance to modernist development planning (Klein 2015). Save Beeliar Wetlands offered an alternative narrative of human cohabitation with ecosystems.

Other examples of the power of the pen include the campaign to stop hydraulic fracturing for natural gas in New York led by a grassroots coalition of artists, activists, and

scholars. Rachel Carson's *Silent Spring* has been credited with inspiring laws that banned DDT, and popular support for the EPA and Clean Air and Water Acts in the US.

Perhaps you know of other "Pen Power." What stories drove the Standing Rock protest? What about Indigenous-led opposition to Canadian tar sands or Brazil's industrialization of the Amazon? How about Ogoni resistance to Shell in the Niger Delta? What protections for the environment do you think the literary arts can achieve? What methods work and what are the limits of their reach?

Imagination *does* do the things writers and scholars say it does. It *can* inspire people to do extraordinary things, as individuals and as groups. But Clark is right to caution against overenthusiasm. It takes a long time and many initiatives to shift cultural narratives. Consider, for example, the way competing cultural narratives have led to political impasse on democracy in Hong Kong, guns in the US, Brexit in the UK, and ranching in Australia.

Waypoint 10.1 The sublime, the beautiful, and the picturesque

Literary representations of nature often fall into one of these three aesthetic categories. Each has different qualities and evokes different emotions and assumptions about nature. Immanuel Kant, William Burke, William Gilpin, and Friedrich Schiller were influential in defining the terms we still use today (see also Chapter 7 on environmental philosophy).

The **sublime** is rugged, rough, gigantic, massive, mysterious, and wild, like mountains, oceans, canyons, jungles. It provokes feelings of awe, reverence, terror, euphoria. Think of John Muir in the Sierras, Ansel Adams in Yellowstone, Thoreau on Katahdin, Wordsworth on Snowdon, Jack London's Yukon, and the "Man from Snowy River": manly encounters with "pure," "wild," nature, and a divine spirit animating all.

The **beautiful** is smooth, symmetrical, small, delicate, light and often related to something familiar and nearby like flowers, formal gardens, birds, cats, deer, fruit trees. It provokes feelings of peace, joy, happiness. Think Audubon's birds, Michelangelo's Venus, Wordsworth's "Daffodils," Mr. Woodhouse's garden in *Emma*: pretty, delicate, feminine, pleasurable encounters with beneficent, tame nature.

The **picturesque** is when a landscape looks like a picture—fairly regular, but with a pleasing irregularity thrown in, for instance, a meadow with trees, haystacks and red poppies. The Impressionists were masters of the picturesque, but other examples include John Constable's Stour Valley paintings, Mr. Knightley's farm in *Emma*, the UK Lake District, Keats' "To Autumn," and parts of Australia, though not nearly enough for English settlers. The picturesque evokes the pleasure of contrasts, of nature tamed yet with a hint of wild irascibility, the essence of rustic, rural, quaint.

Try using these categories on the images included in this chapter: which category do they fit? Can you use them to define landscapes where you live? What kind are portrayed in the literature you read?

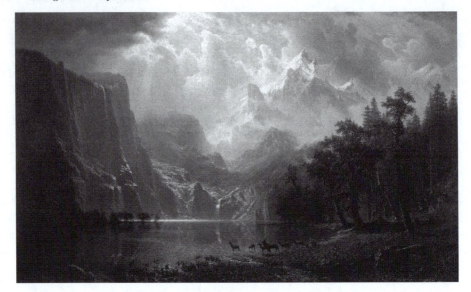

Figure 10.1 "Among the Sierra Nevada" (1868), by Albert Bierstadt.

Image credit: Wilton and Barringer 2002, 230–231 (Wikimedia Commons).

Clark's also right to cast doubt on the absurd notion of "saving the world." What we really mean is "saving humans" by preserving the biosphere on which humans depend. The Earth as a whole will go on whether humans exist or not. In the Anthropocene, saving humans means inspiring people to care more about a fragile biosphere that is not only beautiful, but also our life-support system. It means organizing and mobilizing large numbers of inspired people to force entrenched self-interests to start acting for the long-term benefit of humanity. Literary study can be part of that solution.

We'll start by looking at how literature has inspired care for nature and motivated mass movements. Then we can think about how scholars discern environmental ideas and beliefs conveyed by literature. Then we can make some claims about how the discipline contributes to the Environmental Humanities. Mostly we'll stay in the Anglo-American tradition, but we encourage you to apply the methods and frameworks to other literary traditions where you'll find important contrasts and analogies.

Literary environments

Through setting and situation, literature has always created environments for its subjects to unfold. Humans may be in the foreground, but we need a setting—a time and place—and some minimal situational context for thought, emotion, and action to *take place*. Even in the theater of the absurd, we exist some*where*. The place may "mirror" the author's actual environs, as in much realist narrative, literary journalism, or lyric poetry, or it may project imagined environments, as in sci-fi, fantasy, and much epic poetry. "Cli-Fi," or climate fiction, creates speculative scenarios about what climate change is doing and may do to environments—local and global—helping readers "see" how humans disrupt multi-scale ecosystems. Environments in literature will reflect the author's, ultimately the culture's, assumptions about what environments generally look like, how they function, how they're significant, and how they exist in relation to humans.

Reflection 10.2 Literary influences

Do you like hiking in the woods, climbing trees, or exploring streams? What about foraging berries, mushrooms, or nuts? Maybe your idea of a perfect day is lazing in the grass, gazing at clouds, or floating on ocean swells. Fishing, surfing, hunting, backpacking, skiing—waking up under a tree when dawn's raven's call echoes from a lake's shores.

What's your favorite outdoor pastime? What ideals of being in nature does it evoke? Can you trace any of them to reading? The *Hunger Games* inspired many girls to take up archery. Dr. Seuss's Lorax inspired a generation of Earth care.

Reading about human encounters with nature builds expectations for what marvelous things nature has in store for us. Many of Drew's expectations were formed by reading *Last of the Mohicans, Treasure Island, Swiss Family Robinson*, and later, Wordsworth's "Tintern Abbey." What are your literary influences?

Literary historians often mark the British Romantics (1789–1832) as initiating a new appreciation of nature. Many assert that the Romantics turned to nature in reaction to urban, industrial, economic, and technological changes that dramatically transformed what had been a rural, agricultural country; others suggest that newly discovered environments described by explorers and colonialists inspired Romantics to rethink human–nature relations. There is evidence for both: Defoe's *Robinson Crusoe*, Coleridge's "The Rime of the Ancient Mariner," and Mary Shelley's *Frankenstein* set the action in newly discovered worlds; Wordsworth's *Prelude*, John Clare's "The Lament of Swordy Well," and Jane Austen's *Mansfield Park* contrast the harmonizing influence of nature to urbanization, industrialism, and technological innovation.

Aboriginal Dreaming, Native American myth, Scandinavian song cycles, the Mesopotamian epic Gilgamesh, Greek myth, and the Hebrew Bible exemplify the long tradition of describing human–nature relations in literature, so the British Romantic return to nature is an innovation not an invention. So, what is novel about it? Let's consider an example from Wordsworth's poetry, "A Slumber Did My Spirit Seal" (1800), which offers a surprising acceptance of the interconnected web of nature in which humans are embedded:

A slumber did my spirit seal;
I had no human fears:
She seemed a thing that could not feel
The touch of earthly years.

No motion has she now, no force;
She neither hears nor sees;
Rolled round in earth's diurnal course
With rocks and stones and trees.

We like to start by reading with the poet, noting the most obvious details and trying to understand the intended meaning. Later, we can speculate about possible unintended meanings implied by the language or context. Let's start by noticing the obvious: Wordsworth has divided his poem into two stanzas separated by a blank space. The first stanza is in the past tense and the second is in the present. In the first stanza, the speaker describes a "slumber" that "sealed [his] spirit," suppressing "human fears." This led him to imagine that a girl or woman he knows is immune to "the touch of earthly years." Considering "earthly years" and "human fears" as metaphors for mortality and aging (what could be more human than

fearing getting old and dying?), we could rephrase the stanza thus: the speaker admits that he once deluded himself into believing that a girl he knows could never die. This is a fairly common delusion, particularly when you think about young people—so full of life they seem immortal. A final interesting point is that the speaker says that she "seemed a thing"—things are not alive and don't die, so to suggest that she is a thing—even if she's lively and animated—means that she is not human. We might pause to consider that paradox: the price of immortality is a loss of our humanity, our membership within a community of the living.

The second stanza takes us from the past to the present and notes a change in circumstances. What happened in the gap between the stanzas, between the past and the present? The implication is that she died—she was touched by "earthly years," mortality. But, ironically, this process has been humanizing for both "her" and the speaker. Before, she "seemed a thing" because the speaker fantasized that she transcended Earth as an immortal. Now, the speaker sees her as an earth-bound body commingled with "rocks and stones and trees" spinning around the sun. Her death proves that she is human, an identity she retains even as she's absorbed into the Earth. The speaker leaves us with an image of life's fragility but also its persistence.

Note how this poem cuts against Christian ideas of death. Wordsworth alludes to Genesis 3:19, when God tells Adam that he will "return to the ground, for out of it you were taken; you are dust and to dust you shall return" (Division of Christian Education 1952, 3). For Christians, death is God's curse, a reminder of our sinful, fallen nature, but it is also a liberation of our divine spirits which return to God.

In this poem, however, Wordsworth leaves out any reference to spiritualization. "She" has a purely physical nature. Like the rest of creation, we are bodies that emerge from the earth and return to it in a natural cycle. Note the soft "s" rhymes and alliteration, the regular meter, and the lack of punctuation in the last two lines: the quiet, reverential hush indicates the speaker's contentment. Death does not cause repressed "Human fears" to burst out in weeping, rage, or submission to God; instead, fear of mortality dissipates in calm assurance that we are all part of an interconnected web of living matter.

Comparing this poem's idea of human–nature relations to dominant ideas in the late Enlightenment illustrates what else is different about Wordsworth. Most Enlightenment theologians, philosophers, and naturalists saw the world in dualist terms, with absolute divisions between living and dead, soul and body, human and nature (see Chapter 7). Wordsworth's poem unifies these opposites into a web of interdependencies. Humans are a part of nature, not apart from nature. That idea is often repeated in Romantic writing: consider *Frankenstein*'s monster, Coleridge's "The Rime of the Ancient Mariner," Part Four, or Percy Shelley's *Prometheus Unbound*, Act IV. It is a concept that starts us on the path to Darwin's image of a tangled bank in *The Origin of Species* (1859) and then Frederic Clements' idea of the harmonious equilibrium in climax forests (1916) and then to Donna Haraway's "natureculture" in *When Species Meet* (2004).

Case Study 10.2 Nature tropes

Literature depicts nature through figurative language: image, metaphor, simile, symbol, personification. These are called "tropes," a Greek term for words that "figure" or "depict." Excavating the dominant tropes from literature gives insight into that culture's ideas and beliefs about nature and human–nature relations. The following is drawn from Greg Garrard's (2012) definitions.

Pastoral: Evolved from Greek and Roman literatures, the pastoral evokes an idealized European Nature—idyllic, peaceful, abundant, harmonious, and picturesque. In its more pantheistic forms, nature is a benevolent divinity, like John Keats' "Season of

mists and mellow fruitfulness" in "To Autumn." It can be an escapist fantasy encouraging us to ignore real nature, or it can be a setting that attunes us to the nonhuman, as in Coleridge's "Frost at Midnight."

Wilderness: In pre-modern literatures, wilderness is a place of exile, suffering, and evil, but since the Romantic period (1789–1832), it has defined untamed landscapes. If the pastoral is gentle, nurturing, and harmonious, the wilderness is sublime. For William Cronon, the wilderness trope perpetuates an illusion that nature is the:

> unfallen antithesis of an unnatural civilization that has lost its soul. It is a place of freedom in which we can recover our true selves we have lost to the corrupting influences of our artificial lives. Most of all, it is the ultimate landscape of authenticity
>
> Cronon (1996, 80)

We invoke the wilderness idea when we preserve "wild" areas but tolerate degraded environments at home. In contrast, Gary Snyder points out that even "our bodies are wild" (quoted in Garrard 2012, 91).

Apocalypse: With violent, grotesque images, apocalypse suggests a titanic struggle between good and evil, and a prophetic warning to change our behavior before it's too late. "Apocalypse is the single most powerful master metaphor that the contemporary environmental imagination has at its disposal" (Buell 1995, 285). It has dominated environmentalist discourse from Thomas Malthus' *Essay on the Principle of Population* (Appleman 2004) to Rachel Carson's *Silent Spring* (1962). Climate change is often represented with the apocalyptic trope; as in Leonardo DiCaprio's film, *Before the Flood* (2016).

What kind of tropes are at work in the landscape images in this chapter? What relationship between humans and the environment is suggested by the tropes? What are the hidden implications? What about the literature you read? Something like Tolkien's *The Lord of the Rings* might include multiple tropes at once.

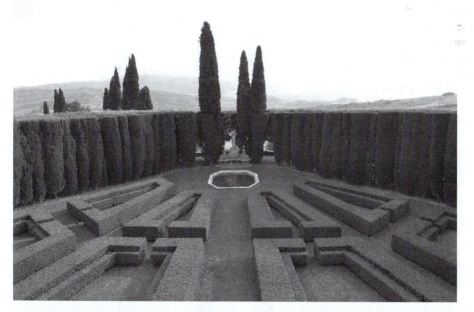

Figure 10.2 "Gardens in Villa, Tuscany" (2016).

Image credit: Awaxi (Wikimedia Commons).

Romanticism is still a dominant way of thinking about nature. You may unconsciously repeat Wordsworthian ideas if you think of being in nature as restful, healing, and sacred (see Wordsworth's "Lines Composed a Few Miles above Tintern Abbey," stanza 2). Romantic ideas influenced people to preserve nature, something almost incomprehensible prior to the nineteenth century. Until then, in Western cultures, nature tended to be construed as an enemy, a waste, or a raw material. Civilization's purpose was, for the most part, to turn nature into useful products, tame it, or develop it. The Romantic period flipped that narrative on its head. Suddenly, civilization threatened pure, wild nature. Too much civilization weakened humanity with labor-saving technologies and comforts. Additionally, civilization polluted nature, destroying its capacity to revitalize and reconnect humans with God's sacred Creation. A "back to nature" movement was born (Worster 1994).

Ralph Waldo Emerson and Henry David Thoreau theorized and experimented with these ideas (see Chapter 1). While Wordsworth and Emerson speculated about returning to nature, Thoreau puts the ideas to the test. Some years later, Walt Whitman and John Muir followed suit, glamorizing hard living in rural outbacks for civilized white men. "Going Bush" meant shedding civilization's false temptations in order to confront reality in its purest form, a "macho Romanticism" cultivated by Theodore Roosevelt and a host of late nineteenth-century adventurers and survivalists, including proto-environmentalist hunting, fishing, and outing clubs.

The Romantics got us to think differently about nature and the human, but new ideas have developed since then. Science was a major reason, as the amateur naturalism practiced by so many literary writers in the eighteenth and nineteenth centuries was codified into biology, geology, botany, zoology, and so forth. Literature influenced Darwin who influenced Victorian writers from Tennyson to Matthew Arnold, Thomas Hardy, George Elliot, Gerard Hopkins, and Jack London.

But science is by no means the last word on nature. Literary writers reformulate scientific ideas, field-testing them, so to speak. By studying human emotions, perceptions, and reactions to being in specific environments, often in conjunction with non-Western traditions, writers have influenced science. Furthermore, science tells us nothing about the value of nature, only how it functions. We turn to literature and the humanities generally to understand why nature is meaningful.

Modern and contemporary writers continue to ask the same questions Romantics did: what is the difference between nature and human? Important American writers who wrestled with that question include Robert Frost, Wallace Stevens, Zora Neil Hurston, Langston Hughes, Gary Snyder, Edward Abbey, Wendall Berry, Annie Dillard, Terry Tempest Williams, Barry Lopez, Linda Hogan, Rachel Carson, Derek Wolcott, and Mary Oliver. Some of them still agree that nature is indeed "the nurse, / The guide, the guardian of [our] heart, and soul / Of all [our] moral being" ("Lines" l. 110–112, Wordsworth 2000).

These nature writers have also dramatically extended the Romantic influence on mass movements. Since the late nineteenth century, literary ideas of nature have been central to all levels of environmental work, from local land preservation and the creation of national parks and walking trails to environmental justice. Literature has inspired fights for clean water, air, endangered species, and equal access to green spaces. Activists recite literature when they mobilize to stop dams, bridges, industrial plants, nuclear power stations, ocean dumping, logging, fossil fuel development, pipelines, land development, and exploitive animal technologies around the world—and when they hold powerful elites responsible for damages. Today, if you ask an environmentalist what he or she is fighting for, you'll likely hear an idea of nature that can be traced back to literary sources. And that's not just because activists are idealistic. The literary argument for nature is strong and practical: if healthy, functioning

ecosystems are the sacred, moral center of our being, you cannot compromise on how we treat it. By contrast, scientists calculate compromise up to supposedly identifiable thresholds.

So how do you decode literature's ideas of nature? And how can you start recognizing the way literature shapes and is shaped by our ideas of nature? Let's turn to tools of the trade.

Reading literary environments

Good reading starts with choosing a focus and following a logical line of questions. You are seeking evidence in the text to support your understanding of the meaning. If there's not enough evidence, your interpretation was wrong: reread. Expect a process of trial and error. As E. D. Hirsch explained, you are looking for the *most* probable, *defensible* meaning from among a limited set of possible meanings (Hirsch 1960).

To read a text for its literary environment, there are two main focal points. The first is thinking *about* literature, often through a historical lens. You can ask what specific idea of nature is represented in a work of literature, where it came from, and how it shaped future thinking. You can recognize this method in our earlier analysis of "A Slumber Did My Spirit Seal."

A second approach is thinking *with* literature, participating in the text's imaginative work of constructing an environment. You can ask whether the literature teaches you how to perceive interconnectedness, or what Timothy Morton (2010) calls "ecological thought." Two important types of ecological thought are "thinking complexity" and "scale framing" (Clark 2015). Applied to literary environments, thinking complexity means looking for the reciprocal yet contradictory and unequal relations that sustain a system. Scale framing means considering how small systems, like a community or forest, are always nested within larger systems, like a city or watershed. What is sustainable or moral at one level may be unsustainable and immoral at another, creating new dilemmas for deciding on the right course of action (Heise 2008). For example, when an upstream community fertilizes its lawns, nitrogen runoff can cause toxic algae blooms on the downstream end of the watershed. Literature that teaches scale framing and thinking complexity can prepare readers intellectually and ethically to work through the "wicked problems" of the Anthropocene (Clark 2015).

Reflection 10.3 The Ecological Thought

How do we think about the planet? Literary philosopher, Timothy Morton (2010), identifies "The Ecological Thought" as thinking interconnectedness: not thinking about interconnectedness, but the act of perceiving existence as a vast, interconnected mesh. It "includes all the ways we imagine how we live together…existence is always coexistence" (4). Aldo Leopold's essay, "Thinking Like a Mountain" is ecological thought.

For Morton, all art requires ecological thought, and ultimately always refers back to its own "environing" process. Art doesn't just reflect the world so much as create a world; thus ecological thinking is hardwired into art and even language.

Environmental literary criticism ("ecocriticism") aims to expose a text's ecological thought, which is often ignored, concealed, or repressed. Thus Lawrence Buell (2009) refers to a text's ecological thought as its "environmental unconscious": a knowledge of interconnectedness or coexistence suggested in a text. There can be an activist edge to ecological thought: calling people to account for the limited ways that they prefer to

imagine the world. Many capitalists, for example, ignore knowledge of the externalities—climate change, extinction, toxicity, wage slavery—created by their business practices. Modern people think of themselves as unique individuals, repressing the fact that we are walking ecosystems of symbiotic microbes. Art can encourage the ecological thought; it can also disguise it, like the Wizard of Oz.

What about you? Can you think the ecological thought when you read literature and look at the world? Be careful—as Morton remarks, once you start, you can't stop thinking ecologically!

You can follow the steps of the first approach by referring back to our "Slumber" analysis. We started by noticing details of setting and situation, imagery and figurative language, particularly descriptions of non-humans and landscapes. We observed the way characters and speaker interacted with or reflected on non-humans and their environment. We considered whether there was any conflict among characters about how to treat non-humans and the environment, and if there were any consequences for certain treatment. Then we stated the text's human–non-human relationship and considered whether it is destructive or beneficial to thriving ecosystems. We explained why that is, then inferred what ideas, beliefs, or assumptions drove the representation of nature in this text. If you're going to write a longer, researched essay, you would trace that idea to other literature, art, philosophy, law, politics, economics, and science of the time. As we did with "Slumber," you might try to demonstrate that this idea of human–nature relations is an alternative to, or critique of, a dominant cultural narrative; conversely, you might show that it is symptomatic of dominant ideas.

The second approach is a bit harder because it requires playing some philosophical "what if" games. You can follow a similar process for summarizing the text's intended idea of nature, but then ask a different set of questions: what could this literary work teach us about living in our environment that we don't know or have forgotten? Could reading it train our imaginations to scale up our habits of mind so that we can think across complex, linked, multi-scale systems, and manage the paradoxes and contradictions of being human in the Anthropocene? Note how you are using the work of literature as a model for ecological thinking—you're thinking *with* the text, not just *about* the text.

Waypoint 10.2 Ecocriticism

Nature writers like Thoreau, Wordsworth, Muir, and others inspired the environmental preservation movements of the late nineteenth century. For example, John Muir was responsible for founding the Sierra Club and persuading Theodore Roosevelt to preserve Yosemite, while Wordsworth is credited with inspiring the UK's Land Trust movement. Preservationism inspired a new set of nature writers in the mid-twentieth century (Aldo Leopold, Rachel Carson, Edward Abbey) who inspired a broader and more politically active, justice-oriented environmentalism (Buell et al. 2011). This integration of literature and activism fused in the 1990s as a new critical reading practice called "ecocriticism." Ecocriticism studies "the relationship between literature and the physical environment" (Glotfelty and Fromm 1996, xix). In the 1990s,

ecocriticism focused on non-fiction nature writing, but since then has been applied to other forms of literature, writing, film, TV, digital media, art, architecture, design, and cultural behaviors (Garrard 2012, 5). Its goal is to "evaluate texts and ideas in terms of their coherence and usefulness as responses to environmental crisis" (Kerridge and Sammells 1998, 5). Like critical race studies and feminism, ecocriticism blends scholarship with activist purpose.

Here is an example of the second approach. Aldo Leopold's famous essay, "Thinking Like a Mountain," begins:

> A deep chesty bawl echoes from rimrock to rimrock, rolls down the mountain, and fades into the far blackness of the night. It is an outburst of wild defiant sorrow, and of contempt for all the adversities of the world. Every living thing (and perhaps many a dead one as well) pays heed to that call. To the deer it is a reminder of the way of all flesh, to the pine a forecast of midnight scuffles and of blood upon the snow, to the coyote a promise of gleanings to come, to the cowman a threat of red ink at the bank, to the hunter a challenge of fang against bullet. Yet behind these obvious and immediate hopes and fears there lies a deeper meaning, known only to the mountain itself. Only the mountain has lived long enough to listen objectively to the howl of a wolf.
>
> Leopold (1949, 129)

The passage is rich in sensory data, evoking an entire ecosystem. A sound links each listener in a web of unequal relations—competing, predatory, symbiotic, parasitic—that together composes a whole, the mountain ecosystem, greater than the sum of individual members. At small levels of scale, individuals see the wolf as a threat to be exterminated in their self-interested pursuit of "safety, prosperity, comfort, long life, and dullness" (Leopold 1949, 133). But if we shift up to the mountain's level of scale, we see that the wolf prevents these individual interests from destroying the ecosystem on which they all depend. It's not that the individuals are wrong to pursue their own interests; they're just short-term, simplistic, small-scale thinkers. Only the mountain can "think" at the appropriate level of scale and complexity to understand the dynamic balance of interdependent populations necessary to sustain an ecosystem.

By modeling "thinking like a mountain," the story encourages us to "think ecologically" about how our competitive self-interests must be regulated by empathy, reciprocity, synergy, and cooperation at higher levels of scale. How would thinking like a mountain change your self-interested pursuits in, say, what to eat, what shirt to buy, how to commute?

Reflection 10.4 The Big Bad Wolf

Regarding the wolf as a threat to be exterminated in the pursuit of "safety, prosperity, comfort, long life, and dullness" is not that strange. Fairy tales like "Little Red Riding Hood" memorialize our ancient terror of predators like wolves, tigers, lions, sharks. What other literary references to predators can you find? Do you think modern civilization can learn to live with these animals?

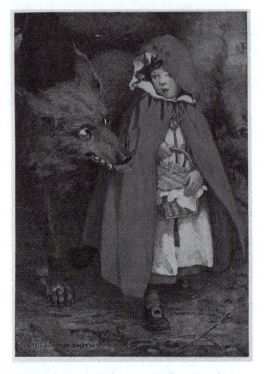

Figure 10.3 "Little Red Riding Hood" (1911), by Jessie Willcox Smith.

Image credit: Wikimedia Commons.

Aldo Leopold (1887–1948) was an internationally respected animal ecologist who literally wrote the book on *Game Management* (1933). But the collection of essays in *A Sand County Almanac* (1949) was (and is) revolutionary because it teaches that ecological thinking should drive both economics and ethics (see Chapters 1 and 7). He considers that "our present problem is one of attitudes and implements … the belief that economics determines all land-use," and an overabundance of enormously powerful technologies (Leopold 1949, 225–226). Economic thinkers "abuse land because [they] regard it as a commodity belonging to us" (viii), an overly simplistic view. Leopold thought that scaling up from economic to ecological thinking was how societies evolved: "When we see land as a community to which we belong, we may begin to use it with love and respect" (viii). If our culture can "think like a mountain," we will have evolved the attitudes necessary to use our land and technologies with "love and respect."

Learning to "think like a mountain" trains our minds to toggle back and forth between different levels of scale and complexity, perhaps *the* important skill for effectively addressing Anthropocene crises. Nearly every nature writer—from Brenda Hillman and Gary Snyder to Amitav Ghosh and Rachel Carson—uses literature to build that kind of the intellectual capacity.

We hope this exercise in "ecological thought" demonstrates that reading and writing can contribute to a more ecologically oriented human society. But remember Timothy Clark's caution that ideas themselves don't cause change. You have to put your words into action. To be effective change-agents, writers, and readers of environmental literature cannot stop at the printed page (Fiedorczuk and Beltran 2015, 206). How could you start putting your literary ideas into action? Well, why not start where all change starts: at home?

Waypoint 10.3 Green imperialism and postcolonial Environmental Humanities

Green imperialism names the process of extending power over the biosphere, the cataloging and reorganization of biota that accompanies all empires. The modern colonialist period which began in the sixteenth century irreversibly altered global biology.

An Environmental Humanities informed by postcolonial theory investigates the ecological violence and displacement in the history of globalization and imperialism (Deloughrey et al. 2015). If the dominant narrative of imperialism and capitalism celebrates universal progress, modernization, and triumph over nature, postcolonial Environmental Humanities exposes the repressed, Indigenous counter-narratives, injustices, uneven development, and inequality. By recovering experiences of environmental dispossession, postcolonial environmental humanists hope to halt green imperialism and support environmental justice movements.

The work of Nigerian writer Ken Saro-Wiwa, Caribbean poet Derek Walcott, and Australian novelist Kim Scott are good places to start. Rob Nixon's (2011) work on the "environmentalism of the poor" provides some essential framing and history.

Being at home in the world

The Greek word for home, *oikos*, forms the root of *ecology*, which literally means "knowledge of home." Etymologically, the ecological thought is knowledge of the complex interdependencies and links across scales that sustain our home, planet Earth. It could also be knowledge of how to create a home or be at home within a local place; in short, how to *dwell* in and with a complex interdependent nature (see Chapter 5). Much early ecocriticism examined the way reading literature could make us conscious of how we can dwell harmoniously.

For example, Gary Snyder's essay collections, *A Place in Space* (2008) and *The Practice of the Wild* (2010), offer meditations on how modern humans can "re-inhabit" Earth. This means developing attention to the interdependent matrix of wild creatures sustaining the places where we live. Rather than trying to adapt the world to our needs, which diminishes the world, we can focus on adapting to the world. We can call this "learning to dwell."

The widespread feelings of alienation, angst, and purposelessness have long been linked to modernity's disregard of dwelling. Modern economies and geopolitical conflicts push people out of their homes into squalid urban slums and refugee camps; war, environmental destruction, pandemics, and financial uncertainty create mass homelessness and migration. The lack of stability is felt across class, race, and nationality so that now most of us feel it is normal to bounce from one utilitarian space to the next. Some even imagine that placelessness is freedom. Yet, sociology demonstrates that the ability to identify with a place is the necessary first step toward developing identity, belonging, and purpose. Maybe a society without a sense of place is directionless (Chapter 5). Thus, a literature of *oikos*, ecological literature, can be an antidote to modernity's displacements and a first step toward learning how to be at home in the world.

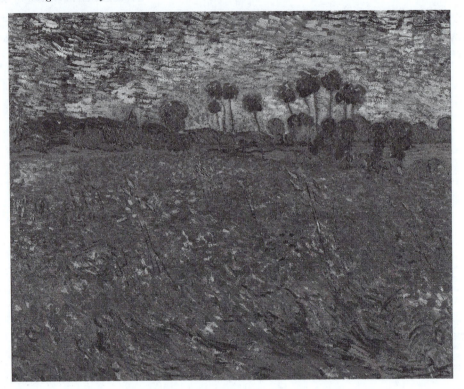

Figure 10.4 "Poppy Field" (1890), by Vincent van Gogh.

Image credit: Wikimedia Commons.

Waypoint 10.4 Dwelling

Ecology, derived from the Greek *oikos* and *-ology*, is literally "the study of home." Literary images of "dwelling" suggest how to "be at home in the world," in contrast to pastoral and wilderness tropes, which figure places away from home. Dwelling also contrasts with apocalypse tropes that envision what may befall "home" if we don't mend our ways. Philosophers Martin Heidegger and Arne Næss theorize dwelling as the foundation of ecological ethics.

Ecocritics often celebrate writers for how they imagine humans dwelling, from which they derive ethical principles for living responsibly within ecosystems. American writer Wendell Berry describes dwelling as the process of developing reciprocal relations with the biotic community; for him, "being at home in the world" is when we become most fully human.

Yet others use dwelling as a test of belonging: "who dwells" can divide "insiders" from "outsiders," or natives from immigrants. Debates over who belongs are at the center of opposition to immigrants and refugees around the world. Dwelling is the central philosophy in "blood and soil" fascism.

Does dwelling have value for distinguishing ethical living? Can it be separated from exclusionary politics? Once you start formulating standards for how to be "at-home-in-the-world," you can easily slip into discriminating between who belongs and who doesn't. Find some literature that represents dwelling: how is it used?

Environmental literature shows us how to "see" the places where we live, revaluing what we've overlooked or ignored, and entering into more reciprocal relationships of care. Literature's ability to "see it new" can often reframe our ordinary places with startling urgency:

so much depends
upon

a red wheel
barrow

glazed with rain
water

beside the white
chickens.

William Carlos Williams' statement in "The Red Wheelbarrow" (1923), "so much depends" seems overly dramatic in relation to the ordinary domestic details that follow. Unless, that is, your livelihood, comfort, and peace depend upon the webs of relations hinted at in the sketch. A sense of being "at home" means knowing intimately the individuals that make up the larger whole, and the dynamic, reciprocal relations that allow us to claim belonging in that place, to say that "we dwell here" and this is our home. Literature can help us relearn how to dwell on this planet, initiating a cognitive evolution that modern humans desperately need if we are to address our environmental crises. If we do that, we'll have to acknowledge poets as the legislators of that new world we build.

Case Study 10.3 Climate Change Narratives

Within the last twenty years, there has been a boom in stories about a world affected by the changing climate. Often, these stories fit into the genre of "science fiction," a subgenre of "speculative fiction." "Cli-fi," as this subgenre is now known, often presents "apocalyptic" visions of future environments reshaped by catastrophic climate change. As Adam Trexler notes, the roots of cli-fi go back to the Cold War, and the eco-thriller has always featured in storytelling (Trexler 2015).

Both serious literature and pulp fiction thematize climate change, and both can be considered an influential means for disseminating the science of climate change. Margaret Atwood, Jeannette Winterson, Barbara Kingsolver, Kim Stanley Robinson, Ian McEwan, T. C. Boyle, and Octavia Butler are among the more literary writers. Many films now address climate change, *Avatar* (2009) and *Snowpiercer* (2013) most dramatically.

What these narrative artists confront, of course, is the challenge of representing climate change, which is not only abstract and "unsituated," but also a collective problem. That collective focus does not fit the modern novel's focus on individual moral adventure (Ghosh 2016). Even novels that have skillfully integrated the science of climate change, like Kingsolver's *Flight Behavior* (2012), retain a focus on the individual protagonist's moral adventure (Clark 2015, 182).

Can literature adequately represent climate change, or any of the other planetary crises in the Anthropocene? Trexler is optimistic. Whether fiction can inspire collective action is a yet more vexed question. As we noted, changing the cultural narrative is a long, slow process, but this is what cli-fi attempts to do.

Have you read any "cli-fi"? Has it shaped your attitudes toward climate change? Recent titles include Ghosh's *Gun Island* (2019), Kim Stanley Robinson's *Ministry for the Future* (2020), Jenny Offil's *Weather* (2020), and Lynda Millet's *A Children's Bible* (2020). Identify a book that has been influential and explain how, pointing to specific examples in your behavior.

How we dwell on this planet we call "home" is a significant area of concern for ecological literature, but other areas are also important. Critical animal studies examines how literature represents human relations to animals and other living beings. Postcolonial ecocriticism evaluates how literature both supports and challenges global forces of economic and political domination that have disproportionately damaged the environments on which poor and Indigenous people depend. Posthumanism looks at how literature engages our definition of "the human," human exceptionalism, and anthropocentrism. Empirical ecocriticism applies social scientific methods to the analysis of environmental art—often involving quantitative and qualitative analyses—to test the central claims of the Environmental Humanities, namely that literature encourages ethical attitudes and promotes responsible actions toward the natural world. New materialism attends to the way literature represents matter as having a kind of agency, generally a quality reserved for humans. And biosemiotics examines the way everything that lives, from cells to biospheric entities, communicate through some form of sign system. These new ecocritical directions are informed by the sciences, other humanities, and social sciences. Traditional literary analytical skills are the vital core of all ecocriticism. As you add more knowledge to your arsenal, you will be able to frame your questions about how literature represents "the environment" in more exciting and interesting ways.

Chapter summary

This chapter has examined the way literature has embodied ideas about human–nature relations and encouraged us to think ecologically. The British Romantic period marks a shift in ecological understanding, repurposing pastoral, wilderness, apocalypse, and dwelling tropes to challenge assumptions that humans stood apart from nature. More recent literature continues to ask the question, "what is the human place in the world?" describing the emotional, intuitive, and spiritual meaning of being a part of interdependent webs of co-creating life. Can we relearn how to dwell in this world? Our survival may depend on the wisdom and empathy that environmental literature can impart.

Exercises

1. Select a particular outdoor place and return to it every week for at least a half-hour, both physically and creatively. While you are in your place, practice sensory attention to everything within the boundaries. Write a series of ten meditations about your experience

of place: for example, how the natural and built environments intersect and collide; how the place appears to each of your senses; how the place evolves through time; how climate change will affect your place, and so forth. The final meditation should reflect on whether this experience of "embedding in place" has increased your sense of belonging and responsibility (from Lawrence Buell 2009).

2. Use "scale framing" on a work of literature. Start with the protagonist's "human scale": how are his or her actions, decisions, point of view, and values shaped by the human scale? Then increase the scale to the level of bioregional or socio-natural ecosystem which are implied in the setting. How is his or her current behavior at odds with the interests of the bioregion or ecosystem? If the protagonist were "thinking like a mountain," how would his or her behavior change? Considering these scale conflicts, what is the "least worst action" that the protagonist should take? How different is that from what he or she does take?

3. Take any favorite work of literature and analyze its representation of the environment. How would you classify that representation, using the tropes listed in Case Study 10.2? Is it sublime, beautiful, or picturesque (Waypoint 10.1)? Is the environment background or foreground, or co-shaper of the human action? Does it encourage you to "think ecologically"? How might you argue for its help or hindrance in inspiring readers to remedy anthropogenic threats to the environment?

4. Take your meditation journal from exercise one and turn it into a collected edition of personal essays. Consider incorporating other expressive art: sampled music, photographs, painting, drawing, found art, film. Write an introduction that reflects on how literature inspires ecological thought and a practice of dwelling. Append an annotated bibliography of works that inspired your ecological thought. Create a PowerPoint or other multimedia presentation that you can share.

Annotated bibliography

The field of literature and environment is enormous, so we restrict our recommended reading list to a few anthologies that will get you started, plus a classic guide to ecocritical work. You can also look for writing by the authors we've mentioned in this chapter.

Adelson, G., Engell, J., Van Anglen, K.P., Ranalli, B. 2008. *Environment: An Interdisciplinary Anthology*. London: Yale University Press. A topically oriented anthology of key works in the sciences and humanities reflecting the place of the human on earth; it builds science literacy while emphasizing the importance of humanities disciplines like literature for addressing Anthropocene crises.

Garrard, Greg. 2012. *Ecocriticism. The New Critical Idiom*. 2nd ed. London and New York: Taylor & Francis. This short introduction to the method of environmental literary analysis covers key terms and approaches, reviews the method's origins and development, and offers further reading.

Keegan, Bridget and James C. McKusick. 2001. *Literature and Nature: Four Centuries of Nature Writing*. London: Pearson. This anthology includes the essential Anglo-American nature writing in poetry, prose, fiction, non-fiction, travel writing, and essay from the Renaissance to the end of the twentieth century. Its lack of other Anglosphere and world writing is a liability, but it is a foundation on which to build.

Vidya Sarveswaran, Scott Slovic, Swarnalatha Rangarajan. 2019. *Routledge Handbook of Ecocriticism and Environmental Communication*. London: Taylor & Francis. This anthology of scholarly essays on environmental literature and communication arts charts the history and current practice of analyzing human–nature relations in cultural forms. International in scope, it considers how new trends in information technology are changing the field.

Weblinks

Dragonfly.eco is an excellent database dedicated to literature about our natural world and the human relation to it. It features recent environmental fiction from around the world, including cli-fi, popular, highbrow, children's, young adult, criticism, author interviews, news, and reviews. https://dragonfly.eco/

Humanities for the Environment Global Network is an exciting, broad-ranging website documenting the way humanities and the arts can contribute to solving global and local environmental problems. It curates past projects and material to guide you in developing your own projects. https://hfe-observatories.org/

The Association for the Study of Literature and the Environment is the leading international organization for literature and environment studies, with links to other regional affiliates in Australasia, Europe, and North America. It has many resources for further study, including the flagship journal *ISLE*, and discussions of the topics addressed in this chapter. www.asle.org

The Rachel Carson Center for Environment and Society hosts a trove of digital content related to culture and the environment. It is of interest to teachers, scholars, students, and the general public. www.environmentandsociety.org

References

Abrams, Meyer Howard, and Stephen Greenblatt. 2006. *The Norton Anthology of English Literature*. 8th ed. Vol. D. New York and London: W. W. Norton.

Appleman, Philip, ed. 2004. *An Essay on the Principle of Population by Thomas Robert Malthus*, 2nd ed. A Norton Critical Edition. New York and London: W. W. Norton.

Buell, Lawrence. 1995. *The Environmental Imagination: Thoreau, Nature Writing, and the Formation of American Culture*. Cambridge: Harvard University Press.

Buell, Lawrence. 2009. *Writing for an Endangered World*. Cambridge: Harvard University Press.

Buell, Lawrence, Ursula K. Heise, and Karen Thornber. 2011. "Literature and Environment." *Annual Review of Environment and Resources* 36: 417–440.

Carson, Rachel. 1962. *Silent Spring*. Boston and New York: Houghton Mifflin.

Christie, Douglas E. 2017. "Nature Writing and Nature Mysticism." In *Routledge Handbook of Religion and Ecology*, edited by Willis Jenkins, Mary Evelyn Tucker and John Grim, 229–236. New York and London: Routledge.

Clark, Timothy. 2015. *Ecocriticism on the Edge: The Anthropocene As a Threshold Concept*. London: Bloomsbury.

Cronon, William. 1996. "The Trouble with Wilderness: or Getting Back to the Wrong Nature." In *Uncommon Ground: Rethinking the Human Place in Nature*, edited by William Cronon, 69–90. New York: W. W. Norton.

Deloughrey, Elizabeth, Jill Didur, and Anthony Carrigan, eds. 2015. *Global Ecologies and the Environmental Humanities: Postcolonial Approaches*. London: Routledge.

Division of Christian Education, National Council of the Churches of Christ, USA. 1952. *The Holy Bible, Containing the Old and New Testaments*. Revised Standard Version. New York and Glasgow: William Collins, Sons.

Fiedorczuk, Julia, and Gerardo Beltran. 2015. *Ecopoetics: An Ecological "Defence of Poetry"*. Varsovia: Museo de Historia del Movimiento Popular Polaco.

Gaynor, Andrea, Peter Newman, and Philip Jennings, eds. 2017. *Never Again: Reflections on Environmental Responsibility after Roe 8*. Perth: University of Western Australia.

Ghosh, Amitav. 2016. *The Great Derangement: Climate Change and the Unthinkable*. Chicago: University of Chicago Press.

Glotfelty, Cheryll, and Harold Fromm, eds. 1996. *The Ecocriticism Reader: Landmarks in Literary Ecology*. Athens: University of Georgia Press.

Heise, Ursula K. 2008. *Sense of Place and Sense of Planet: The Environmental Imagination of the Global*. Oxford: Oxford University Press.

Hirsch, Eric D. 1960. "Objective Interpretation." *PMLA* 75 (4): 463–479.

Kerridge, Richard, and Neil Sammells. 1998. *Writing the Environment: Ecocriticism and Literature*. London: Zed Books.

Klein, Naomi. 2015. *This Changes Everything: Capitalism vs. The Climate*. London: Penguin Books.

Klein, Naomi. 2017. *When No is Not Enough: Resisting Trump's Shock Politics and Winning the World We Need*. Chicago: Haymarket Books.

Leopold, Aldo. 1949. *A Sand County Almanac, and Sketches Here and There*. New York and Oxford: Oxford University Press.

Morton, Timothy. 2010. *The Ecological Thought*. Cambridge: Harvard University Press.

Nixon, Rob. 2011. *Slow Violence and the Environmentalism of the Poor*. Cambridge: Harvard University Press.

Snyder, Gary. 2008. *A Place in Space: Ethics, Aesthetics, and Watersheds*. Berkeley: Counterpoint Press.

Snyder, Gary. 2010. *The Practice of the Wild*. Berkeley: Counterpoint Press.

Thoreau, Henry D. 2008. "Walden." In *Walden Civil Disobedience and Other Writings*, edited by William Rossi. New York & London: W. W. Norton.

Trexler, Adam. 2015. *Anthropocene Fictions: The Novel in a Time of Climate Change*. Charlottesville: University of Virginia Press.

Wilton, Andrew and Tim Barringer. 2002. *American Sublime: Landscape Painting in the United States 1820–1880*. Princeton: Princeton University Press.

Wordsworth, William. 2000. *William Wordsworth: The Major Works*. New York: Oxford University Press.

Worster, Donald. 1994. *Nature's Economy: A History of Ecological Ideas*. 2nd ed. Cambridge: Cambridge University Press.

11 Environmental theater

Performing nature

Chapter objectives

- To review the contribution of ecological theater, or ecotheater, to the development of the Environmental Humanities
- To appreciate theater's growing attention to socio-ecological urgencies
- To explain developments in site-specific drama, ecoactivist grassroots theater, climate change performance, and multispecies collaboration
- To apply ideas central to theater, including engagement, participation, and co-creation, to analyzing depictions of nature in the Anthropocene

Deliberating species

Created by Phantom Limb Company (PLC), the dark comedy *Twelve Angry Animals* is a contemporary ecological reworking of Reginald Rose's *Twelve Angry Men*. Broadcast in 1954 as a teleplay, Rose's classic narrates the deliberations of twelve jurors over the fate of a nineteen-year-old accused of fatally stabbing his abusive father. PLC's adaptation of the original courtroom drama recasts each of the male jurors as a representative of an endangered animal species including a lion and gorilla. Played by masked performers and set in post-apocalyptic New York, the jurors convene in an abandoned courthouse to decide if the last surviving human should be held responsible for obliterating the biosphere. The play imaginatively addresses environmental (in)justice and more-than-human rights, among other issues.

Twelve Angry Animals serves as an epilogue to the *Environmental Trilogy*, a series of dramatic works created by Phantom Limb Company between 2011 and 2019 to foreground climate change, biodiversity decline, and other human–nature problems. PLC's first play, *69°S*, was inspired by Sir Ernest Shackleton's fabled Trans-Antarctic Expedition, 1914–17, and blends movement, dance, puppetry, photography, film, and music to highlight the vulnerability of the Antarctic to climate change disruption. Appearing in 2016, the second production, *Memory Rings*, narrates various stories of the oldest known living tree, a 5,000-year-old Great Basin bristlecone pine in California named Methuselah after the venerable biblical persona (Figure 11.1). The third play, *Falling Out*, addresses the Fukushima Daiichi nuclear tragedy that struck Japan in 2011. Like its two predecessors, *Falling Out* melds puppetry and dance—specifically butoh, an avant-garde performance style that emerged in Japan after the Second World War.

DOI: 10.4324/9781351200356-11

Figure 11.1 The ancient bristlecone pine forest of Inyo County, California, is estimated to be five millennia old.

Image credit: TiggyPop (Wikimedia Commons).

Reflection 11.1 Theater in the Anthropocene

The ongoing work of the Phantom Limb Company (PLC) exemplifies contemporary theater's increasing sensitivity to ecological issues, from climate upheaval and nuclear catastrophe to endangered species and human–nature estrangement. Created to be performed, theatrical works have a unique capacity for inspiring progressive environmental and social transformation. Visit the catalogue of works on the PLC website (http://phantomlimbcompany.com/productions). You can also search for clips of *Falling Out*, *Memory Rings*, *69°S*, and *Twelve Angry Animals* on video-sharing platforms such as YouTube and Vimeo. What ecovalues are evident in the *Environmental Trilogy*? What do these works say about human–nature relations in the Anthropocene? What purposes do they serve?

Ecotheater: imaginative impressions of sustainable futures

Chapter 9 presented key examples of performative environmental art, notably Barry Thomas' *Vacant Lot of Cabbages* (1978), Joseph DeLappe's *Project 929: Mapping the Solar* (2013), the Brandalism Project's subvertising activities during COP21 (2015), and Andy Goldsworthy's *Hedge Walk* (2017). We defined *performativity* as a characteristic of environmental art that reinforces ecological values through modes of performance including, for instance, the real time participation of audience members in the execution of the work (see Waypoint 9.3). In its focus on disseminating sustainable values and inspiring socio-ecological change through performance, much contemporary environmental art shares ground with ecological theater—or

ecotheater—the subject of the present chapter. This section characterizes ecological theater as a significant and steadily expanding area of the Environmental Humanities. Ecotheater brings aspects of performance to bear on concerns of environmental racism, climate disturbance, habitat loss, biodiversity decline, resource appropriation, and the misguided human impetus to dominate nature. Alongside this notion of ecotheater as human dramatizations of the environment, it is also important to bear in mind that *nature is innately performative*. The example of the courtship dances of sandhill cranes (*Grus canadensis*) (Figure 11.2) and the coordinated movements of honey bees within hives demonstrate this point.

To begin with, let's sketch the essentials of a play—defined as a dramatic story written in dialogue and performed by actors for an audience in a theater or another venue. Ecotheatrical performances often take place outdoors or at sites that become integral to the story. Like other literary works, a play typically includes a plot (storyline), characters (human or non-human personae), dialogue, setting (time and place), conflict, and resolution. There are various genres of plays—from tragedies and comedies to tragicomedies and melodramas. However, unlike novels, short stories, and poems (see Chapter 10), plays are usually designed by their creators to be performed rather than only read on the page, thus requiring a collaborative or institutional structure for creativity to take place.

Additionally, the quality of *liveness*—of sharing the same place and time of the performance—is essential to theater productions. Accordingly, a play offers a communal experience of certain humanistic—and, for our purposes, ecohumanistic—themes. Furthermore, just as a book contains chapters, a play is organized into acts, although some plays consist of merely one act; acts are subsequently divided into scenes. The term *play* denotes the text—or script—written by a playwright as well as the performance of that script before an audience. (See Waypoint 11.1 for a synopsis of basic terminology crucial for our understanding of ecotheater.) We'd add that these conventions define the typical properties of a play, from

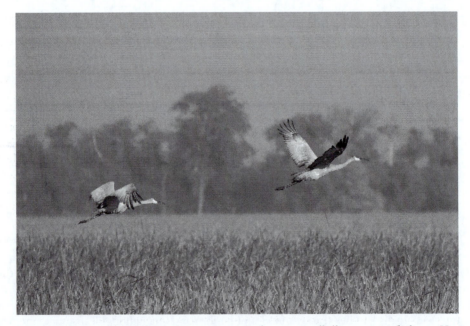

Figure 11.2 Nature is inherently performative, as evident in sandhill cranes in flight at Horicon National Wildlife Refuge in Wisconsin.

Image credit: Dori (Wikimedia Commons).

which some examples will deviate substantially. It is the nature of art to innovate or break conventions as part of its creative evolution. So consider these "rules of thumb," not absolute requirements for what defines a play.

As theater scholar J. L. Styan (1960) observed, "The quality in a play that distinguishes it is its animation—not of actors acting and speaking, but of our *imaginative impressions*" (64, emphasis added). Through the use of some or all of the above elements, contemporary ecotheater imaginatively engages the environment, more-than-human beings, and human–nature relations, generating impressions of sustainable possibilities. In Theresa J. May's definition, ecotheater is the combination of "the theatrical styles, devices, characterizations, settings, and stories that tell the human story within the ecological story" (2005, 93).

Reflection 11.2 Nature as performance

This section explores early definitions of ecotheater, an important specialization within the Environmental Humanities. However, we are also suggesting that nature is inherently performative. What does this mean? Well, bears fight and play. Birds sing and soar. Plants flower and seed. The northern lights scintillate overhead. Are these mating behaviors, natural phenomena, or ecological performances?

One way to consider these questions is to ask whether these natural performances are instinctual or intentional. But you can also think about whether performativity requires intention, or if it must only inspire "imaginative impressions." Geophysical events arguably inspire imaginative impressions on all life forms.

Write down three examples of nature as performative. Reflect on the difference between nature as performative and nature performed. What is your evidence and reasoning?

Ecotheater began to crystallize in the mid-1990s—a history that the next section of this chapter will trace in more detail. Early definitions of ecotheater emphasize both performance as a means to confront the ecocatastrophes of preceding decades, namely acid rain, global warming, and nuclear calamity, and critique traditional theater's humanistic reduction of nature to setting or metaphor. In 1994, theater scholar Una Chaudhuri called for new modes of site-specific performance that would directly engage "the actual ecological problems of particular environments" (1994, 24). For Chaudhuri, the problem was that "a largely negative ecological vision permeates the theater of [the twentieth] century" (23). Yet, she saw that theater can be a site of both "ecological alienation and potential ecological consciousness" and envisioned a more sustainable future which involved "a transvaluation so profound as to be nearly unimaginable at present. And in this [she insisted] the arts and humanities—including the theater—must play a role" (25).

Theater scholar Downing Cless theorized that theater will help propel this transvaluation at the grassroots, or community-based, level if it employs five qualities:

1. *a simple production style* emphasizing acting, singing, and movement;
2. *an episodic structure* in which a performance is organized into short scenes;
3. *audience contact* where viewers become participants in the production;
4. *documentary references* in which characters and storylines reflect real people and events; and
5. *activist protagonists* who confront environmental crises in their communities. (Cless 1996, 99)

Narrative is also a vital element, as Theresa J. May (2005) emphasizes. Recent definitions of ecotheater highlight the agency of nature within dramatic productions—the environment as more than setting and metaphor but as active character or even protagonist. Julie Hudson (2020) proposes that the most powerful transvaluation can be achieved when ecotheatrical pieces represent the environment "in ways intended and perhaps also not necessarily intended by the production team or expected by spectators" (2).

Waypoint 11.1 Overview of essential theater terminology

- *Blocking*: the positioning of actors on the stage during a performance
- *Characters*: the human and non-human personae at the center of a theatrical work who change over the course of the performance
- *Dialogue*: the verbal exchange between characters or actors through which the central narrative tension develops
- *Director*: the individual who supervises the production of a play or other dramatic work
- *Drama*: a fictional narrative performed in a playhouse or other venue in front of spectators
- *Dramaturgy*: the applied study of how to stage the script, including operation of technical dramatic elements
- *Liveness*: the quality of immediacy in which the audience shares the same place and time of the performance
- *Performance*: the act of presenting a dramatic work to entertain or educate an audience; or, more broadly, the process of accomplishing a task or achieving a purpose
- *Play*: a dramatic story composed by a playwright and performed by actors for an audience in a theater or other space
- *Playwright*: an author who specializes in writing plays
- *Scenography*: the crafting of theatrical environments, atmospheres, or moods
- *Script*: the textual version of a play or other performance
- *Stagecraft*: the technical features of a performance, including scenery, lighting, costumes, audio-visual components, and props

Reflection 11.3 Ecodramaturgy

All of the terms defined in Waypoint 11.1 can be oriented toward the environment and ecological issues. *Ecodramaturgy*, for instance, is the practice of staging theatrical works that place nature at the front and center, including the work's environmental context, and the function of its narrative within socio-ecological communities. *Ecodrama* is a piece that aims to strengthen the environmental consciousness of an audience or to explore a community's relationship to the natural world. How would you redefine the terms in Waypoint 11.1 when you prefix them with "eco"?

Before going further, let's clarify the technical distinction between environmental theater and ecological theater. Rather than interchangeable, these terms carry discrete meanings. Appearing in the late 1960s as an outgrowth of the avant-garde New American Theater movement, *environmental theater* denotes a form of theater that incorporates the audience into the work, thereby diminishing the sense of the separation between spectators and performers. In environmental theater, the performance space encompasses the spectators; the stage partially or entirely surrounds the audience. Consequently, environmental theater is described as *non-frontal* and *spectator-incorporative*. A case in point is Bread and Puppet, a grassroots puppet-based theater located in Vermont that—over its more than five decades of activity—has employed the techniques of environmental theater such as staging performances on streets, at protests, and in fields (Figure 11.3). As Case Study 11.1 elaborates, Bread and Puppet began as environmental theater but later embraced ecological theater more explicitly. The point to remember is that environmental theater is defined by its staging techniques, while ecological theater is defined by its purpose: to recognize the environment as a material agent or a subject of ethical concern (Marranca 1996).

Case Study 11.1 Bread and Puppet Theater

Founded in 1963 by German sculptor-dancer Peter Schumann (born 1934), Bread and Puppet Theater began playing weekly shows in low-income neighborhoods in New York City. Emphasizing the function of theater in social activism, performers would distribute sourdough bread to attendees, and thus the name was born. In its early years, Bread and Puppet became a common sight at public marches against the Vietnam War. The group's frugal aesthetic centered around puppets made from papier-mâché, burlap, string, staples, and other rough materials. For instance, originally performed with life-size puppets in 1966, the piece *Fire* narrates the trauma of seven days in a Vietnamese community incinerated by bombing. The piece addresses the interlinked human and non-human consequences of war.

In 1970, Bread and Puppet relocated to an old dairy farm in Glover, Vermont. Since then, the group's shows have confronted a spectrum of subjects—from capitalism and militarism to ecology and extinction. Recent performances with conspicuous ecological motifs include "Anti-Tar Sands Manifesto Pageant" (2014) and "The Extinction Rebellion Parade" (2019). As part of the People's Climate March, "Anti-Tar Sands" featured performers in caribou costumes protesting the mining of the Athabasca oil sands. The ongoing extraction of these crude oil deposits near Fort McMurray, Canada has resulted in the broadscale devastation of land, water, and wildlife. Bread and Puppet's 2019 piece, furthermore, was developed in collaboration with Extinction Rebellion, a global movement that seeks to turn the tide of climate change, species loss, and ecosystemic collapse.

Search for clips of these two Bread and Puppet works on a video-sharing platform. What techniques do the performers use to disseminate ecological messages and propagate an ethics of nature?

In sum, *ecotheater* focuses on performances and performers—such as those of Bread and Puppet—with environmentalist themes. Additionally, while reinforcing the connections between theater, activism, and sustainability, *ecodramaturgy* offers a valuable basis for staging

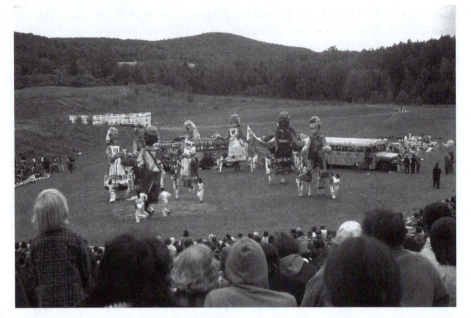

Figure 11.3 Bread and Puppet Theater relocated from New York City to Glover, Vermont in the 1970s. Image credit: Walter S. Wantman (Wikimedia Commons).

long-established works from a fresh ecological perspective. And, using ecotheater studies, environmental humanists have a framework for analyzing ecological themes in the plays, for instance, of Shakespeare or George Bernard Shaw. In this spirit, Theresa J. May presents a list of questions to consider while developing an environmental analysis of a theater piece. Questions include:

- "How does a performance engage or reflect (even as 'wallpaper') the environmental issues of its time and place?"
- "What are the clues to the ecological conditions of the 'world of the play'? How do those conditions intersect with representations of race, class, and gender?"
- "How does the play reflect specific and historically situated philosophical paradigms of thinking about the human place in nature?"
- "How does the play propagate or subvert the master narratives that sanction human exploitation of the land?" (May 2007, 105)

You will find these questions useful for any analysis of any cultural product, from music and literature, to art, architecture, and digital media. However, from May's standpoint, ecotheater engages particular aspects of the Anthropocene debate through the power of performed narratives to incite environmental awareness. Indeed, in its focus on liveness and art-as-activism, ecotheater contributes distinctively to the Environmental Humanities.

Performing nature: Ecotheater history and theory

Over three decades, the linked fields of *ecotheater* and *ecotheater studies* have developed within the overarching context of the Environmental Humanities. The term *ecotheater* signifies works of theater that dramatize environmental concerns whereas *ecotheater studies* means the critical analysis of those works.

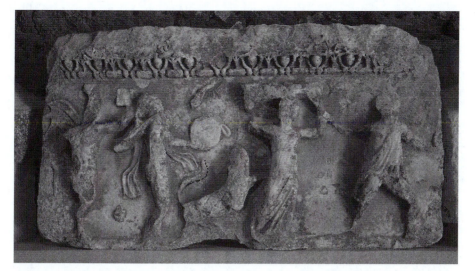

Figure 11.4 This frieze from the second century AD depicts the Festival of Dionysus.

Image credit: Carole Raddato (Wikimedia Commons).

This section deepens our investigation of ecotheater through an emphasis on its history and theory. The global theater tradition originates in the epics, legends, stories, myths, rituals, and festivals of oral societies. For millennia, dance, music, and celebration have enhanced social cohesion, strengthened community identity, and facilitated the sharing of knowledge between generations. Many early forms of theater were inherently *environmental* insofar as performances took place outside, engaged natural elements, dramatized the ecological order, and strove to ensure beneficial outcomes such as plentiful rain and abundant harvests (Zarrilli 2010).

Western theater can be traced back to ancient Greece. Athenian tragedy appeared in the sixth and fifth centuries BC through the plays of Aeschylus, Sophocles, and Euripedes. The Festival of Dionysus—or Dionysia—was held in honor of Dionysus, the god of wine, fruit, and fertility (Figure 11.4). Attended by up to 16,000 participants, Dionysia featured tragedies, comedies, and burlesque tragicomedies known as satyric dramas. By 300 BC, theaters were widespread throughout Greece; the use of masks and costumes during performances were commonplace. Other traditions emerged elsewhere in the world, including in China around 400 BC and India in 200 BC. Regrettably, space does not allow us to go further into these diverse and fascinating histories but, for more background information, you can consult a resource such as John Russell Brown's comprehensive *The Oxford Illustrated History of Theatre* (1995) or Phillip Zarrilli and colleagues' *Theatre Histories: An Introduction* (2010). In developing a global perspective on contemporary ecotheater, it is crucial to consider these theater lineages, although our emphasis in this chapter is principally the Western tradition originating in ancient Greece.

Waypoint 11.2 Brief selection of theater genres

- *Absurdism*: focuses on the irrationality of the human condition, the struggle to find meaning, and the failure of communication
- *Comedy*: provokes amusement through humorous techniques with an emphasis on lighthearted reflection and a happy ending

- *Commedia Dell'Arte*: popularized in Italy in the sixteenth century and known for blending dance, music, and comedic dialogue
- *Melodrama*: exaggerates characters, places, and events in order to appeal to viewers' emotions
- *Musical Theater*: combines singing, acting, dancing, and dialogue; also known as musicals
- *Physical Theater*: relies on a range of physical gestures as the central medium of narration
- *Surrealism*: emphasizes the intricacies of the subconscious through surprise, fragmentation, juxtaposition, and other methods
- *Tragedy*: addresses, usually in a solemn tone, the discomfort or suffering experienced or instigated by a character
- *Tragicomedy*: melds features of tragedy and comedy

As the example of the harvest- and fertility-themed Festival of Dionysus implies, theater has maintained an intimate connection to nature throughout its history. In this regard, May (2005) observes that theater has "always served as a forum where people negotiate and generate relationships to their environments (wild, cultivated, industrial, virtual)" (86). However, the particular environmental consciousness that defines contemporary ecotheater emerged in the twentieth century in reaction to growing awareness of humanity's collective destruction of environments, and in parallel to the growth of ecologically oriented activism, art, history, and literature. We can see the early stirrings of what will become ecotheater in the nineteenth-century Norwegian writer Henrik Ibsen's (1828–1906)'s *An Enemy of the People*, described as the "granddaddy of environmental plays" (Chaudhuri 1994, 24). The drama centers on the conflict between brothers Thomas and Peter Stockmann over the future of a small Norwegian town. Peter is the town's wealthy mayor, whereas Thomas is a physician charged with overseeing a newly opened spa with curative mineral springs. Thomas becomes increasingly outspoken about the impacts of an upstream tannery on the water system, but his warnings are met with hostility from Peter and the townsfolk who prioritize the economic benefits from industrialization. The activist-physician consequently becomes ostracized as an enemy of the people. What's more, Ibsen's tragicomedy *The Wild Duck* (1884) dramatizes themes of species loss and extinction through the environmental callousness that underlies the downfall of the Ekdal family, culminating in the suicide of their fourteen-year-old daughter Hedvig.

In the American theater tradition, early environmental representations tend to highlight the sublime and picturesque qualities of the landscape rather than the ecological and cultural implications of expansionism. For instance, debuting in 1905, David Belasco's melodrama *The Girl of the Golden West* reinforces ideas of the land as a scenic marvel and commodity to be exploited. Written by Rodgers and Hammerstein, the musical *Oklahoma!* centers on the courtship of a farm girl against the backdrop of post-World War II free market economics romanticizing a landscape expropriated from Cherokee people through American assimilationist policies. Nevertheless, by the mid-twentieth century, ecological themes began to appear more forcefully in acclaimed plays such as Arthur Miller's *Death of a Salesman*, first performed in 1949, and Lorraine Hansberry's *A Raisin in the Sun*, which made its Broadway debut in 1959. Set in Southside Chicago, *A Raisin in the Sun* confronts disparities of environmental justice in African American neighborhoods especially through the deleterious effects of urban pesticides introduced through mid-twentieth-century advances in industrial chemistry.

Case Study 11.2 Indigenous ecotheater

Indigenous ecotheater reflects the critical link between environmental justice and Indigenous rights. The diverse productions in this vibrant area of ecotheater relate the environment crisis, including climate change, to the historical and contemporary oppression of Indigenous communities. Indigenous ecodramas from various global traditions—Native American, Canadian First Nations, Aboriginal Australian, and others—express a common desire for cultural endurance and ecological flourishing. In such works, the active presence of the environment diminishes the engrained Western opposition between natural and human worlds. As Melissa Colleen Campbell argues, "Indigenous playwrights are at the vanguard of acknowledging their role in the protection of the environment and engaging in (theatrical) activism to help reshape both their relationship (and our relationship) with the eco-crisis" (Campbell 2014, para. 3).

Founded in 1976 by sisters Muriel Miguel, Gloria Miguel, and Lisa Mayo, Spiderwoman Theater is regarded as the first Indigenous women's theater ensemble in the United States. The name derives from the Hopi deity Spider Grandmother or Kokyangwuti. Inspired by Spiderwoman Theater, Chichimec-Otomi activist-playwrights Elvira and Hortencia Colorado founded Coatlicue Theater Company in the late 1980s. Their play *Walks of Indian Women–Aztlan to Anahuao* from 1988, as an example, narrates Native American women's history both before and after European colonization. Furthermore, Assiniboine playwright William S. Yellow Robe Jr.'s drama *Grandchildren of the Buffalo Soldiers*, which premiered in 2006, interrogates the interconnected histories of African American and Native American people.

More recently, in 2017, the Inuvialuit, Dene, and Cree playwright Reneltta Arluk directed *The Breathing Hole*. Spanning 500 years, the saga tells the story of a polar bear named Angu'juaq born in an Inuit community in 1534. Angu'juaq encounters British explorer John Franklin in 1832 and witnesses the Anthropocene disorder of the present. The director pioneered various forms of puppetry, including giant polar bear puppets, to convey a message about the effects of climate change on Indigenous peoples.

The 1990s saw a marked expansion of ecotheater practice and theory. In this regard, Theresa J. May (2021) points to "an ecological turn in U.S. theater during the 1990s" (203) brought about by changes within the field of theater as well as a shift within environmentalist discourse toward new notions of justice and ethics. Appearing in 1992, Robert Schenkkan's Pulitzer Prize-winning drama *The Kentucky Cycle* stages the environmental history of the Cumberland Plateau region. Nine one-act plays chronicle seven generations of Kentuckians from 1775 to 1975, emphasizing their conflicted relationships to the land as a source of livelihood and economic gain. Considered the first mainstream American play to dramatize capitalism's role in ecological deterioration, *The Kentucky Cycle* critiques the frontier myth as the principal ideology behind the environmental crisis (May 1999). Also debuting in 1992, Puerto Rican playwright José Rivera's *Marisol* features a young Latinx heroine trapped in a dystopian urban world on the cusp of ecological apocalypse (May 2021, 203). As May further comments, "These plays personalized environmental issues by exploring the ethical questions and the decision-making processes that precede human action" (203).

Reflection 11.4 Eco-cabaret

Theresa J. May (2021) observes that, although environmental themes in theater emerged well before the 1990s, as demonstrated by the plays of Ibsen and Hansberry, the decade inspired new theater forms oriented toward environmental justice. In fact, many of the creative challenges that ecodramatists now negotiate are still being shaped by developments in the green theater of the 1990s.

One of those developments is the eco-cabaret. A cabaret can be defined as a theatrical performance featuring music and dance that is staged at a popular venue such as a nightclub. In 1992, the Underground Railway Theater of Boston produced an eco-cabaret on the environmental legacy of American colonization. Calling urgent attention to Native American social inequalities, *The Christopher Columbus Follies: An Eco-Cabaret* contrasted environmental justice in 1492 and 1992.

Research the defining features of the cabaret. What are the advantages and downsides of embedding environmental concerns in forms of popular entertainment such as the cabaret?

In response to the green turn in performance during the 1990s, ecotheater studies began to coalesce as a discrete branch of the Environmental Humanities. In 1991, the conference *Theater in an Ecological Age*, held in Seattle, Washington, attracted performance scholars interested in environmental issues. Soon after, Lynn Jacobson (1992) published the article "Green Theatre" in *American Theatre*. Co-edited by Erika Munk and Una Chaudhuri, a 1994 issue of *Theater* on green performance provided a pivotal mapping of the field (May 2021, xiii). In her seminal theorization, Chaudhuri (1994) warned that "theater's complicity with the anti-ecological humanist tradition has to be of critical concern to us" (28). In the same year, Larry K. Fried and Theresa J. May released *Greening Up Our Houses: A Guide to a More Ecologically Sound Theatre* (1994), the first book to scrutinize the technical aspects of theater, such as scenography, from the perspective of environmental sustainability.

As should be expected, growth in this new form of theater took place in community venues far from the bright lights, blown-up budgets, corporate sponsorship, and large environmental impacts of Broadway or London's West End. During this decade, grassroots ecotheater with a "community-based aesthetic" flourished (Cless 1996, 80). Environmental themes included pesticides and clear-cutting as well as the philosophical origins of ecological crisis and possibilities for a more equitable future for all beings. As a case in point, Kalamu ya Salaam's 1995 play *The Breath of Life* is set in an area known infamously as Cancer Alley, in southeastern Louisiana along the Mississippi River, where numerous petrochemical plants poison African American workers (Magelssen 2017, 227). Additionally, Cherríe Moraga's play *Heroes and Saints* (1992), and Teatro Nuestro's *La Quinceanera* (1990), dramatize the health hazards of pesticides used by migrant farmworkers (Cless 1996, 84).

Case Study 11.3 Southeast Asian ecodramaturgy

From Timor-Leste and Indonesia to Brunei Darussalam and the Philippines, Southeast Asian theater has a strong environmental foundation in which natural and supernatural domains interweave sinuously. Agrarian in emphasis, traditional performances depict human interactions with flora, fauna, demons, and dieties. For example,

shadow-puppetry known as *wayang kulit* (literally "shadows on leather") is a popular form of traditional theater on the island of Java, Indonesia (Figure 11.5). Originating in animistic spiritualities predating Islam and Christianity, *wayang kulit* features stories of human relationships to wild species, such as a healing plant known as *maosadilata*. Two other traditions—*bangsawan*, the traditional opera of Indonesia, Malaysia, Singapore, and Brunei, and *likay*, an improvisational folk theater from Thailand—narrate environmental themes and communicate ideas about human–nature entanglements (Diamond 2014).

Another example of contemporary ecodramaturgy in Southeast Asia is the Kinnari Ecological Theater Project (KETEP), one of the few theaters in the region dedicated entirely to ecodramaturgy. An objective of ecodramaturgy is to speak on behalf of nature, a crucial aim given the extent of ecological devastation in Southeast Asia. KETEP's namesake, the *kinnari*, is a bird-woman hybrid found in Hindu and Buddhist mythologies. Founded in 2010 by theater scholar Catherine Diamond, KETEP performances incorporate puppetry, costumes, singing, dancing, and traditional motifs adapted to address contemporary environmental debates.

A recent performance, *The Song of Koun Lok* from 2020, is an adaptation of a Khmer (Cambodian) story about an evil mother who, after falling in love with a thief, schemes to kill her children. Her three daughters transform into *koun lok* birds and survive in the wild. In the KETEP version, the thief is a wildlife poacher whose illegal activities benefit the greedy mother. Explore other KETEP performances here: www.kinnarieco-theatre.org/perform.html.

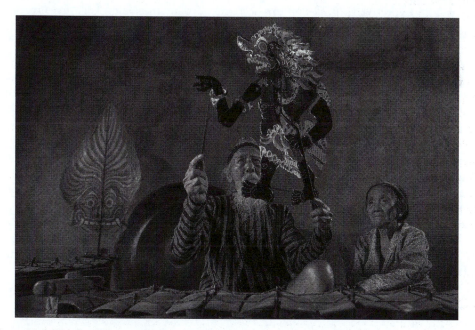

Figure 11.5 Wayang Kulit is a traditional form of puppet theater in Java, Indonesia.

Image credit: Candra Firmansyah (Wikimedia Commons).

The greening of American theater in the 1990s precedes the development of ecotheater studies. May (2007) attributes the slow adoption of ecological approaches to performance scholars' narrow understanding of ecology as merely a trope for "the multifarious, dynamic, and interdependent relationships between, for example, production and reception, actors and space, or theatre and its social context" (100). To embrace nature as an embodied presence, ecotheater studies needed to consider how human and more-than-human bodies bear the markings of environmental policies and practices. As ecotheater studies drew theories and methods from other Environmental Humanities disciplines, like history and philosophy it began reorienting itself at a time of mounting global crisis (May 2005, 85).

Today, ecotheater is seen as a performance in which "the *active presence* of the environment on stage comes through, with or without the intention or even sometimes the awareness of those involved" (Hudson 2020, 5, emphasis added). Ecotheater studies, meanwhile, continues to examine the transformative ecological potential of site-specific, community-engaged productions and counter theater's entrenched humanism, as Carl Lavery's edited collection *Performance and Ecology: What Can Theatre Do?* (2018) illustrates. Lavery's collection foregrounds the liveness of the theatrical medium and the capacity of performance to affect spectators on a visceral level, opening up possibilities for, and perspectives on, Anthropocene ecoperformance and the more-than-human agents in theatrical productions. The book theorizes theater as deeply integrated with ecologies, and nature as inherently performative.

Reflection 11.5 Theater for Africa

Although our chapter thus far has concentrated on North American ecotheater, case studies 11.2 and 11.3 introduced Indigenous ecotheater and Southeast Asian ecodramaturgy, respectively. In closing this section, we want to acknowledge the diverse manifestations of ecotheater globally. One example is Theater for Africa, a Southern African company that, since 1989, has focused on environmental narratives informed by traditional storytelling. Their debut play *Horn of Sorrow*, for instance, confronts the extinction of the white rhino (*Ceratotherium simum*).

Research a theater tradition that we have not yet addressed in this chapter. What are its environmental foundations? To what extent does it thematize human–nature relations? Is there a growing sense of ecological urgency in recent works of that tradition?

Hope for the Earth? Current trajectories in ecotheater

In this chapter, we have characterized ecotheater as a contemporary mode of environmental performance that centralizes the transformation of places over time in response to ecological realities. New climate scenarios and novel modes of knowing nature can be imagined and enacted through performance. Unknown, opaque, or embedded facets of human–nature relations can become palpable through the intervention of performers. In this regard, May (2021) asks "how might theater participate in the transformation of conscience and consciousness so desperately needed now?" (2). As she concludes:

> Theater can consciously and directly engage the complex economic, scientific, and cultural challenges of climate change and climate justice, (re)imagining what it means to be

Figure 11.6 Theater offers a compelling medium for educating the public about plant and insect diversity. But how might the theater of tomorrow engage non-humans as participants rather than as part of the setting?

Image credit: J. C. Ryan.

human in the age of the Anthropocene. Through its unique embodied, immediate, and communal qualities, theater can advocate for environmental justice, develop a sense of connection between human and nonhuman communities, and strategically animate the ecological world so that the very boundaries between nature and culture, self and other, begin to dissolve.

May (2021, 280)

In this concluding section, we consider May's claims by examining three dynamic areas of the field: Anthropocene theater, climate change theater, and multispecies theater (Figure 11.6).

Waypoint 11.3 Overview of ecotheater genres

- *Anthropocene Theater*: dramatizes the urgencies of the present age in which humankind has become a biospheric force
- *Bioregional Theater*: thematizes and takes place in bioregions, defined as areas delineated according to watershed boundaries
- *Ecocritical Theater*: brings the ecocritical paradigm into dialogue with theater studies; theater that develops ecological critique
- *Ecofeminist Theater*: advocates the vital importance of non-patriarchal values to the defense of nature

- *Environmental Justice Theater*: introduces considerations of environmental racism and Indigenous rights to theatrical works
- *Indigenous Ecotheater*: addresses Indigenous views of the natural world and the environmental crisis, including climate change
- *Climate Change Theater*: confronts the immediacies of oceanic warming, rising sea levels, carbon emissions, and climate politics
- *Multispecies Theater*: engages more-than-human beings as active participants in, and contributors to, theater-devising processes
- *Site-specific Performance*: develops in response to a physical location and is staged at the site rather than a theater venue

To begin with, Anthropocene theater responds to the specific urgencies of the current epoch in which humankind has become a planetary agent, precipitating a global extinction event (see Chapter 3). Themes common to Anthropocene theater include carbon emissions, ocean acidification, biodiversity loss, environmental justice, and Indigenous rights. This form of theater aims to create an immediate experience of the vast, virtually inconceivable scales of time and space according to which global change is unfolding. Performance scholar Marissia Fragkou (2019) invokes the phrase "ecologies of precarity" to describe the linkage between environmental and social concerns in twenty-first-century theater. Theater's response to Anthropocene precarities—entailing the destabilization of ecosocial networks—has brought about "a dynamic resurgence of politics" in performance practice and theory (3). As a case in point, the Berlin-based Theater of the Anthropocene aims to develop "an aesthetic forum to present problems and conflicts, to negotiate solutions in play, and to establish controversies in urban society and the public" (Theater of the Anthropocene 2020, para. 5). Set in an arboretum, their recent production *Requiem for a Forest* turns attention to the effects of climate change on the world's forests through dramatic interpretations of ancient literary works such as the *Epic of Gilgamesh*.

Located within the overarching frame of Anthropocene theater, climate change theater narrates stories of climatic disruption and engenders empathy for those affected. Provoking questions of ecojustice, climate change theater "serves the crucial and collective imaginative work of feeling into the realities of climate change while radically reimagining ourselves and our world" (May 2021, 239–240). One of the earliest plays to dramatize climate change is Caryl Churchill's apocalyptic *The Shriker*, premiering in 1994. The eco-fairytale centers on a magical protagonist who shapeshifts into various people and objects in an attempt to manipulate two teenage mothers, Lily and Josie. Through the interplay of dance, movement, music, and linguistic experimentation, the narrative links environmental degradation to the deterioration of mental wellbeing. Churchill's tale prefigures the proliferation of climate change plays during the 2010–20 period. Debuting in 2011, for instance, Duncan Macmillan's *Lungs* tells the story a thirty-something urban couple struggling to decide to start a family on a quickly warming planet. Anxious about endangered species, melting glaciers, human overpopulation, and the food miles of vegetable imports, the couple grapples with their personal responsibility for the world's precarious state. In 2014, furthermore, Macmillan collaborated with climate scientist Chris Rapley on *2071*, a "theatricalized science lecture" on the climate change debate (May 2021, 240).

Case Study 11.4 Climate Change Theater Action

Founded in 2015 by Elaine Ávila, Chantal Bilodeau, Roberta Levitow, and Caridad Svich, Climate Change Theater Action (CCTA) is a collaborative ecotheater initiative showcasing performances from around the world. The objective of the participatory project is to promote local and global action on climate. Staged biennially, CCTA's suite of short climate change plays coincide with the United Nations Conference of the Parties (COP) meetings. Taking place between September 15 and December 21, CCTA-2019 overlapped with COP25 in Madrid, Spain. CCTA-19 involved over 220 partners (universities, colleges, theaters, museums, arts organizations, schools, youth organizations, environmental advocacy organizations, faith groups, radio programs, and individuals) in 28 countries creating performances with more than 3,000 artists.

Events in 2019 ranged from public performances, ecodramas, and readings, to podcasts, radio shows, and multimedia productions. In the Ukraine, for instance, the youth theater group AmaTea presented an experimental piece consisting of the plays *A Letter from the Ocean* (Caridad Svich), *Drip* (Yolanda Bonnell), *Laila Pines for the Wolf* (Hassan Abdulrazzak), *The Arrow* (Abhishek Majumdar), and *It Starts with Me* (Chantal Bilodeau). The five works combined drama, choreography, video animation, and original music. Presented in the Ukrainian language, AmaTea's contribution to CCTA-19 took the form of a multidisciplinary collaboration between Ukrainian actors, theater director Olena Rosstalna, choreographer Svetlana Likhtina, visual artist Vladislav Boyko, and Norwegian composer Sveinung Nygaard (CCTA).

CCTA is an exemplar of collaborative ecotheater on a global scale that incorporates digital technology for purposes of climate activism. Exercise 5 invites you to learn more about the CCTA project and to consider getting involved.

Multispecies theater is an emergent area of ecotheater guided by at least three aims:

1. to dramatize species decline, loss, and extinction at local, regional, and global scales;
2. to engender feelings of empathic identification with other species in audience members as well as performers and directors; and
3. to engage more-than-humans respectfully and ethically as participants and protagonists in performances, thereby asserting the agency of nature.

Multispecies theater draws from developments in posthumanist theory and, more specifically, the concept of multispecies ethnography (Kirksey and Helmreich 2010). Our discussion of multispecies theater indeed brings us full circle to the 5,000-year-old Great Basin bristlecone pine of Phantom Limb Company's *Memory Rings* introduced at this chapter's opening. Yet, while some multispecies performances address the botanical and zoological, others confront issues of piscine diversity. Performed in 2018 at the Toronto Fringe Festival and directed by Martha Ross, the play *Upstream Downstream* is narrated through the bodies of the salmon-human hybrids Sojo and Beagle (Johnson and Simpson 2019). The work integrates physical theater (see Waypoint 11.2), clowning, and bouffon, a French theater form based on parody. This particular combination aided the performers in their desire to embody salmon

and, in doing so, to develop an affective relationship to the species through the medium of theater (Johnson and Simpson 2019, 3).

Reflection 11.6 Multispecies theater

Multispecies theater foregrounds the innate performativity of more-than-humans. Theatrical works in this mode strive to collaborate with animals, birds, fish, plants, fungi, rocks, and others. However, as nature cannot vocalize as humans do, care, respect, and ethics must be built into multispecies partnerships.

Identify two to three current examples of multispecies theater. What are the promises and perils of this approach to ecotheater?

Chapter summary

Chapter 11 has characterized ecological theater—or ecotheater—as a lively area of specialization within the Environmental Humanities. The chapter has employed the term *ecotheater* to denote, on the one hand, works of theater that dramatize environmental concerns and, on the other, the critical analysis of those works by performance scholars. Marked by an escalating interest in socio-ecological issues among performers, actors, directors, playwrights, and performance scholars, ecotheater encompasses diverse kinds of drama, comedy, melodrama, satire, and parody. The aim of ecotheatrical works is to advance environmental thinking and enable audiences to participate—in an engaged and sustained way—in ecological debates. More precisely, ecotheater is both educational and political in orientation. This chapter's first part clarified the difference between *environmental theater* (appearing in the 1960s as an extension of the New American Theater movement) and *ecotheater* (gaining traction in the 1990s as an ecoactivist trajectory in theater). Site-specific drama, grassroots theater, community initiatives, climate change performance, multispecies collaboration, and eco-multimedia productions all fit within the scope of ecotheater. Case studies of Bread and Puppet community theater, Indigenous ecotheater, Southeast Asian ecodramaturgy, and Climate Change Theater Action illustrated the diverse global expressions of ecotheater. Lastly, we invited readers to think about nature as innately performative. A shift from the notion of *nature performed* (depicted and portrayed) to *nature as performative* (collaborating and creating) opens up possibilities for embracing the agency of the more-than-human world and devising a new ethics of the environment as the Anthropocene continues to reconfigure the everyday lives of humans and others.

Exercises

1. Using Downing Cless' five attributes of grassroots ecotheater, conduct an analysis of *one* community-based play—from any decade or cultural tradition—mentioned in this chapter. As we have already seen, the central claim of ecotheater is that performance can transform and thus deepen peoples' understanding of the environment. Accordingly, theater provides an ecopedagogical medium for expanding human awareness of the

threats to nature—and thus to ourselves—posed by the climate crisis. But how do performances accomplish this aim? What are the specific mechanisms behind the ability of theater to shift values? Respond to these questions through a close reading of your selected play.

2. Sketch plans for a site-based performance that addresses *one or more* of the following five issues: (i) carbon emissions; (ii) rising sea levels; (iii) the clear-felling of old-growth rainforests; (iv) the land-based sovereignty of Indigenous people; and/or (v) the ecological aspects of the coronavirus. Draw on research from this and other chapters from the book. Referring to Waypoints 11.2 and 11.3, select one or more genres for your performance. Where will the performance be located? Who will be involved? What will be its title, lead characters, and general storyline? You are welcome to include graphic representations (sketches, drawings, photographs, animation, etc.) of your envisioned work.

3. Devise a multispecies performance piece that engages animals, plants, fungi, rocks, water, or air—or any other creatures, elements, or objects—as participants, collaborators, and co-creators. What will be the role of more-than-humans in the performance? How will people collaborate with them? What measures will be taken to ensure their equitable and ethical treatment throughout the process? In your performance proposal, include a title, plot summary, and list of performers.

4. View the trailer for the 2018 play *Black Men Walking*: www.youtube.com/watch?v=-kOHGHMROd_U. Written by rap artist Andy Brooks who goes by the name Testament, and directed by Eclipse Theater in the United Kingdom, *Black Men Walking* is a response to the white bucolic tradition of walking epitomized by nineteenth-century Romantic writers. Evolving from Ghanaian journalist Maxwell Ayamba's project 100 Black Men Walk for Health begun in 2004, the play situates the transformative act of men walking together in the context of five centuries of Black British history. In what ways can walking be considered a form of collaborative ecological performance?

5. Visit the Climate Change Theater Action (CCTA) website: www.climatechangetheatreaction.com. Familiarize yourself with the performances held in 2015, 2017, and 2019. Select *one* climate change piece from any year and briefly comment on the techniques the work employs to communicate information about climate. Summarize your discoveries and impressions in one or two paragraphs. For a more ambitious semester project, click the "Join Us" tab at the top of the screen to learn about what is required to become a project contributor. Then, sign up for the CCTA mailing list to receive updates about events planned for the upcoming year. Pitch a proposal to your class for staging one of the plays to coincide with the next COP.

Annotated bibliography

Aronson, Arnold. 1981. *The History and Theory of Environmental Scenography*. London: Methuen Drama. This early study of environmental theater provides a valuable overview of avant-garde performance, street theater, public spectacles, and immersive pieces in which the theater space encompasses the audience, creating a visceral experience that transcends the visual sense.

Chaudhuri, Una. 1997. *Staging Place: The Geography of Modern Drama*. Ann Arbor: University of Michigan Press. The first book-length treatment of the notion of place in modern theater, Chaudhuri's work investigates expressions of homecoming, homelessness, immigration, and exile in a range of

dramatic productions. The themes of place, nature, and culture elaborated by Chaudhuri have been central to ecotheater scholarship over the last three decades.

Fried, Larry K. and May, Teresa J. 1994. *Greening Up Our Houses: A Guide to a More Ecologically Sound Theatre*. New York: Drama Book Publishers. This seminal reference work outlines theater strategies—from set design to onstage performance management—that minimize environmental impacts. Fried and May's handbook was written with green theater practitioners in mind.

Fuchs, Elinor, and Una Chaudhuri, eds. 2002. *Land/Scape/Theater*. Ann Arbor: University of Michigan Press. This edited volume theorizes the concept of *landscape* as integral to modern theater's dramatization of space and place.

Giannachi, Gabriella, and Nigel Stewart, eds. 2005. *Performing Nature: Explorations in Ecology and the Arts*. Bern: Peter Lang. This collection of essays interrogates the ways in which theater reinforces—or calls into question—ideas of nature, human–environment relations, and sustainability. Contributors appraise the transformative potential of site-specific theater as well as the idea of the natural world as intrinsically endowed with performative capacity.

Kershaw, Baz. 2007. *Theatre Ecology: Environments and Performance Events*. Cambridge: Cambridge University Press. This is one of the first book-length studies to consider the influence of climate change and other ecological crises on the theory and practice of theater.

Marranca, Bonnie. 1996. *Ecologies of Theater: Essays at the Century Turning*. Baltimore: John Hopkins University Press. Marranca's scholarly elaboration of environmental theater centralizes the role of geography and climate—though not climate change—on performances of various kinds. The book reminds us of the distinction between environmental theater and ecological theater, although, as our chapter has suggested, these two traditions overlap to an extent. For instance, ecological theater often makes use of immersive forms of staging.

May, Theresa J. 2021. *Earth Matters on Stage: Ecology and Environment in American Theater*. London: Routledge. The first extended study to bring ecotheater into dialogue with ecocriticism, May's book investigates how American theater—throughout the twentieth century and into the present—has influenced popular perceptions of the environment. May considers canonical dramas as well as lesser-known grassroots productions. Her final chapter includes valuable insights into climate change theater in the United States.

Weblinks

9Thirty Theater Company. This New York-based company strives to enhance the capacity of performers to address ecological concerns in their work. http://9ttc.org/about.php

Climate Change Theatre Action. Held biennially, this large global ecotheater initiative coincides with United Nations COP meetings. www.climatechangetheatreaction.com

Earth Matters on Stage (EMOS). Founded by Theresa J. May and Larry Fried in 2004, EMOS is a collective of activists, educators, performers, and researchers who believe in the role of theater in responding to the environmental crisis. www.earthmattersonstage.com

Kinnari Ecological Theater Project. This ecotheater project foregrounds environmental urgencies in Southeast Asian countries. www.kinnarieco-theatre.org

Phantom Limb Company (PLC). This company focuses on climate and environmental justice through movement, puppetry, and multimedia. http://phantomlimbcompany.com

Qaggiavuut! The work of this performing arts network centers on issues of decolonization, healing, wellness, and language in Inuit societies. www.qaggiavuut.ca/en/home

Spiderwoman Theater. Founded in 1976, this company produces urban Indigenous performances. www.spiderwomantheater.org

Theater des Anthropazän (Theater of the Anthropocene). Based in Berlin, Germany, this group is concerned with the social, cultural, and environmental perturbations of the Anthropocene. http://theater-des-anthropozän.de/en/home

References

Brown, John Russell, ed. 1995. *The Oxford Illustrated History of Theatre*. Oxford: Oxford University Press.

Campbell, Melissa Colleen. 2014. "Reclaiming Indigenous Voices and Staging Eco-Activism in Northern Indigenous Theatre." *Seismopolite: Journal of Art and Politics*, December 10. http://www.seismopolite.com/reclaiming-indigenous-voices-and-staging-eco-activism-in-northern-indigenous-theatre.

Chaudhuri, Una. 1994. "'There Must Be a Lot of Fish in That Lake': Toward an Ecological Theater." *Theater* 25 (1): 23–31. doi: 10.1215/01610775-25-1-23.

Cless, Downing. 1996. "Eco-Theatre, USA: The Grassroots is Greener." *The Drama Review* 40 (2): 79–102.

Diamond, Catherine. 2014. "Whither Rama in the Clear-Cut Forest: Ecodramaturgy in Southeast Asia." *Asian Theatre Journal* 31 (2): 574–593.

Fragkou, Marissia. 2019. *Ecologies of Precarity in Twenty-First Century Theatre: Politics, Affect, Responsibility*. London: Bloomsbury.

Hudson, Julie. 2020. *The Environment on Stage: Scenery or Shapeshifter?* New York: Routledge.

Jacobson, Lynn. 1992. "Green Theatre." *American Theatre* 8 (11): 17–25, 55.

Johnson, Morgan, and Alexandra Simpson. 2019. "Upstream Downtown: Theatre Creation Through a Feminist and Multispecies Lens." *The Goose* 17 (2): 1–11.

Kirksey, S. Eben, and Stefan Helmreich. 2010. "The Emergence of Multispecies Ethnography." *Cultural Anthropology* 25 (4): 545–576. doi: 10.1111/j.1548-1360.2010.01069.x.

Lavery, Carl, ed. 2018. *Performance and Ecology: What Can Theatre Do?* London: Routledge.

Magelssen, Scott. 2017. "'Some Are Born Green, Some Achieve Greenness': Protest Theater and Environmental Activism." In *Public Performances: Studies in the Carnivalesque and Ritualesque*, edited by Jack Santino, 222–238. Logan: Utah State University Press.

May, Theresa J. 1999. "Frontiers: Environmental History, Ecocriticism and *The Kentucky Cycle*." *Journal of Dramatic Theory and Criticism* 14 (1): 159–178.

May, Theresa J. 2005. "Greening the Theater: Taking Ecocriticism from Page to Stage ." *Interdisciplinary Literary Studies* 7 (1): 84–103.

May, Theresa J. 2007. "Beyond Bambi: Toward a Dangerous Ecocriticism in Theatre Studies." *Theatre Topics* 17 (2): 95–110. doi: 10.1353/tt.2008.0001.

Styan, J. L. 1960. *The Elements of Drama*. Cambridge: Cambridge University Press.

Theater of the Anthropocene. 2020. "*The Theatre*." Accessed October 4. http://theater-des-anthropozän.de/en/the-theatre/.

Zarrilli, Phillip. 2010. "Oral, Ritual, and Shamanic Performance." In *Theatre Histories: An Introduction*, edited by Phillip Zarrilli, Bruce McConachie, Gary Jay Williams, and Carol Fisher Sorgenfrei, 15–51. London: Routledge.

12 Environmental film

Projecting nature

Chapter objectives

- To review the contribution of environmental film, or ecocinema, to the growth of the Environmental Humanities
- To explain cinema's increasing attention to socio-ecological issues
- To describe historical developments in film leading to the emergence of various ecocinema genres including documentary, animation, and fictional films
- To apply introductory knowledge of performance theory to reading environmental films
- To recognize the implications of environmental images for the conservation of animals, plants, and ecosystems

Harvesting honeycomb

Directed by Tamara Kotevska and Ljubomir Stefanov, *Honeyland* (2019) is a documentary film narrating the everyday life of Hatidže Muratova, a Macedonian apiarist of Turkish descent, who harvests honey from wild bees in the isolated village of Bekirlija, North Macedonia. In the film, as Muratova gently extracts the honeycomb—the sheets within the hive composed of hexagonal cells of wax enclosing larvae, pollen, and honey (Figure 12.1)—she can often be heard addressing the bees with these words of ecostewardship, "half for me, half for you." The sustainable methods, part of traditional wisdom passed down from her grandparents, contrast sharply to those of the newcomer, Hussein Sam, who steals Muratova's knowledge of bees, exhausts the wild hives, and then abandons the village.

The film dramatizes issues pertinent to the Environmental Humanities, namely climate change, species loss, ecosystemic collapse, natural resource exploitation, unhinged consumerism, and urban-rural conflict. Although focused on a lone keeper in a remote community, the film speaks more broadly of the loss of wild bees around the world as a result of land clearance, disease outbreaks, insecticides, food supply decline, and anthropogenic disruptions of the seasons. As key pollinators, wild bees are critical not only for wild habitats but also for agriculture. The dwindling of bee populations, therefore, has implications for global food security (Embry 2018).

Reflection 12.1 Cinema and the environment

Honeyland uses a suite of techniques to communicate, through the film medium, the urgency of safeguarding traditional knowledge of wild bees. A technique known as fly-on-the-wall situates the camera inconspicuously in the shot to avoid interfering with the narration. Even during moments of emotional intensity, Hatidže Muratova never

DOI: 10.4324/9781351200356-12

speaks directly to the camera and, what's more, the filmmakers are careful not to disturb the bees themselves as participants in the film. However, during chaotic scenes involving the Sam family, especially those of the second half of *Honeyland*, the camera shakes noticeably from side to side.

Using an online video-sharing platform, such as YouTube or Vimeo, view a short clip of *Honeyland*. What other techniques does the documentary film employ? Use the terms from Waypoint 12.1. From an ecological perspective, why are ecofilms such as *Honeyland* important in the Anthropocene?

Green film criticism and environmental consciousness

The fields of ecological art, theater, and film are intimately related in the Environmental Humanities. Indeed, for many practitioners of ecoart and ecotheater working today, film is an integral part of their artistic productions. Yet, unlike art and theater—with extensive traditions stretching across millennia—film has a much shorter history, emerging in earnest in the 1890s. Nonetheless, in its relatively short 130-year history, film has become a compelling medium for depicting the environment and, in recent decades, dramatizing ecological realities and envisioning sustainable futures. In addition, many current filmmakers—including Tamara Kotevska and Ljubomir Stefanov who created *Honeyland*—are also passionate environmental activists. As one of the fastest growing, most influential cultural forms in the humanities, film has become an indispensable component of the Environmental Humanities.

Figure 12.1 A honeycomb contains bee larvae.

Image credit: Waugsberg (Wikimedia Commons).

This chapter uses the terms *ecocinema* to refer to films with an environmental focus and *ecocinema studies* to point to the scholarly specialization within the Environmental Humanities that is concerned with such films. Ecocinema studies asks the following types of questions:

- In what ways have films from different genres—from low-budget documentaries to big-budget features—constructed nature as a passive backdrop to human dramas?
- What has been the role of cinema in the formation of social and cultural attitudes toward the environment?
- How does cinema reinforce or contest aesthetic perceptions of nature, for instance, as beautiful, picturesque, or sublime?
- How effective is ecocinema as an artistic medium for encouraging audiences to adopt environmentally sensitive values and behaviors? How can we measure that?
- And, finally, what steps are necessary for cinema to integrate sustainable production practices entailing fewer adverse ecological side effects? (Chu 2016, 14).

Responding to these and other questions first requires familiarity with the lingo of cinema studies. For more cinema basics, consult Jill Nelmes' concise *Introduction to Film Studies* (2012) or Annette Kuhn and Guy Westwell's *A Dictionary of Film Studies* (2020).

Waypoint 12.1 Overview of essential cinema terminology

- *Celluloid*: the original transparent material employed to record motion pictures; often used as a synonym for film in general
- *Diegetic elements*: aspects of the story, including events, characters, and dialogue, as opposed to the narration, or the style in which the story is told
- *Dissolve*: a transition technique for going from one shot, or image, to the next
- *Extended duration*: a film shot that lasts comparatively longer than others; also known as a continuous shot or long take
- *Fly-on-the-wall*: a technique that positions the camera unobtrusively in the shot to avoid interrupting the narrative
- *Filmography*: a list of films organized for a particular purpose such as to showcase the achievements of an actor or director
- *Mise-en-scène*: the layout of the stage and arrangement of actors in a film scene
- *Moving image*: a visual work characterized by the appearance of movement including films, television programs, and online media
- *Non-diegetic elements*: aspects of the narration style, or how the story is told rather than the core story elements
- *Rough cut*: the unpolished version of a film before the final cut that often exhibits flaws or lacks advanced production effects
- *Score*: original music composed for a specific film
- *Sequence*: the arrangement of shots
- *Shot*: the fundamental unit of a film; comparable to an image, term, or word
- *Time-lapse*: a technique used frequently in ecodocumentaries that condenses changes in nature unfolding slowly over time
- *Voice-overs*: a technique in which a voice that is separate from the story, and thus non-diegetic, tells the story

Originating in the mid-1990s, ecocinema studies is a branch of film studies focused on the relationship between cinema, the environment, and more-than-human beings. It is often used interchangeably with the older term *green film criticism* (Ivakhiv 2008), and draws from environmental studies, ecocriticism, ecotheater, critical animal and plants studies, postcolonial analysis, and, most recently, climate change theory. Ecocinema studies develops critical approaches to a wide range of films of various genres and periods, though it tends to focus on environmentally themed films—from Jacques Cousteau's underwater documentary *The Silent World* (1956) to Roland Emmerich's apocalyptic feature film *The Day After Tomorrow* (2004). James Cameron's *Avatar* (2009)—which introduced our overview of environmental philosophy in Chapter 7—is further representative of the kinds of films gathered under the umbrella of ecocinema studies.

Reflection 12.2 Underwater cinematography

Co-directed by Jacques Cousteau and Louis Malle, *The Silent World* is one of the first works of underwater cinematography in which filmmakers used submersible cameras while snorkelling or scuba diving (Figure 12.2). Despite its pioneering methods as well as Cousteau's legacy as a marine conservationist, the film has been harshly criticized for its destructive impact on the ocean habitats it features. Viewers are confronted by scenes of the crew bludgeoning sharks, blowing up coral reefs, and committing other acts of aquatic vandalism.

Using any online video-sharing platform, view a clip of *The Silent World*. What is your first impression of the film? What cinematographic techniques does it appear to employ? In what ways can underwater documentary filmmakers minimize their impacts on the marine habitats they depict? Contrast Cousteau's film with *Blue* (2016), directed by Karina Holden (here's the trailer: https://vimeo.com/bluethefilm2017). What differences do you notice in tone, style, and human relations with the ocean?

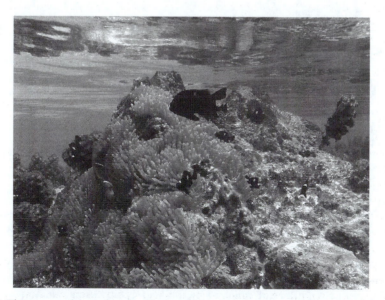

Figure 12.2 This image of a coral reef at Huahine, French Polynesia, is an example of the increasing prevalence of underwater photographic technologies.

Image credit: William Landi.

In contrast to *ecofilm studies*, which are critical techniques that can be applied to any film, David Ingram (2000) defines *ecological cinema* as films with prominent environmental messages. Alternatively, film scholar Scott MacDonald (2004) defines ecocinema by its effect on viewers: as a filmmaking tradition that evokes the illusion of being immersed in nature. For MacDonald, the fundamental role of ecocinema is to retrain viewers' "perception, as a way of offering an alternative to conventional media-spectatorship [and] consumerism" (109). Bridging these two, film scholar Sheldon Lu (2009) defines ecocinema as "cinema with an ecological consciousness. It articulates the relationship of human beings to the physical environment, earth, nature, and animals from a biocentric, non-anthropocentric point of view" (2). Like many ecocinema scholars, however, Lu neglects plants and other non-animals in his definition—a deficiency that is addressed later by Case Study 12.2 on plant cinematography.

Case Study 12.1 Ecocinema in Vietnam

Vietnamese film is a growing area of interest for scholars of Southeast Asian ecocinema. Environmental concerns in Vietnam relate to the many legacies of colonialism, including land and forest degradation, wetland loss, biodiversity decline, water and air pollution, wildlife trafficking, and climate disturbance. For example, throughout the 1960s, the US military sprayed millions of gallons of extremely toxic chemicals across the landscape, including the infamous defoliant known as Agent Orange. That ecological vandalism has especially harmed Indigenous Vietnamese, aggravating inequitable land distribution and destroying their subsistence-based livelihoods.

These concerns have featured prominently in Vietnamese film. For instance, *Story of Pao* (2006), directed by Ngô Quang Hải, is a drama based on a novel about the Hmong of northern Vietnam. The film portrays Hmong people's interdependencies with the mountainous landscape and alludes to the disruption of traditional human–nature relations. Another example is *2030* (2014), a futuristic science fiction romance directed by Nguyễn Võ Nghiêm Minh. The film dramatizes the effects of climate change on southern Vietnam where people have retreated to houseboats while corporations construct floating farms that require genetic manipulation to cultivate food crops.

View *Story of Pao, 2030, The Buffalo Boy* (2004), or any other Vietnamese film with environmental themes. Ensure that the film was made by a Vietnamese director. Now refer to Waypoint 12.1. What techniques does the film employ to narrate ecological messages? Skip ahead to Waypoint 12.2. Which genre best describes the film? Try to be as precise as possible in your analysis. Refer to specific scenes to support your answers. What are the advantages of studying international ecocinema?

Films such as *Story of Pao* and *2030* engender awareness of the environment, conservation, climate, politics, and human–nature relations while encouraging reflection on what it means to inhabit the Earth sustainably, but don't necessarily encourage activism. In Paula Willoquet-Maricondi's (2010b) distinction, they are not, *environmentalist films* with "consciousness-raising and activist intentions" oriented toward conservation; rather, they are, *ecocinema*, which encompasses a wider range of films, such as nature documentaries, without explicit activist messages (45). Both kinds of films communicate similar values of interconnectedness and interdependence. Thus ecocinema studies approaches film broadly to understand how

visual representations position nature through the camera frame, the editing process, and the reception of the film by audiences (Willoquet-Maricondi 2010a, 8).

Reflection 12.3 Anthropomorphism in film

Anthropomorphism is a strategy used in films in which human attributes, such as the ability to speak, are given to non-human characters. Anthropomorphism is an example of the cultural construction of non-human life. It can be created at any stage of the filmmaking process, from the writing of a script to the editing of scenes. Movies such as *Finding Nemo* (2003) and *March of the Penguins* (2005) that use anthropomorphism have been criticized for misrepresenting the actual behaviors of animals.

In ecocinema studies, anthropomorphism tends to be viewed in a negative light. Nonetheless, can you think of any positive aspects of anthropomorphism? Consider the impact on audiences who identify more readily with human-like characters. If a greater good is achieved, do the ends justify the means? Who decides? In answering these questions, you're welcome to refer to specific films.

Stephen Rust and Salma Monani highlight the power of ecocinema and its scholarly analysis to shift awareness away from anthropocentrism and toward biocentrism or ecocentrism. Ecocinema studies and the films central to the field acknowledge "ways of seeing the world other than through the narrow perspective of the anthropocentric gaze that situates individual human desires at the center of the moral universe" (Rust and Monani 2013, 11). Ecocinema scholars such as Rust, Monani, Willoquet-Maricondi, and others work from the premise that nature is constructed in film by cinematic technologies, filmmakers' intentions, viewers' preferences, entertainment industry fads, political formations, and a multitude of other factors. They therefore examine how films are created, promoted, and received by the public.

Waypoint 12.2 Overview of essential film genres

- *Animation*: demonstrates the usage of non-photographic techniques such as hand drawing and computer-generated imagery (CGI)
- *Avant-garde*: experiments with the conventions of light, motion, space, and time including non-linear narration
- *Cinéma vérité*: involves a participatory style of ethnographic filmmaking focused on the self-revelation of a film's subject
- *Comedy*: provokes laughter and is characterized by a lightness of tone and a happy ending
- *Diasporic*: work produced by members of a community, exiled from its original homeland, which expresses the experience of displacement or exile
- *Direct*: entails fly-on-the-wall observation of crisis or drama with minimal interference by the film crew
- *Documentary*: addresses real-life issues, organizations, places, and people with the aim to educate, inform, or persuade

- *Documentary short*: has a short running time in comparison to a full-length documentary film; often shown at film festivals
- *Ethnographic*: enacts the theories, approaches, and terminologies of anthropology and sees filmmaking as a social research tool
- *Feature*: lasts for more than one hour and serves as the centerpiece of a cinematic experience or theater event
- *Feminist*: narrates feminist perspectives, women's issues, and sexist stereotypes; incorporates feminist modes of storytelling
- *Melodrama*: dramatizes moral predicaments and conflicts, typically in families, and provokes emotional reactions in viewers
- *Propaganda*: disseminates strong political messages through misleading information; regarded by critics as unethical
- *Slow*: exhibits an austere or minimalist style that employs extended duration to engender a meditative or contemplative mood
- *Structural*: explores the visual and cognitive features of the film medium through experimentation based on self-reflection
- *War*: features combat scenes that govern the fate of a film's characters

Imaging nature: ecocinema history and theory

Despite the efforts of many early inventors around the globe, such as English photographer Eadweard Muybridge who constructed the zoopraxiscope in 1880 as a forerunner of the film projector, the French brothers, Auguste and Louis Lumière, are credited with the first commercial

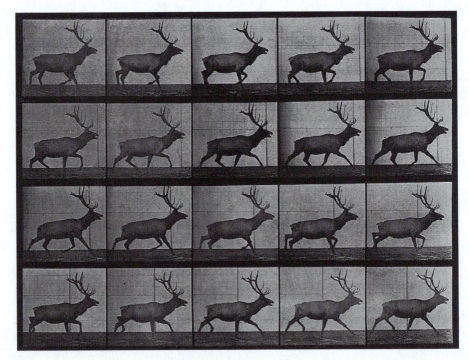

Figure 12.3 Eadweard Muybridge's photogravure features a moose walking.

Image credit: Wellcome Collection Gallery (Wikimedia Commons).

Figure 12.4 This image depicts a scene from the comedy *L'Arroseur Arrosé* (1895).

Image credit: MOMA Collection (Wikimedia Commons).

advances in film. They designed the "cinematograph," a breakthrough invention that made image capture, development, and projection possible in one device. Shown at a public venue in 1895, the first moving picture projections were short films under one minute long. In the Lumière brothers' 45-second silent film *L'Arroseur Arrosé*—also known as *The Waterer Watered* or *The Tables Turned on the Gardener*—a man watering a garden is perplexed by an abrupt drop in water pressure. Behind the gardener, a young male jokester steps on the hose, impeding the water flow. As the gardener tilts the hose up to peer into the opening, the boy releases his foot, causing a water jet to soak the gardener and blow off his brimmed hat. Regarded as the first slapstick comedy film, *L'Arroseur Arrosé* can also be considered one of the earliest cinematic depictions of the landscape, specifically of trees, flowers, water, and soil (Figure 12.4).

Reflection 12.4 Film and environmental contamination

The history of image capture is also a history of environmental contamination. Early methods of processing film released an array of non-biodegradable chemicals into the environment, poisoning aquatic systems and other habitats. In many ways, digital technologies have removed the need for these toxic procedures. Nonetheless, digital image capture is not without a negative side and filmmaking, like theater and installation or landscape art, continues to have an outsized ecological impact. Describe at least three adverse ecological impacts of digital filmmaking.

In the first decade of the 1900s, the global film industry began to blossom, but most films created during this period construct the environment as the backdrop of the narrative. Directed by Frederick S. Armitage and A. E. Weed, *Down the Hudson* (1903) is a rapidly-moving documentary short accompanied by a piano score and filmed from the deck of a boat navigating inlets and coves while heading north from Haverstraw Bay to Newburgh, a distance of about thirty miles. The documentary depicts railways and other infrastructure along the Hudson as well as a panoply of steam and sailing vessels on the river, showing how the fascination with human-built environments and technologies overshadows natural environments. To produce the frenetic succession of scenes, the filmmakers innovated the use of time-lapse (see Waypoint 12.1). A hand crank projector called a Mutoscope enabled audiences to view the film. The aesthetics of *Down the Hudson* would influence river documentaries produced later in the twentieth century such as Peter Hutton's experimental *Study of a River* (1997) and Andrej Zdravič's *Riverglass: A River Ballet in Four Seasons* (1997).

By the mid-twentieth century, influenced by advances in color, sound, and cinematography, the nature documentary genre became popular, with some films exhibiting overt conservation messages. Directed by James Algar and released by Walt Disney Productions, *The Vanishing Prairie* (1954) is a 71-minute color documentary about the flora and fauna of the American prairie, originally stretching from Mississippi to Colorado. The documentary focuses on extinct species that existed before the arrival of European settlers, and species such as the prairie dog that were then endangered. *The Vanishing Prairie* was part of Disney's *True-Life Adventures* series produced between 1948 and 1960, coinciding with the advent of botanical nature documentaries (see Case Study 12.2).

Case Study 12.2 Plant cinematography

The botanical documentary focuses on plant ecology and conservation. It has benefited more than other nature documentary styles from technical breakthroughs that afford glimpses into the mysterious lives of plants.

Written and narrated by David Attenborough, the documentary *Kingdom of Plants 3D* (Williams 2012) was filmed over a year at the Royal Botanical Gardens, Kew, England. It integrates advances in time-lapse cinematography, stereoscopic polarization, and infrared filming to make visible the details of plant existence. Additionally, audience members were encouraged to become active participants by using special tablets to speed up and slow down flowering. A review of the film in the *Guardian* stresses the importance of time-lapse as a technique to understand the uniqueness of plants: "it's only when you speed them up that they reveal their true nature" (Wollaston 2012, para. 5).

Despite its technical novelty, Attenborough's documentary can be appreciated as a relatively recent instance of the more-than-100-year-old lineage of "plant cinematography" (Petterson 2011, 90). The British naturalist and filmmaker, Frank Percy Smith, pioneered time-lapse methods in landmark documentaries such as *Birth of a Flower* (1911) and *The Germination of Plants* (1911), becoming one of the first cinematographers to capture the opening of a bud. Moreover, in 1912, the photographer Arthur Clarence Pillsbury produced a time-lapse documentary to advocate the protection of Yosemite wildflowers threatened with extinction. Pillsbury aimed to "instill a love for [plants], a realization of their life struggles so similar to ours, and a wish to do something to stop the ruthless destruction of them" (Pillsbury 1937).

View any film mentioned in this case study. What methods does the film use to depict the world of plants? What ethical attitudes toward botanical life are evident in the films?

In the 1960s and 1970s, the intensification of the environmental movement in conjunction with the public impact of non-fiction such as Carson's *Silent Spring* (1962) prompted the appearance of feature films with palpable ecological messages (ecocinema). A well-known example is Richard Fleischer's dystopian sci-fi survival film *Soylent Green* (1973). Set in New York City in 2022, the film dramatizes overpopulation, pollution, ecosystemic collapse, and climate catastrophe resulting in rife poverty and famine. Early Japanese environmental documentaries include filmmaker Noriaki Tsuchimoto's *Minamata: The Victims and Their World* (1971) and *The Shiranui Sea* (1975). Both films center on Minamata, Kumamoto Prefecture, Japan, where, between 1932 and 1968, residents suffered from mercury poisoning due to methylmercury released from a nearby chemical factory. Much like *Silent Spring*, the films called attention to environmental health threats from industrial activity.

Reflection 12.5 Beauty and ecocinema

The question of beauty in nature is central to the Environmental Humanities. Chapter 7 introduced this question in the context of ecoaesthetics. Indeed, documentaries such as *The Shiranui Sea* are replete with beautiful landscape scenes that, at times, can be said to belie the urgency of the ecological issues they portray.

To what extent should the aesthetics of beauty figure into documentaries about ecological crises? In responding to this question, you're welcome to refer to any environmental documentary you can get your hands on.

Independent filmmaker James Benning is important to consider. He has featured urban, rural, and wilderness landscapes extensively throughout his long career. His avant-garde *One Way Boogie Woogie* (1977) comprises sixty one-minute shots of an industrial area near Milwaukee, Wisconsin. The film was later reprised as *27 Years Later* (2006). Both the original and sequel address the decline of the filmmaker's home city and its urban ecologies. Scene 48 of the original film depicts a smokestack billowing thick, white smoke over the duration of the shot. The equivalent scene from 2006 again hones in on the cloud-like smoke—though this time in the absence of the stack structure—as faint industrial noises can be heard in the background. The similarly meditative *Deseret* (1995) is a sweeping cinematic survey of the natural and cultural history of Utah from the mid-1800s to the late 1900s, including scenes of Native American rock art. Benning's best known work, however, is *California Trilogy* comprising *El Valley Centro* (1999), *Los* (2000), and *Sogobi* (2002). The water crisis in California is the trilogy's prevailing emphasis. Each film is based on 150-second shots, for a total of 105 shots across all three. For instance, *Sogobi*—meaning "Earth" in the Shoshone language—opens with images of roaring river rapids followed by quiet snow-draped trees. Striking visual and auditory contrasts between the two scenes disturb a sense of placid reverie. Godfrey Reggio's *Qatsi* trilogy (1982, 1988, and 2002) is a comparable avant-garde set of documentaries, though their scope is sweeping and global, designed to interrogate the costs of technology and the built environment on humanity and the more-than-human world.

In more recent years, the environmentalist documentaries, *An Inconvenient Truth* (Guggenheim 2006), *Inconvenient Sequel: Truth To Power* (Cohen and Shenk 2017), and *Planet of the Humans* (Gibbs 2019), have elevated environmentalist film to the center of public discourse. Focused on former US Vice President Al Gore's efforts to bolster awareness of climate change, *An Inconvenient Truth* became a surprisingly high-grossing box office phenomenon, catapulting Gore to a 2007 Nobel Peace Prize and vilification by right-wing media. *Inconvenient Sequel* further traces Gore's campaign to encourage governments to adopt renewable

energies and support the United Nations Paris Agreement to reduce carbon emissions. In contrast to Gore's embrace of big government's technocratic schemes, Jeff Gibb's *Planet of the Humans* (2019) critiques the collusion between big government and the corporatization of the green energy sector, as well as some environmental groups' hidden links to the fossil fuel industry. To maximize the film's visibility, the executive producer, Michael Moore, released *Planet of the Humans* on YouTube where it could be seen for free in its entirety (see Exercise 5 of this chapter). However, YouTube, a private corporation, removed this highly controversial film from its platform on May 25, 2020, only to return it twelve days later after accusations of censorship. (It is now also available to view on the subscription-rental platforms, Amazon, Apple, and Google.) Censorship of art critical of state and corporate action is even more intense in other countries; for instance, in China, where former Chinese journalist, Chai Jing's documentary, *Under the Dome* (2015), which portrays the health consequences of the coal industry, was censored by the Chinese government four days after it was released.

Waypoint 12.3 Overview of essential ecocinema terminology

- *Andro-centric/Gyno-centric film*: imparts a male/female perspective through the narration of a film
- *Ecocinema*: exhibits or promotes environmental consciousness through diverse genres including feature films and documentaries
- *Ecocinema studies*: analyzes the ways in which films centralize ecological themes, questions, and concerns
- *Ecofeminist film*: foregrounds the connections between the oppression of women and the degradation of the environment
- *Ecological science fiction*: dramatizes nature and planetary crisis through futuristic concepts based in scientific advances
- *Ecologizing cinema*: introduces ecological perspectives to mainstream films through viewer-initiated media responses
- *Ecomedia studies*: examines the representation of the environment in non-print media such as film, television, and video games
- *Environmentalist film*: expresses overt ecopolitical messages related to biodiversity conservation and climate change
- *Green film criticism*: constitutes an early synonym for ecocinema studies used frequently by film scholar Adrian Ivakhiv (2008)
- *Greening of Hollywood*: refers to the application of ecological attitudes and practices to the Hollywood film industry
- *Nature documentary*: portrays the lives of animals, plants, insects, and other organisms usually in their natural habitats
- *Plant cinematography*: develops techniques such as time-lapse to make visible to audiences the changes plants undergo over time
- *Speciesist camera*: projects ideologies reflecting species hierarchies on more-than-humans during the filmmaking process
- *Transnational ecocinema*: considers global examples of ecocinema beyond the field's historical emphasis on Hollywood films
- *Zoomorphic realism*: represents wild or domestic animals as accurately as possible and with minimal modification

Environmental humanists require conceptual tools to analyze films and cinematic history just as botanists need quadrats to perform field surveys and medical researchers need electron microscopes to do lab work. We call our tools "conceptual frameworks" or just "theory." Emerging in the 1970s, film theory is a broad, vital area of film studies that applies diverse conceptual frameworks to understanding the complex ways in which films operate in the world. For ecocinema studies, the most important theories are *semiotics*, *psychoanalysis*, *feminist theory*, *phenomenology*, *postcolonialism*, and *narratology*. Other important film theories include adaptation, formalist, Marxist, queer, and race theories. The best approach to theory overload is to select one or two theories and delve into them as deeply as possible. For further background on this rich and evolving area of cinema scholarship, consult Ruth Doughty and Christine Etherington-Wright's accessible introduction, *Understanding Film Theory* (2018).

The timeliness of film? Current trajectories in ecocinema studies

In recent years, the field of ecocinema studies has continued to enlarge its understanding of ecocinema by incorporating interdisciplinary and transdisciplinary studies of time, space, ethics, aesthetics, justice, animals, plants, health, wellness, pollution, toxicity, sustainability, and resilience.

Three of the most difficult questions scholars have been wrestling with concern the contradictions or paradoxes inherent to ecocinema:

1. the dependence on and fascination with environmentally destructive, advanced technology to create films;
2. the risks of creating illusions of an idealized nature that disengage viewers from actual nature; and
3. the problem of reinforcing passive modes of engaging with these mesmerizing art forms.

Avatar (2009), for instance, may pronounce judgement on the exploitative nature of technologically advanced civilizations, but it does so through advanced technologies that made it the second most expensive film in history. We can legitimately ask whether that money would be better spent directly on preservation efforts. Likewise, *Bambi* (1942) may be the most important animal-rights animation ever, but its anthropomorphic projection and "Disneyfication" of nature create an idealized illusion of "how nature should be" that is now an impediment to sustaining urban-wildland ecosystems.

The third question is one of the most pressing in ecocinema studies. As contributors to the recent book, *On Active Grounds: Agency and Time in the Environmental Humanities* (Boschman and Trono 2019), put it, "Can ecocinema itself, or ecocinematic forms of interpretation, draw forth changes in human behaviour (58). The question shows how concerns of early ecocinema scholars have advanced (see Reflection 12.7).

The contributors answer their own question by proposing two modes of engaging ecologically with all kinds of films. The first, *ecocinematic viewing*, is a form of active spectatorship in which a viewer actively analyzes mainstream films through the lens of ecological critique in order to reflect on personal experience. This helps mobilize their engagement with environmental issues in their personal lives. In the second, *montagist reply*, spectators go one step further by producing online media that creatively interpret mainstream films from ecological perspectives. Both modes are active and interventionist, though they depend on the availability of non-specialist, user-friendly film production tools as well as the online dissemination of creative media, for instance, through YouTube, Facebook, and Instagram. In short, from

this point of view, *all films* can be framed ecologically through new storytelling platforms, a process known as *ecologizing cinema*, and this inspires behavioral change in viewers.

Reflection 12.7 Ecocinema and activism

The capacity of film to effect tangible change in the world has been a recurring question in ecocinema studies since the field's inception thirty years ago. Sometimes, however, ecocinema and activism intersect unequivocally. This is true of the 2011 "Avatar Protests" during which Cambodian activists staged demonstrations in Phnom Penh dressed as the Na'vi from the film *Avatar*. The campaigners opposed the government's leasing of land, particularly in Prey Lang, to foreign and domestic industries. Home to more than 200,000 Indigenous people, the Prey Lang Forest is Southeast Asia's largest intact lowland evergreen woodland ecosystem. The protestors' usage of a recognizable aesthetic from a popular Western film drew global attention to deforestation in Cambodia and asserted the importance of conservation.

Conduct an online search for additional examples of ecocinema's role in environmental debates. How did the films promote awareness or facilitate change?

Like ecoart and ecotheater, the field of ecocinema studies continues to diversify within the overarching framework of the Environmental Humanities. Current areas of research emphasis include ecomedia, the Anthropocene, climate change fiction (cli-fi), transnational approaches especially those involving Chinese and Italian cinema, and urban environments. These areas are introduced briefly below.

Ecomedia studies is a field that examines the representation of the environment in non-print forms of media emphasizing the environmental aspects of technology, activism, advocacy, communication, journalism, rhetoric, and discourse (see Chapter 13). You can think about *ecocinema studies* as a specialization within *ecomedia studies*—which in turn is a specialization within the Environmental Humanities. An ecomedia perspective on film highlights the increasing uptake of relatively simple, user-friendly filmmaking platforms by online creators for purposes of environmental activism and advocacy.

As a case in point, ecoconscious users of the video-sharing app TikTok have promoted climate change awareness through time-lapse videos. These video shorts—or what could be called *very short shorts*, *video bursts*, or *online microcinema*—enable users to dramatize the alarming long-term consequences of climate change for humans and the biosphere. For instance, spanning 1,000 years from 2019 to 3019, Anna Bogomolova's 15-second TikTok video "Effects of Global Warming on a Human" depicts dying flowers, empty water bottles, and regurgitated plastic. (To view the video, see the Weblinks section at the end of this chapter.) What's more, free online content, such as the popular TED talks available on YouTube, addresses a variety of ecological topics—from climate change and ocean plastic to zero waste and renewables—from the viewpoints of diverse environmental experts.

Comparable to Anthropocene theater discussed in Chapter 11, the field of Anthropocene cinema studies confronts the immediacies of the current age, specifically the perils of humanity assuming the role of biospheric agent. Comprising non-fictional documentary and fictional feature films—and everything in between—this emergent ecocinematic genre strives to produce a poignant, emotional, and informative experience of the Anthropocene concept. To be sure, one reason why ecocinema is likely to become ever more pertinent to

the ecohumanist examination of Anthropocene urgencies is film's unique capacity to affect a viewer's apprehension of time (see Chapter 3).

Through its ability to compress and elongate time within a narrative, film enables audiences to access the otherwise perplexing and overwhelming phenomenon of deep geological time at the core of the Anthropocene concept. As environmental humanists note, "Thinking about deep time is challenging: deep time is strange and warps our sense of belonging and our relationships to Earth forces and creatures" (Ginn et al. 2018, 213). Yet, despite its strangeness, deep time "manifests through places, objects, and practices" (213).

As scholars have commented, "The Anthropocene is to natural science what cinema, especially early cinema, has been to human culture. It makes the familiar world strange to us by transcribing the dimensionalities of experience into celluloid" (Fay 2018, 3). Films such as director Terrence Malick's experimental *The Tree of Life* (2011)—which, in a non-linear fashion, traverses time's expanse from the birth of the universe to the present era—can facilitate insights into the mindboggling multidimensionality of deep time. Another example of Anthropocene cinema is the Canadian documentary *Anthropocene: The Human Epoch* (2018) by Jennifer Baichwal, Nicholas de Pencier, and Edward Burtynsky. The film premiered as part of the Anthropocene Project of multimedia exhibitions at Canadian and European galleries (see Filmography).

Climate change cinema has existed longer than Anthropocene cinema, going back to roots in the sci-fi and disaster genres of the 1950s, 1960s, and 1970s. The cult classic *Soylent Green* (Fleischer 1973) can be regarded as the first climate change film. The 1990s heralded the appearance of a diverse mix of environmentalist features films and television programs such as the musical animation *FernGully: The Last Rainforest* (1992), the TV miniseries *The Fire Next Time* (1993), and the dystopian action film *The Day After Tomorrow* (2004). According to director Michael Svoboda (2020), since the appearance of *The Day After Tomorrow*, filmmakers have produced more than sixty climate change films across seven genres: disaster, apocalypse, dystopia, psychological thriller, comedy, children's animation, and alien films (sci-fi). In response to the visibility of climate change politics in the news media, cli-fi films—and academic research on them—are expected to become more prevalent, particularly as part of environmental film festivals (see Case Study 12.3).

Case Study 12.3 Environmental film festivals

A film festival is typically an annual, multi-day presentation of films and related events at one or more screening locations in a city or region. An environmental film festival is exclusively devoted to ecological subject matter. Often sponsored by environmental organizations, foundations, and magazines, ecofilm festivals present platforms for inspiring action on behalf of the Earth and fostering awareness of ecological issues. Although the first ecofilm festivals appeared in the late 1970s and early 1980s in the US, the last three decades have witnessed a multiplication of festivals in urban areas, rural towns, and university venues (Duvall 2017, 47–48). Some ecofilm festivals are geared toward general audiences interested in the appreciation of the natural world, whereas others exhibit a stronger activist slant.

Founded in 1977, one of the oldest ecofilm festivals is the International Wildlife Film Festival in Missoula, Montana. The Environmental Film Festival in Washington,

DC, moreover, is often labelled the largest of its kind in the world. Founded in 1993 by organizer Flo Stone, the yearly event includes film screenings at embassies, museums, galleries, libraries, universities, and local movie theaters. Running for nearly twenty years, the Wild & Scenic Film Festival in Nevada City, California, has traditionally been a five-day event featuring films, workshops, filmmaker talks, and social events. Outside of the US, ecofilm festivals are also flourishing. The Environmental Film Festival Australia, for instance, has been held since 2010 in Melbourne, Sydney, Adelaide, Canberra, and Hobart with support from Green Party politicians Bob Brown and Adam Bandt. Since 2014, the tiNai Ecofilm Festival has highlighted the ecocinema of India (see the Weblinks section for links to all five film festivals).

Visit the websites of the film festivals listed in Weblinks or identify other festivals through your own research. How is each festival structured? What ecological topics have dominated recent festivals? What kinds of environmental audiences do they cater for? Grassroots? Activist? Enthusiast? Corporate? Consumerist? How do environmentalist values align with the practices?

Waypoint 12.3 defined *transnational ecocinema* as a genre of ecocinema that appraises films from various cultures and countries, thus broadening the field's original spotlight on mainstream US productions. Film scholars Pietari Kääpä and Tommy Gustafsson first employed the term in their edited book *Transnational Ecocinema: Film Culture in an Era of Ecological Transformation* (2013) in order to encourage discussion of global films in ecocinema debates.

A transnational emphasis figures prominently in recent ecocinema scholarship. For instance, a section of *Chinese Environmental Humanities: Practices of Environing at the Margins* (Chang 2019) is dedicated to "Chinese Ecocinema and Ecomedia Studies." In a similar vein, *Ecology and Chinese-Language Cinema: Reimagining a Field* (Lu and Gong 2020) investigates developments in the growing area of Chinese ecocinema. Likewise, Elena Past (2019) has advanced understanding of environmentalism in Italian cinema.

Another current trajectory is urban ecocinema. With the exception of Benning's *One Way Boogie Woogie* (1977), the *Quatsi* Trilogy (1982, 1988, 2002), and some other early films attentive to technology and the built environment, ecocinema—and ecocritical studies of films—have largely privileged rural and wilderness landscapes. Robin L. Murray and Joseph K. Heumann's *Ecocinema and the City* (2019) seeks to redress this gap by exploring the mediation of city habitats and urban environmentalisms in documentaries and fictional films. With the steady urbanization of the global population and reliance on artificial intelligence, ecocinema that addresses technology and the urban environment will become an ever more salient indicator of environmental urgencies associated, for instance, with resource distribution, inequality, poverty, overpopulation, and pollution. As a case in point, the documentary *The City Dark* (2011) explores the physical and mental ramifications of light pollution. The global ubiquity of electric lighting has led to the diminishment of darkness such that the pleasure of seeing the stars at night has become a rare privilege for most people. Yet humankind has always maintained an intimate relationship to the sky and constellations. What will become of darkness in a world preoccupied with light? Can we be humbled by the incomprehensible otherness of stars when all we can see is our own self-generated light?

Chapter summary

This chapter has defined *ecocinema* as a genre of film exhibiting or encouraging environmental values. In contrast, *ecocinema studies* denotes the scholarly specialization within the Environmental Humanities concerned with the ecological meaning of films as well as cinema's broader relationship to the natural world. Over the course of its relatively short history, film has become a persuasive medium for depicting the environment, communicating ecological immediacies, and imagining sustainable alternatives. While the first environmental films featured the natural environment as a backdrop to human affairs and their technical flamboyance, contemporary films are more conscious of the primacy of the environment and the urgency of changing human behaviors. The conclusion addressed current areas of emphasis within the field including ecomedia, the Anthropocene, climate change, transnational outlooks, and urban environments. The chapter's three case studies explored ecocinema in Vietnam, plant cinematography, and environmental film festivals. As environmental debates intensify, ecocinema is sure to become an ever more vital Environmental Humanities intervention.

Exercises

1. Guided by the six questions that ecocinema studies asks of films, as listed at the beginning of this chapter, develop an analysis of one film we have mentioned in Chapter 12. Ecocinema scholars claim that film can enhance environmental awareness and engender positive change. How do films accomplish these feats? What are the mechanisms underlying film's supposed capacity to transform values? Respond to these questions through a close reading of your selected film.

2. View Frederick S. Armitage and A. E. Weed's black and white documentary *Down the Hudson* (1903): www.youtube.com/watch?v=EYXeyJBazmc. Using any of the terms from Waypoint 12.1, write a short review of the film from the perspective of someone in the 2020s. What techniques does the film innovate? What does the film reveal about the relationship between technology, transportation, commerce, rivers, and environmental change? For a more advanced project, compare *Down the Hudson* to Peter Hutton's *Study of a River* or Andrej Zdravic's *Riverglass*: what has changed in terms of how films represent nature, humans, and technology?

3. Create a concept for a film that thematizes *one or more* of the following five issues: (i) urban poverty; (ii) noise pollution; (iii) water access; (iv) endangered species trafficking; and/or (v) the psychological distress of climate change. Referring to Waypoints 12.2 and 12.3, select one or more genres for your film. Where will the film take place? Who will be involved? What will be its title, characters, and story arc? You can include graphic representations (sketches, drawings, photographs, storyboards, etc.) of your proposed film.

4. Explore the International Wildlife Film Festival (IWFF) website: https://wildlifefilms.org. Click the "About" tab at the top right of the page to learn more. Then go to "Submissions" to familiarize yourself with what is required. Page down to review the IWFF submission categories. Now use Nadia Bozak's book, *The Cinematic Footprint* (2012), included in the Annotated Bibliography, to consider the environmental impact of film festivals: do the potential benefits from raising consciousness outweigh the environmental impacts? Summarize your general impressions of IWFF.

5. View *Planet of the Humans* (2019) by Jeff Gibbs (executive produced by Michael Moore): www.youtube.com/watch?v=Zk11vI-7czE&t=4s. Describe the structure and style of the documentary. What is the film's general message about green energy? What sorts of reviews did it receive? What controversies did it create? As a filmmaker, how does Jeff Gibbs' "voice" compare to Sir David Attenborough's?

Annotated bibliography

Bozak, Nadia. 2012. *The Cinematic Footprint: Lights, Camera, Natural Resources*. New Brunswick: Rutgers University Press. Bozak's title is the first in-depth study of the environmental dimensions of film production, distribution, and consumption. The author develops the concept of the "hydrocarbon imagination" to track the historical emergence of film as a medium.

Crist, Eileen. 1999. *Images of Animals: Anthropomorphism and Animal Mind*. Philadelphia: Temple University Press. A landmark work in zoocritical studies of media, Crist's monograph examines historical and contemporary representations of animal behavior.

Cubitt, Sean. 2005. *EcoMedia*. Amsterdam: Rodopi. Cubitt's study focuses on the mediation of environmental issues in popular film and television with case studies of Japanese animation, wildlife documentary, and TV drama.

Ingram, David. 2000. *Green Screen: Environmentalism and Hollywood Cinema*. Exeter: University of Exeter Press. Bringing film studies into conversation with environmental politics and history, Ingram argues that mainstream cinema reinforces romantic views of wilderness, wildlife, and land development.

Kääpä, Pietari, and Tommy Gustafsson, eds. 2013. *Transnational Ecocinema: Film Culture in an Era of Ecological Transformation*. Bristol: Intellect. The contributors to this collection aim to broaden the field of ecocinema studies beyond its historical emphasis on Hollywood films through ecological analyses of East Asian, Latin American, and Australian films.

MacDonald, Scott. 2001. *The Garden in the Machine: A Field Guide to A Field Guide to Independent Films about Place*. Oakland: University of California Press. This early publication in the field examines representations of place in the avant-garde and mainstream cinema of the United States.

Mitman, Gregg. 1999. *Reel Nature: America's Romance with Wildlife on Film*. Cambridge: Harvard University Press. Mitman's monograph suggests that a combination of social demands and emerging technologies generated the popular images in nature documentaries and television programs that have widely influenced contemporary perceptions of wildlife.

Rust, Stephen, Salma Monani, and Sean Cubbitt, eds. 2013. *Ecocinema Theory and Practice*. New York: Routledge. A foundational text in ecocinema studies, this edited collection introduces key concepts in ecocinema theory, aesthetics, ethics, and practice in documentary and fictional films.

Weblinks

Anthropocene Cinema. This academic blog explores connections between cinema and the Anthropocene. www.anthropocene-cinema.com

Bogomolova, Anna. A 15-second TikTok video, "Effects of Global Warming on a Human" demonstrates the uptake of video production software by the environmentally concerned public. www.tiktok.com/@anna/video/6711663104222039301

Eckerd College Environmental Film Festival. This campus-based ecofilm festival has been running since 2008. www.environmentalfilmfest.com

Environmental Film Festival Australia. Since 2010, this Australian film festival has taken place annually in cities across the country. www.effa.org.au

Environmental Film Festival in the Nation's Capital. Based in Washington, DC, this is considered the largest environmental film festival in the world. https://dceff.org

Finger Lakes Environmental Film Festival (FLEFF). Located at Ithaca College in Upstate New York, FLEFF is an example of a regional environmental film festival. www.ithaca.edu/fleff/

Green Film Network (GFN). With its headquarters in Innsbruck, Austria, this association promotes communication and collaboration regarding ecocinematic engagements with environmental issues. http://greenfilmnet.org

Indonesia Nature Film Society. This organization supports the production of documentaries about Indonesian nature and culture. http://inaturefilms.org

International Wildlife Film Festival (IWFF). Founded in 1977 in Missoula, Montana, IWFF is the oldest environmental film festival in the world. https://wildlifefilms.org

The Anthropocene Project. Through the interplay of art, film, virtual reality, and science, the project explores Anthropocene urgencies and planetary futures. https://theanthropocene.org

tiNai Ecofilm Festival. Based in India, this ecofilm festival calls attention to ecocinema in South Asia. https://teff.in/

Wild and Scenic Film Festival. Taking place annually in California, this five-day festival involves numerous partnerships with local grassroots organizations. www.wildandscenicfilmfestival.org

Filmography

Algar, James. 1954. *The Vanishing Prairie*. United States: Buena Vista Distribution.

Armitage, Frederick S., and A.E. Weed. 1903. *Down the Hudson*. United States.

Attenborough, David. 1979. *Life on Earth*. UK: BBC, Warner Bros.

Attenborough, David. 1984. *The Living Planet*. UK: BBC.

Attenborough, David. 2020. *A Life on Our Planet: My Witness Statement and a Vision for the Future*. United States: Netflix.

Baichwal, Jennifer, Nicholas de Pencier, and Edward Burtynsky. 2018. *Anthropocene: The Human Epoch*. Canada.

Benning, James. 1977. *One Way Boogie Woogie*. United States: Benning, James.

Benning, James. 1995. *Deseret*. United States.

Benning, James. 1999. *El Valley Centro*. United States.

Benning, James. 2000. *Los*. United States.

Benning, James. 2002. *Sogobi*. United States.

Benning, James. 2006. *One Way Boogie Woogie/27 Years Later*. United States.

Cameron, James. 2009. *Avatar*. United States: 20th Century Fox.

Cheney, Ian. 2011. *The City Dark*. United States: Public Broadcasting Service (PBS).

Cohen, Bonni, and Jon Shenk. 2017. *An Inconvenient Sequel: Truth to Power*. United States: Paramount Pictures.

Cousteau, Jacques, and Louis Malle. 1956. *The Silent World*. France: Rank Organisation.

Emmerich, Roland. 2004. *The Day After Tomorrow*. United States: 20th Century Fox.

Fleischer, Richard. 1973. *Soylent Green*. United States: Metro-Goldwyn-Mayer.

Gibbs, Jeff. 2019. *Planet of the Humans*. United States: Rumble Media and YouTube.

Guggenheim, Davis. 2006. *An Inconvenient Truth*. United States: Paramount Classics.

Hải, Ngô Quang. 2006. *Story of Pao*. Vietnam.

Hutton, Peter. 1997. *Study of a River*. United States.

Jing, Chai. 2015. *Under the Dome*. China.

Kotevska, Tamara, and Ljubomir Stefanov. 2019. *Honeyland*. North Macedonia: Neon.

Kroyer, Bill. 1992. *FernGully: The Last Rainforest*. Australia and the United States: 20th Century Fox.

Malick, Terrence. 2011. *The Tree of Life*. United States: Fox Searchlight Pictures.

McLoughlin, Tom. 1993. *The Fire Next Time*. United States.

Minh, Nguyễn Võ Nghiêm. 2004. *The Buffalo Boy*. Vietnam: Global Film Initiative.

Minh, Nguyễn Võ Nghiêm. 2014. *2030*. Vietnam: Saigon Media.

Reggio, Godfrey. 1982. *Koyaanisqatsi: Life Out of Balance*. United States: American Zoetrope.

Reggio, Godfrey. 1988. *Powaqqatsi: Life in Transformation*. United States: Golan Globus.

Reggio, Godfrey. 2002. *Naqoyqatsi: Life as War*. United States: Qatsi Productions.

Smith, Frank Percy. 1911a. *The Birth of a Flower*. United States.
Smith, Frank Percy. 1911b. *The Germination of Plants*. United States.
Tsuchimoto, Noriaki. 1971. *Minamata: The Victims and Their World*. Japan.
Tsuchimoto, Noriaki. 1975. *The Shiranui Sea*. Japan.
Williams, Martin. 2012. *Kingdom of Plants 3D*. United Kingdom.
Zdravič, Andrej. 1997. *Riverglass—A River Ballet in Four Seasons*. Slovenia.

References

Anderson, Roger C. 1975. "Ecocinema: A Plan for Preserving Nature." *BioScience* 25 (7): 452.

Boschman, Robert, and Mario Trono, eds. 2019. *On Active Grounds: Agency and Time in the Environmental Humanities*. Waterloo: Wilfrid Laurier University Press.

Carson, Rachel. 1962. *Silent Spring*. Boston: Houghton Mifflin.

Chang, Chia-ju, ed. 2019. *Chinese Environmental Humanities: Practices of Environing at the Margins*. Cham: Springer Nature.

Chu, Kiu-wai. 2016. "Ecocinema." *Journal of Chinese Cinemas* 10 (1): 11–14. doi: 10.1080/17508061.2016.1142728.

Dixon, Wheeler Winston, and Gwendolyn Audrey Foster. 2009. *A Short History of Film*. New Brunswick: Rutgers University Press.

Doughty, Ruth, and Christine Etherington-Wright. 2018. *Understanding Film Theory*. 2nd ed. London: Palgrave Macmillan.

Duvall, John A. 2017. *The Environmental Documentary: Cinema Activism in the 21st Century*. New York: Bloomsbury.

Embry, Paige. 2018. *Our Native Bees: North America's Endangered Pollinators and the Fight to Save Them*. Portland: Timber Press.

Fay, Jennifer. 2018. *Inhospitable World: Cinema in the Time of the Anthropocene*. Oxford: Oxford University Press.

Ginn, Franklin, Michelle Bastian, David Farrier, and Jeremy Kidwell. 2018. "Introduction: Unexpected Encounters with Deep Time." *Environmental Humanities* 10 (1): 213–225. doi: 10.1215/22011919-4385534.

Ivakhiv, Adrian. 2008. "Green Film Criticism and Its Futures." *Interdisciplinary Studies in Literature and Environment* 15 (2): 1–28.

Kuhn, Annette, and Guy Westwell. 2020. *A Dictionary of Film Studies*. 2nd ed. Oxford: Oxford University Press.

Lu, Sheldon H. 2009. "Introduction: Cinema, Ecology, Modernity." In *Chinese Ecocinema: In the Age of Environmental Challenge*, edited by Sheldon H. Lu and Jiayan Mi, 1–13. Hong Kong: Hong Kong University Press.

Lu, Sheldon H., and Haomin Gong, eds. 2020. *Ecology and Chinese-Language Cinema: Reimagining a Field*. London: Routledge.

MacDonald, Scott. 2004. "Toward an Eco-Cinema." *Interdisciplinary Studies in Literature and Environment* 11 (2): 107–132.

Murray, Robin L., and Joseph K. Heumann, eds. 2019. *Ecocinema and the City*. London: Routledge.

Nelmes, Jill, ed. 2012. *Introduction to Film Studies*. 5th ed. London: Routledge.

Past, Elena. 2019. *Italian Ecocinema Beyond the Human*. Bloomington: Indiana University Press.

Petterson, Palle B. 2011. *Cameras into the Wild: A History of Early Wildlife and Expedition Filmmaking, 1895–1928*. Jefferson: McFarland & Company.

Pillsbury, Arthur C. 1937. *Picturing Miracles of Plant and Animal Life*. Philadelphia: J. B. Lippincott.

Rust, Stephen, and Salma Monani. 2013. "Introduction: Cuts to Dissolves—Defining and Situating Ecocinema Studies." In *Ecocinema Theory and Practice*, edited by Stephen Rust, Salma Monani and Sean Cubitt, 1–13. New York: Routledge.

Svoboda, Michael. 2020. "Cli-fi Movies: A Guide for Socially-Distanced Viewers." *Yale Climate Connections* May 7. https://yaleclimateconnections.org/2020/05/cli-fi-movies-a-guide-for-socially-distanced-viewers/.

Trono, Mario. 2019. "A Better Distribution Deal: Ecocinematic Viewing and Montagist Reply." In *On Active Grounds: Agency and Time in the Environmental Humanities*, edited by Robert Boschman and Mario Trono, 57–86. Waterloo: Wilfred Laurier University Press.

Willoquet-Maricondi, Paula. 2010a. "Introduction: From Literary to Cinematic Ecocriticism." In *Framing the World: Explorations in Ecocriticism and Film*, edited by Paula Willoquet-Maricondi, 1–22. Charlottesville: University of Virginia Press.

Willoquet-Maricondi, Paula. 2010b. "Shifting Paradigms: From Environmentalist Films to Ecocinema." In *Framing the World: Explorations in Ecocriticism and Film*, edited by Paula Willoquet-Maricondi, 43–61. Charlottesville: University of Virginia Press.

Wollaston, Sam. 2012. "TV Review: Kingdom of Plants." *The Guardian*. May 26. https://www.theguardian.com/tv-and-radio/2012/may/26/tv-review-kingdom-of-plants.

13 Environmental journalism
Mediating ecological issues

Chapter objectives

- To explain the contribution of environmental journalism to the development of the Environmental Humanities
- To describe the relationship between environmental journalism and allied fields including nature writing, travel writing, science journalism, environmental literature, and environmental communications
- To review the general principles and methods of media and communications employed by journalists when covering the environment
- To become familiar with the impacts of digital technologies on public engagement with linked Anthropocene crises

Investigating environmental crime

At the time of his brutal murder in 2015, independent journalist Jagendra Singh had been investigating sand extraction along the Garra River in Uttar Pradesh, India. Singh had published Facebook posts accusing a high-profile local politician of corruption related to mining activities. Two weeks later, freelance journalist Sandeep Kothari was assassinated in Madhya Pradesh for similarly exposing land grabbing and illicit mining. In 2016, three motorcycle gunmen murdered Karun Misra of the *Jansandesh Times* while, in 2018, Sandeep Sharma, a reporter for a Madhya Pradesh television station, was run over by a truck in broad daylight. In June 2020, Shubham Mani Tripathi, a correspondent for *Kampu Mail*, was shot dead while riding his motorcycle. All five slain Indian journalists had come up against the powerful sand mining mafia—a black market network controlling the unlawful and environmentally disastrous harvesting of sand from riverbeds around the country to supply global construction demands (Figure 13.1). Internationally, sand mining accounts for 85% of all mineral extraction, totalling approximately 40 billion tons per year valued at an estimated US$100 billion. A significant portion of sand mining, though, is conducted illegally.

Environmental journalists worldwide face harassment, violence, imprisonment, and grave bodily harm as they bring ecological crimes—such as unregulated mining—to the attention of the public and attempt to effect political change. According to the Committee to Protect Journalists, between 2010–19 globally, thirteen environmental journalists were murdered and another sixteen died under suspicious circumstances. And journalists very often are activists. The international watchdog Global Witness reports that, in 2019 alone, 212 environmental activists were killed—about four each week—with 40% from Indigenous communities. Most activists opposed the destruction of their land at the hands of agribusiness and mining. To highlight this issue, the *Guardian*'s series "Green Blood" investigates the jailing, torture,

DOI: 10.4324/9781351200356-13

Figure 13.1 Suction pumps extract sand from a riverbank in India.

Image credit: Sumaira Abdulali (Wikimedia Commons).

and murder of environmental journalists in India, Russia, Tanzania, Guatemala, Brazil, and elsewhere. In a world *consumed with consumption*, telling the truth has never been so treacherous.

Reflection 13.1 The risks of ecological truth-telling

Environmental journalists have the power to expose wrongdoing and corruption at various political levels. Yet the consequences for reporters can range from online harassment and social alienation to indefinite imprisonment and violent death.

Visit the *Guardian's* "Green Blood" investigative series produced by the Forbidden Stories project: www.theguardian.com/environment/series/green-blood. Select one story. What happened to the journalist? What environmental issue was he or she covering?

Reporting environmental facts: journalism and ecological concerns

What is journalism? How is it distinct from literary writing, as discussed in Chapter 10? What practices characterize the field and how do journalists contribute to environmental debates? How does new media affect coverage of the environment? And what about objectivity? If a journalist is also an activist, does that bias reporting? (Sachsman et al.2010, xiii). In an era of memes, fake news, information overload, and social media saturation, these far-ranging questions are important to ask.

According to the American Press Institute, all specializations within journalism—from sports, entertainment, and travel to politics, science, and environment—involve the

collection, analysis, creation, and presentation of verified content. Journalists follow a professional code of ethics requiring them to certify the accuracy of their content. Only verified content can be published as "news," and all news organizations have multiple fact-checking systems in place, from editors to ombudsmen to an audience that can object to published news stories. This professional code of ethics distinguishes journalism from DIY YouTube channels, state-run media, conspiracy theories, and other unverified forms of content.

As a form of communication, news keeps us apprised of constantly changing events, issues, and trends in the world at large. Journalism recognizes the critical importance of rigorously corroborated news in the decision-making processes of individuals, communities, organizations, societies, and governments. Delivering a forum for public debate, journalism reflects the ethics of its professionals (American Press Institute 2020).

Mindful of the value of objective reporting, most journalists remain committed to disclosing truth backed by facts. To a greater or lesser extent, practitioners also strive to maintain independence from the subjects they cover. Nonetheless, the premise of journalistic objectivity is fiercely contested especially when journalists become activists. For more journalism fundamentals, consult an introduction such as Bill Kovach and Tom Rosenstiel's *Elements of Journalism* (2014).

Journalism is indeed vital to public awareness of—and engagement with—ecological issues. Both traditional and new media provide people around the world with the bulk of their information about environmental events (see Waypoint 13.1). A study by the Pew Research Center, for instance, indicates that most American adults obtain information about current science-related issues—energy, biodiversity, climate, and food—from general news sources and documentaries (Gottfried and Funk 2017). Before the emergence of new media, newspapers, television programs, and radio broadcasts served as the main outlets for environmental coverage. However, with the waning of traditional print-based news formats in the last twenty years, reporters concentrating on environmental matters have largely turned to freelance, online journalism. The digital world has now become the foremost domain for all brands of journalism, including those concerned with science and nature (Sachsman and Valenti 2020).

Reflection 13.2 Fake environmental news

If fake news is untrue content presented as genuine, then fake environmental news is false information about the environment disguised as news. For decades, misinformation has hindered public engagement with climate and environmental science (see Waypoint 2.1). Social media of late has become a breeding ground for variations of misinformation. A recent study by Friends of the Earth found that climate denialists post, on average, four times more than climate scientists and activists on Twitter. While denialists flood the Twittersphere with dross, experts struggle to get factual messages across.

To where do you turn for environmental news? How do you ensure that the information you receive is as accurate as possible?

Regardless of their medium—traditional, digital, or a combination of both—environmental journalists must be good storytellers who strive to help readers and viewers discern between competing claims about ecological issues (Bødker and Neverla 2012). As we have seen during our jaunt through the Environmental Humanities in this book, such issues challenge clear boundaries between culture, economy, policy, politics, science, and technology. Crossing fluidly between these domains, environmental journalists translate technical and specialist knowledge for public consumption and often advocate for more-than-human justice. In *Green Ink* (1998), conservationist Michael Frome defines environmental journalism

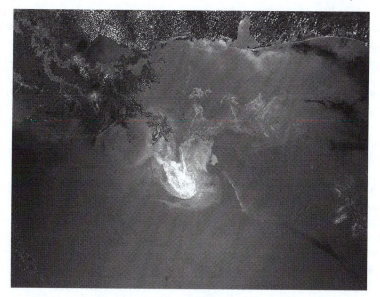

Figure 13.2 In 2010, the Deepwater Horizon oil spill, shown here in a NASA satellite image, was the subject of extensive media coverage.

Image credit: NASA/GSFC, MODIS Rapid Response (Wikimedia Commons).

as more than objective reporting on issues such as water pollution and land appropriation. For Frome, environmental journalism represents:

> a way of living, of looking at the world, and at oneself. It starts with a concept of social service, gives voice to struggle and demand, and comes across with honesty, credibility, and purpose. It almost always involves somehow, somewhere, risk and sacrifice.
>
> Frome (1998, 21)

Giving voice to lives impacted by ecological catastrophes such as oil spills (Figure 13.2), journalism has the ability to influence environmental agendas by elevating unseen events to public scrutiny (Sachsman et al. 2010, 27–28).

Waypoint 13.1 Overview of Essential Media Terminology

- *Broadcast media*: refers to the distribution of video and audio through electronic technologies such as television
- *Beat reporting*: focuses on covering specific places, issues, communities, organizations, or institutions for an extended period
- *Civic journalism*: integrates journalism and democracy to engage citizens and encourage debate; also called public journalism
- *Digital journalism*: refers to the distribution of news through digital rather than print or broadcast media; also known as online journalism

- *Digital media*: signifies media produced digitally and presented through screens; includes Internet and mobile communications
- *Internet media*: comprises email, websites, blogs, vlogs, podcasts, webinars, streaming, and web-based radio and television services
- *Interactive media*: engages users directly by presenting content in response to input; examples are social media and online games
- *Framing*: highlights the angle from which news is presented as well as the media emphasis that confers broader meaning to events
- *Mass media*: denotes communication systems that make media content available to mass audiences; also called traditional media
- *Mobile mass communication*: indicates communication enabled through the use of mobile phones, tablets, and other portable devices
- *New media*: relies on computers for production and dissemination in contrast to television, radio, print, and other kinds of old media
- *Podcasting*: addresses particular topics in episodes available as audio files downloaded to subscribers' personal devices
- *Print media*: depends on a material object, such as a book, newspaper, pamphlet, or billboard, to disseminate information
- *Radio journalism*: broadcasts information or news in a radio format rather than through print-based media

Environmental journalism is positioned within the broader scholarly umbrella of *environmental communication*—defined as any communication activity that engages ecological contexts and concerns. Environmental communication specialists assert that forms of communication and media strongly influence our perceptions of the more-than-human world and our thinking about environmental problems. The field of environmental communication recognizes that the environment "we experience and affect is largely a product of how we have come to talk about the world" (Cantrill and Oravec 1996, 2). In comparison to environmental literature and ecocriticism (Chapter 10), studies of environmental communication are usually oriented toward transmitting information. Topics can include environmental reporting, conflict resolution, green movements, conservation rhetoric, marketing, advertising, and representations of ecological issues in pop culture (Cox 2013, 12). *Ecospeak* is one of the earliest major studies of environmental communication (Killingsworth and Palmer 1992).

Reflection 13.3 Environmental journalism and Indigenous people

Around the globe, journalistic biases create problems for Indigenous communities. Establishment media representations can lead to the marginalization of Indigenous voices and the perpetuation of colonial narratives. According to the research project, A Shared Future, news coverage of Indigenous participation in renewable energy development can reinforce racist stereotypes. The researchers analyzed the depiction of Canadian First Nations people in news coverage of renewable energy projects between 2008–17. The team observed that many articles confer greater value to Western experts than to Indigenous sources.

Visit the project website: http://asharedfuture.ca/. How can environmental journalists ensure that their coverage of Indigenous people is fair, balanced, and sensitive?

Environmental journalism has a close connection to nature writing, examined in detail in Chapter 10. Nature writing is typically defined as non-fiction, fiction, or poetry that describes the natural world, more-than-human life, and human–environment relations through detailed observations, emotional responses, and memory, using a literary style. Although having diverse historical precedents—including in Ancient Greek and Roman literature—Western nature writing emerged fully in the nineteenth century with British Romantic and American Transcendental movements. To a significant extent, environmental journalism has drawn—and continues to draw—from that nature writing tradition. Carson's landmark *Silent Spring* (1962), for instance, is a work of both nature writing and environmental journalism. And Pulitzer Prize-winning environmental journalist John McPhee has also written acclaimed creative non-fiction about the New Jersey landscape in *The Pine Barrens* (1968) and the Alaskan wilds in *Coming into the Country* (1977).

Case Study 13.1 African environmental journalism and Oxpeckers

Environmental journalism in Africa focuses on urgent concerns of climate change, human population growth, resource extraction, wildlife trafficking, biodiversity decline, unsustainable forestry, freshwater pollution, and government corruption. Yet, African journalists face myriad obstacles related to the lack of professional training, limited access to scientific information, and hostile political circumstances. As in Asia, South America, Europe, and elsewhere, journalists in Africa have been routinely detained without justification. In 2013, for instance, Rodney Sieh, editor of the Liberian newspaper *Frontpage Africa*, was fined and imprisoned for publishing a story about embezzlement by a minister of agriculture. What's more, journalists in the Democratic Republic of Congo have been attacked while covering local opposition to SOCO International's oil exploration in Virunga National Park.

Founded by journalist Fiona Macleod in 2013 and based in South Africa, the Oxpeckers Center for Investigative Environmental Journalism is the continent's first journalistic contingent dedicated to ecological issues. Named after a bird species endemic to Africa, the Center covers environmental news in southern Africa and other regions with ground-breaking stories on wildlife trafficking, poaching, canned hunts, climate disruption, illicit mining, and water pollution. Practicing geojournalism, Oxpeckers brings digital mapping and spatial data analysis to bear on traditional investigative approaches aimed at tracing ecological misconduct in Africa. Oxpeckers journalists specialize in what is known as cryptotrafficking, online crimes in which cyberspace becomes a marketplace for the unlawful wildlife trade estimated globally to be worth between US$7 billion and US$23 billion per year.

The availability of e-commerce platforms and social media continue to supply outlets for animal trafficking worldwide. Review the cryptotrafficking stories published on the Oxpeckers website: https://oxpeckers.org/investigations/cryptotrafficking. What tools and techniques did reporters use to conduct these investigations?

Environmental journalism, moreover, is related to *science journalism*—a genre of journalism that aims to make specialized research and technical jargon accessible to popular readerships. Journalists working in this genre cover scientific advances, technical processes, experimental innovations, and the public reception of new theories. Science reporters address researchers'

conflicts of interest as well as the policies, politics, and legalities impacting biology, botany, zoology, astronomy, physics, medicine, environment, conservation, geography, and other scientific disciplines. Concerns of gender, race, equality, and justice also figure into the practice of science journalism (Angler 2017, 3). One of the first periodicals to feature science journalism was *Digdarshan*, a multilingual magazine first published in 1818 in Bengali, Hindi, and English, and showcasing articles on the major scientific breakthroughs of the nineteenth century.

An early science correspondent was American Emma Reh Stevenson (1896–1982), a writer on archaeology, agriculture, and soil conservation. As part of her efforts to popularize science, Stevenson journeyed through Mexico in the 1920s and 1930s reporting on the excavation of prehistoric sites (Figure 13.3). Stevenson's writing, therefore, can also be understood as travel journalism. This journalistic genre places attention on destinations, attractions, events, landscapes, and cultures as well as the practices and processes of travel. Although *travel journalism* and *travel writing* are often used interchangeably by scholars, these two terms are in fact distinct. Whereas travel writing accommodates fictional, imagined, and poetic narratives, travel journalism emphasizes factual news reporting. Characteristically in the form of short pieces, travel news reporting appears in print and on television as well as in blogs and social media (Cocking 2020, 14). Many leading environmental journalists, such as John McPhee and Bill McKibben, are also green travel journalists whose writings blur the distinctions between journalistic categories.

Figure 13.3 American science journalist Emma Reh Stevenson travelled in Oaxaca, Mexico in the 1930s. Image credit: PDTillman (Wikimedia Commons).

Reflection 13.4 Adventure travel journalism

Adventure travel journalism involves the work of reporters, editors, bloggers, vloggers, photojournalists, and traditional broadcasters who feature stories of outdoor exploits and sustainable, or green, travel. Adventure travel journalists attempt to convey the sublime appeal of mysterious, dangerous, rugged, wild, or lesser-known locations. Prominent periodicals of this kind are *Backpacker Magazine, Outside, and National Geographic*. The writings of American mountaineer Jon Krakauer, moreover, fit within the scope of adventure journalism. Professionals working in this genre aim to produce accurate accounts of exotic and remote places, such as Mount Everest, yet without romanticizing the land and people. What other special ethical concerns apply to adventure travel journalists?

Environmental journalism is increasingly moving from books, newspapers, and magazines to documentary films, interactive online media, and, more recently, virtual reality (VR) platforms, though the subject matter has stayed the same. Chapter 12 presents a range of works that blend filmmaking and journalism—and in which *ecocinema* becomes a form of *ecoreporting*. A case in point is Chinese journalist Chai Jing's *Under the Dome* (2015), investigating the interlinked health and environmental consequences of the Chinese energy sector. Weaving between interviews, site visits, and the filmmaker's own narration of her unborn daughter's tumor, the film presents a pointed criticism of the coal industry in China, an approach that could be compared to Terry Tempest Williams' memoir, *Refuge: An Unnatural History of Place* (1991). Another example of the crossover between environmental reporting and non-print media is the work of photojournalist Danfung Dennis, director of the first 3D 360-degree film *Zero Point* (2014) as well as several eco-virtual reality documentaries. Dennis' short VR film *Melting Ice* (2017) depicts the loss of the Greenland ice sheet due to a warming climate. In addition to film and virtual reality, online media provide channels for disseminating environmental news. The popular digital platform, BuzzFeed, for instance, publishes environmental content on YouTube. Similarly, the online magazine *Grist* features podcasts on climate, food, and sustainability. It should be noted as well that a steadily growing source for environmental information is the green blogosphere, enabling public discourse on ecological issues while challenging the traditional hierarchy between experts and audiences (Cox 2013, 180). A question to consider is whether these new mediums affect the presentation of environmental journalism's traditional subjects.

One area where the medium may change the message is in the question of *advocacy*—of journalists taking positions of support for ecological causes rather than attempting to remain impartial in their presentation of news. In *Green Ink* (1998), Michael Frome encourages journalism students to become Earth advocates: "I do teach a different kind of journalism, advocacy journalism on behalf of the environment … my point is that we ought to be advocates for the health and safety of the planet" (ix). Environmental journalism of the type supported by Frome is guided by a specific social intent or political objective. As a pivotal work of environmental advocacy, Carson's *Silent Spring* (1962) aimed to transform US policies on the regulation of synthetic pesticides. The book prompted a national ban on the insecticide DDT for agricultural purposes and inspired the rise of the environmental movement including the creation of the US Environmental Protection Agency. Yet, some environmental journalists argue that advocacy interferes with the need to maintain accuracy, thoroughness, balance, fairness, and transparency (Wyss 2019, 223–225).

Waypoint 13.2 Overview of essential ecojournalism terminology

- *Citizen environmental journalism*: occurs when people without professional journalism backgrounds share information about an environmental incident or issue to broaden public awareness
- *Eco-VR*: engages the use of VR, or virtual reality, technologies to simulate real-life situations for purposes of ecological activism, advocacy, and information dissemination
- *Ecomedia*: focuses on the relationship between non-print media and the natural world; generally encompasses film, television, gaming, digital media, music, visual art, and popular culture
- *Environmental communication studies*: explores forms of communication and media that influence perceptions of the more-than-human domain and our thinking about environmental urgencies
- *Environmental discourse*: points to the social processes that construct knowledge and meaning in terms of nature; challenges the idea that science is an unbiased, objective account of reality
- *Environmental journalism*: involves researching, validating, writing, producing, and disseminating news about the environment, more-than-human communities, and ecological concerns
- *Environmental news*: refers to a broad spectrum of information about the environment including firsthand citizen accounts of human–nature conflicts that go beyond the journalist's function
- *Environmental rhetoric*: highlights the elements of speech and writing necessary to inform, convince, or motivate audiences; its opposite is known as *anti-environmental rhetoric*
- *Green beat*: covers particular places, issues, communities, organizations, institutions, or social groups for an extended or concentrated period of time vis-à-vis environmental news
- *Green blogosphere*: comprises blogs connected through online communities in which contributors, both with and without training in journalism, publish their views about ecological matters
- *Green travel journalism*: calls attention to the ecological impacts of travel, sustainable alternatives to conventional tourism, and destinations of potential interest to ecofriendly tourists

News about nature: environmental journalism history and theory

Environmental news often centers on dramatic, heart-rending, and *doom-filled* events such as oil spills, nuclear catastrophes, natural disasters, melting glaciers, and wildlife poaching. Consider, for example, a recent headline "Why Scientists Are So Worried About Antarctica's Doomsday Glacier" (Nemo 2020). In this regard, ecojournalist Peter Dykstra (2016) admits that "our subject matter is almost invariably gloomy (extinctions! oil spills! dead trees!), hard to grasp (parts per billion?), and full of future projections (climate change?)" (para. 7). Nonetheless, many environmental problems are either invisible or evident only to scientific specialists capable of identifying microscopic impacts on bodies and long-term changes to ecosystems. Indeed, the challenge environmental reporters have faced since the birth of

the field is the acquisition of sufficient technical knowledge of the issues they cover—from the chlorofluorocarbons (CFCs) responsible for ozone depletion to the industrial carcinogens that cause cancer. Beginning in early 2000s, this objective has been complicated by the widespread downsizing of newspapers, especially in the United States, leading to the sharp decline of reporters with ecological expertise. Environmental journalism, furthermore, must negotiate its public perception as synonymous with green politics (Cox 2013, 143–176). The question of advocacy—and its relation to journalistic objectivity—remains a central debate.

Reflection 13.5 Environmental journalism and scientific knowledge

Studies report that less than 5% of US journalists have completed an undergraduate major in a science discipline. Moreover, only 25% of journalism program administrators believe that their students have received sufficient training to interpret scientific statistics critically. What are the implications of inadequate scientific knowledge for environmental reporting? How can journalists enhance their competence in scientific debates?

The emergence of environmental journalism in the 1960s and 1970s parallels the growth of the ecological movement in the West. Following the appearance of Carson's *Silent Spring* (1962), stories of endangered species, air pollution, oil spills, nuclear radiation, and other

Figure 13.4 Pictured circa 1920, the heavily industrialized Cuyahoga River in Cleveland, Ohio, empties into Lake Erie.

Image credit: Library of Congress, Prints & Photographs Division, HAER OHIO,18-CLEV,17-8 (Wikimedia Commons).

disasters began to occur, with greater frequency, in the news media. In 1969, for instance, *Time* featured shocking coverage of Cleveland's Cuyahoga River (Figure 13.4) set ablaze after sparks from a train ignited the petroleum-saturated debris on the surface of the water. The magazine presented dramatic images, which in fact were archival photos from 1952 of a larger fire on the same river. Subsequently, the Cuyahoga became an icon of escalating environmental tensions in the US and, in conjunction with other developments, inspired the passage of the Clean Water Act in 1972 (Latson 2015). Around this time, mass media outlets began to receive environmental press releases from government agencies, industry representatives, and citizen groups. In response, Richard W. Darrow, president of a public relations firm, described what he saw as "the great ecological communications war" between conflicting public relations interests. Concerned about corporate America's increasingly negative, anti-green perception, Darrow (1971) decried the "unrealistic legislative restraints and crippling administrative restriction" resulting from new environmental laws (18).

Environmental reporting also gained traction during the twentieth century in countries other than the United States. In the early 1900s, for instance, Brazilian journalist-geographer Euclides da Cunha published a number of non-fiction works, including the book *Os Sertões* translated as *Rebellion in the Backlands*, highlighting the failures of land management in Brazil. In particular, his essay "The Desert Makers" from 1901 provides a vivid account of the negative effects of human behaviors on Brazilian rainforest ecosystems (Nielson 2020). Moreover, beginning in the 1960s, environmental photojournalists in Japan began documenting Minamata disease, a neurological syndrome caused by mercury poisoning. Photojournalist Shisei Kuwabara visited the Minamata Municipal Hospital in 1960 to take documentary photos that would become part of his exhibition *Minamata-byō* (*Minamata Disease*). W. Eugene Smith and Aileen M. Smith later brought global attention to Minamata disease with their book *Minamata* (1975), considered a landmark work of twentieth-century photojournalism. (See Chapter 12 for a discussion of documentary films about Minamata.) Furthermore, in India in the 1970s, the pioneering environmental journalist Darryl D'Monte was inspired by the campaign to protect the Silent Valley in Kerala. Activists and journalists eventually convinced then-Prime Minister Indira Gandhi to halt the proposed construction of a dam across the Kunthipuzha River, and the area eventually became a national park (Figure 13.5).

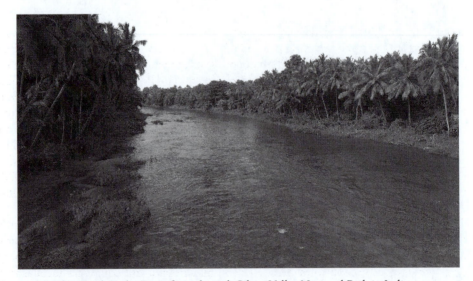

Figure 13.5 The Kunthipuzha River flows through Silent Valley National Park in India.

Image credit: Ramesh Kunnappully (Wikimedia Commons).

Case Study 13.2 Marjory Stoneman Douglas and the Everglades

Journalist Marjory Stoneman Douglas remains an important figure in the history of American environmental journalism. She was a passionate defender of the Everglades of southern Florida. By the time she died in 1998 at the age of 108, she was widely known as the "grande dame" of Everglades conservation. Douglas first worked as an assistant editor of *The Miami Herald* newspaper before turning to independent journalism and wetlands activism, two endeavors that remained closely linked throughout her life. Through her potent combination of writing and activism, she became pivotal to the campaign to create the Everglades National Park in the 1940s and co-founded the Friends of the Everglades in the late 1960s.

A region of 600,000 hectares of subtropical wetlands stretching from the Kissimmee River near Orlando to Florida Bay, the Everglades is now considered a national treasure. Designated an International Biosphere Reserve and a World Heritage Site, the area encompasses diverse species such as the American alligator (*Alligator mississippiensis*), the Florida panther (*Puma concolor*), the manatee (*Trichechus manatus laterostris*), and the piping plover (*Charadrius melodus*). Since the 1700s, however, nearly half of the Everglades has been drained for development and agriculture. The endemic panther, moreover, was nearly exterminated through hunting and habitat loss.

First published in 1947, Douglas' *The Everglades: River of Grass* features real stories of discovery, conquest, ecology, and loss. The book opens with the assertions, "There are no other Everglades in the world. They are, they have always been, one of the unique regions of the earth, remote, never wholly known" (Douglas 2007, 5). Her journalistic account would prove critical to transforming the largest swamp in the United States into the nation's best-known wetland conservation area. Following the book's publication, Douglas successfully campaigned against the construction of the massive Everglades, or Big Cypress, Jetport. Her life and work encourage us to think about wetland journalism as a swamp-focused specialty within environmental journalism.

In 1969, in the wake of the Cuyahoga River disaster, the *New York Times* started a regular green beat, a practice subsequently adopted by several major news outlets in the US. After Earth Day, ecological news reporting reached a zenith, especially in the San Francisco Bay area where, in 1971, fifteen media outlets employed sixteen environmental reporters (Sachsman 1976, 54). In other words, at that time, nearly one-third of all newspapers, television stations, and radio stations in San Francisco had full-time ecojournalists. During the 1980s, support for environmental journalism declined only to climb again in 1989 with the *Exxon Valdez* disaster in Alaska, an event that released approximately 11 million gallons of crude oil into Prince William Sound. The Society of Environmental Journalists (SEJ) was created in 1990 to provide "educational opportunities and vital support to journalists of all media who face the challenging responsibility of covering complex environmental issues" (SEJ 2020, para. 3). By the end of the 1990s, however, the pendulum swung again and environmental reporters became scarcer due to a changing media landscape and other factors.

Nonetheless, by the mid-2000s, environmental coverage experienced a resurgence with *Time* magazine's reporting on climate change in conjunction with the release of Al Gore's documentary film *An Inconvenient Truth* (2006). By all accounts, ecojournalism is only gaining more ground in the third decade of the millennium. In 2020, SEJ's membership comprised more than 1,500 journalists, researchers, and academics working in various news

media in the US, Canada, and forty-four other nations (SEJ 2020, para. 1). SEJ's Fund for Environmental Journalism, moreover, presently supports news projects in four areas: (i) climate and conservation in North America; (ii) water quality and accessibility in the US; (iii) agriculture, food, water, and sustainability in the Mississippi River Basin; and (iv) oceans and coastal environments globally, including fisheries and seaside habitat restoration. *The Guardian*, furthermore, claimed in 2020 to publish an environmental story every three hours on average with special focus on the linkage between Covid-19 and environmental destruction (Carrington 2020).

Reflection 13.6 Funding environmental journalism

As fewer newspapers employ reporters dedicated to the environment, many ecojournalists have needed to freelance. Grant programs offer one source of support for freelancers. An example is the GRID-Arendal Grant for Investigative Journalism, directed toward environmental crime in developing countries. Previous grant recipients have covered gold mining in Colombian rainforests and deforestation in Kenyan national parks. The evaluation criteria prioritize the project's potential to reach a broad audience and to effect positive change.

Visit the GRID-Arendal website: www.grida.no/news/17. Can you come up with an idea for an environmental news project that would fit within the current GRID-Arendal guidelines?

A number of media concepts guide the theory and practice of ecojournalism. We will discuss four: *agenda-setting* (or *agenda-building*), *narrative framing*, *cultivation analysis*, and *media engagement continuum* (Cox 2013, 143–176). These principles allow us to understand the social dimensions of environmental news reporting and, more specifically, the interaction between the media and individuals in what communications scholars call the *public sphere*.

The first concept, *agenda-setting* or *agenda-building*, emphasizes the impact of environmental news on public perception of an issue's importance. By flagging the issues that society should be concerned about, the media can define which issues will be visible or remain invisible to the public (Hansen 2015, 28). As political scientist Bernard C. Cohen (1963) famously asserted, the press "may not be successful much of the time in telling people what to think, but it is stunningly successful in telling its readers what to think *about*" (13). Cohen's distinction between *what to think* and *what to think about* captures the essence of agenda-setting (Cox 2013).

The second concept, *narrative framing*, refers to the manner in which media outlets arrange facts into coherent stories—or narratives—that enhance audience understanding of the problem, responsible parties, likely victims, and potential solutions. The purpose of narrative frames ranges from the self-serving (sustain audience interest, sell media products, and achieve political agendas) to the story-serving (clarify, contextualize, connect to audiences). Framing also activates certain emotions—fear, anxiety, guilt, and so on—that engage audiences' sympathies (Lakoff 2010, 71). As a case in point, media framing of the Sea Shepherd campaign to halt Japanese whaling in the Antarctic might hone in on stories of confrontation between protagonist-heroes (activists), antagonist-villains (whalers), and target-victims (whales) (Figure 13.6).

Figure 13.6 Docked here in Melbourne, Australia, the ship *Farley Mowat* was purchased in 1996 by the Sea Shepherd Conservation Society to conduct ocean activism campaigns.

Image credit: David w ng (Wikimedia Commons).

Figure 13.7 In the 1990s, the northern spotted owl debate placed this threatened species, *Strix occidentalis caurina*, in the media spotlight.

Image credit: John and Kaen Hollingsworth; USFS Region 5, Pacific Southwest (Wikimedia Commons).

The third concept, *cultivation analysis*, suggests that ongoing exposure to news media messages tends to result in audience agreement with the ideas conveyed by those messages. Theorists posit that this conditioning leads to the phenomenon of *mainstreaming* in which media messaging overrides individual perspectives. In relation to the environment, cultivation analysis indicates that the absence of environmental imagery or the prioritization of other news items can lead to anti-ecological or ecologically indifferent attitudes. An early study using cultivation theory associated television viewing with general apprehension about the deteriorating condition of the natural world although not in reference to specific threats such as pollution or species loss (Figure 13.7). The researchers found that regular television viewing in fact made individuals less willing to make sacrifices for the good of the biosphere (Shanahan et al. 1997).

The fourth concept, *media engagement*, often relies on numerical data, such as downloads and views, to theorize audience interaction with environmental issues on a continuum from active to passive. The general aim is to quantify the impact of environmental news on the public. Some researchers, however, stress the limitations of largely quantitative approaches to understanding public engagement with media.

Reflection 13.7 Media engagement continuum and the environment

Critics of media engagement theory argue that the impacts of journalism cannot be determined by analyzing numerical information alone. The media landscape, nevertheless, is saturated with headlines announcing "most downloaded" and "most retweeted" news items.

Search for a current environmental story on Twitter, YouTube, Google, or another digital medium. What data does the publisher use to claim active public engagement with the story? What are some implications for framing, agenda-setting, and cultivation practices in journalism? Do journalists *make* the news or *report* the news?

New green beats? Current trajectories in environmental journalism

At the end of 2020, a year defined by the coronavirus pandemic and catastrophic wildfires, Meera Subramanian, then-President of the SEJ, commented that:

> the toll of the COVID-19 pandemic on human life is nowhere close to over, nor are the impacts to the journalists and journalism the public depends upon for information. SEJ remains committed to ensuring that coverage of environmental issues remains steadfast, even in these unsteady times.
>
> Subramanian (2020, para. 1)

Two decades prior to Covid-19, the decline in traditional print newspapers began to transform journalism, in general, and environmental journalism, in particular. Despite these profound changes in the media landscape, digital media offer new avenues for green reporting. Considering the dynamics of the present, this section gives an overview of three recent trajectories in ecojournalism: *climate reporting, citizen environmental journalism,* and *ecodigital journalism.*

The field of the Environmental Humanities equips journalists—as well as those researching media and communications—with the skills necessary to understand virus outbreaks, climate

change, environmental racism, and other complex issues that resist historically entrenched divisions between the natural, social, and cultural. To be certain, verified environmental information—the cornerstone of ecojournalism—remains essential to confronting ecological problems and devising solutions. Drawing from the sciences, social sciences, arts, and humanities, the pluralistic knowledge base of the Environmental Humanities enhances the work of students, teachers, and practitioners of ecojournalism.

Research has shown that many consider climate change an abstract phenomenon that is difficult to comprehend (Schäfer and Painter 2020). Yet, general knowledge of climate change comes mostly from news media. A recent study by Reuters, for instance, found that television is the public's most vital source of information about climate change, followed by online-born news sites, social media, and blogs. Television's prominence is likely due to its visual effect: "Watching glaciers melt or seeing images of plastic clogging up our oceans can often have more impact than reading a news article containing scientific details of climate change" (Andi 2020, 53). Social media, however, is the leading source for climate news among the 18–24 age group.

In this context, *climate reporting* entails collecting, assessing, selecting, and publishing information about climate-related issues. Journalists specializing in this subset of ecoreporting make information about the causes and impacts of climate change available to diverse audiences. The sources used in climate journalism are not only technical and scientific but represent a broad spectrum of interest groups.

Case Study 13.3 Covering the climate beat

As discussed in Chapter 2, climate change is an immensely complex, planetary-scale, cultural-natural issue that exceeds the power of ordinary perception. Over the past fifteen years, climate journalism has emerged as a crucial source of information for enhancing public awareness of the problem. The term *climate beat* can be defined as focused, extended coverage of the people, places, creatures, communities, and social systems impacted by climatic disruption. In this regard, two prominent online news sources chasing the climate beat are *InsideClimate News* (ICN) and *Covering Climate Now* (CCNow).

Founded in 2007, ICN focuses on renewable energy, nuclear power, carbon economies, and ecological science. A recipient of the Pulitzer Prize for National Reporting, ICN is one of the largest environmental news organizations in the United States. ICN's audience comprises general readers, activists, policymakers, regulators, researchers, corporations, government bodies, and non-profit institutes. In 2012, ICN brought widespread attention to the Kalamazoo River disaster in which a pipeline fracture in 2010 released more than one million gallons of diluted bitumen, or dilbit, coming from Canada's Athabasca oil sands. A finalist for the Pulitzer Prize for Public Service, ICN's 2015 story "Exxon: The Road Not Taken" investigates the corporation's attitude toward climate change science.

Founded in 2019, CCNow is an international partnership of more than 400 news outlets dedicated to accurate and fair climate reporting. CCNow understands good climate coverage as that which explores the human causes of heat waves, droughts, and other climatic events; humanizes the issue through attention to individuals and communities; acknowledges the disproportionate effects of environmental degradation on

minority groups and economically disadvantaged populations; does not limit climate concerns to science journalism; and explores practical solutions to ecological impasses.

Visit the websites of ICN (https://insideclimatenews.org) and CCNow (www.coveringclimatenow.org). Select one story from each news portal. What issues are addressed? Who and/or what is affected? Apply analyses of agenda-setting, narrative framing, cultivation, and media engagement. How do these media outlets handle reporting?

In addition to climate reporting, a current trajectory in ecojournalism is known as *citizen environmental journalism*. Before the rise of Internet, citizens often would provide firsthand accounts of particular events and perform other voluntary functions integral to covering environmental crises. Over the last three decades, however, the proliferation of user-friendly digital communication technologies has enabled people to engage more fully in independent and, sometimes, accidental ecoreporting; for instance, through the use of smartphones to take images, create short documentary videos, send ecotweets, or upload multimedia information about ecological incidents to Facebook or Instagram. Two key examples of citizen journalism in action are the Deepwater Horizon oil spill in the Gulf of Mexico in 2010 (Figure 13.2) and the Fukushima Daiichi nuclear disaster in Japan in 2011 (Figure 13.8). During the Deepwater Horizon catastrophe, an online crowdsourcing campaign supplied critical information about the spill. The real time eyewitness accounts offered by local residents supplied journalists with essential material for more faithfully covering the disaster. During the Fukushima Daiichi tragedy, moreover, citizen journalists used websites to crowdsource data about radiation levels, thus helping to redress the lack of information available to the public about the disaster area (Allan and Ewart 2015).

Reflection 13.8 Ecological crowdsourcing

A merger of the terms *crowd* and *outsourcing*, crowdsourcing is an ever more widespread practice entailing the acquisition of information from a group or "crowd." Environmental crowdsourcers often use digital media collaboratively to achieve a goal such as the procurement of data about an incident or real time monitoring of an event. What's more, crowdsourced data gathered by citizen groups have become crucial to environmental research. An example of a long-term crowdsourcing initiative is the Atlas of Living Australia: www.ala.org.au.

Visit the ALA website. What is the project's aim? How does it use crowdsourcing to achieve this aim? How are fact-checking and objectivity handled?

Citizen environmental journalism connects to the rapidly evolving area of *ecodigital journalism*—where environmental journalists use digital technologies and online platforms. Digital media allow reporters to capitalize on a diverse mix of media—from photos, maps, infographics, videos, and podcasts to interactive animation, Twitter feeds, hyperlink listings, member discussion forums, and user comments sections—that have transformed environmental journalism. As a case in point, the website of the global citizen science organization Earthwatch, founded in 1971, offers a substantial listing of podcasts with conservationists,

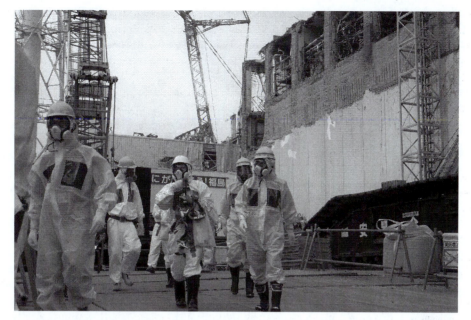

Figure 13.8 Members of the International Atomic Energy Agency (IAEA) depart the Fukushima Daiichi Nuclear Power Station in 2013.

Image credit: Greg Webb/IAEA (Wikimedia Commons).

scientists, naturalists, and other experts (see the Weblinks section at this chapter's end). Ecodigital journalism has also given rise to online-born news organizations (see Case Study 13.3). Websites such as these make it possible to develop long-term, ongoing, in-depth coverage of specific environmental topics, notably climate change and biodiversity loss. Whether they can continue to maintain the objectivity, accuracy, reliability, and professional ethics of traditional media will depend on practitioners, audiences, and institutional contexts.

Chapter summary

Chapter 13 defined *environmental journalism*, or *ecojournalism*, as a journalistic concentration within the Environmental Humanities committed to fair and accurate coverage of the environment, ecological issues, and human–nature interactions. Environmental journalism reflects the broader context of *environmental communication*—characterized as forms of communication focused on ecology, more-than-human life, sustainability, and solutions to climate change, resource depletion, and other problems. At the core of ecojournalism is the question of advocacy in which reporters display unequivocal support for ecological causes instead of attempting to remain neutral or objective in their coverage. Focused on making knowledge of the environment accessible and immediate for general audiences, ecojournalism has evolved in dialogue with nature writing, travel writing, science journalism, and environmental literature. Although the emergence of this journalistic genre in the West is usually traced to the environmental movement of the 1960s and specifically the publication of Rachel Carson's *Silent Spring* (1962), other traditions of ecojournalism took shape during the twentieth century in Brazil, Japan, India, and elsewhere. Four theories provide keys for identifying and analyzing the social dynamics of ecoreporting: agenda-setting, narrative framing, cultivation analysis, and media engagement. Current trajectories in environmental journalism include

climate reporting, citizen environmental journalism, and ecodigital journalism. In coming decades, the increasing ubiquity of digital communication platforms, especially social media, will continue to transform environmental reporting in response to ecological problems.

Exercises

1. Advocacy is still a hotly contested topic among practitioners and scholars of environmental journalism. Critics argue that an advocacy position can cloud a reporter's judgement. Yet, when it comes to environmental racism, climate disruption, deforestation, wildlife trafficking, and other issues, many journalists believe that it is impossible and, even, unethical to remain objective. Consulting a news website such as Environmental News Network, www.enn.com, review three recently published environmental stories. What are the stories about? Who and/or what was affected by the issue? Do the reporters attempt to remain objective, or is there a sense of advocacy in the writing? Is it ethical to remain an objective bystander in the midst of a crisis?

2. In the practice of journalism, *the inverted pyramid* is a news writing technique that places the most important facts first. The who, what, when, where, and why of the topic appear at the very beginning, followed by finer details that fill in the background of the story. Select an environmental issue currently impacting the place where you live. Applying the inverted pyramid structure, draft a news story about the issue.

3. Journalists often interview a range of stakeholders—activists, citizens, conservationists, landowners, scientists, researchers, academics, politicians, and so on—when covering the environment. Conduct a five- to ten-minute interview with someone engaged in the climate change debate. The interview can be done in-person, via video conferencing, or through any other means. What questions did you ask your interviewee? What views did your interviewee express about the changing climate? Write up a summary that responds to these two questions and includes key quotes from the interview.

4. Two important approaches to environmental journalism are photojournalism and videojournalism in which news is presented through still images and moving images, respectively. Propose a photojournalism or videojournalism project that addresses wildlife trafficking in any countries of your choice. What trafficked species or set of species will you cover? Where does the trafficking take place? Who is involved? What are the environmental costs of the illegal activities? What kinds of photos or videos will work best to convey the severity of wildlife trafficking to an international audience?

5. The second section of this chapter introduced agenda-setting, narrative framing, cultivation analysis, and media engagement continuum. Applying one of these theories, examine how a current environmental issue is being reported in the media.

Annotated bibliography

Angler, Martin. 2017. *Science Journalism: An Introduction*. London: Routledge. This accessible guide provides practical information oriented toward producing journalistic content about science, technology, and industry.

Doyle, Julie. 2016. *Mediating Climate Change*. London: Routledge. The author explores how the mediation of climate change affects our thinking about the issue.

Frome, Michael. 1998. *Green Ink: An Introduction to Environmental Journalism.* Salt Lake City: University of Utah Press. This pioneering text provides valuable insights into environmental journalism as well as stories of other journalists who left their mark on the field as we know it.

Herndl, G. Carl, and Stuart C. Brown, eds. 1996. *Green Culture: Environmental Rhetoric in Contemporary America.* Madison, WI: University of Wisconsin Press. This early publication in environmental communication argues that ecological issues reflect different discourses about the Earth.

Lewis, M. Jane, David B. Sachsman, Renee M. Rogers, Bernadette West, and Michael R. Greenberg. 1995. *The Reporter's Environmental Handbook.* New Brunswick: Rutgers University Press. This early publication in the field is a practical guide for journalism professionals interested in covering air pollution, urban sprawl, bioterrorism, and other environmental issues.

Sachsman, David B., James Simon, and JoAnn Myer Valenti. 2014. *Environmental Reporters in the 21st Century.* London: Routledge. This co-authored book appraises the development of the American environmental beat as an outgrowth of broader changes in journalism and technology.

Sachsman, David B. and JoAnn Myer Valenti, eds. 2020a. *The Routledge Handbook of Environmental Journalism.* London: Routledge. This substantial thirty-seven-chapter collection is the single most up-to-date and geographically comprehensive source of information about environmental journalism around the world. Six parts cover the history of journalism and the environment; environmental journalism in the United States; in Europe and Russia; in Asia and Australia; in Africa and the Middle East; and in South America.

Wyss, Bob. 2008. *Covering the Environment: How Journalists Work the Green Beat.* London: Routledge. This valuable primer provides practical insights into environmental journalism through four sections: introducing the beat; reporting the beat; writing the beat; and understanding the beat.

Weblinks

Center for Environmental Journalism (CEJ). Located at the University of Colorado, Boulder, the CEJ aims to enhance journalists' knowledge of the scientific, social, political, and economic dimensions of environmental issues. www.colorado.edu/cej

Committee to Protect Journalists (CPJ). This independent organization advocates for press freedom internationally and defends the rights of journalists. https://cpj.org

Covering Climate Now (CCNow). This journalism partnership brings together more than 400 news sources from around the world including television, radio, online, and print outlets. www.covering-climatenow.org

Earth Journalism Network (EJN). Members of this global network of journalists are interested in environment and climate. https://earthjournalism.net

Earthwatch. Podcasts feature conservationists, activists, and other expert speakers on current environmental topics. https://earthwatch.org/stories/podcasts

EnviroLink. As of the world's oldest and largest environmental information clearinghouses, EnviroLink Network is committed to creating dialogue between volunteers and organizations across the globe. www.envirolink.org

Environmental Health News (EHN). Founded in 2002, EHN publishes environmental news with an emphasis on health and climate. www.ehn.org

Forum of Environmental Journalists in India (FEJI). This organization focuses on training media practitioners and forming partnerships between various agencies concerned with environment and development in India. www.feji.org.in

Inside Climate News (ICN). This Pulitzer Prize-winning news organization is dedicated to climate change, energy, and environment. https://insideclimatenews.org

Knight Center for Environmental Journalism. Founded at Michigan State University in 1994, the Knight Center trains student and professional journalists in environmental reporting. https://knight-center.jrn.msu.edu

Oxpeckers Center for Investigative Environmental Journalism. Africa's first environmental journalism organization has pioneered the practice of geojournalism. https://oxpeckers.org

Pew Research Center. Using opinion polls, demographic analysis, and other data-focused methods, Pew conducts research about major issues including the environment. www.pewresearch.org

Reporters Without Borders (RSF). Founded in 1985 by journalists in France, RSF promotes freedom of information globally. https://rsf.org/en

Society of Environmental Journalists (SEJ). Created in 1990, SEJ focuses on North American environmental journalism. www.sej.org

The Guardian Environment Network. This clearinghouse serves as a nexus for environmental news websites. www.theguardian.com/environment/series/guardian-environment-network

Filmography

Dennis, Danfung. 2014. *Zero Point*. United States.

Dennis, Danfung. 2017. *Melting Ice*. United States.

Guggenheim, Davis. 2006. *An Inconvenient Truth*. United States: Paramount Classics.

Jing, Chai. 2015. *Under the Dome*. China.

References

Allan, Stuart, and Jacqui Ewart. 2015. "Citizen Science, Citizen Journalism: New Forms of Environmental Reporting." In *The Routledge Handbook of Environment and Communication*, edited by Anders Hansen and Robert Cox, 186–196. London: Routledge.

American Press Institute. 2020. "*Journalism Essentials*." Accessed November 6, 2020. https://www.americanpressinstitute.org/journalism-essentials/what-is-journalism/.

Andi, Simge. 2020. "How People Access News About Climate Change." In *Reuters Institute Digital News Report 2020*, edited by Nic Newman, 52–55. Oxford: Reuters Institute for the Study of Journalism.

Bødker, Henrik, and Irene Neverla. 2012. "Introduction: Environmental Journalism." *Journalism Studies* 13 (2): 152–156.

Cantrill, James G., and Christine Oravec. 1996. "Introduction." In *The Symbolic Earth: Discourse and Our Creation of the Environment*, edited by James G. Cantrill and Christine L. Oravec, 1–7. Lexington: University Press of Kentucky.

Carrington, Damian. 2020. "*3,000 Articles, 100m Readers: A Year of Our Best Environment Journalism*." *The Guardian*. Accessed November 6, 2020. https://www.theguardian.com/environment/2020/oct/05/3000-articles-100m-readers-a-year-of-our-best-environment-journalism.

Carson, Rachel. 1962. *Silent Spring*. Boston: Houghton Mifflin.

Cocking, Ben. 2020. *Travel Journalism and Travel Media: Identities, Places, and Imaginings*. London: Palgrave Macmillan.

Cohen, Bernard. 1963. *The Press and Foreign Policy*. Princeton: Princeton University Press.

Cox, Robert. 2013. *Environmental Communication and the Public Sphere*. 3rd ed. Los Angeles: SAGE.

Darrow, Richard W. 1971. *Communication in an Environmental Age*. New York: Hill and Knowlton.

Douglas, Marjory Stoneman. 2007. *The Everglades: River of Grass*. Sarasota: Pineapple Press. Original edition, 1947.

Dykstra, Peter. 2016. "Analysis: Environmental Journalism Reaches Middle Age, With Mixed Results." *Environmental Health News* September 24.

Gottfried, Jeffrey, and Cary Funk. 2017. "Most Americans Get Their Science News From General Outlets, But Many Doubt Their Accuracy." *Pew Research Center* September 21.

Hansen, Anders. 2015. "Communication, Media and the Social Construction of the Environment." In *The Routledge Handbook of Environment and Communication*, edited by Anders Hansen and Robert Cox, 26–38. New York: Routledge.

Killingsworth, M. Jimmie, and Jacqueline S. Palmer. 1992. *Ecospeak: Rhetoric and Environmental Politics in America*. Carbondale: Southern Illinois University Press.

Kovach, Bill, and Tom Rosenstiel. 2014. *The Elements of Journalism: What Newspeople Should Know and the Public Should Expect*. 3rd ed. New York: Crown.

Lakoff, George. 2010. "Why It Matters How We Frame the Environment." *Environmental Communication* 4 (1): 70–81. doi: 10.1080/17524030903529749.

Latson, Jennifer. 2015. "The Burning River That Sparked a Revolution." *Time* June 22.

McPhee, John. 1968. *The Pine Barrens*. New York: Farrar, Straus and Giroux.

McPhee, John. 1977. *Coming into the Country*. New York: Farrar, Straus, and Giroux.

Nemo, Leslie. 2020. "Why Scientists Are So Worried About Antarctica's Doomsday Glacier." *Discover* November 14.

Nielson, Rex P. 2020. "Nefarious Agents of Ecological Collapse: 'The Desert Makers' by Euclides da Cunha." *ISLE: Interdisciplinary Studies in Literature and Environment* 0 (0): 1–21. doi: 10.1093/isle/isaa017.

Sachsman, David B. 1976. "Public Relations Influence on Coverage of Environment in San Francisco Area." *Journalism & Mass Communication Quarterly* 53 (1): 54–60. doi: 10.1177/107769907605300108.

Sachsman, David B., James Simon, and JoAnn Myer Valenti. 2010. *Environmental Reporters in the 21st Century*. London: Routledge.

Sachsman, David B., and JoAnn Myer Valenti. 2020b. "Introduction: Environmental Journalism." In *Routledge Handbook of Environmental Journalism*, edited by David B. Sachsman and JoAnn Myer Valenti, 1–15. London: Routledge.

Schäfer, Mike S., and James Painter. 2020. "Climate Journalism in a Changing Media Ecosystem: Assessing the Production of Climate Change-Related News Around the World." *Wiley Interdisciplinary Reviews: Climate Change* e675: 1–20. doi: 10.1002/wcc.675.

Shanahan, James, Michael Morgan, and Mads Stenbjerre. 1997. "Green or Brown? Television and the Cultivation of Environmental Concern." *Journal of Broadcasting and Electronic Media* 41 (3): 305–323. doi: 10.1080/08838159709364410.

Smith, W. Eugene, and Aileen M. Smith. 1975. *Minamata: The Story of the Poisoning of a City, and of the People Who Chose to Carry the Burden of Courage*. New York: Holt, Rinehart and Winston.

Society of Environmental Journalists (SEJ). 2020. "SEJ's History." Accessed December 5, 2020. https://www.sej.org/about-sej/history.

Subramanian, Meera. 2020. "SEJ President's Report: Gratitude and Grit at the End of 2020." Accessed December 7, 2020. https://www.sej.org/publications/sej-presidents-report/gratitude-and-grit-end-2020.

Williams, Terry Tempest. 1991. *Refuge: An Unnatural History of Place*. New York: Pantheon.

Wyss, Bob. 2019. *Covering the Environment: How Journalists Work the Green Beat*. 2nd ed. New York: Routledge.

14 Conclusion

Back to the future Environmental Humanities

Chapter objectives

- To examine recent developments in the Environmental Humanities including the blue humanities, energy humanities, extinction studies, and paleoenvironmental humanities
- To explain emerging transdisciplinary approaches to studies of animals, plants, fungi, microorganisms, natural resources, and human–nature interactions
- To recognize the value of the Environmental Humanities in identifying the ecological foundations of the Covid-19 pandemic
- To review how the Environmental Humanities inspires positive ecological change, imagines sustainable societies, and cultivates hope for the Earth

Rewilding the urban

In March 2020, during the coronavirus lockdown, a wild cougar was seen roaming the empty streets of Santiago, the Chilean capital city of 6 million people. Drawn out of Santiago's drought-stricken foothills by hunger and thirst, the mountain lion soon became disoriented in the eerily quiet urban maze. One month later, in Tel Aviv, Israel, jackals began scavenging for food in Yarkon Park, a popular urban recreational area that ordinarily receives 16 million human visitors per year.

Cougars in Santiago and jackals in Tel Aviv are but two examples of the unusual wildlife encounters in city environments reported in the news during the Covid-19 outbreak. Others include Berliners and New Yorkers who reported hearing songbirds. Perhaps you've heard about bears, wolves, coyotes, elephants, or birdlife roaming your cities. Across the globe, the sudden decline in human mobility in 2020 led to a sharp drop in water, air, and noise pollution as well as poaching and trafficking. To describe the global slowdown of society, especially in relation to reduced petroleum-based travel, a team of ecologists proposed the term *anthropause* (Rutz et al. 2020). After centuries of satisfying the voracious industrial appetite of humankind, the coronavirus anthropause marked an unprecedented moment of biospheric respite. The ecologists behind the anthropause idea are part of the Covid-19 Bio-Logging Initiative, a consortium of researchers using the latest sensor technologies to measure changes in wildlife behavior in response to reduced human activity during the pandemic. Through the analysis of bio-logged data—for example, an animal's GPS location, speed of travel, and physiological condition—the initiative aims to advance understanding of human–wildlife interactions (International Bio-Logging Society 2020).

DOI: 10.4324/9781351200356-14

Figure 14.1 The endangered tucuxi (*Sotalia fluviatilis*) is a freshwater dolphin endemic to the Amazon basin.

Image credit: Allen Sheffield (Wikimedia Commons).

For many of us, the appearance of wild animals in cities during the anthropause offers a hopeful sign of ecological rejuvenation. One of the few joys of the lockdowns were these urban wildlife encounters as clear air, silence, and darkness came back to city streets. Statistics, however, reveal a different story. Consider, for instance, the most recent update of the International Union for Conservation of Nature (IUCN) Red List of Threatened Species, which calls attention to thirty-one recent extinctions. In total, the IUCN Red List enumerates 128,918 species, of which 35,765—or 28% of all assessed species worldwide—are threatened with extermination, including 40% of all amphibians, 26% of all mammals, and 100% of all freshwater dolphins (IUCN 2020) (Figure 14.1). Those recently declared extinct by the IUCN consist of seventeen freshwater fish species endemic to Lake Lanao in the Philippines, three Central American frogs, and nine Asian oaks.

Reflection 14.1 Species extinction

The December 2020 update of the IUCN Red List of Threatened Species confirms thirty-one recent extinctions. Conservation science tends to communicate the urgency of extinction through statistics and other objective methods. However, as environmental humanists point out, extinction is a stark finality that sets in motion a complex array of cultural, social, familial, emotional, and psychological disturbances.

Select one animal or plant that has become extinct in the last decade, perhaps one that you personally witnessed. What factors led to the extinction? What are the broader cultural, social, and other implications of its permanent physical disappearance from the planet?

The Environmental Humanities: old roots, new seeds

As the preceding thirteen chapters have shown, the Environmental Humanities has undergone a steady expansion over the last decade. Several foundational publications have contributed to defining the field as transdisciplinary, pluralistic, and emergent. Notable recent studies include *The Environmental Humanities: A Critical Introduction* (Emmett and Nye 2017), *Environmental Humanities: Voices from the Anthropocene* (Oppermann and Serenella 2017), and *The Routledge Companion to the Environmental Humanities* (Heise et al. 2017). The field has also advanced of late through in-depth attention to the ecologies of invasive species (Frawley and McCalman 2014), river ecosystems (Kelly et al. 2017), disability studies (Ray and Sibara 2017), environmental injustice (Gladwin 2018), the uncanny (Giblett 2019), and theology (Giblett 2018) in addition to crucial concerns of agency and time (Boschman and Trono 2019). Regional and country-specific investigations include *Italy and the Environmental Humanities* (Iovino et al. 2018) and *Chinese Environmental Humanities* (Chang 2019) as well as chapters focused on Estonia, Finland, Norway, and other European nations in *Framing the Environmental Humanities* (Bergthaller and Mortensen 2018).

On the whole, these publications characterize the Environmental Humanities as a forward-thinking field with old roots: stretching back to prehistoric cultures, yet bearing new seeds for an environmentally equitable future. Alongside the upsurge in scholarly books, Environmental Humanities research centers have germinated in Australia, Canada, Denmark, England, Germany, the Netherlands, Norway, South Africa, Sweden, Switzerland, the United States, and other parts of the world. Moreover, an increasing number of universities offer undergraduate and graduate degrees in the field. The florescence of the field has led scholars to investigate strategies for teaching the Environmental Humanities creatively as "an open, experimental, emergent space of possibilities—not to be locked down by an overly prescriptive canon or set of methodologies" (O'Gorman 2019, 458).

Our book's chapter structure reflects our belief, as authors, that understanding the Environmental Humanities necessitates a solid grounding in the field's disciplinary roots. As we see it, an important aspect of the movement between disciplinarity and transdisciplinarity at the heart of the Environmental Humanities is language itself. How can environmental humanists describe the emergent phenomena of the Anthropocene? What language transformations are required to articulate experiences of the radical changes occurring constantly around—and within—all beings? To this end, since 2014, the Living Lexicon for the Environmental Humanities has called attention to the ways in which particular keywords—from absence and belonging to resilience and sacrifice—might push the field into "interesting directions that take seriously this dual imperative for *critique* and *action*" (Environmental Humanities 2020, para. 2, emphasis added). New lexicons are needed to articulate the complex human–nature entanglements of our present era.

Reflection 14.2　Teaching the Environmental Humanities

As EH has blossomed in recent years, scholars have become more concerned with developing effective strategies for teaching undergraduates and graduates. Consider how you would present an introductory lecture to a first-year Environmental Humanities class. Your students have varied academic backgrounds, skills, and interests. Whereas some students are focused on politics and conservation, others aspire to become environmental artists or writers. What strategies would you use to inspire interest in the Environmental Humanities—and the environment in general—to this diverse group?

Animal and plant studies

Also known as anthrozoology, human–animal studies (HAS) emerged in the 1990s through the collaborative efforts of diverse scholars—anthropologists, biologists, geographers, historians, philosophers, psychologists, and others—with a common interest in the animal world. Over the last thirty years, HAS has evolved as a discrete trajectory within the Environmental Humanities. Inherently transdisciplinary, the field explores the myriad complexities between humans and animals—wild, domestic, and feral—from various perspectives. Sometimes described more precisely as *human–non-human–animal studies*, HAS interrogates the very idea of *the animal* in light of the evolutionary reality that humans are also animals. The field thus aims to develop new ways of understanding animals and human–animal interactions (Marvin and McHugh 2014).

An integral aspect of HAS is the recognition that animals are part of human stories and histories but also have their own stories and histories. As agents in themselves, animals are intimately entangled with humans yet produce forms of meaning independent of ours. HAS researchers, accordingly, attend to issues of animal ethics, such as meat consumption, in the tradition of Peter Singer's landmark publication *Animal Liberation* (1996, originally 1975). An example of a current topic of interest in human–animal studies is the Malayan pangolin (*Manis* spp.), a mammal regarded by some virus researchers as the vector for the Covid-19 pandemic (Figure 14.2).

Reflection 14.3 Human–animal studies and the ethics of meat eating

The consumption of animal flesh remains an important question in human–animal studies. People adopt vegetarian and vegan lifestyles for different reasons, including animal welfare, environmental impacts, health concerns, or simply a preference for the taste of plant foods. Do you think consuming animals as food (or medicine) is ethically justifiable?

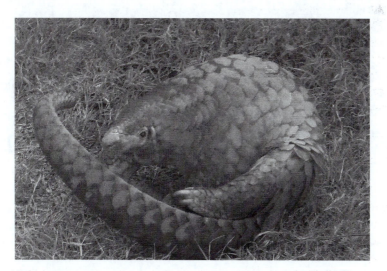

Figure 14.2 Also known as scaly anteaters, pangolins are found in Asia and Africa.

Image credit: Flickr (Wildlife Alliance) (CC BY-SA 2.0).

In addition to human–animal studies, the field of human–plant studies (HPS) has taken shape over the last decade through the work of scholars such as philosopher Michael Marder (2013) and biologist Anthony Trewavas (2014). Researchers in this field respond to the traditional Western characterization of plants—including herbs, shrubs, and trees—as passive, sessile, and silent; as green backdrops to human affairs. To be certain, humans tend to think of plants in narrow utilitarian terms as foods, medicines, fibers, dyes, materials, ornaments, decorations, and so on. As the plant-focused version of human–animal studies, HPS field offers a transdisciplinary framework for understanding vegetal beings as intelligent, conscious, and capable subjects—as agents in their own right rather than solely as objects to be manipulated for human needs (Figure 14.3). Toward this end, the field draws from advances in the biological sciences (specifically plant cognition), social sciences (ethnobotany), philosophy (critical plant studies), history (botanical history), literary studies (phytocriticism), and other scholarly approaches to people-plant relationships. Like HAS, HPS also addresses ethical concerns, including the genetic manipulation of seeds and the possibility that plants experience pain (Ryan *forthcoming*).

Figure 14.3 Touch-me-not (*Mimosa pudica*) is a species commonly used in scientific studies of behavior and learning in the plant world.

Image credit: Flickr (Hafiz Issadeen) (CC BY 2.0).

Case Study 14.1 Optical technology and sacred plants

Bringing social science (anthropology) into dialogue with biological science (botany), ethnobotany investigates the practical uses of plants by particular cultural groups, including Indigenous communities. Within the field of ethnobotany, ethnopharmacology focuses on traditional botanical medicines and assesses the commercial viability of various therapeutic plants. Some ethnobotanists and ethnopharmacologists specialize in sacred plants, or spiritually important species used in ceremonies, rituals, and for healing purposes. An example of a sacred plant is holy basil or tulsi (*Ocimum tenuiflorum*), a healing herb worshipped by some devotees of Vaishnava Hinduism.

The project "Microcosms: A Homage to Sacred Plants of the Americas," a collaboration between biology researcher Jill Pflugheber and Latin American literature scholar Steven F. White, brings technological innovation to the study of sacred plants. "Microcosms" lies at the confluence of science, environment, technology, culture, and art. The project employs confocal microscopy (short for confocal laser scanning microscopy), a specialized optical technique that enables the three-dimensional imaging of the interior of an object or organism. The confocal process results in vivid representations comparable to works of abstract art. For the project, the researchers selected more than seventy plants considered sacred by Indigenous groups of North and South America. One plant featured in the work is sweetgrass (*Hierochloe odorata*), known as Óhonte Wenserákon in the Mohawk (Kanien'keha) language and Wicko'bimucko'si among Chippewa people. Sweetgrass is used by Native North Americans for basketry, healing, and smudging. A stunning confocal depiction of sweetgrass shows organic purple forms floating over the green inner structure of the plant (Figure 14.4; or see the project website below).

The overall aim of "Microcosms" is to enable viewers to see the plant world in new ways. Visit the online gallery here: https://library.artstor.org/#/collection/100089947. Select one plant. Examine its image carefully. How does the confocal visualization enhance your appreciation of the species?

Figure 14.4 This confocal image shows sweetgrass (*Hierochloe odorata*), a species held as sacred among Native North American cultures.

Image credit: Jill Pflugheber and Steven F. White.

Arctic and Antarctic humanities

The *Arctic humanities* investigates the art, literature, and material culture associated with the Arctic, including the region's Indigenous people (Chukchi, Iñupiat, Saami, and others) aiming to counter the dominant view of Arctic knowledge as the domain of ice cores, climate data, and other scientific measures. Like the Artic humanities, the *Antarctic humanities* considers competing depictions and imaginings of the polar region through various disciplinary stances.

In their beauty, ruggedness, and remoteness, the Arctic and the Antarctic hold a prominent place in humankind's imagining of the planet. Yet, knowledge of the Arctic and Antarctic historically has been dominated by scientific observation and data collection designed to facilitate industrial development and resource extraction, rather than social science and humanities paradigms. Nevertheless, the profound impacts of climate change—visible in the dramatic loss of sea ice and snow cover—draw attention to the importance of political, social, cultural, humanistic, and arts-based approaches to addressing major issues in these regions. Especially with regard to climate change, humanities techniques are leveraged to enhance knowledge of this mysterious and misunderstood regions. As such, the fields acknowledge the Arctic and Antarctic as "series of representations that are always selected, distilled, and packaged by humans" (Roberts, Howkins, and van der Watt 2016, 14).

Asian Environmental Humanities

As an academic field, the Environmental Humanities has emerged predominantly from the English-language—or "Anglo-European"—contexts of North America, Europe, and Australia (Chapter 1). Nonetheless, the world's geographically largest and most densely populated continent, Asia has become acutely vulnerable to climate change, water and air pollution, biodiversity decline, and ecodisasters. Through the dedication of environmental scholars, based both within and outside of the continent, the *Asian Environmental Humanities* is becoming a lively contributor to the global evolution of EH particularly in its regional emphasis on East Asia, South Asia, and Southeast Asia (Chang 2019, Chu 2016, Diamond 2014, Ryan 2017, Thornber 2014).

Blue humanities

The *blue humanities* is an emerging specialism within the Environmental Humanities that focuses on water, hydrological systems, and aquatic life. Highlighting the increasingly aquatic orientation of ecological scholarship, the field views oceans and freshwater bodies—from deep sea zones and coral reefs to lakes and rivers—as sites of transdisciplinary inquiry (Campbell and Paye 2020). Calling attention to the intimate—and intricate—relationships between humans, more-than-humans, and water, the blue humanities marks a shift from the terrestrial to the aquatic, particularly in anthropology, geography, history, and literary studies.

Covering 71% of the Earth's surface, oceans contain 97% of all the planet's water. Within the world's immense interconnected oceanic systems—collectively called the World Ocean or Global Ocean—marine species range in size from microscopic phytoplankton to enormous cetaceans such as the blue whale (*Balaenoptera musculus*) (Figure 14.5). According to the National Oceanic and Atmospheric Administration, or NOAA, 91% of all marine species are scientifically unclassified and, additionally, about 80% of the Global Ocean remains unmapped.

What's more, merely 3% of the Earth's water is fresh. Sequestered in glaciers, ice caps, soil, the atmosphere, and elsewhere, most fresh water is off limits; in fact, only 0.5% of all known water is both potable and accessible. Imagine if the world's water resources amounted to 100 liters (or 26.4 gallons): the usable portion would be only 0.003 liter (0.0008 gallon or one-half teaspoon). As these figures indicate, fresh water is a precious resource that humankind should avoid taking for granted.

Figure 14.5 Featuring a blue whale (*Balaenoptera musculus*), this Faroe Islands postage stamp is an example of the representation of cetaceans in popular culture and offers a possible subject of research in the blue humanities.

Image credit: Edward Fuglø (Wikimedia Commons).

Blue humanists refer to "the oceanic turn" as a shift toward critical and creative work that recognizes water as a physical agent and symbolic force (DeLoughrey 2017). The issues investigated by blue humanists include climate change, rising sea levels, and ocean acidification in addition to lesser-publicized concerns over the impacts of underwater sonar on cetaceans and the implications of deep-sea mining (Case Study 14.2). Scholars of the blue humanities, furthermore, examine the crucial role of technology in mediating relationships between people and water, especially the sea (Alaimo 2019). A salient example of this issue is the deployment of manned submersibles over the last six decades to chart the Marianas Trench, the deepest part of the ocean. Scholarship in the blue humanities, consequently, reminds us of our interdependencies with water in all of its manifestations.

Case Study 14.2 The blue humanities and deep sea mining

According to the International Union for Conservation of Nature (IUCN), deep sea (or seabed) mining entails the extraction of mineral deposits from the deep sea, defined as the region of the ocean below 200 meters (656 feet) and covering about 65% of the planet's surface. Deep sea mining focuses on the retrieval of silver, gold, copper,

manganese, nickel, lithium, cobalt, zinc, and other minerals required to manufacture, for instance, mobile devices (smartphones and tablets) and renewable energy technologies (photovoltaic cells and wind turbines). This relatively new, though controversial, form of mining involves scraping the ocean floor, inevitably destroying deep marine habitats such as hydrothermal vents rich in sulfide deposits. In 2010, Nautilus Minerals became the first company to harvest seabed minerals commercially and even developed deep sea robots to facilitate the process. AI will dramatically increase the feasibility of deep sea mining.

Although its exact short- and long-term ecological impacts are largely unknown, deep sea mining undoubtedly affects deep sea organisms adapted to the extreme and demanding conditions below the ocean's photic, or sunlit, upper zone. Exhibiting gigantism, bioluminescence, chemosynthesis, and other physiological adaptations to deep sea habitats, many of these creatures are otherworldly figures of the human imagining of the deep ocean. Some species have only recently been discovered by biologists.

Given humanity's insatiable mineral appetite, deep sea mining is expected to increase in coming years. What are the likely ecological impacts of seabed mining? What regulations should be implemented to minimize its effects? Or, as Sir David Attenborough has recently urged, should deep sea mining be banned entirely?

Emergency humanities

In 2020, in response to Covid-19, climate change intensification, catastrophic wildfires, and rampant species extinctions, the organizers of the Association for the Study of Literature and Environment (ASLE) biennial symposium proposed the term *emergency humanities* to refer to a growing area of the Environmental Humanities focused on the manifold urgencies facing the biosphere today (Welling et al. 2020). Emergency humanists stress that "the humanities and the study of culture are indispensable, especially given the need for a critical approach to the [Covid-19] crisis and the measures taken in response to it" (Bachmann-Medick 2020, 80–81).

The emergency humanities are likely to grow, resulting from the "pandemic turn" that is predicted to affect all areas of the humanities in coming years (Bachmann-Medick 2020, 78). It is well known that human–nature relationships are the basis of Covid-19; and that pandemics impact marginalized groups disproportionately (Jørgensen and Ginn 2020, 498) (see Chapter 6). Through critical approaches to politics, economics, geography, biology, history, the social science, religion, philosophy, and technology, the emergency humanities draws together holistic knowledge to pioneer pragmatic, scientific, humanistic solutions to crises like Covid-19 (Bachmann-Medick 2020, 82–83).

Scholarly interest in emergency is especially evident in the field of environmental history (Chapter 6). As a case in point, the International Consortium of Environmental History Organizations (ICEHO) recently launched "Epidemics and Ecologies: Reading in the Time of COVID-19." The project aims to stimulate more historical analyses of the linkage between human mobility, virus outbreaks, climate change, and biodiversity loss. Environmental-historical assessments of pandemics recognize that

the transmission of infectious diseases accelerates as global ecological change increases (San Martín et al. 2020).

Reflection 14.4 Covid-19 and the Environmental Humanities

Scholars such as Doris Bachmann-Medick (2020) argue that the Covid-19 pandemic will transform humanities research and send humanists into uncharted waters.

What do you think of the idea of the *pandemic turn* in the humanities? Have you noticed an increased discussion of the pandemic as an academic topic in your classes? In what ways is the Environmental Humanities essential to formulating responses to crises, emergencies, and urgencies?

Energy humanities

First appearing in 2014, the term *energy humanities* refers to a growing body of scholarship applying humanities-based frameworks to energy research. Energy humanists assert that "today's energy and environmental dilemmas are fundamentally problems of ethics, habits, values, institutions, belief, and power—all traditional areas of expertise of the humanities and humanistic social sciences" (Boyer and Szeman 2014, para. 6). The field explores, on the one hand, the production and consumption of energy and, on the other, artistic, literary, activist, and philosophical engagement with energy issues during the present age of intense human-driven change. In many ways, the aims of the energy humanities overlap closely with those of the emergency humanities. In both its renewable and non-renewable forms, energy is an urgent concern that underlies climate change, species loss, habitat degradation, and other global catastrophes (Szeman and Boyer 2017, 9). Researchers in the energy humanities also delve into the concept of *petroculture*, signifying the manifold ways in which oil has defined modernity and molded cultural life since the birth of the petroleum industry in 1850s (Wilson et al. 2017) (Figure 14.6).

Reflection 14.5 Petroculture and the energy humanities

Over the last decade, the term *petroculture* has gained widespread usage in the energy humanities thanks to the work of Stephanie LeMenager and others. Simply put, petroculture calls attention to our dependence on petroleum products for everyday needs.

Select a place you know well: your home, village, town, community, school, campus, or city. Give a concrete example of a petroculture existing in this place that demonstrates humanity's utter reliance on oil. Alternatively, reflect on your own behavior: how many times a day do you take an action without thinking about how it is dependent on oil? What actions are "unthinkable" or "impossible" because of the way oil dependence shapes our thinking? What would happen if you started thinking about liberating yourself from oil dependency in everyday habits?

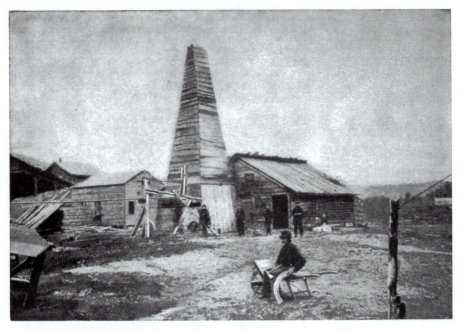

Figure 14.6 Constructed in 1859, the Drake Well in Pennsylvania spurred the development of the global petroleum industry.

Image credit: Ida Tarbell (Wikimedia Commons).

Extinction studies

We live in an age of extinction. This concern informs *extinction studies*, a field investigating the aesthetic, cultural, ecological, emotional, ethical, social, and spiritual dimensions of extinction. The objective of this specialized area of the Environmental Humanities is to trace the values, beliefs, and worldviews that have led to the present catastrophe. Approaching extinction as both biological and cultural, scholars examine the ways in which societies recognize, understand, and respond to this urgency (Elmore 2020, 6). The editors of *Extinction Studies: Stories of Time, Death, and Generations*, the defining publication in this field, maintain that "there is no singular phenomenon of extinction; rather, extinction is experienced, resisted, measured, enunciated, performed, and narrated in a variety of ways to which we must attend" (Rose et al. 2017, 2–3).

Over the last 500 years, human activities have resulted in the extirpation of an estimated 680 vertebrate species in addition to countless invertebrates and more than 500 are estimated to disappear in the next two decades. Also known as the Holocene or Anthropocene extinction, this is the sixth mass extinction unfolding around us in an ongoing, global event driven by the actions of *Homo sapiens* (see Chapter 3). The United Nations *Global Assessment Report on Biodiversity and Ecosystem Services* estimates that 1 million species worldwide are at risk of extinction (Díaz 2019). Yet, extinction not only pertains to individual species but also to the loss of populations of organisms (or what are called *local extinctions*). The demise of species or populations, in turn, diminishes the vitality of ecosystems as integrated wholes and sets in motion subsequent extinction events: "close ecological interactions of species on the brink tend to move other species toward annihilation when they disappear—*extinction breeds extinction*" (Ceballos et al. 2020, 13596, emphasis added). Extinction studies attends to the interconnected nature of extinction and its socio-economic and cultural drivers.

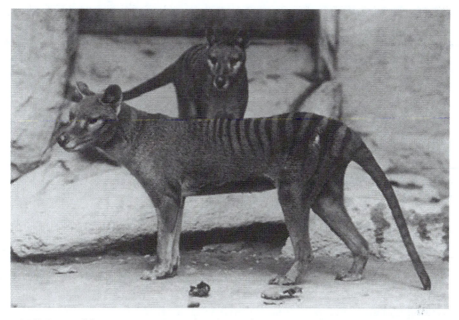

Figure 14.7 Pictured here circa 1903 at the National Zoo in Washington, DC, the thylacine or Tasmanian tiger (*Thylacinus cynocephalus*) was a carnivorous marsupial that became extinct in the 1930s.

Image credit: E. J. Keller from the Smithsonian Institution archives (Wikimedia Commons) (Public Domain).

Case Study 14.3 The crisis of plant, fungi, and insect extinction

When we think of the term *extinction*, what immediately springs to mind? Whales and dolphins? Elephants and rhinoceroses? Snow leopards and Eurasian wolves?

To date, the field of extinction studies has focused largely on mammals, birds, reptiles, amphibians, fish, and other vertebrates. This likely reflects the fact that vertebrates are easier to study than other organisms. However, this reality could also be attributed to the phenomenon that could be called *vertebra-centrism*, a variant of zoo-centrism that underscores the human privileging of life forms with anatomies comparable to our own. The edited collection *Extinction Studies* (Rose et al. 2017), for instance, displays a vertebra-centric orientation with chapters dedicated to the golden lion tamarin, monk seal, leatherback sea turtle, and crow.

Despite the vertebra-centric bias of much extinction research, the Anthropocene is dramatically impacting plants, fungi, arthropods (insects and arachnids), mollusks (snails and squids), annelids (earthworms and leeches), cnidarians (jellyfishes and corals), and myriad other life forms. Undoubtedly, there are species that will become extinct before they are known to science. Indeed, a staggering 40% of all plant species will soon become extinct if conservation measures aren't taken.

In the case of arthropods, ecologists estimate that there are 5.5 million insect species but only 20% of these have been named. As a result of habitat degradation, climatic disturbance, and other factors, insects make up half of the 1 million species facing

extinction in coming decades. What's more, estimated at 12 million species worldwide, fungi including yeasts, molds, and mushrooms are also at risk. Fungi provide a multitude of services essential to biospheric functioning. The estimates of fungal extinction, though, are much less precise than for other organisms in part because relatively little is known about this kingdom.

Research one plant, fungus, or insect species that is likely to become extinct unless conservation strategies are immediately implemented. What has led to the decline of the species? What practical steps can be taken to rescue the species from the brink?

Medical environmental humanities

The relationship between human, more-than-human, ecosystemic, and planetary health is the central concern of the *medical environmental humanities*, which shares ground with the emergency humanities, especially in terms of the coronavirus pandemic. Covid-19 has brought to light the dynamic interconnections between human and Earth health—between people, place, and planet. In this regard, the med-ecohumanities reflects developments in the "planetary health humanities," focused on the contribution of the arts, humanities, and social sciences to both human and environmental wellbeing (Lewis 2020).

Emerging specifically from debates in bioethics, the medical humanities emphasizes the social dimensions of health, wellness, healing, illness, death, medicine, and the body. Medical humanists examine narratives of sickness, suffering, and recovery from diverse perspectives—cultural, historical, literary, philosophical, religious, and more. Since its beginnings in the 1990s, the field has evolved into an invaluable framework for training medical practitioners in the concepts and methods of the humanities and allied areas of the arts and social sciences (Fitzgerald and Callard 2016).

The med-ecohumanities, therefore, deals with questions of health, environment, conservation, and human–nature interactions in an era of climate crisis. Possible topics of research include literary representations of contaminated environments in nineteenth-century British literature as well as performances of curative songs among Indigenous Amazonian communities. The med-ecohumanities investigates salient current issues such as the ecological origins of the coronavirus as well as historical subjects, as shown in the case of *Tacuinum Sanitatis* (Figure 14.8) and the question of why medieval manuscripts represent medicinal species as human–plant hybrids. Ensuring a focus on health, wellbeing, healing, and embodiment in the Environmental Humanities, the field opens up exciting new prospects for study.

Reflection 14.6 Medical environmental humanities

The med-ecohumanities is an example of the synergies that arise when two scholarly fields strike dialogue after decades of following separate growth curves. As with the medical humanities, the med-ecohumanities could eventually become an integral part of medical training. What are the benefits of future physicians learning about the relationship between medicine, health, environment, and the humanities? How might knowledge of the arts enhance a physician's practice of medicine and interactions with patients?

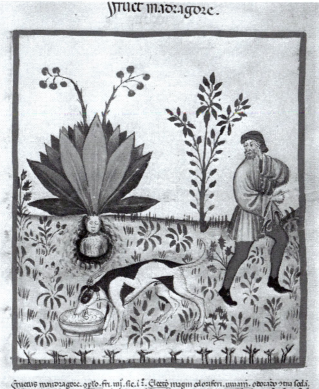

Figure 14.8 Mandrake (*Mandragora officinarum*) featured here in *Tacuinum Sanitatis* manuscript (ca. 1390) has a long history as a herbal medicine.

Image credit: Hans Biedermann (Wikimedia Commons) (Public Domain).

Paleoenvironmental humanities

Attentive to the complexities of deep time, then, the *paleoenvironmental humanities* (PEH) is a new trajectory in the Environmental Humanities with only a handful of published studies to date (Hussain and Riede 2020, Roddick 2018). Paleoarchaeology investigates human evolution through the fossil remains of chimpanzees, bonobos, gibbons, orangutans, gorillas, *Homo sapiens*, and other hominids, studying the material evidence from a broad timeframe—from the emergence of human ancestors during the Miocene epoch around 15 million years ago to the end of the last ice age about 10,000 years ago. Deep time reflects Earth history; it is a sense of time that registers in *millionennia* (millions of years) rather than millennia (thousands of years) or centuries (hundreds of years) (Figure 14.9).

Drawing on paleoarchaeology, PEH develops the idea of *human–climate relations*, the connections between human behaviors and climatic alteration in the context of ecological change across deep geological timescales. By offering a long-term view of human–climate interactions, the paleoenvironmental humanities addresses the dominant concerns of the Environmental Humanities, namely the Anthropocene, climate crisis, deep time, and human agency (Case Study 14.4).

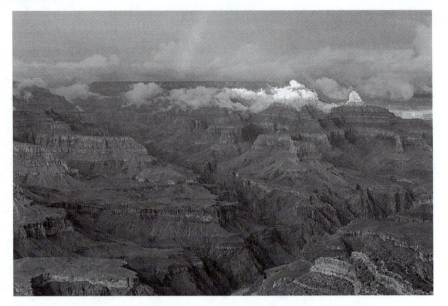

Figure 14.9 The Grand Canyon offers a window into deep time.

Image credit: Tuxyso, CC BY-SA 3.0 (Wikimedia Commons).

Case Study 14.4 Chronophobia and the Environmental Humanities

Time and temporality are important to the study of the Environmental Humanities. While these concepts are sometimes used interchangeably, they in fact carry different meanings. On the one hand, *time* measures the movement from the past to the present and future. Much like a clock, watch, or calendar, time is an instrument that standardizes the passage of moments through the imposition of units (seconds, minutes, hours, days, months, years, decades, and so on). On the other hand, *temporality* is a philosophical premise denoting our perception and experience of time as well as its social construction. As a case in point, depending on their geographical location, Aboriginal Australian societies recognize between two and seven seasons, demonstrating a sense of temporality that differs markedly to that which underlies the Anglo-European four seasons.

The aim of the paleoenvironmental humanities is to reinforce a deep time perspective in the Environmental Humanities through empirical examination of archaeological evidence. Considering that humans tend to have an innate aversion to deep time, this is a crucial undertaking. In her book *Timefulness: How Thinking Like a Geologist Can Help Save the World* (2018), geologist Marcia Bjornerud defines the term *chronophobia* as the human denial of deep time due to the existential dread and disorientation the concept causes. Most individuals, she argues, have little sense of planetary history, evolutionary timescales, and geological periods. In relation to climate change and the Anthropocene, the dangers of "temporal illiteracy" (7) are real and immediate. In contrast to chronophobia, *chronophilia* is, literally, "the love of time" whereas *timefulness* is an outlook that strives to position the human in Earth history and promote deep time awareness.

Close your eyes and consider deep time. What notions, images, or sensations arise? How do you feel when you contemplate Earth history? How might Bjornerud's idea of *timefulness* save the world?

Wetland humanities

About twenty-five years ago, environmental humanist Rod Giblett's *Postmodern Wetlands* (1996) inaugurated the *wetland humanities* with his call for the recognition of swamps as both biologically and cultural significant. Among the most biodiverse and fertile environments on the planet, wetlands are crucial to sustaining all life. Including swamps, marshes, sloughs, bogs, billabongs, and other waterbodies, wetlands are ecosystems saturated with water long enough to give rise to specially adapted flora and fauna. Mixing water and earth, wetlands fall between the strict categories of the aquatic and terrestrial. These important ecosystems filter pollutants, protect human settlements from storms, and provide habitat for an array of organisms. Frequently compared to biological supermarkets, some wetlands produce ten times more biomass than a wheat field. Nonetheless, wetlands of all sizes can be found across the globe. Indeed, many of the world's famous cities—New York, Washington DC, Paris, London, Melbourne, and many others—were built on swamps.

Despite their ecological primacy, wetlands have been drained, degraded, and reclaimed throughout history, and representation as sources of disease and discomfort in most cultural art forms. In response to the broad negative perception of swamps, the *wetland turn* in the Environmental Humanities explores human–swamp relations from artistic, cultural, historical, literary, philosophical, and psychological perspectives. The wetland humanities also addresses the field's predominant emphasis on rivers, lakes, and oceans, as evident in the blue humanities. Recent work in this area proposes the idea of a *wetland culture* signifying, on the one hand, cultural expressions (paintings, poems, performances, etc.) that closely involve swamps and, on the other, the ways in which swamps as non-human agents give rise to these cultural forms over time (Ryan and Chen 2019).

Chapter summary

Chapter 14 has outlined ten current trajectories in the Environmental Humanities that collectively demonstrate the considerable diversity and timeliness of the field as scholars from a multitude of disciplines increasingly turn their attention to human–nature relations in the Anthropocene. The developments briefly overviewed in this chapter include animal and plant studies; Arctic and Antarctic humanities; Asian Environmental Humanities; blue humanities; emergency humanities; energy humanities; extinction studies; medical environmental humanities (or med-ecohumanities); paleoenvironmental humanities; and wetland humanities. Specializations such as the emergency humanities and medical environmental humanities have gained momentum in the context of the Covid-19 pandemic and the debate over its ecological origins. Other focus areas are devoted to envisioning alternatives to the despair of the Anthropocene and to enlivening possibilities for human–nature harmonization. Four case studies offered detailed insight into some of these developments: optical technology and sacred plants; the blue humanities and deep sea mining; the crisis of plant, fungi, and insect extinction; and chronophobia and the paleoenvironmental humanities. Regardless of its bountiful variations, the Environmental Humanities as a cohesive transdisciplinary field continues to inspire constructive environmental change, enabling scholars and the public alike to embrace practical sustainability, devise radical solutions, and cultivate radiant hope for the living planet.

Exercises

1. Design a fifteen-minute lecture for first-year university students on any aspect of the Environmental Humanities. Your class will consist of science, engineering, social science, business, humanities, and arts majors. Select two or three brief case studies that

exemplify the role of collaboration and exchange between disciplines in addressing environmental problems. You are welcome to present your response to this exercise in the form of a lecture outline or slide presentation.

2. You have been asked to give a fifteen-minute talk to staff and students at SunRise University Medical School on the contribution of the medical environmental humanities to the training of physicians. How can knowledge of the med-ecohumanities enhance the practice of medicine and doctor-patient relations? Present two or three brief case studies to support your argument for including the med-ecohumanities in the future expansion of the SunRise University Medical School curriculum. You can respond to this exercise in the form of a lecture outline or slide presentation.

3. Geologist Marcia Bjornerud alerts us to the perils of *chronophobia* and *temporal illiteracy* (Case Study 14.4). For Bjornerud, an awareness of deep time and Earth history should be an essential characteristic of the Anthropocene public. You have been invited to give a fifteen-minute lesson on deep time to a fifth-grade science class. What teaching strategies will you employ to enable your students to think about deep time, planetary timescales, and Earth history? We encourage you to present your response to this exercise in the form of a lesson plan.

Annotated bibliography

Albrecht, Glenn. 2019. *Earth Emotions: New Words for a New World*. Ithaca: Cornell University Press. This monograph explores Albrecht's influential concept of *solastalgia* and theorizes the Symbiocene as an age of greater symbiotic alignment between humans and nature.

Bjornerud, Marcia 2018. *Timefulness: How Thinking Like a Geologist Can Help Save the World*. Princeton: Princeton University Press. A geologist by training, Bjornerud urges the public development of *timefulness* as awareness of the Earth's deep history and knowledge of the extent of human impacts on the biosphere.

Mišík, Matúš, and Nada Kujundžić, eds. 2021a. *Energy Humanities. Current State and Future Directions*. Cham: Springer Nature. This edited collection offers the most current overview of the energy humanities including critical analyses of energy transitions, decarbonization, climate policy, nuclear power, and other key debates.

Ray, Sarah Jaquette, and Jay Sibara, eds. 2017. *Disability Studies and the Environmental Humanities: Toward an Eco-Crip Theory*. Lincoln: University of Nebraska Press. This groundbreaking volume is the first to bring the field of disability studies into dialogue with the Environmental Humanities through the examination of imperialism, slow violence, toxicity, ableism, environmental justice, and other topics.

Rose, Deborah Bird, Thom van Dooren, and Matthew Chrulew, eds. 2017a. *Extinction Studies: Stories of Time, Death, and Generations*. New York: Columbia University Press. This essay collection is the most comprehensive current resource for scholars interested in extinction studies but, as elaborated earlier in this chapter, emphasizes vertebrates, such as mammals, reptiles, and fish, over invertebrates.

Ryan, John C., Patrícia Vieira, and Monica Gagliano, eds. 2021. *The Mind of Plants: Reimagining the Nature of Vegetal Life*. Santa Fe: Synergetic Press. Featuring over fifty contributors from diverse fields, this critical plant studies anthology explores the possibility of the vegetal mind as well as the ways in which humans *mind* the plant world through gestures of care and kinship.

Szeman, Imre, and Dominic Boyer, eds. 2017a. *Energy Humanities: An Anthology*. Baltimore: Johns Hopkins University Press. This collection of essential readings in the burgeoning field of the energy humanities focuses on the linkages between energy, society, and culture.

Wilson, Sheena, Adam Carlson, and Imre Szeman, eds. 2017a. *Petrocultures: Oil, Politics, Culture*. Montreal: McGill-Queen's University Press. This book charts the profound influence of oil on how we imagine and interact with the world.

Weblinks

African Observatory for Environmental Humanities. Emphasizing African ecologies, this international research group aims to identify, explore, and demonstrate the contributions of the arts and humanities to addressing environmental challenges. www.up.ac.za/south-african-observatory-for-environmental-humanities

Anthropocenes Network. This international network of scholars in the sciences, social sciences, humanities, and arts is committed to the development of innovative approaches to environmental research. https://anthropocenes.org

Bachelor of Arts in Environmental Humanities, Sterling College, Vermont, USA. This undergraduate program includes courses in environmental literature, creative writing, art, philosophy, and cultural studies. https://sterlingcollege.edu/academics/environmental-humanities

Centre for Health, Medical, and Environmental Humanities, University of Liverpool, UK. The work of this interdisciplinary group centers on questions of climate change, environment, health, and human–animal relations. www.liverpool.ac.uk/humanities-social-sciences-health-medicine-technology/themes/environmental-humanities

Deep Sea Mining Campaign. This project of the Ocean Foundation aims to raise awareness of the ecological consequences of deep sea mining. www.deepseaminingoutofourdepth.org

Doctoral Program in Environment and Society, Rachel Carson Center (RCC), Munich, Germany. This doctoral program invites candidates in the humanities, social sciences, and natural sciences to study topics at the interface between nature, environment, and culture. www.proenviron.carsoncenter.uni-muenchen.de/index.html

Energy Humanities. Edited by Imre Szeman and colleagues, this website offers a wealth of material on the energy humanities. www.energyhumanities.ca

Environmental Humanities Center, Amsterdam, Netherlands. Founded at Vrije Universiteit in 2016, this center aims to bring together researchers, students, and members of the public interested in humanities approaches to environmental concerns. https://environmentalhumanitiescenter.com

Environmental Humanities Graduate Program, University of Utah, Salt Lake City, Utah, USA. This master's program focuses on communication, literature, history, climate justice, and leadership. https://environmental-humanities.utah.edu

Environmental Humanities Program, High Meadows Environmental Institute (HMEI), Princeton University, Princeton, New Jersey, USA. This program encourages environmental scholarship among faculty members, researchers, and students from humanities disciplines. https://environment.princeton.edu/research/environmental-humanities

Environmental Humanities South, University of Cape Town, South Africa. This research cluster explores issues of sustainability, wellbeing, and nature with a special emphasis on Africa. www.envhumsouth.uct.ac.za

Environmental Humanities Switzerland. The aim of the network is to strengthen humanistic environmental research in Switzerland. https://environmentalhumanities.ch

Epidemics and Ecologies. This page offers a useful collection of information about the pandemic humanities. www.iceho.org/epidemics-and-ecologies

Extinction Studies. The work of this humanities group concerns all dimensions of species extinction. http://extinctionstudies.org

Humanities for the Environment Network (HfE). The objective of this initiative of the Consortium of Humanities Centers and Institutes is to consolidate information about research into the humanities and environment. https://chcinetwork.org/networks/humanities-environment

KTH Environmental Humanities Laboratory, KTH Royal Institute of Technology, Stockholm, Sweden. This initiative focuses on environment, energy, media, and technologies. www.kth.se/en/2.48036/2.45962/environmentalhumanities

Nordic Environmental Humanities. This website offers a gateway for Environmental Humanities research in the Nordic region. https://nordic-envhum.org

Oslo School of Environmental Humanities (OSEH), Oslo, Norway. This initiative promotes humanistic environmental research at the University of Oslo. www.hf.uio.no/english/research/strategic-research-areas/oseh

Pandemics in Context. This valuable collection of resources sheds light on humanistic responses to pandemics including Covid-19. www.environmentandsociety.org/mml/pandemics-context

Petrocultures. Founded in 2011 at the University of Alberta, Canada, this group supports research into the social, cultural and political consequences of oil consumption. www.petrocultures.com

Sweetgrass, Microcosms: A Homage to Sacred Plants of the Americas. Featured in the discussion of confocal microscopy in Case Study 14.1, sweetgrass is a plant species held as sacred among Native North Americans. https://library.artstor.org/#/asset/28708824;prevRouteTS=1603248374183

References

Alaimo, Stacy. 2019. "Introduction: Science Studies and the Blue Humanities." *Configurations* 27 (4): 429–432. doi: 10.1353/con.2019.0028.

Bachmann-Medick, Doris. 2020. "The Humanities – Marginalized After Corona?" In *13 Perspectives on the Pandemic: Thinking in a State of Exception*, edited by Rabea Rittgerodt, 78–83. Berlin: Walter De Gruyter.

Bergthaller, Hannes, and Peter Mortensen, eds. 2018. *Framing the Environmental Humanities*. Leiden: Brill.

Boschman, Robert, and Mario Trono, eds. 2019. *On Active Grounds: Agency and Time in the Environmental Humanities*. Waterloo: Wilfrid Laurier University Press.

Boyer, Dominic, and Imre Szeman. 2014. "The Rise of Energy Humanities: Breaking the Impasse." *University Affairs* February 12.

Campbell, Alexandra, and Michael Paye. 2020. "Water Enclosure and World-Literature: New Perspectives on Hydro-Power and World-Ecology." *Humanities* 9 (3): 1–15. doi: 10.3390/h9030106.

Ceballos, Gerardo, Paul R. Ehrlich, and Peter H. Raven. 2020. "Vertebrates on the Brink as Indicators of Biological Annihilation and the Six Mass Extinction." *PNAS: Proceedings of the National Academy of Sciences of the United States of America* 117 (24): 13596–13602. doi: 10.1073/pnas.1922686117.

Chang, Chia-ju, ed. 2019. *Chinese Environmental Humanities: Practices of Environing at the Margins*. Cham: Springer Nature.

Chu, Kiu-wai. 2016. "Ecocinema." *Journal of Chinese Cinemas* 10 (1): 11–14. doi: 10.1080/17508061.2016.1142728.

Cruikshank, Julie. 2006. *Do Glaciers Listen? Local Knowledge, Colonial Encounters, and Social Imagination*. Vancouver: University of British Columbia Press.

DeLoughrey, Elizabeth. 2017. "The Oceanic Turn: Submarine Futures of the Anthropocene." In *Humanities for the Environment: Integrating Knowledge, Forging New Constellations of Practice*, edited by Joni Adamson and Michael Davis, 242–258. London: Routledge.

Diamond, Catherine. 2014. "Whither Rama in the Clear-Cut Forest: Ecodramaturgy in Southeast Asia." *Asian Theatre Journal* 31 (2): 574–593.

Díaz, Sandra, et al. 2019. *The Global Assessment Report on Biodiversity and Ecosystem Services: Summary for Policymakers*. Bonn: Intergovernmental Science-Policy Platform on Biodiversity and Ecosystem Services (IPBES).

Elmore, Jonathan. 2020. "Introduction: The Urgency of Story During the Sixth Mass Extinction." In *Fiction and the Sixth Mass Extinction: Narrative in an Era of Loss*, edited by Jonathan Elmore, 1–12. Lanham: Lexington Books.

Emmett, Robert, and David Nye. 2017. *The Environmental Humanities: A Critical Introduction*. Cambridge: MIT Press.

Environmental Humanities. 2020. "Living Lexicon for the Environmental Humanities: Absence– Wit(h)nessing." *Environmental Humanities*. Durham: Duke Uuiversity Press.https://read.dukeupress.edu/environmental-humanities/pages/lexicon

Fitzgerald, Des, and Felicity Callard. 2016. "Entangling the Medical Humanities." In *Edinburgh Companion to the Critical Medical Humanities*, edited by Anne Whitehead and Angela Woods, 35–49. Edinburgh: Edinburgh University Press.

Frawley, Jodi, and Iain McCalman, eds. 2014. *Rethinking Invasion Ecologies from the Environmental Humanities*. London: Routledge.

Giblett, Rod. 1996. *Postmodern Wetlands: Culture, History, Ecology*. Edinburgh: Edinburgh University Press.

Giblett, Rod. 2018. *Environmental Humanities and Theologies: Ecoculture, Literature and the Bible*. London: Routledge.

Giblett, Rod. 2019. *Environmental Humanities and the Uncanny: Ecoculture, Literature and Religion*. London: Routledge.

Gladwin, Derek, ed. 2018. *Ecological Exile: Spatial Injustice and Environmental Humanities*. London: Routledge.

Heise, Ursula, Jon Christensen, and Michelle Niemann, eds. 2017. *The Routledge Companion to the Environmental Humanities*. 1st ed. London: Routledge.

Hussain, S. T., and F. Riede. 2020. "Paleoenvironmental Humanities: Challenges and Prospects of Writing Deep Environmental Histories." *WIREs Climate Change* 11 (e667): 1–18. doi: 10.1002/wcc.667.

International Bio-Logging Society. 2020. "*News: COVID-19 Bio-Logging Initiative*." Accessed Decemebr 13, 2020. https://www.bio-logging.net/#about.

Iovino, Serenella, Enrico Cesaretti, and Elena Past, eds. 2018. *Italy and the Environmental Humanities*. Charlottesville: University of Virginia Press.

IUCN. 2020. "*European Bison Recovering, 31 Species Declared Extinct – IUCN Red List*." Accessed December 13, 2020. https://www.iucn.org/news/species/202012/european-bison-recovering-31-species-declared-extinct-iucn-red-list

Jørgensen, Dolly, and Franklin Ginn. 2020. "Environmental Humanities: Entering a New Time." *Environmental Humanities* 12 (2): 496–500. doi: 10.1215/22011919-8623252.

Kelly, Jason M., Philip Scarpino, Helen Berry, James Syvitski, and Michel Meybeck, eds. 2017. *Rivers of the Anthropocene*. Berkeley: University of California Press.

Lewis, Bradley. 2020. "Planetary Health Humanities—Responding to COVID Times." *Journal of Medical Humanities* 42: 3–16. doi: 10.1007/s10912-020-09670-2.

Marder, Michael. 2013. *Plant-Thinking: A Philosophy of Vegetal Life*. New York: Columbia University Press.

Marvin, Garry, and Susan McHugh. 2014. "In It Together: An Introduction to Human–Animal Studies." In *Routledge Handbook of Human–Animal Studies*, edited by Garry Marvin and Susan McHugh, 1–9. London: Routledge.

Mišík, Matúš, and Nada Kujundžić. 2021b. "Introduction." In *Energy Humanities. Current State and Future Directions*, edited by Matúš Mišík and Nada Kujundžić, 1–21. Cham: Springer Nature.

O'Gorman, Emily, et al. 2019. "Teaching the Environmental Humanities." *Environmental Humanities* 11 (2): 427–460. doi: 10.1215/22011919-7754545.

Oppermann, Serpil, and Iovino Serenella, eds. 2017. *Environmental Humanities: Voices from the Anthropocene*. London: Rowman & Littlefield International.

Ritchie, Hannah, and Max Roser. 2020. "*Energy*." Accessed December 31, 2020. https://ourworldindata.org/energy.

Roberts, Peder, Adrian Howkins, and Lize-Marié van der Watt. 2016. "Antarctica: A Continent for the Humanities." In *Antarctica and the Humanities*, edited by Peder Roberts, Lize-Marié van der Watt and Adrian Howkins, 1–23. London: Palgrave Macmillan.

Robinson, Kim Stanley. 1997. *Antarctica*. London: HarperVoyager.

Roddick, Andrew P. 2018. "The Paleoenvironmental Humanities: Climate Narratives, Public Scholarship , and Deep Futures." *Current Swedish Archeology* 26: 79–85. doi: 10.37718/CSA.2018.07.

Rose, Deborah Bird, Thom van Dooren, and Matthew Chrulew. 2017b. "Introduction: Telling Extinction Stories." In *Extinction Studies: Stories of Time, Death, and Generations*, edited by Deborah Bird Rose, Thom van Dooren and Matthew Chrulew, 1–17. New York: Columbia University Press.

Rutz, Christian, et al. 2020. "COVID-19 Lockdown Allows Researchers To Quantify the Effects of Human Activity on Wildlife." *Nature Ecology and Evolution* 4 (9): 1156–1159. doi: 10.1038/s41559-020-1237-z.

Ryan, John Charles, ed. 2017. *Southeast Asian Ecocriticism: Theories, Practices, Prospects*. Lanham: Lexington Books.

Ryan, John Charles, ed. n.d. *forthcoming*. "Passive Flora? Reconsidering Nature's Agency through Human–Plant Studies." In *Nature and Sustainability Beyond Humanism: A Reader in Environmental Anthropology*, edited by Sarah Osterhoudt and Kalyanakrishnan Sivaramakrishnan. Seattle: University of Washington Press.

Ryan, John Charles, and Li Chen, eds. 2019. *Australian Wetland Cultures: Swamps and the Environmental Crisis*. Lanham: Lexington Books.

San Martín, William, Alexandra Vlachos, and Graeme Wynn. 2020. "*Epidemics and Ecologies: Reading in the Time of COVID-19*." Accessed December 30, 2020. http://www.iceho.org/reading-in-the-time-of-covid-19.

Singer, Peter. 1996. "Animal Liberation." In *Animal Rights: The Changing Debate*, edited by Robert Garner, 7–18. Basingstoke: Macmillan.

Sörlin, Sverker. 2017. "Scaling the Planetary Humanities: Environmental Globalization and the Arctic." In *The Routledge Companion to the Environmental Humanities*, edited by Ursula Heise, Jon Christensen, and Michelle Niemann, 449–458. London: Routledge.

Szeman, Imre, and Dominic Boyer. 2017b. "Introduction: On the Energy Humanities." In *Energy Humanities: An Anthology*, edited by Imre Szeman and Dominic Boyer, 1–14. Baltimore: Johns Hopkins University Press.

Thornber, Karen. 2014. "Literature, Asia, and the Anthropocene: Possibilities for Asian Studies and the Environmental Humanities." *The Journal of Asian Studies* 73 (4): 989–1000. doi: 10.1017/S0021911814001569.

Trewavas, Anthony. 2014. *Plant Behaviour and Intelligence*. Oxford: Oxford University Press.

Welling, Bart, Jacob Goessling, and Jordan B. Kinder. 2020. "*A Nearly Carbon Neutral Virtual Symposium*." Accessed December 30, 2020. https://www.asle.org/stay-informed/asle-news/humanities-on-the-brink-energy-environment-emergency-asle-2020-virtual-symposium/.

Wilson, Sheena, Adam Carlson, and Imre Szeman. 2017b. "On Petrocultures: Or, Why We Need to Understand Oil to Understand Everything Else." In *Petrocultures: Oil, Politics, Culture*, edited by Sheena Wilson, Adam Carlson and Imre Szeman, 3–19. Montreal: McGill-Queen's University Press.

Index

Page numbers in *Italics* refer to figures.